CHAUCER

CHAUCER

Visual Approaches

Edited by
Susanna Fein and David Raybin

The Pennsylvania State University Press University Park, Pennsylvania

Library of Congress
Cataloging-in-Publication Data

Names: Fein, Susanna, 1950– , editor. | Raybin,
 David B., 1951– , editor.
Title: Chaucer : visual approaches / edited by
 Susanna Fein and David Raybin.
Description: University Park, Pennsylvania :
 The Pennsylvania State University Press,
 [2016] | Includes bibliographical references
 and index.
Summary: "A collection of twelve illustrated
 essays modeling innovative approaches to read-
 ing Chaucer's visual poetics. Essays explore
 connections between Chaucer's texts and vari-
 ous forms of visual data, medieval and modern,
 that can deepen and inform our understanding
 of Chaucer's poetry"—Provided by publisher.
Identifiers: LCCN 2016018580 |
 ISBN 9780271074801 (cloth : alk. paper)
Subjects: LCSH: Chaucer, Geoffrey, –1400—
 Criticism and interpretation. | English
 poetry—Middle English, 1100–1500—History
 and criticism. | Illumination of books and
 manuscripts—England—History—To 1500. |
 Chaucer, Geoffrey, –1400—Symbolism. | Art
 and literature—England—History—To 1500. |
 Art, Medieval—Themes, motives.
Classification: LCC PR1924 .C455 2016 |
 DDC 821/.1—dc23
LC record available at https://lccn.loc.gov
 /2016018580

Published by
The Pennsylvania State University Press,
University Park, PA 16802–1003

The Pennsylvania State University Press is a mem-
ber of the Association of American University
Presses.

It is the policy of The Pennsylvania State Uni-
versity Press to use acid-free paper. Publica-
tions on uncoated stock satisfy the minimum
requirements of American National Standard for
Information Sciences—Permanence of Paper for
Printed Library Material, ANSI Z39.48–1992.

Typeset by
click! Publishing Services

Printed and bound by
Thomson-Shore

Composed in
Adobe Garamond and Futura

Printed on
Sappi Flo matte

Bound in
Arrestox

CONTENTS

ILLUSTRATIONS

As editors of the *Chaucer Review*, we are pleased to celebrate a milestone anniversary for the journal. This collection of essays, *Chaucer: Visual Approaches*, commemorates the *Chaucer Review*'s fiftieth year in service to the international community of Chaucer scholars. We have chosen to mark this occasion by calling attention to a field that seems to be still somewhat underdeveloped, and yet is, at this moment in Chaucer scholarship, ripe for future research of an exciting kind. As Robert Correale and Mary Hamel observed more than a decade ago, despite widespread evidence that "non-literary sources—such as memory, manuscript production and illumination, and iconography"—profoundly affected Chaucer's poetry, such nontextual influences still remain relatively little examined. A key feature these neglected sources have in common is that, in the medieval period, each one encompassed a visual art. Correale and Hamel predicted that "in years to come, increased interest in these and similar kinds of 'sources'" would "shap[e] the contours" of future studies.[1] And, indeed, each of these sources is central to one or more of the visually oriented approaches that inform the chapters in this volume

In offering to Chaucerians and other medievalists an amply illustrated volume of essays, we hope to display an array of models for how Chaucer may be read alongside visual evidence. The universe of medieval research is rapidly being opened up by a new accessibility to manuscripts and printed early books. With digitized facsimiles and other types of medieval imagery being exquisitely reproduced in high-quality, easy-to-use formats, readers possess a previously unheard-of access to a wide array of evidence. We can now examine the visual essence of Chaucer's earliest textual records alongside many of the most sumptuously illuminated manuscripts of Great Britain and the Continent. With the essays in this volume adding such evidence to the common store of primary resources, it is our hope that this book will deepen the ways that Chaucer's modern-day audience reads, teaches, and studies the poet, and that it will inspire outlooks that are deeply conceived and historicized in ways that involve the visual culture of his time.

Given the current interest of many literary scholars and art historians in exploring convergences of text and image (a phenomenon now frequently termed an *imagetext*),[2] it may seem surprising that visually oriented scholarship has, in recent decades, only

sporadically focused on the works of Geoffrey Chaucer.[3] V. A. Kolve's groundbreaking *Chaucer and the Imagery of Narrative* (1984) might have been expected to precipitate a flurry of visually informed Chaucerian practice, but, strangely, perhaps because of the singular scope of Kolve's achievement, few succeeding scholars have taken up this book's challenge. Kolve's later *Telling Images: Chaucer and the Imagery of Narrative II* (2009) remains unusual, therefore, in how it approaches Chaucer's poetry from the sustained perspective of imagery. While many scholars of Chaucer and other fields have astutely uncovered and defined elements of a contemporary medieval visual poetics, there still does not exist any kind of unified sourcebook for the theories and practices introduced by this research for Chaucerians. This volume seeks to begin to fill that lacuna by displaying how current formulations regarding the intersection of text, image, and cultural meaning can significantly inform the ways we approach Chaucer's art.

Almost immediately upon Chaucer's death, illustrators for the *Canterbury Tales* sprang up. Most early Chaucer manuscripts had decorative programs, and a good many included images of human figures. Surviving illustrations include portraits of Chaucer (seemingly the earliest surviving depictions of any English poet) as well as images of his pilgrim narrators—pictures that imply contemporary artists expressing their responses to the verbal descriptions in the *General Prologue*. Some of the most familiar representations include, of course, the pilgrim portraits in the Ellesmere manuscript, the Chaucer portrait in a manuscript of Hoccleve's *Regiment of Princes*, and the frontispiece to a *Troilus and Criseyde* manuscript where Chaucer is shown reciting before a courtly audience.[4] Other early fifteenth-century specimens include four different poet portraits inside illuminated initials in *Canterbury Tales* manuscripts;[5] a frontispiece introducing the *Complaint of Mars*;[6] and other assemblages of pilgrim portraits.[7] All of these illustrations are now readily available online as well as in print.

The practice of illustrating Chaucer's texts continued with the transition from scribal manuscripts to printed editions. Although William Caxton's 1476 first edition of the *Canterbury Tales* did not contain illustrations, an extensive series of woodcuts was central to the design of his 1483 second edition, and a series also appeared in Wynkyn de Worde's edition of the *Canterbury Tales* in 1498. Over the centuries it has been common for editions of Chaucer's works to include visual interpretations of the poet and his speakers. William Blake, Edward Burne-Jones, and Rockwell Kent are but some of the most prominent among many artists whose programs of paintings, woodcuts, engravings, and drawings have adorned the pages of deluxe Chaucer editions or been displayed in museums. Scholarship on the history of pictorial response to Chaucer has been marked most recently by William Finley and Joseph Rosenblum's handsome collection *Chaucer Illustrated* (2003). Work such as this offers essential background for the essays in the present volume. But, alongside a focus on how Chaucer's texts were illustrated, this volume

of visual criticism also explores a host of iconographic and perspectival topics, as well as a range of historicized methodological approaches.

We have organized the new essays of this volume into three large categories of visual criticism: part I, "Ways of Seeing"; part II, "Chaucerian Imagescapes"; and part III, "Chaucer Illustrated." In the "Ways of Seeing" section are clustered keen reminders of how medievals saw the world in ways that often contrast with how moderns might contemplate the past through our own temporal and visual biases. What are some useful methods that can cause us to adjust our ways of seeing to better comprehend how a medieval person articulated his or her experience in the world? The historicized ways of seeing displayed here involve richly cross-disciplinary work: (1) correlating artistic expressions to literary art by attending closely to each medium and its attendant contexts; (2) seeking the formal, imagistic role of memory banks in medieval artistic creation; (3) opening our eyes to striking innovations in architectural space and perspectival representation; and (4) detecting how devotional literacy was honed and trained by means of verbal-visual diagrams of intellectually intricate, didactic graphic design. The methods shown in this section highlight intersections with the domains of art history, manuscript illumination, memory and cognition, rhetorical theory, architecture, optical perspective, graphic design, contemplative religion, and pedagogy.

The section begins with Ashby Kinch's bracing chapter on "Intervisual Texts, Intertextual Images: Chaucer and the Luttrell Psalter." Here Kinch puts the *Canterbury Tales* in dynamic dialogue with the Luttrell Psalter, a landmark of fourteenth-century English manuscript illumination. Although scholars have deployed Luttrell for evidence of Chaucer's "world," and vice versa, they tend not to treat the two works as aesthetic equals. Kinch argues that scholars of both literature and art need to attend patiently to the adjacent field's norms and values, methods and contexts, instead of treating only their own preferred object of value. He urges the necessity of bridging, in practical terms, the theoretical concepts of *intervisuality* and *intertextuality* to bring the two fields closer together. For Chaucerians, Kinch's provocative reading of the Luttrell Psalter artists' "meta-artistic play, which draws special attention to the conditions of artistic creation," leads to flashes of recognition regarding very similar impulses in our poet. The semiotically complex image-texts of Luttrell suggest how much medieval viewers/readers of a generation earlier were prepared to be delighted by displays of artistic self-referentiality, playful irreverences, and social ironies, such as were Chaucer's stock-in-trade.

The next chapter, "Creative Memory and Visual Image in Chaucer's *House of Fame*," by Alexandra Cook, is grounded in the classical and medieval concept of artificial memory—that is, the mental making of "memory places." Cook counters notions that memory in the *House of Fame* is portrayed as being subject to flaws and distortions, arguing that Chaucer uses the topoi of memory in ways inflected by the productive memory

matrices fashioned, in particular, by the thirteenth-century rhetorician John of Garland. John's use of visual cues to divide the matter one wishes to remember is similar to those cues performed by speaking pictures in the aerial spaces of Fame's houses, and juxtaposing John's matrices with Chaucer's poem suggests analogies between the creative memory and poetry. Like the rhetorical workings of medieval memory theory, Chaucer's vernacular poetry is ultimately based in synthesis: it generates new material precisely by supplementing and refiguring the classical texts it memorializes. Cook's chapter thus deploys rhetorical memory theory in an original manner, showing how in the *House of Fame* Chaucer calls up images as a method by which to renew and refashion the classical past, and as a way for himself to become part of its memorializing *fama*.

Sarah Stanbury's chapter, "'*Quy la?*': The Counting-House, the *Shipman's Tale*, and Architectural Interiors," emphasizes how much built structures are inherent to the cultural fabric of people's lived experiences, situating each individual within a visually compartmented, material setting of walls and functional spaces—spaces used familiarly and yet connotative of status and susceptible to fashionable trends. In the *Shipman's Tale*, Chaucer orients house and action around a private room reserved for calculating. Looking at Chaucer's portrayal of domestic space, Stanbury proposes that the Saint-Denis merchant's counting-house reflects architectural innovations in bourgeois house design in England as well as on the Continent. Chaucer's representation corresponds, moreover, with fascinating reorientations of interior space in painting, a recalibration of visual relationships that social historians have traced in part to the centrality of the home in a newly mercantile world. In examining the idea and terminology of the counting-house as an architectural feature in urban houses, Stanbury suggests that Chaucer references models of bourgeois spatial design that have a broad reach in late medieval aesthetics: the sanctification of private space and furnishings. By means of a multimodal analysis of architectural space, Stanbury sharpens and contextualizes how Chaucer deploys this visual/spatial feature in the narrative structure of the *Shipman's Tale*.

In the fourth chapter, "The Vernon Paternoster Diagram, Medieval Graphic Design, and the *Parson's Tale*," Kathryn Vulić scrutinizes the Paternoster diagram occupying most of a page in the monumental Vernon manuscript—surely one of the most extraordinary visual/literary representations to survive from late medieval England. As in the *Parson's Tale*, where Chaucer writes that "in the orison of the *Pater noster* hath Jhesu Crist enclosed moost thynges" (X 1039),[8] the designer's interest is mainly on the sins and their remedies. Collating different kinds of visual evidence (iconography, paleography, graphic layout, etc.), Vulić leads us through the diagram's structure, texts, and optical details. Graphic design defines its seven petitions, laid out in nine columns and sixteen rows of text, translation, and commentary in English and Latin. Letter size, ink color, nonfigural drawings, and a single foliate head delineate interrelated concepts. In its complex mixture of horizontal and vertical logic, the Vernon diagram creates an absorbing meaning-by-graph

that casts each word as an image. By educating us in another medieval "way of seeing," Vulić's chapter aptly bookends Kinch's chapter about the intervisuality and intertextuality shared by many medieval artists and poets. Her study intricately describes another variety of visual/verbal rhetoric that Chaucer's audience would have readily grasped and valued as a benefit to their inner lives, wherein "word and image work together to provoke deep thought and engagement with the experience of prayer."

The second section, "Chaucerian Imagescapes," considers specific cultural realms of clustered imagery that were habituated elements in Chaucer's normal mental experience of the world, but that are, generally speaking, much faded or forgotten from the ways we record our experiences today. Studies of narrative imagery have long sought to recover meanings from ways of thought belonging to artists, often based in signs that people from another era reflexively noted in their environments. It is worth reminding ourselves what things medievals "saw" that we might overlook—that is, how they adorned their communal worlds with visual tokens that affected the ways experience was verbalized. The domains discussed in this section display a wide range, from religious to secular to aesthetic: (1) reflexive visualizations of a sacred icon in cultural response to shared eucharistic practice; (2) humorous cross-Channel understandings and visualizations of tavern behavior; (3) reflections on how medieval thinkers including Chaucer saw poetry and painting, the "sister arts," as intertwined; and (4) the visual-narrative admixture that belongs to the lore of miracles recorded at churches and cathedrals, in stories and stained glass. The imagescapes chosen here revolve on the Passion of Christ, the "ape-ness" of drunken men, the medieval aims of imagetexts themselves (visual art merged with poetry), and the storytelling imagery that attaches to iconic hagiography. The future potential for exciting studies on other newly defined imagescapes is very broad indeed.

Chapter 5, "Standing under the Cross in the *Pardoner's* and *Shipman's Tales*," inaugurates the "Chaucerian Imagescapes" section with a transition in focus from the "Ways of Seeing" category. Susanna Fein argues that a signally important Chaucerian imagescape was available to fourteenth-century readers—namely, a sacramentally inflected "shared visual poetics tinged with the visionary," which remains steadily poised (invisibly yet apprehensibly) behind and beyond these tales' actions and words. Resting side by side in the *Canterbury Tales* manuscript tradition, the *Pardoner's* and *Shipman's Tales* individually prompt readers to mentally apprehend the iconic sign of Jesus suffering on the Cross. The visualization is evoked by verbal oaths that contain profanity and double entendre, as well as by specific figural likenesses to the Passion scene. While the tales' materialists see only what is physically before them, their impious oaths summon all-seeing God, who watches them act willfully in spiritual blindness. The invisible divine presence thus stealthily enters these narratives, allowing for spiritual sights and insights confirmed in the final oaths pronounced by the Host when the tales conclude. To grasp the powerful workings of a reflexive mental image—grounded in firm belief, ripe to be cued by unmistakable

prompts—offers an approach that, as Fein explains, expands our understanding of Chaucer's imagistic art.

Chapter 6 surveys a far different sort of imagescape informing Chaucer's quotidian existence, this one wholly secular and jocular, though not without a whiff of wry, philosophic reflection on the human condition. Communicated through a wealth of visual information gathered from various library archives and museum collections, Laura Kendrick's chapter on "Disfigured Drunkenness in Chaucer, Deschamps, and Medieval Visual Culture" takes as its point of departure Chaucer's frequent references to drinking, along with widespread cultural comparisons of drunken men to apes. When Chaucer's Cook, reeking of alcohol, sways on his horse, the Manciple posits that he has drunk of "wyn ape" (*Manciple's Prologue*, IX 44)—that is, is so intoxicated he is "ape-drunk." To contextualize this mocking reference, Kendrick turns to poems in which the French poet Eustache Deschamps satirizes the drinking habits of leading members of the French court, imagining an "Order of the *Baboe*"—a comic society cognate with chivalric societies popular among French and English nobility. Turning to material culture, Kendrick shows how an association of apes with drunkenness was depicted by images of *babewyns* and monkey business in ornate manuscripts and on metal drinking cups. By exploring the underlying imagescape of human drunkenness being akin to "ape-ness," this study delivers much informative insight into how fourteenth-century visual media recorded attitudes on the grotesque excesses of tavern-goers and courtier fraternities.

In the next chapter, "The *Franklin's Tale* and the Sister Arts," Jessica Brantley uses statements made by Chaucer's Franklin as a touchstone for exploring interartistic theory and practice in the late Middle Ages. The Franklin's modest mention of his deficient understanding of the "colours of rethoryk" (V 726) raises real questions about the twin arts of poetry and painting. Was there a contemporary philosophy of visual/verbal representation that underlies the Franklin's comment? Brantley suggests that the intermedial mixing of the *Franklin's Tale* is not motivated by a desire for increased verisimilitude, but instead by a sense of how artifice is embedded in each system of representation. It is not nature that the Franklin is finally interested in, but rather the colors "as men dye or peynte" (V 725). In developing the black rocks as a potent metaphor, Chaucer aligns "the magical human power that seems to move the rocks with the divine creative power that first formed them." In Brantley's view, then, the *Franklin's Tale* articulates a Chaucerian "treatise on poetry and painting—his theory of the imagetext." Her thoughtful exploration of the Franklin's fraught statement on "colours" thus ushers in a provocative new perspective on the very idea of "imagetext," one refracted both practically and theoretically, in ways both culturally medieval and specifically Chaucerian.

David Raybin, in chapter 8, "Miracle Windows and the Pilgrimage to Canterbury," introduces a specific imagescape that is arguably Chaucer's touchstone for his iconic association of Canterbury with a storytelling pilgrimage: the Cathedral's magnificent

early thirteenth-century windows, which display in brilliant color and light the miracles of Thomas Becket. Raybin's wide-ranging, historically contextualized study reminds us that medieval visual arts utilized many more media than simply paint and parchment. Once narrative imagery has been enshrined for centuries in colorful glass within soaring Gothic windows, refracting light on a hallowed public space of pilgrimage and worship, it becomes itself a powerful text that literally illumines the viewer/reader. In stained-glass depictions crafted nearly two hundred years before Chaucer devised the *Canterbury Tales*, artists included stories of not only priests and nuns but also secular folk of diverse occupation and social rank. Raybin contextualizes his reading by noting Chaucer's long-term residency in the shire of Kent, his narrative uses of vivid pictorial glass in earlier poems, and the telling, pseudo-Chaucerian reimaging of the pilgrims as tourists gazing on the Canterbury windows in the early fifteenth-century *Tale of Beryn*. The study brings us back to remembering that the pilgrims' immediate destination was a real place that then, as now, encases treasured stories in visual beauty.

The third and final section of this book on visual approaches to Chaucer looks at "Chaucer Illustrated." Here the contributors aim to articulate new methods within what has been, historically, a well-worked field. The four chapters presented here offer new perspectives based in literary iconography, scribal notation, manuscript illumination, and modern book illustration. Their authors provide methods by which to see and read images or signs that adorn Chaucer's texts, including (1) how iconographical traditions in England borrowed prevalent patterns from the *Roman de la Rose*, a sophisticated Continental model; (2) how underlining in manuscripts, usually in red, betrays vestiges of how the *Parliament of Fowls* was received in the fifteenth century; (3) how ornament and design in the important Ellesmere manuscript suggest a mode of subtle commentary on the text; and (4) how a modern avant-garde artist irrepressibly infused her artwork with eclectic, stimulating responses to Chaucer's tales. The methods shown here open some new pathways simply by way of their daring: challenging received opinion on how supposedly unsophisticated are fourteenth-century English illustrators; using small scribal details to detect the mental habits of educated fifteenth-century readers; unlocking verbal/visual readings in the decorated margins of Ellesmere; and exposing the subjectivity of all critical acts through the unabashed brilliance of a sculptor-illustrator.

The first chapter in this group, Joyce Coleman's "Translating Iconography: Gower, *Pearl*, Chaucer, and the *Rose*," subtly bridges the move from "Chaucerian Imagescapes" to this third category, "Chaucer Illustrated," by explicating how a famous portrait of Chaucer, in which he is shown reading a book (probably *Troilus*) to a courtly audience, borrows its subject and pose from the influential *Roman de la Rose*, an imagetext of high cultural valence. Coleman explores, by means of a convincing sweep of the visual data, how iconography derived from *Rose* exemplars was variously reconfigured in manuscripts holding three major Middle English texts. Such iconography appears in the confession

scene in Gower's *Confessio Amantis*, the dreamer scene in *Pearl*, and the "sermon" scene in Chaucer's *Troilus and Criseyde*. In each case, the author's nativization of the *Rose* ethos was matched by an illuminator who visually appropriated *Rose* images, with the iconic reference serving both to connect the Middle English text to the high status of the French source and to mark out an independent reimagining of the tradition. The original viewers of these illuminations were invited to display their transcultural sophistication by recognizing the restaging of a prestigious iconography in an English-language context. Coleman's analysis ultimately mounts a defense of English illumination against claims of its supposed inferiority to French art, and she demonstrates, concomitantly, what such programs of illustration can teach us about English poetry.

The next chapter, "'Qui bien aime a tarde oblie': Lemmata and Lists in the *Parliament of Fowls*," isolates for close study a different type of visual manuscript feature, this one effected by scribes or early owners. Comparing two manuscript copies of the *Parliament*, Martha Rust notes how locating the poem's lists of tragic lovers (lines 286–92) and of bird species present at the Valentine's Day gathering (lines 337–64) is easy because the scribes of these two manuscripts have underlined in red ink the names in the two lists. The lengthy bird list becomes itself an eye-catching feature on a manuscript page because twenty-four out of twenty-eight consecutive lines begin with the word *The*. Rubrication and repetition call readers out of the world of the dream vision, focusing them instead on the space of the book at hand and recalling them, in turn, to other bookish situations that feature lists of birds, lovers, or other categories of things. Primary among these bookish situations would be volumes quite familiar to the gentlemen who owned copies of *Parliament*—namely, books of Latin grammar that conferred value on long lists of nouns and reveled in the collection of lexical items. An interesting benefit of Rust's visual approach rests in its provocative investigation of the identities of two early reader owners of manuscripts containing Chaucer's dream poem. Rust sketches profiles of these gentlemen from different parts of England—men who would have shared similar grammar school experiences, wherein underlined lists would recall specific associations acquired from specific texts taught commonly to all. Thus has Chaucer been "illustrated" in a most bookish manner.

Chapter 11, "The Visual Semantics of Ellesmere: Gold, Artifice, and Audience," by Maidie Hilmo, continues the focus on exceptional visual elements worthy of special notice in early manuscripts of Chaucer. Such elements and their effects are, of course, wholly effaced in modern editions. The center of attention here, the Ellesmere manuscript, has long been prized not only for its text but also for its elegance of presentation, with lush, gold-adorned borders, decorated letters, marginalia, and illustrations of Chaucer's pilgrims. Hilmo suggests that these elements are intercalated with text to create meaning in nonverbal ways. Among the effects is the application of gold and other expensive coloration to the portraits of specific pilgrims, implying distinctions in status. Ellesmere was designed, according to Hilmo, to be savored as a "holistic visual-literate experience,"

wherein text and decoration "work seamlessly together" in a "grand display," establishing the book's suitability for ownership by an aristocratic connoisseur. When the pilgrim portraits are viewed in their collective manuscript context, they create more meaning than when they are viewed as a group isolated from the volume's resplendent display. To gauge the book in toto, one sees that the Ellesmere scribe and artists convey a sumptuous portrait of Chaucer designed to attract, please, and inform an elite audience.

In the final chapter, "Drawing Out a Tale: Elisabeth Frink's *Etchings Illustrating Chaucer's 'Canterbury Tales,'*" Carolyn P. Collette details how, in 1972, the British sculptor Frink completed a monumental illustrated edition to accompany Nevill Coghill's translation of the *Canterbury Tales*. Collette's sensitive account of Frink's engravings conveys both their intrinsic power and the ways each image creatively "departs from, yet builds on the literal text." The limited-edition volume is an extravaganza—large, expensive, and challenging. It includes nineteen etchings hand-drawn directly on copper plates. With pages more than twice the size of those in the Vernon manuscript, the volume "is almost impossible to lift or move." For Chaucerians, Frink's accomplishment as illustrator offers a startling new perspective on the *Tales* by presenting an outsized focus on men, horses, and sex. Her artistry exposes how individual perception shapes the craft of interpretation. Collette astutely observes how Frink's etchings cause us to consider "the perennial question of the imbrication of an author's intention and an audience's inference in interpretation," a question that arises from "the combination of empathic imagination and inference that lies at the heart of critical practice." Frink herself was consistent and transparent in describing her work as centered in feeling, not representation. To quote the translator Coghill's summation about his illustrator, Frink's etchings "speak of Chaucer for our own times, as Burne-Jones and William Blake spoke for theirs, and earlier still the Ellesmere manuscript. There is always more to see in Chaucer."[9]

There *is* always more to see in Chaucer. Scholarship has made abundantly clear how thoroughly the poet was invested in medieval and classical literature, religion, and philosophical thought. The *Chaucer Life-Records* compiled by Martin M. Crow and Clair C. Olson document the civil servant's work in and around London and his many and frequent journeys across England and the Continent. The essays in this volume seek to remind us that, as he read and traveled, Chaucer had an eye for the details in whatever he encountered. His poetry and prose reflect a profound, sustained immersion in the many facets of his culture's visual reflexes and habits. As we find new ways to bring our own eyes into contact with Chaucer's, we will discover an extraordinarily rich vision. It is our hope that as readers reflect on the essays in this book, they will not only see Chaucer differently but also be inspired to uncover visual Chaucers of their own.

Susanna Fein and David Raybin

NOTES

1. Correale and Hamel, eds., *Sources and Analogues*, 2:x.

2. See, for example, Mitchell, *Picture Theory*, 94–107; and Brantley, "Vision, Image, Text," esp. 315–17.

3. A notable exception is Stanbury, "Visualizing."

4. These manuscripts are San Marino, Huntington Library MS El 26 C; London, British Library MS Harley 4866; and Cambridge, Corpus Christi College MS 61, respectively.

5. London, British Library MS Lansdowne 851; Oxford, Bodleian Library MS Bodley 686; Oxford, Bodleian Library MS Rawlinson poet. 223; and Tokyo, Takamiya Collection MS 24

(Devonshire manuscript). On these and later Chaucer portraits, see Pearsall, *Life of Geoffrey Chaucer*, 285–305; and Cooper, "Chaucerian Representation."

6. Oxford, Bodleian Library MS Fairfax 16.

7. "Oxford Fragments" (Manchester, John Rylands Library MS English 63, and Philadelphia, Rosenbach Museum and Library MS 1084/2); and Cambridge, University Library MS Gg.4.27.

8. All citations from the works of Chaucer in this volume derive from Chaucer, *Riverside Chaucer*, unless otherwise noted.

9. Coghill, "Introduction," in Frink, *Etchings Illustrating Chaucer's "Canterbury Tales."*

ACKNOWLEDGMENTS

We warmly acknowledge the strong and enthusiastic community of medieval scholars who have made our editorship of the *Chaucer Review* a deeply rewarding experience. This book's topic arose when the journal sponsored three sessions on "Text and Image" at the Forty-Eighth International Congress on Medieval Studies in Kalamazoo, Michigan, in May 2013. This event sparked the idea that "Visual Approaches" was a fitting way to celebrate the *Chaucer Review*'s transition from its first to its next fifty years. For the results, some beginning at those sessions, some originating elsewhere, we are indebted to our group of visually attuned and literarily gifted contributors: Jessica Brantley, Joyce Coleman, Carolyn Collette, Alexandra Cook, Maidie Hilmo, Laura Kendrick, Ashby Kinch, Martha Rust, Sarah Stanbury, and Kathryn Vulić. We also thank others for inspiration and friendly encouragement: Kathy Ashley, Julia Boffey, Martha Carlin, Rebecca Davis, Tony Edwards, Kristen Figg, John Friedman, Paul Hardwick, Ruth Hoberman, Bobby Meyer-Lee, Stephen Partridge, and Tara Williams.

Kent State University has provided generous institutional support for this book. For this, we extend a special thank you to Grant McGimpsey, former vice president, and Paul E. DiCarleto, current vice president, of Kent State's Office of Research and Sponsored Programs, as well as to Robert Trogdon, chair of the English Department. David appreciates the support for his research provided by the Office of Research and Sponsored Programs at Eastern Illinois University.

For our own contributions, we are grateful for incisive comments received at the 2014 University of Illinois Medieval Studies Seminar, the 2015 London Chaucer Conference, and the 2015 University of Alabama Hudson Strode Renaissance Program Lecture Series. Research conducted in London and Canterbury was serendipitously supported by the National Endowment for the Humanities, which put us there while we directed the 2014 NEH Summer Seminar on the *Canterbury Tales*. While this book was being formed, Susanna, as Fall 2014 Visiting Professor, benefited from the climate of inquiry that exists among medievalists at the University of Notre Dame.

We are most of all grateful to the Pennsylvania State University Press for its long-standing support of the *Chaucer Review* and its many endeavors, symbolically capped by

this book. Director Patrick Alexander and Editor in Chief Kendra Boileau offered continuous encouragement and advice. The editorial team of Cate Fricke, Hannah Hebert, Jennifer Norton, Laura Reed-Morrisson, Julie Schoelles, and Alex Vose has been a thorough pleasure to work with, and we extend singular praise to copyeditor Nicholas Taylor, whose attention to detail delighted our authors. PSUP nurtures its journals well. Thanks to its ongoing support, Chaucer studies has evolved vibrantly over the past fifty years, and it shall continue to do so.

PART I

WAYS OF SEEING

ONE

Intervisual Texts, Intertextual Images

Chaucer and the Luttrell Psalter

Ashby Kinch

One of the most striking of English Gothic manuscripts, the Luttrell Psalter (London, British Library MS Additional 42130) consists of a calendar, the psalms and canticles, a litany with collects, and the Office of the Dead. It is closely related in key stylistic traits and shared content with deluxe manuscripts from East Anglia—the Ormesby and Rutland Psalters—and from London workshops—the Smithfield Decretals and the Taymouth Hours.[1] The Luttrell Psalter was produced in two campaigns by five different artists who occasionally worked in tandem.[2] Only fourteen lines of text appear on each large page (360 × 245 mm), providing ample space for marginal illustrations, which appear on 200 of the 309 folios. The staggering scope of the marginal illustration was a conscious design principle, unique in its period.[3] Due to the abundant scenes of daily life that appear in the margins, images culled from the Luttrell Psalter have been a mainstay of popular publications on the daily life of medieval England for over two centuries. Modern authors draw especially from the manuscript's representations of games (e.g., fols. 157r, 158v, 159r, 161r), agricultural practices (fols. 170r–173v), and feast preparations (fols. 204r–208r).[4] Students of Chaucer are familiar with scenes from the Luttrell Psalter, as reproductions of its marginal images regularly appear in books aiming to illustrate "Chaucer's World,"[5] even though work on the Luttrell Psalter was begun in the 1330s (before Chaucer was born) and abandoned by 1345.[6]

This habit of decontextualizing medieval manuscript images (and the Luttrell Psalter is by no means unique in serving this illustrative function) obscures the complex conditions under which such a deluxe manuscript was produced, received, and transmitted. By contextualizing both the psalter itself as well as its use and abuse in modern scholarship, Michael Camille's *Mirror in Parchment* corrects some of the critical imbalances resulting from the "assumption that pictorial representations are an unmediated and direct expression of the 'real.'"[7] This tendency can be seen in even so astute a critic of the visual arts as V. A. Kolve, whose *Chaucer and the Imagery of Narrative* transformed the way Chaucerians look at images. At a key moment of definition, Kolve uses this very term— "unmediated"—to characterize the difference between Chaucer's "narrative images" and what he terms "symbolic images." The latter, he states, are "known from other medieval contexts, both literary and visual, where their meanings are stipulative and exact, unmediated by the ambiguities and particularities of fiction."[8] The idea of an "unmediated" image enables Kolve to approach visual material as static cultural evidence, which does not require sophisticated interpretation when placed alongside the "ambiguities and particularities" we so cherish in Chaucer. Indeed, in later work Kolve claimed that the Luttrell image of a carter on folio 173v "records medieval life free of transcendent system, fitted catch-as-catch-can into the uncommitted space of the manuscript's borders" (fig. 1.1).[9] While the interpretive energy Kolve generates in his penetrating readings of Chaucer justifies to some extent this neutralization, the Luttrell Psalter is neither "free of transcendent system" nor are its images "fitted catch-as-catch-can." The manuscript is designed to showcase a particular transcendent system, chivalric power, as realized in the local English village context in which that power was manifest. Its images are thoroughly mediated by this context, as well as by the craft practices of medieval illustration, which generate their own "particularities" or, in Paul Binski's phrase, forms of "serious intelligence."[10]

As several decades of excellent scholarship on the Luttrell Psalter have revealed, the overlapping contexts of devotional reading, aristocratic display, and regional politics provide powerful tools by which to analyze the surprising and endlessly fascinating links among image, text, and the social and political world of pre-plague England.[11] Despite its affiliation with contemporary illustrated devotional manuscripts, the Luttrell Psalter is an idiosyncratic production that catered to the tastes, interests, political aspirations, and anxieties of its patron, Sir Geoffrey Luttrell, who appears in a famous arming scene on folio 202v, beneath the caption "Dominus Galfridus Louterell me fieri fecit" (Lord Geoffrey Luttrell had me made) (fig. 1.2). The magisterial execution of this image and a companion feast scene eleven folios later, on 208r (fig. 1.3), have been the focus of recent scholarship because these scenes represent an ideology of lordship, providing insight into how a specific patron attempted to sacralize his lordship by means of imagery.[12] These images suggest that he is both the divinely sanctioned *dominus* who realizes God's plan for order in a chaotic world, and also a humble penitent who seeks comfort in an all-powerful

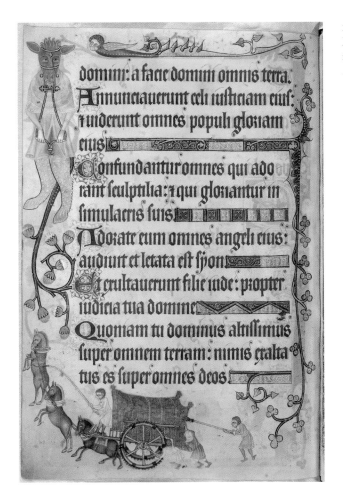

FIG. 1.1 Carter in margin, Luttrell Psalter. London, British Library MS Additional 42130, folio 173v.

God. The feast image realizes the correspondence between *dominus* and *Dominus* in a particularly effective way by echoing the form and design of a Last Supper image occurring in an earlier section of the manuscript (fol. 90v), here with Luttrell occupying the place of Christ.[13] These images place Luttrell in the literal and symbolic center of a domestic ideology that links material, domestic, and spiritual economies.[14] This conceptual subtext, built on a key intervisual echo within the manuscript, loses its force when excerpted from the manuscript context, as in Roger Sherman Loomis's *A Mirror of Chaucer's World*, where he uses the feast image to illustrate the greed of friars.[15]

The Luttrell Psalter, like many of its contemporary devotional manuscripts, is also designed to generate maximum cognitive impact. As Lucy Freeman Sandler has noted, images in psalters functioned "to provide a heightened and intensified experience of *reading*, through the discovery of all the riches both apparent and concealed in the words. If the words give rise to the images, the images disclose the depths of meaning in the text."[16] English Gothic manuscripts are distinguished from their Continental counterparts in part

FIG. 1.2 *Bas-de-page* arming of Sir Geoffrey Luttrell, Luttrell Psalter. London, British Library MS Additional 42130, folio 202v.

FIG. 1.3 *Bas-de-page* feast scene (detail), Luttrell Psalter. London, British Library MS Additional 42130, folio 208r.

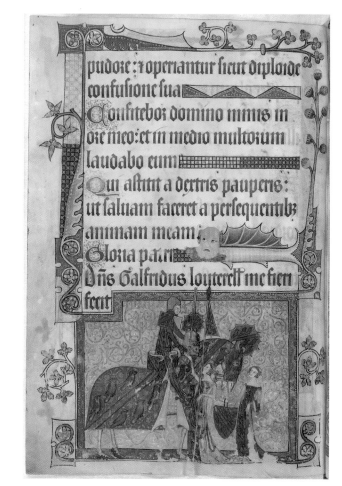

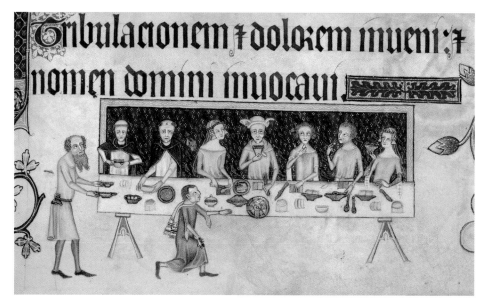

by the range and diversity of narrative material running through the margins, often in *bas-de-page* sequences that encourage readers to link images on consecutive pages, and thus to construct narrative structures that function independently of the text they illustrate.[17] To read these images well requires not only the ability to develop connections between marginal images and the text on the page—a "vertical" relationship that places the text in a privileged position—but also to read "horizontally" for the relationships between and among manuscript images. Attending to this intervisual context provides some of the manuscript's most interesting interpretive moments. These reading practices also bring literary and visual studies together through the concept of intervisuality, a term coined by analogy with intertextuality.[18] As Camille writes, intervisuality "means not only that viewers seeing an image recollect others which are similar to it, and reconfigure its meaning in its new context according to its variance, but also that in the process of production one image often generates another by purely visual association."[19]

This sense of the complex relationship between text and image (as well as between image and image) has resulted in a shift of critical attention away from the sociological model of the margin (based on the metaphorical mapping of "center" and "periphery" onto the manuscript page) to a perceptual or cognitive model (based on the kinds of reading and thinking induced by marginal imagery).[20] Recent essays by Laura Kendrick and Paul Binski have argued that the sociological theory of the margin has its roots in modernist aesthetics, which unnecessarily forecloses some of the dynamic interplay between and among images throughout the manuscript page; this interplay is better explained by means of concepts like *varietas* drawn directly from medieval aesthetic practice.[21] An open approach to the margins also accounts well for the fact that not all of the marginal material is morally coded as "outside." In addition to the grotesques and *babewyns* that draw our attention, much of the marginal imagery in the Luttrell Psalter belongs to conventional religious narratives. There are, for example, an extended sequence of saints (fols. 29r–60v, 104r–108v); a Life of Christ (fols. 86r–96v); and scenes from the Life of the Virgin, including miracles (fols. 97r–105r). And some of its most powerful marginal imagery clearly belongs to the positive self-assertion of its patron as a figure of both political power and devotional humility, far from a sociologically marginal identity. Kathryn Smith has argued recently that the cognitive engagement of the reader with the manuscript page *begins* at the margin, which constructs the "zone of the page most intimately connected to the body of the reader/viewer" and thus offers a "frame that structures the apprehension of its contents and the filter through which they are viewed."[22]

This new approach to the manuscript margin as a frame provides an important conceptual analogue that facilitates a comparison of manuscript art to Chaucer's *Canterbury Tales.* Building on the pioneering insights of Elizabeth Salter nearly fifty years ago, Kendrick has developed the most sustained case to date that Chaucer derived some of his core aesthetic principles from the margins of illustrated devotional books. She argues,

in particular, that Chaucer may have found there the idea of linking material so as to develop a running gloss on central textual matter, which becomes, in essence, an "interludic" space that comments on the text.[23] We can assume that Chaucer's social station and personal investment in books provided him with access to a wide array of contemporary, recent, and older illustrated books. Many such books would have been products of artists and workshops in Paris and Bruges, or books he saw on his trips to Italy.[24] But Chaucer would have found in fourteenth-century English book illustration ample, interartistic analogues for the technique of playing out ideas through his frame material, which requires the reader to connect ideas found in separate cognitive spaces, similar to the margins and core of the manuscript page. We cannot know, of course, whether Chaucer ever saw the Luttrell Psalter—likely, he did not. But I argue here that a sophisticated analysis of the aims, practices, and shared motifs of Chaucer and the artists of the Luttrell Psalter can enrich our understanding of the multimodal aesthetic practices of late medieval visual art and literature.[25] While Chaucerians have tended to approach illustrated manuscripts as an abstract category from which to derive broad Gothic aesthetic principles,[26] I think there is more critical traction to be gained by close scrutiny of a single manuscript like the Luttrell Psalter, seeing it as a close analogue for a literary artist like Chaucer, because it can be approached as a complex work of art with integral design principles.

This chapter aims to demonstrate that a focus on the Luttrell Psalter as a mediating agent rather than a simple "mirror" reveals an imagetext that engages its reader in sophisticated intervisual play similar to the complex mediations Chaucer performs in the *Canterbury Tales*.[27] I do not give interpretive priority to the text over the image, or vice versa, but approach both as "composite arts," in W. J. T. Mitchell's phrase, based on the assumption that "all media are mixed media, combining different codes, discursive conventions, channels, sensory and cognitive modes."[28] We have to challenge ourselves continuously to think of text and image as intrinsically linked—that is, as cognitive doubles of each other—in order to avoid the problem of neutralizing the image in favor of the text, or vice versa. Despite the fact that literary and visual objects are of equivalent value in most current theoretical models of visual study, scholars tend in practice to view one as the privileged site of interpretation, while the other provides static evidence of a common culture, not subject to developed interpretation. In the first part of this chapter I will demonstrate this point by highlighting instances where greater attention to the comparative object opens the two imagetexts to fuller understanding, particularly by recognizing the sophisticated ways both Chaucer and the artists of the Luttrell Psalter engage in highly mediated play with the boundaries of their aesthetic projects. In the second part I turn to historical context as a means to conduct a critical examination of chivalric identity as represented in the Luttrell Psalter through an intervisual analysis of the repeated appearance of the Luttrell arms in the manuscript. The psalter's representation of chivalric identity links it with the historical Chaucer through his testimony in the infamous Scrope-Grosvenor case in the

Court of Chivalry. This underutilized episode from Chaucer's biography demonstrates the entanglement of Chaucer and the Luttrell Psalter in a broader visual culture whose forms merit further study.

In his reading of the *Friar's Tale*, Kolve argues counterintuitively for the carter as a key narrative image, a place where the marginal figure suddenly becomes central to the meaning of the story by crystallizing the idea of the "man in the middle." To illustrate the common tradition of the carter, Kolve extracts an image from the Luttrell Psalter (fig. 1.1), about which he writes, "A steep hill is to be inferred. All available energy and attention, from man and beast alike, is concentrated on that task. The picture bears no discernible relation to the psalm text around which it moves, and it invokes no moral or theological context."[29] While Kolve is right that the image does not invoke an immediate moral context, nor a direct relationship to the text on this particular page, this image is the culminating moment of an important cycle of images of agricultural labor that have to be read narratively across the *bas-de-page* of consecutive folios, in which sowing, reaping, harvesting, and finally transporting the crop are depicted (fols. 170v–173v).[30] All of these images flow from left to right, providing a key visual marker of narrative progress until we arrive at the carter, who drives his cart from right to left. And if we look with our eyes and not our abstractions, we see there is no hill in the image, inferred or otherwise: one nineteenth-century reproduction goes so far as to add a line to this image in order to make it "realistic."[31] But the image can be better explained as a visual joke on the limits of the page: the horses rear up because they have hit the margin of the book.

This self-conscious attention to the limits of design is enhanced by our attention to the other page of the opening (fol. 174r), which has a radically different *mise-en-page*, with a heavy ornamental border and an illuminated initial, because Psalm 97 marks a conventional division in psalter texts. The artist reverses the direction of the carter on the prior page in order to signal overtly the precise point where a limit is imposed by the design of the book itself. The idea of working against the limitation of space and design plays out in a number of images in this section of the manuscript, where the artist develops a metacommentary on the design constraints created by the prior border campaign. Indeed, the concept of spatial constraint is a visual theme throughout: fillers that occur on almost every page often show figures who are squeezed into the available space and whose animal bodies push against these constraints.[32] Laborers in a *bas-de-page* on folio 172v (fig. 1.4) confront the invasion of their workspace by the foliate vines that descend from line fillers, which were completed prior to the marginal illustrations in a separate campaign.[33] One woman drops her scythe as she bends back in surprise, her eyes angled up at the foliation.[34] On the other side of this opening, on folio 173r (fig. 1.5), men are stacking sheaves of wheat, the topmost laborer looking up as he realizes that a piece of descending foliage blocks his upward progress. The constraints of the design sequence,

FIG. I.4 *Bas-de-page* laborers and vines, Luttrell Psalter. London, British Library MS Additional 42130, folio 172v.

including its clash of styles, are converted into elegant moments of bravura where art confronts the limits imposed on it both by social reality and by artistic constraint.

This visual play with the materials and processes of art emphasizes precisely what Kolve denies—the mediating consciousness of the artists, who attend in full awareness to the new world created in the margins. The book might "mirror" the interests of Sir Geoffrey Luttrell, who exerts his authority over a working feudal estate, but it also highlights the artificiality of the representation and thus draws direct attention to the mediating labor of the artists. The Luttrell artists produce what amounts to a new artistic ecology, which they manipulate to great effect, providing a doubled world that occupies the middle space between social reality and artistic imagination. Foliate borders grow into polymorphic *babewyns*, who double their human counterparts by incorporating humanoid features, as well as doubling themselves in the forms of twinned heads emerging from common bodies, mirror bodies attached to a common head, and a number of other variants that display a fascination with the visual motif of duplication and difference (see fols. 84r, 187v, 188r, and 191r, among many others). Horses

FIG. 1.5 *Bas-de-page* laborers and foliage, Luttrell Psalter. London, British Library MS Additional 42130, folio 173r.

balance on tenuous vines, their feet resting on two slightly different horizontal planes (fol. 159r) or on the backs of *babewyns* (fol. 41r). The aesthetic self-consciousness, which draws readerly attention to the shifting relationships between verbal and visual forms, enhances the devotional subject's reading of the psalter text by creating a conceptual interface that maximizes cognitive engagement. Working from this premise, scholars have discovered dozens of word-image puns—broadly known as *imagines verborum*—in the Luttrell Psalter, whereby the text of the psalms is abstracted into component words and phonemes, which generate secondary meanings that are reworked by the images (often ironically) to refer to novel and unexpected scenarios. These *imagines verborum* are now subject to multiple modern interpretations based on the accepted principle that an image might mean more than what it "says" on the visual surface.[35] We are reminded constantly that the text is always mediated by the visual engagement of the reader with the page.

Such meta-artistic play, which draws focused attention to the conditions of artistic creation, is a given for most readers of Chaucer, a writer who regularly foregrounds the

boundary between fiction and reality as part of an overall strategy to complicate a reader's unfiltered sense of his literary world. We could hardly read the *Canterbury Tales* without this concept, which is crucial to its generative ironies and to Chaucer's practice of engaging tough contemporary cultural problems within the safe space of literary play. When we recognize that some of this same mediating work is being done in the Luttrell Psalter and its contemporary manuscripts, we have a broader context for understanding the ability of Chaucer's audience to engage with his navigation of the boundaries between source and retelling, text and voice, and narrative and social agents (including the reader). Chaucer's writing is, right from the beginning, both hybrid and intensely self-conscious of its status as a mediated object, shot through with the writing of others, with which he ambivalently grappled. He directly involves his readers in that process by reminding them of their part in the mediating process.

Awareness of the layered mediation of Chaucer's writing heightens our critical attention to his appearance as an intertextual reference in Camille's book-length study of the Luttrell Psalter, where Chaucer plays roughly the same role that the Luttrell Psalter plays for Kolve: a body of neutral, cultural evidence free of mediating context. For example, the Luttrell Psalter contains a comic image of an ape riding a goat while holding an owl on his arm (fol. 38v), parodically imitating images of knights hunting with falcons that are often depicted in marginal art, including that of the Luttrell itself (fol. 41r). Camille's fascinating discussion of the image stresses its relationship with a distinctive English aphorism, "Pay me no lasse than an ape and an oule and an ase," which appears in a Latin register of legal writs beneath a similar image (an ass is substituted for the goat).[36] Chaucerians might recall that the phrase "of owles and of apes" appears in the *Nun's Priest's Tale* (VII 3092), which Beryl Rowland first glossed by pointing to the pejorative connotations of both animals in marginal imagery, including the Luttrell image.[37] For Camille, Chaucer is merely a witness to the association of this image with the irrational: "A juxtaposition of such elements meant something irrational—'owls and apes' in Chaucer's words."[38]

But to call these "Chaucer's words" is more than a little misleading: the narrative context, which is always paramount in Chaucer, is a deeply embedded quotation. Chauntecleer's debate with Pertelote about the significance of dreams leads him to list examples of dreams that had prophetic significance, including a man who refuses the cautionary warning of a friend's dream and proceeds with a planned sea journey that results in his death. It is not Chaucer, but this unnamed rationalist, cited as an authority by a talking rooster in an argument with his best-loved chicken, who rejects the significance of (seemingly) absurd dreams, which turn out to provide accurate predictions. Whatever Chaucer might have thought about "owls and apes" (or asses for that matter), the intervisual circuit that runs through English visual culture links the Luttrell Psalter and Chaucer's *Canterbury Tales* in an open inquiry about the value of the absurd image. Both instances of this image are part of a verbal-visual dreamspace in which a reader is expected to expend cognitive

energy. If it is true that "men dreme of thyng that nevere was ne shal" (VII 3094), it is also true that such dreams can be engines of creativity, as Chaucer's earliest poetry attests. By no means is this context-dependent reference to "owls and apes" a simple statement on the "irrational," but rather an open invitation to follow the dizzying turns of interpretation that precede and follow.

The concept of mediation is also at stake in Camille's citation of a passage from the *Franklin's Tale* during a discussion of the Luttrell Psalter's Castle of Love image (fol. 75v). Camille places the image in the context of "fantasy battles" performed at court, "the kinds of fantasies described in Chaucer's 'Franklin's Tale' in more positive terms as the work of 'tregetours' or magicians."[39] Whether the image is "positive" depends, of course, on one's take on the *Franklin's Tale*'s outcome, since the "magyk natureel" (V 1125) that drives the plot is far from unambiguously good. The reference to *tregetoures* appears in Aurelius's brother's speech, as he, distraught at his brother's lovesickness, seeks a remedy. That process begins with the narrator exploring the brother's inner thoughts as he conducts an almost desperate search "in remembraunce" (V 1117)—necessarily patchy—of his time in Orléans, where "a book he say / Of magyk natureel" (V 1124–25). But Chaucer habitually complicates textual reception, so we immediately discover that the book was not his, but belonged to his *felawe*, who, as it happens, should not have been reading it at all since he was studying law. And, of course, the brother is not given the book, but steals a glance when his *felawe* is away, as he "hadde [it] prively upon his desk ylaft" (V 1128). The reader's realization of the brother's highly vitiated knowledge frames our response to his "remembraunce" of the work of *tregetoures*, this time mediated from oral transmission, not personal experience ("have I wel herd seye"; V 1142). Chaucer goes out of his way to indicate that this man's confidence is not well justified:

> "For I am siker that ther be sciences
> By whiche men make diverse apparences,
> Swiche as thise subtile tregetoures pleye."
> (V 1139–41)

Aurelius's brother overlooks all the contexts that mediate his partial and fragmentary knowledge, and he equates "sciences" with the low form of "pleye" that alters "apparences" by legerdemain, hardly a trustworthy basis for knowledge. And everywhere in the *Canterbury Tales* where such naïve engagement with texts takes place, we are alerted to the moral or social dangers of bad reading. For Camille, the narrative context of both the story and the larger project evaporates, replaced by a notion of Chaucer's "reportage" of courtly games. The visual culture that links Chaucer with these *tregetoures* does not adequately convey the nuance of the passage's fascinating reflection on the perils of mediated knowledge without further interpretation.[40]

FIG. 1.6 *Bas-de-page* image of Saint Francis and stigmata, Luttrell Psalter. London, British Library MS Additional 42130, folio 60v.

FIG. 1.7 *Bas-de-page* image of bloodletting, Luttrell Psalter. London, British Library MS Additional 42130, folio 61r.

The Luttrell Psalter's Castle of Love image is, in turn, enriched by this more complex view of Chaucer's own mediating practices, as it triggers a range of associations with the dialectic between secular and religious forms of self-understanding—understandings that are woven into many contemporary illustrated manuscripts to which the Luttrell Psalter is related, including the Queen Mary Psalter, the Smithfield Decretals, and the Taymouth Hours.[41] Smith has recently made a convincing case that the inclusion of the secular image cycles of *Beves of Hampton* and *Guy of Warwick* in the *bas-de-page* of the Taymouth Hours is predicated on "the complex interplay of courtly, chivalric, devotional, and penitential themes in this pictorial-textual ensemble."[42] The Luttrell Psalter similarly relies on a reader being able to move nimbly among different frames of reference. One opening that performs this work quite explicitly makes a provocative connection between daily life and an image of popular sanctity. The reader attending to links between images in the *bas-de-page* of folios 60v–61r naturally connects the display of Saint Francis's stigmata with the image of bloodletting across the book gutter (figs. 1.6, 1.7). While imitation of the saints could take extreme forms in medieval culture, this image provocatively suggests that the medical act of opening one's veins has a sacral character that links us with Francis and,

indirectly, with the wounds of Christ. Is the sacral aura of the stigmata reduced by the comparison? Perhaps, perhaps not, but the cognitive work triggered by the juxtaposition functions to stimulate a devotional self-reflection that the image of Francis on his own might not. *Imitatio Christi* is transposed from the unapproachable sacred realm into the lived social life of the devotional reader.

Becoming attuned to the intervisual dialogue of the manuscript provides new interpretations of individual images while also generating a pattern of thinking analogous to the *Canterbury Tales* that accumulates new concepts as it advances. A well-known image on folio 60r, of a woman beating her kneeling husband with a distaff, occurs, for example, in a sequence of images of martyrs (fols. 29r–60v). Taken out of context, the image is a simple misogynist joke, not unlike the contemporary images of domestic inversion from misericords, for example.[43] But, in context, this Luttrell image parodies a specific sequence of martyrs executed by sword, which includes Saint Thomas Becket, Saint John the Baptist, and, later, Saint Bartholomew (fols. 51r, 53r, 108r).[44] And before we arrive at the wife beating her husband, we encounter another variation: a kneeling figure appears with a cut already on his neck and the name "Lancastres" written in a contemporary hand beneath the sword, which is wielded by the executioner (fol. 56r). The image refers to the execution of Thomas, Earl of Lancaster at Pontefract Castle in 1322, where it took several blows to sever his head.[45] The death of Thomas of Lancaster, a key member of the baronial opposition to Edward II, quickly led to attempts to canonize him. Clearly, his appearance here among martyred saints is meant to affirm his significance as a "second Becket" and thus connects Sir Geoffrey Luttrell to the disaffected nobility who rebelled against Edward II.[46] This highly mediated image adopts the iconography of martyrdom to bolster a particular political identity in a vexed environment of conflicting loyalties, as mid-level aristocrats like Luttrell anxiously considered their relation to the monarchy, and thus their conventional notions of chivalry, founded on the tension between self-assertion and submission.[47] The text of the psalms regularly adopts the position of submission to the all-powerful Lord, and the devotional reader is encouraged to reflect on that model in his own social life. That submission is ironized by the text from Vulgate Psalm 31 (a penitential psalm), verse 4, which appears adjacent to the image of the woman beating her husband: "For day and night thy hand was heavy upon me" ("Quoniam die ac nocte gravata est super me manus tua"). The image constructs the angry wife as a domestic analogue of an all-powerful God, but the joke only registers because forms of real vulnerability are acutely manifest in the other martyr images. The visual typology of martyrdom thus moves across several conceptual domains—spiritual, political, domestic—generating an intensive reflection on modes of male vulnerability, particularly concentrated on the vexing question of chivalric male identity forming and justifying itself under the threat of violence.

Chaucerians may well "hear" in this image an echo of the *Monk's Prologue*, in which Harry Bailly complains about the way his wife, Goodlief, tongue-lashes him, culminating

in a mock-monologue in her voice that ends, "By corpus bones, I wol have thy knyf. / And thou shalt have my distaf and go spynne!" (VII 1906–7). The fit of image to text is not perfect, but it is close enough to have rung a bell with Camille, who cites the couplet without interpretive comment.[48] Regardless of whether Chaucer knew this image or an image like it—or, indeed, drew the entire idea from a textual convention—what these images create is a circuit of meaning running through the Luttrell Psalter and Chaucer's text, a circuit that links artists with sophisticated tools at their disposal for drawing out a subtle set of ironies. While we may be reluctant to assume that the artists of the Luttrell Psalter, working for a powerful patron, had the leeway afforded by an author as crafty as contemporary scholarship imagines Chaucer to be, we need the salutary reminder that part of the work devotional books were meant to accomplish is a humbling submission to God in the recognition of one's sin. Based on her work on early fourteenth-century devotional books, Smith has called for further attention to the way that marginal images might force us to theorize "a more variegated late medieval noble subjectivity,"[49] which must of necessity include a recognition that such subjectivity is constructed in and through *conflicts* in identity, not simply through affirmations.

Such conflicts appear even in the most assertive images of self-presentation, like the famous arming scene. For readers of medieval romance, the image appears familiar, evoking the ancient topos of the mounted warrior heading off on a quest.[50] The image is, however, highly unusual in devotional books and has been largely explained as an attempt by Sir Geoffrey, well past his military prime, to assert his lordship in a period of anxiety.[51] His marriage to his wife, Agnes Sutton, depicted here handing him his helmet, fell under scrutiny because it violated the acceptable degrees of consanguinity and threatened to invalidate any offspring of his son's marriage to Beatrice Scrope, depicted here handing him his shield.[52] His dynastic ambitions are painted directly on the bodies of the two women. Agnes Sutton's dress is blazoned with the arms of both the Luttrell family and the Suttons, whose arms also appear on folio 41r on a gilded shield beneath a gilded helm with a fanned crest. Beatrice Scrope's dress is similarly blazoned with the Luttrell arms and the Scrope arms,[53] appearing here and in the margin above a bear-baiting scene (fol. 161r).[54] Heraldic insignia circulate social identities and, along with them, social histories of alliances between families. But the elision of Sir Geoffrey's son Andrew from the arming scene in favor of a focus on the women—who translate the abstract notion of heraldry in embodied form through children—reveals how masculine chivalric identity depends on female bodies.

With the benefit of historical distance, we can see that such anxieties, far from isolated, were endemic to the culture of chivalry in late medieval England and form a social infratext for both the Luttrell Psalter and Chaucer's own engagement with what Lee Patterson has called the "crisis of chivalry." Patterson's reading of Chaucer's *Knight's Tale* includes a pointed examination of an infamous case of the lengths to which knights went

to defend the most obvious instance of their symbolic knighthood: their arms.[55] The Scrope-Grosvenor case, which dragged on from 1385 to 1391 and led to 450 depositions, brings Chaucer and the Luttrell Psalter into conversation with each other and highlights a fascinating intervisual narrative in the Luttrell Psalter. Chaucer gave testimony in the case in 1386,[56] as did Andrew Luttrell, age seventy, son of Sir Geoffrey, and both did so in favor of Richard Scrope, who won the dispute in 1390. But the case was not definitively settled until there was an unusual meeting of the baronial peers at which Robert Grosvenor was obliged to recite an agreement in which he abjured any statement in prior depositions impugning Scrope's honor. Patterson's discussion centers on "not just the highly public, ceremonial nature of the honor exchanges that constituted chivalric culture but the wholly social, even material sense of selfhood that it presupposed."[57] The anxiety of losing control of one's heraldic identity is foregrounded in the Scrope-Grosvenor case because, as Patterson points out, "noble identity depends upon a system of signification . . . that is always open to misuse."[58]

As it happens, the Luttrell Psalter provides a fascinating narrative of such "misuse" of the Luttrell arms, which appear four times in the manuscript before their grand appearance on folio 202v and, again, in the feast scene on folio 208r. Taken together, these six instances provide a narrative focused on the fracturing of chivalric identity in the dispersal of arms through surrogates before they are recombined in the person of Sir Geoffrey. On folio 59r they appear in their smallest form on a pennon attached to a trumpet, like a visual afterthought. On folio 157r (fig. 1.8) a servant bearing a larger pennant with the Luttrell arms—the first step in an amplification of their visual significance—leans forward in pursuit of a cross-legged figure with bellows on his head, holding a helmet. This latter figure, who appears in the manuscript in other guises, is a trickster, his crossed legs suggesting a mockery of the poor servant who desires to recapture his lord's helmet, which has escaped his possession.[59] On folio 163r the arms appear on a hybrid, who dons a helmet, as though the helmet had remained in the marginal world because the trickster had passed it along to him. On folio 171r a shield with the Luttrell arms held by a man sitting atop a bird appears alongside Vulgate Psalm 94, which Ellen Rentz astutely points out was read daily as the standard invitatory psalm.[60]

All of this intervisual context, with the Luttrell arms scattered through the margins and out of Sir Geoffrey's control, serves as preface for the synthetic image in which Luttrell himself appears astride his charger (fig. 1.2). The overdetermination of the arms in this image suggests that he doth protest too much: his insignia appear on his helmet, pennon, pauldron, surcoat, saddle, horse's embroidered surcoat, shield, and headpiece, as well as on the dresses of the two women.[61] Smith notes that, while this image is the only framed miniature in the manuscript, it arises not from the center but from the margin,[62] where it joins the sequence of arms that runs through the *bas-de-page*. In this image all of the various parts of the knightly assemblage that we have seen dispersed throughout the

FIG. 1.8 *Bas-de-page* servant with Luttrell arms, Luttrell Psalter. London, British Library MS Additional 42130, folio 157r.

manuscript are reunited in a coherent, stable whole, represented in its most magisterial form. This image does powerful ideological work, suggesting that Sir Geoffrey's chivalric splendor exerts centrifugal force, drawing his heraldic signs back to him from their scattered locations throughout the manuscript. This narrative possesses a coda, however, in the feast image, which conveys an important resonance with the psalter text that has so far escaped notice: it appears beneath Vulgate Psalm 114, "Dilexi quoniam exaudiet Dominus" (I have loved because the Lord will hear [the voice of my prayer]), the opening words of the Office of the Dead. This is not an accident. As the only part of the church liturgy exactly reproduced in devotional books, the Office of the Dead was central to aristocratic devotional practices. Because of a deep cultural association of the Office of the Dead with the commemoration of ancestry, heraldic insignia often appear alongside the lead image[63]—a highly legible placement adhering to an aristocratic ideology that viewed the transmission of arms as (in D. Vance Smith's phrase) a form of "mortuary

stockpiling."[64] The Luttrell Master utilizes the space behind the feast scene as a tableau in which the arms appear as a tapestry hung above the table, providing a symbolic link between Sir Geoffrey and his ancestors, on whose behalf he prays the Office of the Dead that advances their souls, even as he hopes for future progeny who will do the same. Luxury manuscripts call for visual attention, which can be converted into salvational coin in the devotional economy of late medieval culture. The presentation miniature and the feast scene thus stand as ideological bookends in which two faces of chivalric self-presentation—martial power and religious sanctity—are placed amid images of violence, dangerous and disruptive play, and a profusion of polymorphic forms that suggest a world exceeding its boundaries.

The Luttrell Psalter participated in a broad visual culture where heraldry penetrated into daily life in a wide variety of forms—from livery, to donor plaques in parish churches, to the arms hung above the residences and businesses of the muddled class of gentry who occupied London, Chaucer's home for most of his life. Visual culture is not a lens that Chaucerians have utilized in their thinking about Chaucer's testimony in the Scrope-Grosvenor case, but the poet's engagement with his visual world is tied directly to the unique quality that Patterson observes in Chaucer's deposition: "its urban setting, its circumstantial detail, and especially its narrative form."[65] In a passage that links him as a "witness" to the Luttrell Psalter through the mediating image of the Scrope arms, Chaucer traces an urban itinerary through Friday Street, which was near his home and thus, presumably, a familiar visual landscape; his eyes alight on a "nouvelle signe" hanging above an inn.[66] What is "nouvelle" is not the arms, with which he is familiar, but the "signe" hung in a place where he had not seen one before. The novelty here is a visual attraction breeding curiosity, generating a discussion with an unnamed person about the inn with the (presumed) Scrope arms. The cognitive dissonance that the encounter triggers for Chaucer mirrors Patterson's sense of Scrope's own crisis: a single set of arms should not refer to two people.[67] When Chaucer discovers that the arms were "painted for Robert Grosvenor" and not Scrope—with the key word "depeyntez" repeated twice in the passage—we are reminded that heraldry requires a representational process (painting) and a medium (a body, place, or sign), which mediates its social meaning. This "double" sign in turn triggers Chaucer's own affective memory of his experience in battle at Rheims, twenty-seven years prior, where he first saw the Scrope arms amid the blazing heraldry of battle, at a time of somatic intensity certain to register in his memory. Heraldic signs do powerful work for this "experiencing subject" (in Patterson's phrase), a circuit through whom the sign passes from battlefield to memory to present experience: "Geffray Chaucere esquier del age de xl ans et plus," our forty-something poet who happens to be launching the *Canterbury Tales*.[68]

The way the Luttrell Psalter and Chaucer talk to each other through a heraldic emblem provides an illustrative instance of the rich entangling of images and texts in the fourteenth

century, a period of great artistic innovation. When image and text are grafted together by the work of either culture or scholarship, they change form and become intermediated in ways that require new reading procedures. Further research comparing Chaucer's literary production with aesthetic principles from manuscript illumination will enhance our understanding of his multimodal composition process, just as the rich tradition of scholarship on Chaucer's literary experiment promises to deepen our understanding of the Luttrell Psalter. We will have understood British Library MS Additional 42130 only when we have fully parsed the elusive "me" in the caption of the book's most famous image: "Dominus Galfridus Louterell me fieri fecit" (fol. 202v). This "me" disconnects the book (as speaker) from the artist (as maker), diverting attention toward its patron, who is nonetheless present in the image only through the mediating brilliance of an implied artist. It is an artful moment of hide-and-seek, the likes of which we have come to consider quintessentially Chaucerian.

NOTES

1. See Sandler, *Gothic Manuscripts*, 2:120 (item 107); and Brown, "Historical Context," 24–25. All references to the images in the Luttrell Psalter are to Michelle Brown's facsimile edition. The Luttrell Psalter is now also available in color digital facsimile at *British Library Digitised Manuscripts*, s.v. "Add MS 42130." The Rutland Psalter, Smithfield Decretals, and Taymouth Hours are also viewable at *British Library Digitised Manuscripts*, s.vv. "Add MS 62925," "Royal MS 10 E IV," and "Yates Thompson MS 13," respectively. The Ormesby Psalter is Oxford, Bodleian Library MS Douce 366.

2. For a discussion of the artists, see Sandler, *Gothic Manuscripts*, 2:120; and Camille, *Mirror in Parchment*, 324–30.

3. Emmerson and Goldberg, in "Lord Geoffrey Luttrell had me made," 50–51. Note that only twelve of fifty-six fourteenth-century English psalters are the same size, and none of these has only fourteen lines of text per page (most have between twenty and twenty-eight).

4. See Camille, *Mirror in Parchment*, 25–48, for a critical discussion of this tradition.

5. Some version of this phrase appears in three books published between 1962 and 1967, all featuring the Luttrell Psalter: Rickert, *Chaucer's World*; Loomis, *Mirror of Chaucer's World*; and Hussey, *Chaucer's World*.

6. On the dating of the manuscript, see Emmerson and Goldberg, "Lord Geoffrey Luttrell had me made," 44–48, who argue for the latest date, around 1345. On the artists, see also Sandler, *Gothic Manuscripts*, 2:120, who argues for the earliest date, in the late 1320s.

7. Camille, *Mirror in Parchment*, 29.

8. Kolve, *Chaucer and the Imagery of Narrative*, 61.

9. Kolve, *Telling Images*, 71.

10. Binski, "Heroic Age of Gothic," 11.

11. See, for example, Sandler, *Studies in Manuscript Illumination*, 45–75, 160–64; Camille, "Laboring for the Lord"; and Rentz, "Representing Devotional Economy." For an excellent discussion of the opportunities for cross-disciplinary work between art history and literary history in medieval manuscript illumination, see Alexander, "Art History"; and Emmerson, "Middle English Literature and Illustrated Manuscripts," 130–36.

12. Marks, "Sir Geoffrey Luttrell and Some Companions," 353.

13. See Emmerson and Goldberg, in "Lord Geoffrey Luttrell had me made," 53, who describe it as "slightly shocking."

14. Rentz, "Representing Devotional Economy," 89–90.

15. Loomis, *Mirror of Chaucer's World*, no. 107. See also nos. 104, 108, 116, and 133 for other Luttrell images.

16. Sandler, "Word in the Text," 94.

17. On this narrative tendency and its relationship with literary forms, see Sandler, *Gothic*

Manuscripts, 1:42; Sandler, *Studies in Manuscript Illumination*, 82–83; and Brantley, "Images of the Vernacular," esp. 104–5. On reading across openings and sequences, see Brown, "Historical Context," 1.

18. For the use of this concept in Chaucer studies, see Coleman, "Where Chaucer Got His Pulpit."

19. Camille, *Mirror in Parchment*, 339.

20. Camille's argument in *Image on the Edge*, that the margin is a place of play ultimately contained by the central sacred text, has been influential on the way literary scholars conceive of marginal illustration. But judicious critiques of Camille's work by art historians have opened up an important conversation about how to avoid a reductive, binaristic system modeled on the sociological theory of center and margin. See, for example, Hamburger's review of Camille.

21. See Kendrick, "Making Sense of Marginalized Images," an excellent survey of scholarship on marginal illustration; and Binski, "Heroic Age of Gothic," 14–15. For *varietas* as a rhetorical and aesthetic category, see Carruthers, *Experience of Beauty*, 147–55, where the Ormesby Psalter is her illustrative example.

22. Smith, "Margins," 42, and *Taymouth Hours*, 99.

23. See Kendrick, "Linking the *Canterbury Tales*," and "Les 'bords' des 'Contes de Cantorbéry.'" For Salter's early sense of Chaucer's relationship to marginal illustration, see "Medieval Poetry and the Visual Arts." Holley, in *Chaucer's Measuring Eye*, 35–39, has argued that Chaucer's interest in movement and shifting perspective mirrors the opposition between a static text and a dynamic margin in illustrated manuscripts.

24. See Clarke, *Chaucer and Italian Textuality*, 100–107, where he discusses an illustrated holograph manuscript of Boccaccio's *Decameron*, which included thirteen portraits marking the ends of quires. Fleming, in "Chaucer and the Visual Arts of His Time," 131, discusses the ways contemporary English artists were responding to Italian influence.

25. I am mindful of Kelly, "Chaucer's Arts and Our Arts," which offers important caveats concerning Chaucer's relative lack of direct reference to art in his poetry.

26. This is a venerable tradition in Chaucer studies. See, for example, Muscatine, *Chaucer and the French Tradition*, 167–69, 245–47; Robertson,

Preface to Chaucer, 171–228; and Howard, in *Idea of the "Canterbury Tales*," 219–25, who proposes that interlace designs in late Gothic manuscripts might be an analogue for the isomorphic structure of Chaucer's work.

27. I use the term *imagetext* in the sense developed by W. J. T. Mitchell in his sustained critique of theoretical attempts to divide word and image from each other; see *Picture Theory*, 94–107. For the relevance of the term in understanding medieval visionary writing, see Brantley, "Vision, Image, Text," 315–17.

28. Mitchell, *Picture Theory*, 94–95.

29. Kolve, *Telling Images*, 70–71.

30. Camille, *Mirror in Parchment*, 197.

31. Ibid., 29.

32. For especially humorous versions of this motif of pushing against the constraint of limited space, see folios 15v, 17v, 19v, 21r, and 24r.

33. Sandler, *Gothic Manuscripts*, 2:120.

34. Camille, in *Mirror in Parchment*, 195, describes her resting because "she is suffering from backache," though he does not note how strange it would be to rest a scythe on one's shoulder as one performed back exercises. Brown, in "Historical Context," 14, reads the raised rumps of the female workers as a fertility reference.

35. See, for example, Sandler, *Studies in Manuscript Illumination*, 99; and Camille, *Mirror in Parchment*, 289, both of whom discuss a pun on French *pas* (foot, step) on folio 152v, where the Latin word *passer* appears directly above two naked men playing a foot game that Sandler dubs "paso doblo" and Camille "human quintain." Similarly, folio 160r, which depicts rowers working against two men pulling a rope directly to the right of the Latin "tuum brachium cum potentia," is discussed with differences of interpretive emphasis in Sandler, *Studies in Manuscript Illumination*, 99; Camille, *Mirror in Parchment*, 168–69; and Brown, "Historical Context," 44.

36. Camille, *Mirror in Parchment*, 171–73.

37. Rowland, "Owles and Apes."

38. Camille, *Mirror in Parchment*, 172.

39. Ibid., 118.

40. A better passage to illustrate this form of "magyk natureel" in Chaucer's "textual world" would have been his reference in the *House of Fame* to a specific court magician: "Colle tregetour." The narrator says he saw him "Pleye an uncouth thyng to telle— / Y saugh him carien a wynd-melle / Under a walsh-note shale" (1277–81).

41. The Castle of Love, for example, also appears in the Taymouth Hours, folio 61r, amid a cycle of images of the Virgin, to which it has a dialectical relationship. For the Queen Mary Psalter, see *British Library Digitised Manuscripts*, s.v. "Royal MS 2 B VII."

42. Smith, *Taymouth Hours*, 95. See also Brantley, in "Images of the Vernacular," 104, who argues the broader point that the Taymouth Hours' use of vernacular narrative material "should modify our understanding of late medieval reading practices at large."

43. See, for example, Hussey, in *Chaucer's World*, 111, who uses the image as a visual gloss to the Wife of Bath.

44. Coleman, in "New Evidence," has noted the historical resonance of this same sequence of martyrs.

45. Brown, in "Historical Context," 36, notes that Hooton Pagnell, Luttrell's northern estate, was only nine miles from Pontefract.

46. For a discussion of a recently discovered miniature of Lancaster in the Sellers Hours, see McQuillan, "Who Was St Thomas Lancaster?"

47. Coleman, in "New Evidence," focuses on Luttrell's participation in the raid on Sempringham Priory, which reveals his own investment in the use of force and violence in the maintenance of power.

48. Camille, *Mirror in Parchment*, 299–301. Kendrick, in "Linking the *Canterbury Tales*," 93–94, notes that the Host's speech echoes a visual typology of domestic violence in illustrated manuscripts.

49. Smith, "Margins," 42.

50. Marks, in "Sir Geoffrey Luttrell," 350, notes its similarity to *Sir Gawain and the Green Knight*.

51. See Marks, "Sir Geoffrey Luttrell," 354; and Camille, *Mirror in Parchment*, 49–50.

52. Camille, *Mirror in Parchment*, 95–96.

53. See ibid., 53–54, on Beatrice Scrope's body as the focus of their dynastic hopes. Backhouse, in *Luttrell Psalter*, 58–59, theorizes that their marriage might have been a reason for the commissioning of the psalter.

54. Camille, in *Mirror in Parchment*, 67–69, has interpreted this juxtaposition as a punning reference to Berwick-upon-Tweed, a town crucial in the wars with Scotland in which both Luttrell and his in-law Geoffrey Scrope served.

55. Patterson, *Chaucer and the Subject of History*, 180–86.

56. Crow and Olson, eds., *Chaucer Life-Records*, 370–74.

57. Patterson, *Chaucer and the Subject of History*, 185.

58. Ibid., 186.

59. The pose of the crossed legs occurs in the scene of the Annunciation to the Shepherds (fol. 87v) and in the scene of a servant who presents Christ to Pilate (fol. 91v). See Camille, *Mirror in Parchment*, 62–63, for a claim that the figure represents "worldly vanity."

60. Rentz, "Representing Devotional Economy," 89–90.

61. See Brown, "Historical Context," 4; and Marks, "Sir Geoffrey Luttrell."

62. Smith, "Margins," 34.

63. Roughly contemporary examples include the Taymouth Hours, folio 151r, where the arms of Neville of Raby are painted over the arms of Saint George, the latter indicating royal ownership, on which see Smith, *Taymouth Hours*, 241, 246 (fig. 148); and the Bohun Psalter, folio 142r, with its multiscene depiction of a funeral where a shield hung from the catafalque identifies the deceased as a FitzAlan, on which see Sandler, "Political Imagery," 131–35, and *Illuminators and Patrons*, 59–60 (fig. 58). Both of these manuscripts may be viewed in digital color facsimile at *British Library Digitised Manuscripts*, s.vv. "Yates Thompson MS 13" and "Egerton MS 3277."

64. Smith, *Arts of Possession*, 46–47.

65. Patterson, *Chaucer and the Subject of History*, 195.

66. Crow and Olson, eds., *Chaucer Life-Records*, 371.

67. Patterson, *Chaucer and the Subject of History*, 186.

68. Crow and Olson, eds., *Chaucer Life-Records*, 370.

TWO

Creative Memory and Visual Image in Chaucer's *House of Fame*

Alexandra Cook

This essay situates a reading of medieval mnemonic practice in the burgeoning history of rhetorical invention. In recent years, a handful of literary historians have elucidated how vernacular writers repurposed old poems to create new ones. Douglas Kelly established that medieval authors generated new material by creating unfaithful translations, a strategy apparent in Jean de Meun's recasting of Guillaume de Lorris's *Roman de la Rose*.[1] Rita Copeland has shown that Chaucer's *Legend of Good Women* is a "secondary translation" of Ovid's *Heroides*, for Chaucer's exegetical translation becomes a vernacular substitute for the classical original.[2] A. J. Minnis has called Chaucer a self-styled *compilator*, a compiler who weaves new text by collecting and rearranging the statements of others.[3] Working in this tradition, I focus on the ways Chaucer uses artificial memory to hybridize rhetorical appropriation and invention in the *House of Fame*. Understanding Chaucer's treatment of artificial memory—a mnemonic system based on associating material with vivid images—necessarily enhances our sense of Chaucer's poetic accomplishment in this vernacular poem. Images, narratives, and "memory palaces" created in the service of artificial memory become visible within, rather than strictly external to, the *House of Fame*. Ultimately, mnemonic forms take center stage, effectively displacing the very classical texts they were designed to memorialize. Chaucer shows that artificial memory offered distinctive ways to assert vernacular *auctoritas* over recollected classical materials, an insight that requires a reassessment of the uses of mnemonics for late medieval poetics. At the same time, acknowledging this rhetorical use for artificial mnemotechnics necessitates rethinking the value and purpose of the *House of Fame*. Chaucer's focus on memory privileges the

vernacular poet's visual and somatic experience and his own pattern of selection among characters, settings, and exempla. With recourse to artificial memory, Chaucer's vernacular poetry is self-authorizing, grounded in synthesis, and generative of new material that comes into being by revivifying, supplementing, and transposing its mnemonic objects.

Despite the fact that our understanding of medieval valuations of memory has shifted dramatically over the past twenty-five years,[4] memory as it appears in this poem is often read according to the modern value system that considers memory a mere servant to the poetic imagination. Many critics who address the topic in the *House of Fame* assume that Chaucer characterizes memory as imprecise and fallible, distorted by false projections and the hazy, subjective perspective of his unreliable narrator.[5] Even Mary Carruthers, who revolutionized our understanding of inventive medieval memory, argues that the *House of Fame*'s multiple references to medieval memory culture constitute nothing more than ornamental embellishment.[6] To the contrary, I argue that Chaucer treats memory in this poem not merely as decorative or preservative, but also as appropriative and creative. In the *House of Fame*, memory is profoundly implicated in the production and reception of poetry.

Against the critical consensus that characterizes memory as one of the contributing features of the poem's supposed subversion of all textual authority, I posit that Chaucer exemplifies the stability of the memory structure as well as the vernacular text. The poem cultivates our awareness of the synthesis that is a distinctive feature of both medieval memory and the vernacular poetic tradition. Medieval mnemonic theory holds that when a reader experiences a strong sensory and emotional reaction to textual images, that reaction is a sign of mental digestion that facilitates retention. Reading is a process of making one's own the text one has "experienced," a necessary preliminary to making its many components a part of one's memory stores. But reading a text and imprinting it on one's memory involves more than retention. The act of imprinting images drawn from preexisting texts so that they become personalized memory images is an appropriative one, as is the act of placing those images into a personal memory space. By staging a series of dramatic moments in which his narrator sees, hears, and senses living moments from classical texts, Chaucer introduces the dynamic of vivid physical perception that was associated with deliberate memory making, and creates for his I-persona the chance to experience a range of visual and sensory cues, to respond to these cues emotionally, and to take action based on his responses. Thus the intensely imagined visual scenes of the poem compose a kind of amplification of classical *materia*, informing and enriching a narrative about the reception of classical textual culture.

The phrase *creative memory* may sound derogatory to the modern reader because the modifier *creative* implies that such a memory is inaccurate. In the context of medieval memory culture, however, a creative memory does not have license to invent independently

of a sense of responsibility to what actually happened. Rather, a rich and accurate memory inventory makes possible precise recollections of varying versions of a given tale, enabling a fecund copiousness of reminiscence. It is because Chaucer's narrator can remember with precision the competing accounts of the legend of Aeneas as written by Virgil and Ovid that he can turn their conflicting views into a story that illustrates fame's propensity to memorialize famous versions of a given event rather than the past as it actually occurred. Then, too, while Chaucer's poem affirms that neither historical fiction nor vernacular romance can be trusted to deliver unaltered, unembellished historical truth, it also shows us that, in the absence of such truth, accurate memories of one's own distinctive visual and somatic experiences can function as a legitimate source of knowledge and authenticity. In turn, Chaucer's care to emphasize the importance of remembering his dream correctly dignifies the vernacular poem in which fragments of classical textual culture reappear, authorizing the poem not only as a vehicle for the transmission of textual culture, but as a worthy object in its own right. Ultimately, Chaucer demonstrates that by remembering accurately and imaging vividly the *fama* (familiar material) of classical textual culture,[7] the vernacular poet can produce a commemorative monument that serves the exigencies of his own particular moment. In the *House of Fame*, remembering is not devalued for the quality of deception but credited—and exploited—for its generative and preemptive properties.

John of Garland and the Inventional Artificial Memory

Chaucer signals his interest in the relationship among poetic invention, the visual, and memory culture by his creation of three architectural structures that feature prominently in the poem. As critics have recognized, the three "houses" traversed by the narrator—the Temple of Glass, the House of Fame, and the House of Rumor—each resemble a medieval memory palace. One form of artificial memory, the memory palace is an imagined architectural space that contains a tableau of *imagines agentes*, imaged figures that cue the memory and solicit an emotional reaction from the remembering thinker. Written approximately 160 years before Chaucer wrote the *House of Fame*, John of Garland's poetry handbook *Parisiana poetria* (ca. 1220, rev. 1231–1235) describes ways to use artificial memory that are highly suggestive when read alongside Chaucer's poem.

The origin legend for artificial memory affirms that the mind retains visual images more readily than any other kind of sensory experience. According to Cicero's *De oratore*, artificial memory was invented by the Greek poet Simonides, who chanted a lyric poem at a banquet to honor his host, then left the room just before the roof collapsed on all who remained inside. When friends and relations could not distinguish among the anonymous dismembered limbs, they turned to Simonides, who was able to visualize the hall and

banquet table and recall precisely where each guest had been sitting. This feat of memory alerted him to the fact that visual imaging and orderly arrangement are highly conducive to retention. Consequently he developed a mnemonic technique in which practitioners imagine localities, form mental images of facts they wish to remember, and then store the images in those localities. The localities or topoi, which often take architectural form, are sequenced in logical order. The technique came to be called "artificial memory" because it is a system wherein practitioners re-create, artfully, conditions presumed to enhance "natural memory." As the story illustrates, artificial memory emphasizes visual experience, the spatial relationships of objects, and the fact that we remember visual spectacles best when they solicit an emotional reaction.

Though the story of Simonides credits a poet with having invented this mnemonic system, the classical *ars rhetorica* that first describe artificial memory—including the *De Oratore*, Pseudo-Cicero's *Rhetorica ad Herennium*, and Quintilian's *Institutio Oratoria*—are handbooks for orators and litigators rather than poets. Yet, even in its classical iteration, artificial memory requires imaginative work that resembles what is necessary for poetic production. The figures of metaphor, personification, and synecdoche are as important to artificial memory as they are to poetry. In the *Rhetorica ad Herennium*, for example, the author prescribes artificial memory as an aid to remembering the facts of a case, offering an example of an imaged scene that includes visual metaphors. For a trial in which one man is accused of poisoning another for an inheritance, Pseudo-Cicero advises, "We shall place the defendant at the bedside, holding in his right hand a cup, and in his left tablets, and on the fourth finger a ram's testicles. In this way we can record the man who was poisoned, the inheritance, and the witnesses."[8] The scene literally depicts the setting, but the specification that the defendant's finger be imprinted with the image of ram's testicles, *testiculi*, is probably meant to suggest *testes* (witnesses). The scrotums of rams were often used to make purses; hence, the image may suggest not only the inheritance but also the money for bribing the witnesses. Later in the same text, to remember that a palace in a particular sequence is the fifth, Pseudo-Cicero advises imagining a (five-fingered) hand imprinted on that space. In the tenth house, he advises imprinting the image of a friend named "Decimus."[9]

Proponents of artificial memory occasionally worried about the fact that it entails such prodigious manufacture of new and metaphorical images. Practitioners from Cicero and Quintilian to Geoffrey of Vinsauf feared that artificial memory might become too prolific, producing a barrage of imagery that could overwhelm natural memory. Accordingly, they cautioned against allowing artificial memory to become too abundant or exotic in its rampant image production.[10] Artificial memory creates mental artifacts full of images that exceed the literal memory goods to which they refer and which they are designed to retain. Yet this very feature of the memory *techne* suggests that artificial memory can be a tool not just for storing familiar *materia* but also for amplifying it and, in the process, creating something new.

When the twelfth- and thirteenth-century authors of the *ars poetriae* wrote handbooks that adapted the rules of the ancient Roman *ars rhetorica* to the purposes of poetic composition, they inaugurated key changes in inventional practice. These changes were to some extent a natural result of shifting the field of action from the antique public podium or court of law to the medieval classroom or study. In the classical handbooks, the active agents in a memory scene were likely to be defendant and victim. Rhetors applied the questions "who, what, where" to the crime scene: who committed the actionable offense, what was the crime, where was it committed? In contrast, medieval rhetors, working in a hermeneutic tradition that conceived invention as the act of amplifying, varying, and ornamenting preexisting texts, made the primary actor the composer himself. In the medieval *artes poetriae*, "where" and "what" describe the action of the composing author: "where he can look for a subject and what that subject will be."[11]

In the *Parisiana poetria*, John of Garland describes how the composer turns to an artificial memory matrix to find and select characters, sayings, and examples encountered in preexisting texts. To create a memory image, he explains, the remembering thinker should apply the rhetorical questions "who, what, where" to *himself and his experience* at the moment of apprehending some new bit of information destined for memory storage:[12] "If memory should fail us on some point, we must then call to mind the time, be it vivid or hazy, when we learned it, the place in which, the teacher from whom, his dress, his gestures, the books in which we studied it, the page—was it white or dark?—the position on the page and the colors of the letters, because all these will lead to the things that we want to remember and select" (37). Here John underlines a vital parallel between literary and memorial creative genesis, for he advises that the practitioner of artificial memory should literally invent a narrative of which he is the protagonist, as a way to remember the authoritative words handed down in traditional *materia*. What's more, key to this creative process are the intensely visual images of the memory scene that documents the figure of a teacher, his dress and gestures, and the light or dark pages of a book inscribed with colorful characters. The narrative that anchors the inventoried material develops when the remembering thinker forges a connection between the material learned and his own multisensory experience.

Another of John's innovations was to make memory a subset of the first canon of classical rhetoric, *inventio* (invention), emphasizing that literary composition depends on being able to select materials from a rich memorial storehouse. In making his discussion of memory part of a larger discussion of invention, John departs from the classical ordering of the five canons of rhetoric, which typically places *inventio* first, followed by *dispositio* (arrangement), *elocutio* (style), *memoria* (memory), and *actio* (delivery). The traditional order implies that one creates a speech, arranges its parts, ensures its eloquence, stores it in the memory, and then retrieves it for delivery. John's reordering insists on the mutually enabling relationship between memorial *inventory* and *invention*. Similarly, in the context of medieval poetry making, memory's most important role is to facilitate creation.

As John describes it, the relationship between invention and memory is limited to two operations that will not be detectable in the finished poem: first, the student uses invention to create a memory matrix; second, the student returns to this somatically vivid, mentally imaged "space" to retrieve the storied material when he wants to create a new composition. In other words, artificial memory is designed to facilitate the *process* of creating a poem, but its anterior usage is not typically evident in the resultant poetic *product*. Certainly John does not specifically recommend that fragments of the mnemonic narrative could or should become discernible within the poem proper. However, his recommendation that the mnemonic narrative record the interaction between student and teacher is suggestive of this possibility. In both medieval commentary and literary tradition, it is common to depict an encounter between a classical *magister* and a medieval narrator, the teacher imparting what is putatively his own ancient wisdom. Such a relationship between an authoritative classical figure and a humble vernacular narrator is depicted both in the *House of Fame* and in its chief contemporary source, Dante's *Divine Comedy*. In *Inferno*, the Dante-pilgrim finds a guide in the character of Virgil, who pilots him through the successive rings of hell. In the *House of Fame*, Chaucer's narrating I-persona encounters a golden eagle that acts as his guide through the starry reaches of the heavens and treats him to a pedantic lecture on the properties of sound. Immediately following the narrator's tour of the Temple of Glass, the golden eagle appears, sweeps the stupefied narrator into the heavens, and tells him to "Awak!" (556) in "the same vois and stevene / That useth oon I koude nevene" (561–62). The narrator recognizes the specific voice of someone he knows, and this somatic cue restores him to lucidity in the present moment. He makes a joking comment that the voice speaks the injunction "Awak!" in much kinder tones than it usually adopts, implying that he has recognized the voice of a teacher who, in the context of a classroom, repeatedly caught the narrator dozing rather than studying.[13] Such a scene indicates how easily the mnemonic procedure used to store and recall materials could resurface in a poem invented from memory stores.

In his description of how to create an artificial memory matrix, complete with two illustrations that depict literal ones, John departs from the rules of classical mnemonic practice. The changes that he makes all emphasize that literary creation depends on judicious selection from memory stores. For example, while classical handbooks recommend making as many mental spaces as the remembering thinker requires, John advises his readers to make three subdivided columns (fig. 2.1), the first of which is divided into three parts containing, respectively, "courtiers with their letters," "city dwellers," and "peasants with their implements." This first column reminds viewers that a choice of character type also determines a choice of high, middle, or low style. The second column foregrounds vernacular invention as well, though in this case the focus is on the experience of the remembering thinker. John's accompanying exposition tells readers that this second column is designed to store "examples and sayings and facts from the authors" (37). Yet in the

FIG. 2.1 John of Garland's model of a memory matrix as columns. Oxford, Bodleian Library MS Lat. misc. d. 66, folio 8r.

depicted column, what is listed as stored are not "sayings from the authors" but "Teachers with their books," "Place," and "Time." In other words, what is stored in the subdivided column is the remembering thinker's *experience*—the strongest aid to a retentive memory.

In the third and final column, John again highlights the experience of the remembering thinker. The column contains "etymologies of words," and John tells his readers to imagine that here are written "all kinds of languages, sounds, and voices of the various living creatures, etymologies, explanations of words, distinctions between words, all in alphabetical order" (37). Then he adds, "But since we do not know every language, nor have heard every word, we resort to those which we have heard" (37–39). Here John emphasizes the subjective and individualized experience of the one who memorizes and selects: while the ideal column includes all the sounds/words ever spoken, a selector can choose only those with which he is familiar. John concludes with a suggestion that one should translate an idea into an allegorical image: "When the teacher makes a philological or etymological explanation of any word, let us gather it into that third column, along

FIG. 2.2 John of Garland's
model of a memory matrix
as a wheel. Oxford, Bodleian
Library MS Lat. misc. d. 66,
folio 7v.

with some natural phenomenon that may symbolize the word in question; and by means of its symbol we shall be able to memorize it and later select it for our own use" (39). This recommendation to employ allegorical images suggests the reason that John's subdivided columns do not store just "etymologies of words" but also "creatures of the earth" and "sky": the earthly and heavenly creatures are likely figurative images meant to serve as mnemonic cues.

John's second memory matrix is a graphic drawing of the *Rota Virgilii* (Virgil's Wheel), a rubric that commandeers classical textual culture, recasting the Virgilian canon as a personal memory space designed for the use of medieval composers. The wheel comprises a circle divided into three sections that form concentric circumferences labeled "High Style," "Middle Style," and "Low Style" (fig. 2.2). These subdivisions contain figures of the soldier or governor (corresponding to the high style), the farmer (middle style), and the shepherd (low style). The sections and subdivisions are designed to remind composers that a choice of character determines a writing style: if one chooses to make one's protagonist

a governor or a soldier, one must implement the high style, and so on. In the form of a memory matrix, the wheel organizes Virgil's three-part literary career: his composition of the *Bucolics*, the *Georgics*, and the *Aeneid*, which fall, respectively, into low (pastoral), middle (didactic), and high (epic) style. The title of the wheel attributes the *intentio auctoris* (authorial intention) of the rubric to Virgil, preserving within its sections the characters and types featured in his works. The rubric itself and the use to which the classical material will be put is distinctively medieval. Chaucer accomplishes a similar transformation in the *House of Fame*.

Chaucer and Inventional Artificial Memory

Chaucer may well have read John of Garland's *Parisiana poetria*.[14] His familiarity with artificial memory and its role in poetic invention is evident. Indeed, Elizabeth Buckmaster, recognizing that the *House of Fame* draws extensively from medieval mnemonic theory, speculates that Chaucer's primary intention was to reveal "the role of *artificiosa memoria* or cultivated memory in the creation of a poem." Similarly, Beryl Rowland argues that the whole poem can be seen as "an externalization of the memory process" whereby poets create memory houses and fill them with imaginative agents.[15] Because the poem makes so many references to memory culture and also records the efforts of a poet to find a subject about which to write, these formulations are tempting. But the poem is not simply a straightforward account of how to use a mnemonic device to find and re-collect material into a new poem. If that were the case, it would not be a poem but rather an instruction manual. It is true that the device of creating architectural "spaces" to restore memory goods finds a parallel in the three architectural houses of Chaucer's poem. But Chaucer's narrator describes himself as lost and wandering within them, not as returning deliberately to these houses to find material on a self-chosen topic. He does not realize his purpose until book 2, when the eagle tells him Jove has sent him to find new "tydynges" (644, 675) of love and to write a poem about them. Similarly, the houses in Chaucer's poem do not appear as the result of purposeful premeditation but instead surface spontaneously in a dream, a mentally imaged environment that the narrator emphasizes is not under his conscious control.

In the context of the *House of Fame*, artificial memory serves both less and also more than its prescribed didactic purpose as Chaucer inherited it from the *ars poetriae* and the vernacular translations of the *Rhetorica ad Herennium*. What is missing—or what Chaucer has rhetorically "abbreviated" from the artificial memory system—is the *deliberate* and *conscious* creation and stocking of memory palaces, and the *deliberate return* with a *specific purpose* in mind. Paradoxically, these changes, which underline the narrator's lack of rhetorical control over the mnemonic, help Chaucer emphasize and amplify artificial

memory's appropriative powers. For example, the memory structures' unsolicited appearances indicate that artificial memory has become so wholly integrated in the narrator's consciousness that it inadvertently shapes the way his mind stores and processes information. By taking poetic license to alter the way the artificial mnemonic usually works, Chaucer alerts readers that artificial memory restructures interior thought, automatically reshaping memory content in ways that inevitably affect its perceived significance and meaning. Chaucer also pushes a step beyond John of Garland's recommendation to create a memory narrative featuring oneself as the protagonist: he offers a poem featuring an I-persona narrator whose dream depicts recognizable elements from artificial memory practice. Thus components of artificial memory production—symbolic images and narratives documenting moments of mnemonic imprinting—become a multivalent form of art that is, in itself, worthy of remembrance. What is more, the vivifying powers of artificial memory, with its capacity to engage the physical senses, become a means to redirect the focus away from stored textual culture and toward the power vernacular writing has to transform mnemonic material into vivid and moving poetry.

All of this is to say, when Chaucer makes the structures of artificial memory visible, he does so in order to make the memory matrix itself the object of poetic abbreviation and amplification. Chaucer's departures from a straightforward account of the practical mechanics of artificial memory enable a brilliant meditation on the ways vernacular poetry shapes—and is shaped by—visual mnemonics and creative memory. Not only does Chaucer transform a utilitarian mnemonic device into a potent and refractive poetic symbol, he also redirects attention away from classical material toward vernacular reception, precisely by making the tool used for preservation his primary focus. That is, he elevates the mnemonic tool by granting it the same status as the *communis materia* from which vernacular poets wove their poems, and, in doing so, he implicitly claims the status of *auctoris* for those who recreate artificial memory images and narratives in the vernacular.

In the dream's dramatic opening scene, Chaucer signals to readers that conventions associated with artificial memory will be used literally to reframe classical iterations of the legend of Aeneas. The narrator finds himself in a large temple, and as he slowly tours the building, he perceives the story unfold via images that he tells us are "peynted" (211) and "graven" (193) on the walls. In its depiction of an architectural space filled with imaginative agents that solicit an emotional response from the viewer, Chaucer's scene includes the classical elements of the memory palace as outlined in Cicero's *De Oratore* and Pseudo-Cicero's *Rhetorica ad Herennium*. But in Chaucer's fourteenth-century version of a memory palace, he also uses a distinctly medieval mnemonic for intensifying the remembering thinker's experience of a given image. The narrator has such a vivid response to the story that he does not just *see* the images—he *hears* them. As Aeneas carries his father away, together they cry, "Allas, and welaway!" (170). In the flight from Troy, Creusa, Iulus, and

Ascanius exhibit such sorrow that "hyt was pitee for to *here*" (180; emphasis mine). The speaking-pictures phenomenon reaches its apex when the narrator reports hearing Dido deliver an entire speech of reproach against Aeneas. Carruthers makes a convincing case that these audible images are inspired by a specific strand of medieval mnemonic theory. She speculates that Chaucer, like Dante before him, read Bono Giamboni's vernacular Italian translation of the artificial memory passage in the *Rhetorica ad Herennium*, in which Bono mandates that memorial images should not be silent ("non mute").[16] Just as Dante incorporates the topos of "visibile parlare" in the Terrace of Pride scene in *Purgatorio*, Chaucer creates his own speaking pictures in the *House of Fame*.[17]

Even as these references to artificial memory showcase Chaucer's knowledge of prestigious Italianate culture, they also elevate his vernacular poetry by calling attention to its evocative verisimilitude. The speaking pictures in the Temple of Glass are not *just* memory images—they are also literal painted images on a wall. As such, their speaking quality refers to a visual art that imitates nature so closely it seems that the created artifact is real. In Dante's *Purgatorio*, the Dante-pilgrim credits God with having created the artful speaking pictures that adorn the Terrace of Pride, images so lifelike they are perceptible to the Dante-pilgrim's senses of sight, smell, and sound. In the *House of Fame*, the narrator indicates two authoritative and prestigious sources for his retelling of the Aeneas story: first, Virgil's *Aeneid* (the poem begins with lines engraved on the wall: "I wol now synge, yif I kan, / The armes and also the man"; 143–44); and second, Ovid's *Heroides* (at the end of Dido's complaint, the narrator tells readers wanting to know "alle the wordes that she seyde" to read "Virgile in Eneydos" or "the Epistle of Ovyde"; 376–79). The exquisite artisanship of the pictures may thus be attributable to the literary skill of Chaucer's classical sources, but as artifacts of artificial memory their speaking quality may be credited to the narrator himself. By association with the artful pictures on the wall and the great literary images created by Virgil and Ovid, Chaucer suggests that memory images are, also, a form of art.

In the scene in which Dido delivers her lengthy lament, Chaucer uses the speaking pictures to imply that the mnemonic reexperiencing of artistic images could be so vivid that it might literally restart the past—and even open up the possibility that the past could happen differently. Such a phenomenon implies that the speaking pictures can make possible the kind of rhetorical appropriation that enables variation from one's sources. Chaucer's narrator insists that Dido tells him something new in his dream:

> In suche wordes gan to pleyne
> Dydo of hir grete peyne,
> As me mette redely—
> Non other auctour alegge I.
>
> (311–14)

The phrase "As me mette redely" makes a specific truth claim: the narrator announces that these are not the exact words Dido spoke to Aeneas centuries ago, nor are they the words written by one of his sources ("Non other auctour alegge I"). The narrator's heightened sensory experience of the speaking pictures suggests that, if only through his intense reception and reexperiencing of the story, the classical past has been pulled into a dynamic and mutually reconstituting relationship with the present. The speaking-pictures feature of the artificial mnemonic enables the possibility that past events are not yet absolutely determined; that is, within certain parameters, they are capable of changing course.

The suggestion is a provocative one. It is therefore initially a bit surprising that the actual ways Dido's speech to Geffrey varies from those she delivers to Aeneas in either of the narrator's classical sources are not particularly original. Chaucer's narrator uses Dido's story as a half-comic exemplum illustrating the duplicity of men in love: essentially, this alteration amounts to framing Dido's complaint as a mnemonic commonplace, her story as important insofar as it reminds readers of an unfortunate but mundane truth repeated everywhere. He underlines the story's use as an exemplum when he likens her fate to those of a series of classical women likewise ill fated in love, citing a number of the stories that will later appear in the *Legend of Good Women*.

The narrator's apparently reductive account of the Dido story, along with his radical abbreviation of the Aeneas legend, has been read by some as evidence that he is yet another unreliable Chaucerian narrator, whose "peculiarly impressionable" character should alert readers that his statements about what he sees transpire are heavily biased.[18] Insofar as memory is implicated in such readings, the tacit assumption is that, like the narrator of the *General Prologue*, the narrator of the *House of Fame* is under the sway of what Robert Hanning has called, with some deprecation, "the erotics of memory": he allows personal feeling to sway him and remembers best what he likes most or least about a given person.[19] Yet if we recognize the narrator's intensive reaction to the speaking pictures as a reference to artificial memory, we cannot assume that this scene indicts the narrator's subjective memory, nor can we presume that in this particular context a subjective memory is a faulty one. Practitioners of the art insisted that strong emotional reactions to stored material are an aid, rather than a hindrance, to accurate retention. Chaucer's achievement is slyly to have used the narrator's care to remember the specifics of his own experience as a pretext to show how the artificial memory can serve as a tool for narrative genesis. If Chaucer has amplified John of Garland's suggestion that the practitioner of artificial memory should create a story about one's reception of stored material as a way to retain it, he has also shown that such alterations can be productively artful.

Despite the eagle's *intentio auctoris*, however, the real story will be the poet-narrator's exploration of his own implication in the operations of the fame that Dido identifies as her scourge. The most germane triggering factor in the Dido-Aeneas affair emerges at the end of Dido's speech, when she levels a final set of accusations at Aeneas:

"O wel-away that I was born!
For thorgh yow is my name lorn,
And alle myn actes red and songe
Over al thys lond, on every tonge."
(345–48)

As we read these lines, we cannot help but be aware that, along with Aeneas (and Lady Fame), Geffrey himself might be the addressee. The lines implicate the narrator as an agent of fame, putting him in the powerful position of determining how Dido will be remembered. Later, in the *House of Fame*, an anonymous "oon" (1869) will ask the narrator himself whether he seeks fame, to which he will respond (perhaps disingenuously) that he does not; he looks instead for tidings of love or "suche thynges glade" (1889). The disavowal intimates the narrator's recognition that, like Dido, he may well be remembered in accordance with another's appropriative aims and intentions. The Dido scene does not entirely disavow a certain apprehension of the artificial memory's transformative powers, but it does emphasize the *techne*'s capacity to give stored material new relevance and new life by pulling it into a compelling and timely relationship to the present.

Chaucer's classical source for the palace of Lady Fame, the second "memory palace" visited by the narrator, is a description of Rumor's house in book 12 of *Metamorphoses*. But Chaucer amplifies and transforms the Ovidian *materia* by translating it into a visual, mnemonic language. This is memory work as a kind of "unfaithful translation" that alters a source by transposing it into a different rhetorical register. Like Ovid's House of Rumor, Chaucer's House of Fame is located at the midpoint of sea, earth, and sky; like Ovid's, Chaucer's house is perched on a mountain; and, like Ovid's, Chaucer's house contains muttering voices that sound like waves of the sea. Both descriptions are rich in metaphor, but while Ovid's description focuses on the aural, Chaucer's focuses on the visible, a transposition that again reminds us of the primacy of place given to sight and the visual image in theories of artificial memory. Ovid reports that the House of Rumor is made of echoing brass ("aere sonanti"; 12.46); there is no silence within; the whole place resounds with noise, repeats all words, and doubles what it hears ("refert iteratque quod audit"; 12.47). Chaucer translates these aural metaphors into visual ones, and also adds visual metaphors of his own. Fame's house is not built of echoing brass, but rather of reflective beryl that makes things seem larger than they are. Ovid's reference to the strangely soft sound of a muttering crowd is similarly "reified," to use Christopher Baswell's serendipitous word: just before their arrival at Fame's house, the eagle informs the narrator that each "speche" (1074) that comes there immediately takes on the physical likeness of its utterer.[20] The added detail that the speech may be "clothed red or blak" (1078) suggests that "speech" may also be written, the red and black colors suggesting letters on a page. Even the description of how "every soun mot to [Fame's palace] pace" (720) translates

the progress of invisible sound into a visual image: the eagle likens it to the spreading of ripples across the surface of water.

Chaucer further exploits artificial memory's mandate to create prolific and linked visual images when he multiplies Ovid's single House of Rumor. Just as stories are given or denied fame in the House of Fame, the narrator learns, they actually come into being in the House of Rumor, products of promiscuous speech that combines lies and truth. When the narrator discovers Rumor's house, the third memory palace, he also discovers retrospectively a sequence that ties the three structures together: the first house contains a famous story, the second house is the site where stories become famous, and the third house is the origin point for the stories themselves. The sequential creation of memory houses, and the prescribed construction of a way to remember their relation to one another, is a common technique for artificial memory. Thus the amplification of Ovid's House of Rumor into multiple houses emphasizes the relationship between creative memory and the genesis of new poetry.

While the narrator tells the anonymous speaker in the House of Fame that he does not seek to become famous, he does profess a new knowledge of its whereabouts. He now knows where Fame dwells, and "eke of her descripcioun" (1903), her "condicioun" (1904), and the "ordre of her dom" (1905). Chaucer's intertwining of artificial memory and the concept of fame makes possible, indeed constitutes, that discovery. Ultimately, Chaucer's mnemonic amplification of fame—and his demonstration of the arts and powers of vernacular poetry—is the true tiding the poem brings to the world.

Conclusion

In her magisterial history of ancient and premodern memory, Frances Yates emphasizes that medieval practitioners conceived of artificial memory as chiefly useful for remembering things pertaining to religious belief, including the vices that might lead to hell and the virtues that might lead to heaven.[21] Accordingly, she reads the *Divine Comedy* as a memory system, with the concentric rings of hell marking a series of memory palaces designed to help readers memorize hell and its punishments.[22] In her depiction of memory culture during the "pious Middle Ages," Yates goes so far as to suggest that "artificial memory has moved over from rhetoric to ethics."[23] Yet the treatments of artificial memory provided by Geoffrey of Vinsauf, John of Garland, and Geoffrey Chaucer require a crucial qualification of this argument. All three remind us that a rote memory that reproduces its sources exactly as originally articulated can only facilitate the kind of slavish borrowing or paraphrase that medieval schoolmasters discouraged in their students.

In the *House of Fame*, Chaucer reconfigures the relation between creative memory and poetic invention in a way possible only in the context of a poem. Here, sensory and

visual experience become a form of amplification, a medium through which proliferate the increasingly complex connections between classical text and medieval reader/perceiver. Recent interpretations of the *House of Fame* have taken the poem as testimony to Chaucer's suspicion of poetry because, like Lady Fame, poets are liars who memorialize the past without regard for strict truth. Chaucer's narrator comes under suspicion as a figure who is emotionally swayed by speaking pictures, and whose emotional reactions cause his memorial account to wander from accurate reproduction of the antique past. Yet his dismembering and re-membering of classical textual culture also serve to draw that culture into living relevance to the present. Ultimately, the *House of Fame* demonstrates how the Middle Ages could capitalize on the putative problem with artificial memory: that the images it produced could supplant or displace that which they were originally designed to preserve. In the context of an inventional tradition that defined poetic creation as the variation and sometimes unfaithful translation of previously existing *materia*, that problem could become the very ground of new invention for medieval composers.

NOTES

1. Kelly, "*Fidus interpres.*"

2. Copeland, *Rhetoric, Hermeneutics, and Translation*, 186–202.

3. Minnis, *Medieval Theory of Authorship*, 190–210.

4. The shift began with the 1990 publication of Carruthers's magisterial *Book of Memory*, followed in 1998 by *The Craft of Thought*. Carruthers challenges a central tenet of Yates's landmark midcentury study of premodern memory, *The Art of Memory*. Yates argues that artificial memory in the Middle Ages was concerned primarily with ethics rather than rhetoric. Carruthers shows instead that premodern memory was closely associated with creative thought and rhetorical invention. Other studies that have advanced our understanding of inventional memory include Enders, *Medieval Theater of Cruelty*; and Coleman, *Ancient and Medieval Memories*.

5. Criticism that addresses the role of memory in the *House of Fame* tends to characterize it as one of the contributing features of the poem's overall lack of unity and thoroughgoing subversion of textual authority. See Baswell, *Virgil in Medieval England*, 220–44; Taylor, *Chaucer Reads the "Divine Comedy,"* 20–49; Kruger, "Imagination and the Complex Movement," 117–34; Amtower, "Authorizing the Reader," 278; Haydock, "False and Sooth," 117; and Powrie, "Alan of Lille's *Anticlaudianus*," 259. In stressing

the imprecise, subjective, and false nature of the narrator's memory of classical textual culture, their arguments represent an influential view that the *House of Fame* continually evokes authoritative structures, including the authority of the written text itself, only to undermine them. See, for example, Delany, *Chaucer's "House of Fame"*; Boitani, *Chaucer and the Imaginary World of Fame*; and Minnis, *Oxford Guides to Chaucer*.

6. See Carruthers, "Italy, *Ars Memorativa*," which argues that the primary reason for the artificial memory motif is decorative—that it endows Chaucer's poem with some of the immense cultural authority of Dante, whom he mimics in creating "speaking pictures."

7. Lewis and Short's *Latin Dictionary* defines *fama* as "that which people say or tell, the common talk, a report, rumor, saying, tradition." The *Middle English Dictionary* includes in its definitions of *fame* "Any report, rumor, or widely circulated opinion." In its Middle English usage, the term could refer to stories that were told and retold until they achieved the status of "traditional subjects"—that is, the familiar *materia* to be rewoven by vernacular composers.

8. Pseudo-Cicero, *Rhetorica ad Herennium*, 214–15.

9. Ibid., 210–11.

10. Cicero raises the claim (in order to refute it) that "memory is crushed beneath the weight of

images and even what might have been retained by nature unassisted is obscured" (*De oratore*, 360). Quintilian repeats the criticism when he asks, "Will not the flow of our speech be impeded by the double task imposed on our memory?" (*Institutio Oratoria*, 4). Geoffrey of Vinsauf includes among the abuses of memory overburdening memory, refusing to make pleasure a part of the process, and accepting Cicero's "exotic" images when they are foreign or user-unfriendly; he recommends that his readers create personalized systems.

11. Copeland, *Rhetoric, Hermeneutics, and Translation*, 163.

12. Citations of John of Garland's poetry handbook are from *Parisiana poetria*, given by page number in the text.

13. Klitgård, in "Chaucer's Narrative Voice," 261, proposes that the voice alludes to the narrator's nagging wife, who habitually routs him out of bed in the morning. The eagle's "mannes vois" (556) and pedagogical lecture on the properties of sound suggest, however, that the voice is that of a teacher.

14. On the likelihood of Chaucer's familiarity with John of Garland's *Parisiana poetria*, see Fisher, "Three Styles"; and Buckmaster, "Chaucer and John of Garland."

15. See Buckmaster, "Meditation and Memory," 163; and Rowland, "Bishop Bradwardine," 48.

16. Carruthers, "Italy, *Ars Memorativa*," 184. A number of critics have connected the speaking-pictures motif to memory, but to my knowledge only Carruthers has connected it to artificial memory. See Kolve, *Chaucer and the Imagery of Narrative*, 24; Minnis, *Oxford Guides to Chaucer*, 199; and Smalley, *English Friars and Antiquity*, 149.

17. See *Purgatorio*, 10.95, in Dante Alighieri, *Divine Comedy*, 2:402. For Carruthers, this passage chiefly shows Chaucer's wish to elevate his poem by enriching it with allusions to Italianate culture ("Italy, *Ars Memorativa*," 183).

18. Delany, *Chaucer's "House of Fame*," 56. See also Taylor, *Chaucer Reads the "Divine Comedy*," 28; and Baswell, *Virgil in Medieval England*, 235–36.

19. Hanning, "Introduction," xxiv.

20. Baswell, *Virgil in Medieval England*, 238.

21. Yates, *Art of Memory*, 55.

22. Ibid., 95.

23. Ibid., 55, 57.

THREE

"*Quy la?*"

The Counting-House, the *Shipman's Tale*, and Architectural Interiors

Sarah Stanbury

In the middle of the *Shipman's Tale*, the story pauses for a sermon on worldliness. After setting up her tryst with the monk daun John, the wife comes to fetch her husband for dinner, chiding him for overzealous attention to his financial affairs. In response he reminds her—and us—of the serious and risky work of merchants. Hardly two out of twelve will thrive into their old age. *World* is the term he uses for the perils of his profession across a lifespan; merchants have to "dryve forth [*endure*] the world as it may be" (VII 231) and keep their affairs private. Because of the fickleness of fortune, we merchants have to pay close attention to "this queynte world" (VII 236), this tricky world. And out into the world is where the merchant is about to go. After his reflection on the risks attendant on his profession, he tells his wife he has to travel from Saint-Denis, the French market town where the tale takes place, to Flanders the next day, indicating to her—and to the reader—that his business circuit takes him between some of the major trading centers of Europe. Her job while he is away is to "governe wel oure hous" (VII 244)—easy enough, since he has supplied her with everything she could possibly need: "Of silver in thy purs shaltow nat faille" (VII 248). She will not want for food, clothing, or cash.

I am grateful to Sarah Luria, Virginia Raguin, and Susan Elizabeth Sweeney for their comments on earlier drafts of this essay.

The location for this speech is the merchant's counting-house, or really the counting-house door. The conversation—which, in light of the wife's clandestine financial dealings with the monk, is laced with comic ironies—happens in curiously indeterminate space. The wife knocks and then teases; the husband declaims. After assuring her that she will have ample resources to manage the house when he is away, he shuts the door, and they go down for dinner. During this dialogue, are they standing at the threshold of the room, the wife outside and the merchant inside, or are they carrying on their conversation across a closed door? The question of where they are, exactly, when the exchange takes place would hardly seem to matter were not for the pointed attention the tale gives to the counting-house and to its door. The tryst in the garden is bracketed by references to the room. Even before the dialogue at the door, the narrator has named the room and detailed the year-end calculating the merchant has gone there to do, laying "his bookes and his bagges many oon" (VII 82) before him on his counting-board and then locking the door behind him:

> The thridde day, this marchant up ariseth,
> And on his nedes sadly hym avyseth,
> And up into his countour-hous gooth he
> To rekene with hymself, wel may be,
> Of thilke yeer how that it with hym stood,
> And how that he despended hadde his good,
> And if that he encressed were or noon.
> His bookes and his bagges many oon
> He leith biforn hym on his countyng-bord.
> Ful riche was his tresor and his hord,
> For which ful faste his countour-dore he shette.
> (VII 75–85)

The narrator's account of the merchant's financial calculating in his counting-house, the wife's teasing comments, and the merchant's first-person homily on the burdens and responsibilities of his profession all annotate, from three different points of view, not only the work of merchants but also the built space in which that work is practiced. Terms for counting, counters, and the room in which money is stored and quantified appear five times: he rises on the third day and goes to his "countour-hous," lays his books and bags before him on his "countyng-bord," shuts his "countour-dore," and later, after the wife knocks at his "countour" (VII 213), he gives her his lecture, and "with that word his countour-dore he shette" (VII 249).

What, indeed, *is* a counting-house? Chaucer's *Shipman's Tale* documents one of the earliest recorded appearances of the room name in English. The first reference to such

a room in English is also Chaucer's, from his early dream vision the *Book of the Duchess*, where the marvels of the narrator's dream exceed the computational abilities of Argus in his "countour."[1] For English speakers today, a counting-house most likely will conjure up the jingle "Sing a Song of Sixpence."[2] In addition to an act of avian violence, the jingle is memorable for its careful domestic staging. Tasks are appropriate to gender and to social class, and all seem to occur in household spaces meant for them or that they somehow design: hanging up clothes by the maid in a garden, bread and honey eaten by a queen in the parlor, money counting by a king in his counting-house. While most houses today are likely to feature a parlor and a garden, they are unlikely to have a counting-house. Counting-houses are lost rooms, part of a lexicon of household anachronism—room names and functions no longer in use. This familiar song, first transcribed in the eighteenth century but perhaps tracing back to the sixteenth, names a counting-house without telling us much about how such rooms were furnished or what went on in them, beyond its couplet linking a powerful man, his money, and a sequestered domestic space.

This essay situates the *Shipman's Tale's* counting-house, also a male preserve, in relation to building practices and household furnishings, including tools for calculating, in late fourteenth-century London, and argues that the room offers a notably intentional staging for the tale's domestic plot. The counting-house represents something of a novelty in 1390s London house design, contemporary evidence indicates. Novelty makes objects, or in this case a room, spring into view; and Chaucer's use of a counting-house as a key site for his story, offering a metacommentary on changing spatial and social practices of bourgeois life, orients the points of view within the household even as it situates the house and its economic practices on the tale's named Continental trading networks: Saint-Denis, Paris, Lombardy, Bruges. Through its novelty, the room also prompts a reflection on developments in architectural privacy, particularly as annotated by the merchant's sermon on mercantile practices and the importance of keeping business affairs secret. From the vantage of his counting-house, so pointedly territorial, the merchant stakes a claim not just on the house, but also on the household.

Working at Home

Readers have long recognized the importance of privacy in Chaucer's writings, particularly the *Canterbury Tales*. As Robert Hanning puts it, privacy, or *pryvetee*, is "central to the poetic enterprise" of the *Canterbury Tales*; for Chaucer, writing is about making things public—about storytelling that negotiates between private and public lives.[3] Yet, despite scholarly attention to privacy and to the design of houses as settings for individual narratives, particularly *Troilus and Criseyde* and the *Miller's Tale*, Chaucer's broader interests in the housing of private life—architecture in late fourteenth-century London and cities

he visited on his Continental travels—have received surprisingly little attention.[4] Private life, more likely than not, takes place at home, and the negotiations that Hanning describes often involve interactions and contrasts between a domestic scene and a broader public—Symkyn's mill-house and the university rooms of Cambridge in the *Reeve's Tale*; Dorigen's castle in Brittany and the philosopher's home in Orléans in the *Franklin's Tale*; the merchant's home and garden in Saint-Denis, center for comings and goings to and from Paris and Bruges, in the *Shipman's Tale*.

Interactions between inside and out also occur within the home itself in rooms used not just for the reading and writing of poetry but also for bureaucratic writing and other kinds of calculating. In a study of privacy in Chaucer's *Miller's Tale*, María Bullón-Fernández suggests that work on Chaucerian *pryvetee* needs to take fuller account of the implications of home as a place of work, reckoning with "home" as a site of competing kinds of labor.[5] The reputation of carpenters and labor guilds for secrecy in late fourteenth-century towns, she notes, gets dramatic play in the multiple violations of boundaries in the *Miller's Tale* and underwrites the comedy when the house, after the carpenter's arm-breaking fall, becomes a place of public ogling. Acted out at home, the raucous domestic plot is also a story about craft identities and community relations. Home serves as a stage on which to tease out anxieties about privacy in the economic sphere of late fourteenth-century urban life[6]—and, I propose, tensions about territorial claims inside the home as well. In the *Canterbury Tales*, work at home comes to include accounting and mental conjuring, such as alchemy and astrology, work that occurs behind closed doors: Nicholas's astonishingly outfitted home study in the *Miller's Tale*, with its overdetermined door; the priest's chamber turned into an alchemy lab in the *Canon's Yeoman's Tale*; the philosopher's book-filled study in the *Franklin's Tale*; and the counting-house, with its closed door, in the *Shipman's Tale*. Indeed, a term for the writing of poetry, which is sourced from home in the dream visions, is *craft*, or work. Rooms at home are repeatedly pictured in Chaucer as sites for, or even shrines to, creative male labor. Some of the rooms in which work takes place get pointed attention, as if to mark them out as desirable or unusual new kinds of spaces for living. Even if the solitary or coterie activities done in studies and private rooms in Chaucer's writings may be at odds with other interests of the household or community, the rooms in which they are practiced come strikingly invested with enjoyment. Their boundaries are not only imagined through assaults from the outside but are generated by walls, doors, and furnishings, all of which turn them into sequestered, masculine workspaces that are well ordered, sometimes dreamy, and even fleetingly and tantalizingly sanctified.

What I suggest we should read as territorial narrative claims on household rooms in Chaucer's writings, and particularly the *Shipman's Tale*, may also bespeak developments in late fourteenth-century urban house design, both in London and in merchant communities that Chaucer visited on his Continental travels, exemplified, for instance, in the large, multiroomed house of the Davizzi family, prosperous fourteenth-century wool merchants,

FIG. 3.1 Palazzo Davanzati, Florence, December 2011.

in Florence, today open to the public as the Palazzo Davanzati (fig. 3.1). In nearby Prato, the merchant Francesco Datini (1335–1410) had his imposing stone palazzo, also now a house museum, built to his exacting specifications only a few years after Chaucer's visits to Tuscany. In London and other English towns in the late fourteenth century, archaeological and architectural evidence similarly attests to the increasing size and complexity of houses. Merchants and prosperous craftsmen were building larger houses and demanding rooms for specialized activities in their houses. Large open halls were being divided into smaller individual rooms, a response in part to urban pressures on available space for building, with changes in both design and ideas about what it means to live or be "at home"—a concept Felicity Riddy terms "'burgeis' domesticity."[7] We can hear some of these developments in new names given to rooms. By 1400, the word *solar*, meaning a private room upstairs, had fallen out of use and been replaced by *chamber*, a term that had previously been used to designate a room on the ground floor. The architectural historian John Schofield attributes this change to the increase in multistory houses with multiple rooms for retiring; rather than a single solar, a house might now boast several chambers in which members of the household would sleep.[8] *Chamber* is the word Chaucer most often uses for bedroom, using *solar* only in the *Reeve's Tale* in reference to "Soler Halle" at Cambridge University (I 3990). Another new room was the parlor. By the second quarter of the fourteenth century, the term *parlor*—a reception room, usually on the ground floor and separate from the great hall—had come into use, a household borrowing from the *parlorium*, the public room in a monastery where one was allowed to speak (from the French *parler*) and receive visitors.[9] Urban houses, such as those of merchants, had expanded in size to comprise four or five rooms, with more and more value placed on privacy and intimacy. Multiple rooms also allowed for clearer distinctions between workspaces (such as brew houses, shops, and workshops) and living spaces (halls, bedrooms, pantries, and

butteries).[10] The term *household* first appears in English in the fourteenth century and was increasingly nuanced with echoes of local sovereignty, even as domesticity developed a vocabulary of intimacy and interiority.[11] With their multiple rooms, urban bourgeois houses also encouraged new formations of sociability. What we think of as privacy, whose salient feature is the physical exclusion of others, was becoming available for a broader spectrum of society. Privacy was becoming a desirable good.

In the Counting-House

The counting-house in the *Shipman's Tale* offers a notably intentional commentary on what private rooms at home are good for, with a spotlight on architectural privacy, task-specific furnishings, articulations of marital and bourgeois ideology, and, especially, territorial claims of male mercantile work. The repeated use of words based on *count* remarks on the crossovers among house design, furnishings, and merchant identity—*countour-hous*, *countyng-bord*, *countour-dore*. *Countours* were also accountants. The merchant—acting as a *countour*—lays his books and bags of money on his "countyng-bord." The table on which one does the work of counting is also a *countour*—or a chest or worktable. *Countours* as tables—perhaps high ones, like counters today—turn up throughout fourteenth-century London inventories. A 1368 inventory of the house of Thomas Kynebell, a London rector, lists one counter—a table—in the hall and two in the chamber.[12] When the wife of the *Shipman's Tale*, fetching her husband for dinner, asks, "How longe tyme wol ye rekene and caste / Youre sommes, and youre bookes, and youre thynges?" (VII 216–17), by "thynges" she may mean small weights for a scale or else *jetons*, small metal stones used for "casting" or calculating, which in French were called *countours* or *comptours* (fig. 3.2). While the merchant has been reckoning his "thynges," the monk—at least up to the point where he meets up with the merchant's wife—has also been walking in the garden saying his "thynges" (VII 91) or paternoster, likely with prayer beads.[13] Both men, in an echo that annotates the similarities in their acquisitional practices, are counting stones.

The intentionality with which Chaucer invests the term *countour* in the *Shipman's Tale* suggests that he may even be Englishing a name for a novel use of household space.[14] *Countour*, in the sense of a room, is not recorded again in English until 1431 in a Yorkshire will.[15] Only later in the century and beyond does *counting* start to appear in conjunction with *house* and show up regularly in inventories and house plans. The 1607 inventory of Robert Lee's house lists five counting-houses, one on the ground floor and four on the first, each of them well fitted with lock and key. Rooms called counting-houses appear frequently in the Treswell surveys, suggesting that they had become, like studies, common features in prosperous houses by the sixteenth century; and if "Sing a Song of Sixpence" originated at this time—perhaps as a veiled allegory, as some scholars have proposed—the

FIG. 3.2 French *jeton* produced for use with a counting-board, circa 1330 (24 mm bronze). The *jeton* is a copy of the gold coins of Charles IV or Philip VI (1322–1350).

reference would have had a rich social *habitus*. How common counting-houses were in fourteenth-century London is far less certain. Indeed, the closest real-time parallel to the *Shipman's Tale*'s counting-house comes from a document Chaucer himself handled. An item in a 1389 inventory of goods in the storerooms at Westminster, handed over to Chaucer's charge when he was Clerk of the King's Works, includes "i countre coopertum de novo cum viridi panno pro domo compoti" (one counter newly covered with a green cloth for a counting-house).[16] In his comprehensive survey of buildings, records, and plans of medieval London houses, Schofield finds little evidence for counting-houses, and Anthony Quiney's survey turns up rooms that might have been used for accounting, but evidence comes from their location rather than furnishings or documented uses or room names.[17]

These records suggest, too, that the *Shipman's Tale*'s counting-house refers to a room in the house and not the separate building that "house" implies to readers today. Many readers of Chaucer, perhaps recalling the counting-house of the "Sixpence" jingle, have assumed the counting-house in the tale to be a separate building, but more likely it was a room in the house itself. For a description of a counting-house's furnishings and location in the house, detailed contemporary evidence comes from the home of Richard Toky, a London grocer. A 1391 debt-recovery inventory of his house itemizes objects by rooms, among which is a "domus computatorii," or counting-house.[18] While the list does not indicate where the rooms are, its room-by-room itemizing suggests that all are part of the house proper: hall, chamber, jewels in the chamber, pantry and buttery, kitchen, counting-house, and storehouse. The Toky inventory is of particular historical interest for its detailed itemizing, with cash values, of the house's furnishings. It includes objects

appropriate to a counting-house, among them a large box bound with iron, a quire of paper, a book of the statutes, locks, a brass balance, thirty-six "countours" (counting-*jetons* or perhaps weights for a scale), a pen case and inkhorn, as well as other items—various pieces of armor and two devotional alabasters—unrelated to the work of accounting. Chaucer's "countour-hous" offers a close English equivalent of Toky's "domus computa-torii." The designation of both rooms as "houses" perhaps distinguishes them from other rooms such as chamber, hall, pantry, buttery, or kitchen. A counting-*house*, like the "store-house" also included in Toky's inventory, indicates a room for the business of household goods and management.

Marked as significant through repetition of its room name, the counting-house in the *Shipman's Tale* is also marked private by its upstairs location. The merchant goes "up" into his "countour-hous" and later, after he shuts the door, goes down to dinner. After she goes to instruct the cooks to get dinner ready, the wife goes "up" to her husband in his "coun-tour." The metric architectural historians use to measure degrees of privacy is the distance from the front door or number of thresholds crossed. The counting-house, upstairs and behind a door, is the tale's most sequestered room.[19] The kitchen is downstairs, the garden outside.

Merchant identity at the threshold of the counting-house gets further reinforcement in the merchant's French "*Quy la?*" (VII 214) when his wife knocks on his door. When the merchant asks "*Quy la?*" whom does he expect to answer? Some readers have taken his French "*Quy la?*" (Who is there?) as a language cue pointing to the tale's French location. In their frequently cited note in *The Riverside Chaucer*, J. A. Burrow and V. J. Scatter-good comment, "This is Chaucer's only use of foreign speech in a foreign setting for local color."[20] Some readers have also proposed that the tale's setting in Saint-Denis indicates the tale must have had a French source, though none has been found.[21] According to Susie Phillips, the merchant's French question and the wife's English reply work as genre mark-ers, giving the merchant outsider status as a foreigner and, by way of contrast, highlighting the wife's "conversational intimacy" in English as a language appropriate to the fabliau. The wife's English reply voices her territorial claim on the rest of the house.[22]

It is worth asking, though, whether the setting is strictly foreign and whether the phrase is for local color. "*Quy la?*" says more about *what* the merchant does than the country in which he does it. While the attention to the merchant's business travels to Bruges and Paris, where he deals with Lombard moneylenders, certainly gives the tale an international reach, the story's details of domestic life—the wife's orders to the kitchen staff, her wardrobe crisis, the monk's strategic fraternizing—situate the tale as readily in London as outside Paris. The merchant's French can be heard as business language, as fully appropriate in London as in Saint-Denis. French was the international business language for northern Europe, partly due to the importance of the Champagne trading fairs.[23] Appropriately for this tale, too, French was also the international language of shipmen.

Until the fifteenth century, according to Maryanne Kowaleski, French was a "maritime lingua franca" among shipmen trading in the Cinque Ports, the coastal towns in Kent and Sussex, and in Flanders.[24] "*Quy la?*" from a merchant ensconced in his private office can be understood as job talk, or business speak, instead of a geographic pin. The question at the door identifies the work going on behind it.

Perhaps it is even business shorthand, annotated by his cropped question "*Quy la?*" (rather than "*Qui est la?*"), a phrase that is neither standard French nor Anglo-French.[25] Does his shorthand French voice the merchant's surmise that the person knocking at the door is another merchant? If so, his query serves as one more gesture marking the counting-house as his task-specific workspace. In *The Familiar Enemy*, Ardis Butterfield describes the *Shipman's Tale* as a "beguilingly local representation of the contorted triangular cross-channel relationships of the late fourteenth century," where words, punning playfully and outrageously, repeatedly make "double-sided linguistic gestures" between French and English.[26] "*Quy la?*" at the door is another such double-sided gesture, turning not on a pun but on the wife's quick English comeback, a riposte that verbalizes the fabliau's territorial combat over household control: "Peter! it am I" (VII 214); that is, "Who did you think it was?" In response to his French question, she follows up with a teasing harangue on her husband's self-importance:

> "What, sire, how longe wol ye faste?
> How longe tyme wol ye rekene and caste
> Youre sommes, and youre bookes, and youre thynges?"
> (VII 215–17)

The paired utterances in French and English join the merchant's language with his labors behind the door, saying more about claims on space within the home than about the house's geographic locale.

And that work is ideologically charged, as readers have noted. John Scattergood argues that the tale is "Chaucer's most highly developed attempt at defining the nature of the bourgeois mercantile ethos."[27] The tale illustrates a new kind of mercantile time-consciousness, and the lecture the merchant gives his wife is what Elliot Kendall has aptly termed a "domestic homily."[28] As a homily, the speech sanctifies merchant labor, eliding it with good household governance. "*Quy la?*," announcing the merchant's professional identity, leads seamlessly into his lecture from inside on the serious work of money, the importance of keeping one's estate "in pryvetee," close to the material and figurative chest. Sarah Rees Jones, in a study of gendered spaces within late medieval households, speculates that the multiple pieces of armor in the counting-house in the Toky inventory may have marked that room as a distinctively masculine domain.[29] The two devotional alabasters listed in the Toky counting-house may also add an touch of domestic piety. Devotional

objects, with the exception of paternoster beads, turn up rarely in fourteenth-century English household inventories, as evidenced by the London Guildhall records—and if they are to be found anywhere it is likely to be in bedrooms, not in counting-houses.[30] In Toky's counting-house, the clutter of armor, paper quires, pen cases, counting-stones, and devotional images seems to conjoin men's work at home with religious devotion in a sanctification of domestic economics.[31] In the *Shipman's Tale*, the merchant spells out these pieties from within his private room. Merchant calculation involves designated space for self-reflective work: "And up into his countour-hous gooth he / To rekene with hymself" (VII 77–78) his annual expenditures. Being a merchant is sober business.[32]

Inside Rooms

To see inside a room, in most forms of fourteenth-century English and Continental paint-ing, is to see through an invisible or cutaway wall. As a final approach to the bourgeois territoriality of the counting-house in the *Shipman's Tale*, I would like to turn, however briefly, to architectural interiors in late fourteenth- and early fifteenth-century painting, looking at relationships between inside and outside, not just as problems in visual repre-sentation, but also of inhabitation. I offer these images as a kind of thought experiment on the *habitus* of domestic life in late fourteenth-century bourgeois culture, following the lead of the social historian Henri Lefebvre in reading space as a practiced set of social and economic networks,[33] and of architectural historians who have understood the modeling of premodern architectural space as an ideogram—as shorthand commentary on relation-ships among public, familial, religious, and civic socialities. Conventions for picturing the articulation of inside and out in late medieval art, especially in images showing merchants at work, can help annotate the faceted views on a counting-house in the *Shipman's Tale*. Chaucer's counting-house is also an ideogram of sorts as a sign of merchant identity, and its door, bracketed by a husband-wife dialogue, is a territorial barrier.

In late medieval manuscript, fresco, and panel painting, the view into churches, castles, bourgeois houses, mangers, and shops is almost always from the outside. Interiors are made visible, opened to our view, in representational techniques that might vary by use of a transparent wall, a frame, or a pulled curtain, but that explicitly stage the exposure of the interior and separate that scene from the viewer. A miniature picturing the death of King Philip in a quarter-page illustration from a late fourteenth-century Parisian manuscript of the *Chroniques de France, ou de saint Denis* can serve as an example (fig. 3.3).

This image is one among several in the manuscript that set events of public assembly or witnessing in an architectural cutaway. On the left, King Philip lies in a bedchamber, his identifying crown still on his head, the moment of death marked through gestures of consternation by the cleric and young man at his bedside. He lies in a canopied bed,

FIG. 3.3　Deathbed of Philip, *Chroniques de France, ou de saint Denis*, after 1380. London, British Library MS Royal 20 C.vii, folio 21b.

with one curtain balled up to permit access. The room on the right appears to be a hall or entranceway, marked by an arched door into the building, as indicated by an elegantly dressed and hatted courtier stepping out into darkness. The figure on the right in parti-colored hose, whose back we see, is exiting the other way. As viewers, we see into these interior rooms through three absent walls, looking in as if at a diorama. As a place or space, both rooms are almost entirely schematic, with the single piece of furniture the important bed of state. That this is a royal death occurring in a palace may also be indicated by the little green turret on the top right. The building, a cutaway or doll's house, sits on a grassy meadow and abuts a backdrop patterned in architectural diaper.[34]

What interests me in this image, from a manuscript produced and circulating in late fourteenth-century Anglo-French court circles, is its dialogue with contemporary schema, both visual and textual, for picturing architectural interiors—and for seeing inside the house. However dreamlike as a floating diorama or cutaway, its organization of interior and exterior relationships is entirely conventional in fourteenth-century architectural illustration.[35] Bold colors and lines direct our eye to focus on the central features of the visual narrative. In a miniature of a regent holding a council, from the same Royal manuscript, the view into the room is framed by a similar cutaway (fol. 144v).[36] In the mid-fourteenth-century Neville of Hornby Hours, a possible London production, architecture is even more notational: the Madonna nurses the Child within a schematic church whose architectural boundaries between inside and out are unclear (fig. 3.4).[37] The front wall

FIG. 3.4 Virgin and Child, Neville of Hornby Hours. London, British Library MS Egerton 2781, folio 12v. Southeast England (London?), circa 1340.

is absent, and the Virgin's left leg reaches out beyond the perimeter of the enclosure. On the left, a kneeling figure, perhaps a donor, his wife behind him, peers in through two buttresses.

Even for Italian painters experimenting with classical techniques for picturing architectural dimensionality, the primary scheme for picturing interiors was the cutaway or frame. For Giotto, often described as a notably "architectonic" painter, the built interior functions primarily as a dramatic text box.[38] John White describes Giotto's treatment of the relationship between interior and exterior space as fundamentally a "cleavage."[39] In Giotto's *Death of the Knight of Celano* from Assisi, the domestic hall is dramatized in architectural elements that are primarily theatrical (fig. 3.5). Francis announces his prophecy standing behind a trestle table on a stage, in front and below a kind of proscenium,

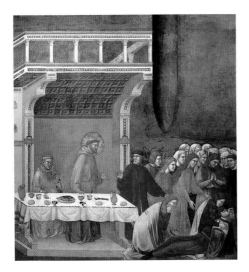

FIG. 3.5 Giotto, *Death of the Knight of Celano*. Basilica of San Francesco, Assisi.

while the knight, mourned by his relatives, lies dead in an indeterminate outside. Beyond some floating architectural signs, what is there to tell us whether the figures are inside or outside? The Gothic interior, as architectural historians have long observed, is a notation, often in shorthand. In the High Middle Ages, according to Chiara Frugoni, "personages have entered the rooms in which they are acting, but these rooms are always either blind shells, or cropped bits of architecture, the précis of a whole structure, or roofless, simply a notation necessary to complete the narrative and also a heraldic symbol, speaking of the person and his actions."[40] For Giotto, Frugoni also notes in her discussion of this painting, architectural elements are "perspectival containers" for people. His paintings display little interaction between people and the built spaces that enclose them; buildings are stage sets for human social interaction and drama, functioning as ideograms rather than as generators of identity. An implied placement of the viewer outside looking in also underwrites architectural permeability rather than privacy, with publicity and participation a social good. With Giotto's fresco, as with the later deathbed scene shown through a transparent wall in the *Chroniques de France*, the pictured death is available to all.

The architecture of the interior undergoes a dramatic and rather sudden transformation in the Low Countries in the 1420s. In this well-documented paradigm change in the history of Western painting, the viewer enters the room. Scholarly explanations for this revolutionary turn in techniques of painting bedrooms and other living areas in Flemish art often look—along with discoveries in perspective—to bourgeois living: shifting valuations of personal and familial privacy; new money and markets for imported stuffs; more *stuff* of all kinds; and, perhaps above all, a need to calibrate religion with the area's robust commerce.[41] Indeed, many Low Country paintings of devotional scenes may well have been commissioned by merchants. Their perspectival interiors, referencing monastic

FIG. 3.6 Jan van Eyck, *Saint Jerome in His Study*, circa 1435. Detroit Institute of Arts.

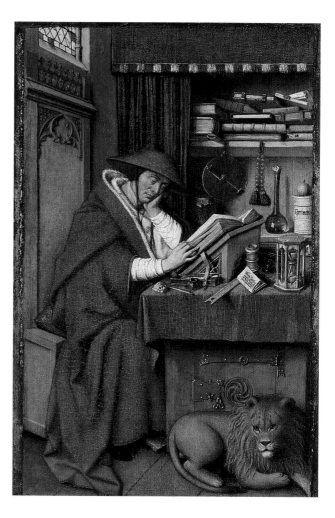

cubiculi, are viewed from within. As Reindert Falkenburg puts it in a study of Robert Campin's *Merode Triptych*, their furnishings, picturing goods newly available through world markets, become part of home's novel "technology of inwardness."[42]

For a particularly apt example of this overlay between mercantile and spiritual values, we can look at Jan van Eyck's *Saint Jerome in His Study* (fig. 3.6), which pictures the saint's study as a private domestic interior that marries sacred and secular labor. Van Eyck creates a harmonious, participatory interior through lines (the floorboards, the lion's paw, the hem of the saint's robe) that logically must extend beyond the frame, a technique that creates what Erwin Panofsky calls an "interior by implication."[43] The room's implicit extension beyond the frame sutures inside and out, inviting the viewer to enter the picture space, which is the room itself. In this interior housing, Jerome's work of biblical translation joins with other kinds of quantitative labor. Saint Jerome, hard at work at his desk, sits surrounded by tools that could serve both mercantile and devotional calculus: an hourglass

FIG. 3.7 Death takes a money changer (detail), Office of the Dead, 1430–35. New York, Pierpont Morgan Library MS M.359, folio 144r.

on the table, an astrolabe, and a rosary hanging from a shelf.[44] In early fifteenth-century Lowlands art, even the new availability of window glass contributed to the painterly revolution by transforming light, for painters, into a sanctifying commodity.[45] The shelves in Jerome's study are illuminated by light filtering in through mullioned glass diamonds in the window high behind his chair. Light harmonizes the market value of fashionable window glass with objects on Jerome's shelves, such as well-bound books and a blown glass carafe.

Even Jerome's green cloth suggests mercantile ethics. Counting-tables were conventionally covered in green cloth, as illustrated in one of the miniatures picturing craftsmen and merchants in an early fifteenth-century French book of hours. In a scene illustrating the Office of the Dead (fig. 3.7), a number of black stones, or counterweights, sit on a counter or chest covered in green cloth.[46] As Death drags him away, the money changer grabs for the gold. Notably, the table for a counting-house listed in Chaucer's Westminster indenture is also covered with green cloth ("cum viridi panno").[47] In Van Eyck's *Saint Jerome* the table is likewise draped with the requisite green, further linking his devotional work of biblical translation with the work of merchants. It is one more detail aligning bourgeois values with devotional pieties: urban architecture, crafted objects, and intellectual work in a sequestered room at home.

Counters and Market Stalls

In the *Shipman's Tale*, the repartee at the counting-house door, drawing attention to the divide between inside and out, and to the household as a set of territorial zones, gestures as well to a merchant's stock-in-trade: exchanges of goods and money. Merchants, after all,

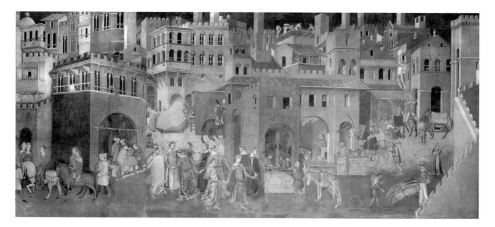

FIG. 3.8 Ambrogio Lorenzetti, *Allegory of Good Government*, 1338–39. Siena, Palazzo Pubblico, Sala della Pace.

move between places and negotiate deals at a distance. When he is not in his counting-house, the merchant in the *Shipman's Tale* is on the road between Saint-Denis, Paris, and Bruges. As a final view of the interior, I would like to turn briefly to visual representations of workshops and market stalls, spaces where merchant business gets done, which can serve as reminders of the public nature of many forms of commerce. Various kinds of shopping in the late fourteenth century would have been negotiated over a counter in an open or semi-open market stall rather than inside an enclosed shop. In Ambrogio Lorenzetti's *Allegory of Good Government* (1338–39) (fig. 3.8), shops mark a clear distinction between inside and out. Lorenzetti's masterpiece is often noted for its novel representation of an actual urban space (Siena) that coordinates people, animals, streets, and buildings in active relationships.[48] In the cobbler's shop, those relationships, negotiated over a counter, articulate with the rest of the city's life. Cobblers sell shoes and boots from an open loggia—with a customer's donkey indicating that the shop opens onto the street.

Other late medieval illustrations of shops are often more ambiguous about the relationship between inside and out, frequently using design techniques of the sectional cut-away that conventionally organize clearly interior rooms. In an early fifteenth-century miniature depicting merchants from a French manuscript of *De Proprietatibus Rerum* (Paris, Bibliothèque nationale de France MS fr. 22531, fol. 257v), the transaction over the money box appears to be taking place outside, yet the ground under the table is tiled. Equally uncertain is the location of the goldsmith's shop in Taddeo Gaddi's painted panel *Saint Eligius Working on a Gold Saddle for King Clothar* (ca. 1360; Madrid, Museo Nacional del Prado).[49] Is it in an indoor arcade, or is it outdoors, as in the fourteenth-century butcher's stalls or today's jewelry shops on Florence's Ponte Vecchio? In many illustrations of shops in the *Tacuinum Sanitatis*, a popular late medieval health handbook, the relationship between inside and out is uncertain, a porous exchange that remarks on multiple

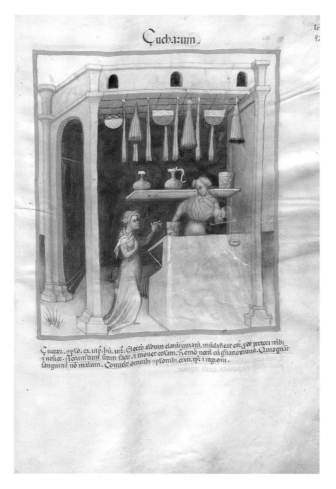

Çucharum.

Çueere. ɔplo. ca. ıııp. hu. ırf. Electo album claruʃiʃmaıı. mıdıfıeat coſ. pʒ pectoʒı reıbı
ꝯ nefice. ʃtcuıı'aſuıȷ ʃıtım facıt. ꝯ mouer colam. Remõ noeti cū gſtatıſmıus. Quıı ɔ gnaſ
ʃanguıne nõ malum. Conuele omnıbʒ ɔplombı. etatı. epı ꝯ regıoıuı.

FIG. 3.9 Sugar (*Cucharum*),
Tacuinum Sanitatis, 1390–
1400. Vienna, Austrian
National Library Cod. Ser.
N. 2644, folio 92r.

kinds of mobility.[50] In an illustration of a shop selling sugar from a Viennese manuscript
of the *Tacuinum*, circa 1390–1400, the pillars and solid building materials imply the shop
is a permanent structure, yet grass tufts growing inside the shop, behind the high coun-
ter, suggest otherwise (fig. 3.9). The illustration, floating the shop itself as a doll's-house
cutaway, details with precise attention the faces, the gestures, and the hardware of sugar
selling, just as it does the counter. Our visual attention focuses on the acts and tools of
exchange rather than on the location where commerce takes place.

In Chaucer's *Shipman's Tale*, the exchange at the counting-house door and the shifts
from threshold to interior orient the house around merchant work, or, as Sara Ahmed might
say, they "disorientate" it. The counting-house is insistently inside. As Ahmed argues in
Queer Phenomenology, things and spaces become newly visible, or newly queer, when unte-
thered from expected functions—"disorientated" as they reprise traditional alliances and
lines of sight. They also become promissory and liberatory as they participate in a redesign
of social relationships.[51] The association of merchants with privacy was a late medieval

cliché. In aligning merchant privacy with novel possibilities in home design, Chaucer gives that commonplace a significant material dimension. Writing thirty or more years before what Jeanne Neuchterlein calls the "deliberately innovative" bourgeois art revolution in the Low Countries,[52] Chaucer would have had the sectional view or cutaway, such as those in the *Chroniques de France*, as his primary artistic model for picturing domestic interiors.

The built space of the counting-house in the *Shipman's Tale* imagines new possibilities of domestic design and use, and it does so through shifting points of view on the room and even on the very question of how those views articulate across a threshold. English rooms are most often named by activity—*parlor* for a room set aside for speaking; *dormer* for a place where one sleeps; *office* for a person serving as an officer; *study* for a mental activity or discipline—as if spaces materialize their human performances. It is perhaps not surprising that the first recorded use of the word *office* in English to mean a room rather than a job is also Chaucer's. In reference to an old woman he is about to cozen, the summoner in the *Friar's Tale* says to his companion (the devil), "I wole han twelf pens, though that she be wood, / Or I wol sompne hire unto oure office" (III 1576–77), with the "office" into which he plans to summon her perhaps designating a room where ecclesiastical business is performed.

Can Chaucer be credited with English neologisms that turn activities into rooms, such as the office and the counting-house? While it is possible that *countour-hous* was already in current use in spoken English or in English writings that are now lost, it is also possible that Chaucer Englished, for the bourgeois home in the *Shipman's Tale*, a business term as used in French and Latin inventories. And it is also possible, and even likely, that his written uses of "countour-hous" and "office" contributed to their later establishment in the language. In the counting-house, person, tools, and space merge into a complex assemblage. Here, as behind other closed doors, bourgeois ethics stake their claims at home, in the house, and in a room of one's own.

NOTES

1. Shortly, hyt was so ful of bestes
That thogh Argus, the noble countour,
Sete to rekene in hys countour,
And rekene with his figures ten—
.
Yet shoulde he fayle to rekene even
The wondres me mette in my sweven.
 (*Book of the Duchess*, 434–37, 441–42)
2. Sing a song of sixpence,
A pocket full of rye.
Four and twenty blackbirds,
Baked in a pie.

When the pie was opened,
The birds began to sing;
Wasn't that a dainty dish,
To set before the king?

The king was in his counting house,
Counting out his money;
The queen was in the parlor,
Eating bread and honey.

The maid was in the garden,
Hanging out the clothes,

When down came a blackbird
And pecked off her nose. (Opie and
 Opie, eds., *Oxford Dictionary of Nurs-
 ery Rhymes*, 394–95)

3. Hanning, "Telling the Private Parts," 108.

4. Woods, in *Chaucerian Spaces*, 14, reads the *Canterbury Tales* through a poetics of space rather than through fourteenth-century building design. For house design in *Troilus and Criseyde*, see Brody, "Making a Play for Criseyde"; Smyser, "Domestic Background"; and Nolan, "Chaucer's Poetics of Dwelling." For *the Miller's Tale*, see Bullón-Fernández, "Private Practices"; Brown, "Shot Wyndowe"; Goodall, "Allone, withouten any compaignye"; Blodgett, "Chaucerian *Pryvetee*"; and Bennett, *Chaucer at Oxford and Cambridge*.

5. Bullón-Fernández, "Private Practices"; see also Mead, "Chaucer and the Subject of Bureaucracy"; and Hersh, "Knowledge of the Files."

6. For Nicholas's room and the idea of privacy, see also Stanbury, "Derrida's Cat and Nicholas's Study."

7. Riddy, "'Burgeis' Domesticity." For the increase in rooms as a feature of late fourteenth-century bourgeois houses, see Dyer, *Standards of Living*, 202–4, discussed in Goldberg, "Fashioning of Bourgeois Domesticity," 136. For changes in the fifteenth century, see Wood, *English Mediaeval House*, 67.

8. Schofield, *Medieval London Houses*, 66.

9. Ibid. For the development of private rooms from 1200 to 1600, see 61–93.

10. Riddy, "'Burgeis' Domesticity," 17.

11. Riddy, "Looking Closely," 215. See also Jones, "Women's Influence," 193–95; and Staley, *Languages of Power*, 89–91.

12. Thomas, ed., *Calendar of Plea and Memoranda Rolls . . . 1364–1381*, 91–92.

13. Also noted by Jager, "*Shipman's Tale*," 255–56.

14. The word *countour* and its variants in Anglo and Old French refer to a variety of accounting aids and jobs, according to the online *Anglo-Norman Dictionary*. The 1376 inventory of Richard Lyons's house, though, itemizes the objects in his "comptour." For the inventory, see Myers, "Wealth of Richard Lyons." See also Smith, *Arts of Possession*, 53.

15. *Middle English Dictionary*, s.v. "countour," b.

16. Crow and Olson, eds., *Chaucer Life-Records*, 407.

17. Schofield, *Medieval London Houses*, 74. Two twelfth-century stone merchants' houses in Southampton had small rooms, perhaps used for accounting, next to their warehouses. The fourteenth-century southern wing on the ground floor of the still-extant merchant's house called Hampton Court in King's Lynn had a counting-house (according to Quiney, *Town Houses of Medieval Britain*, 209) placed in what would have been what Schofield calls the "medieval tradition" (74), or on the ground floor next to the storerooms. Its designation as a counting-house is a surmise based on the room's placement, according to a personal communication from Anthony Quiney. There is no evidence that any of these rooms were called "counting-houses" or that they belonged to a class of rooms designed or designated for that particular function.

18. Thomas, ed., *Calendar of Plea and Memoranda Rolls . . . 1381–1412*, 212–13. I am grateful to Bridget Howlett, senior archivist at the London Metropolitan Archives, for the Latin name. For Toky's possessions and merchants' houses, see Thrupp, *Merchant Class of Medieval London*, 132. Though Scattergood, in "Originality of the *Shipman's Tale*," 213, cites Thrupp (130–34) as the source for his assumption that the counting-house is a separate building, Thrupp (132) names the counting-house in Toky's inventory as among the rooms of the house.

19. Schofield, "Social Perceptions of Space," 203; McSheffrey, *Marriage, Sex, and Civic Culture*, 120–34; and Burger, "In the Merchant's Bedchamber," 241.

20. Chaucer, *Riverside Chaucer*, 912. See also Taylor, "Social Aesthetics," 302.

21. Scattergood, "*Shipman's Tale*," 2:566.

22. Phillips, "Chaucer's Language Lessons," 49.

23. Reyerson, "Merchants of the Mediterranean," 5; Le Goff, *Marchands et banquiers*, 102; Butterfield, *Familiar Enemy*, 220.

24. Kowaleski, "French of England," 108.

25. I am indebted to Susan Crane for advice on this phrase. Phillips, in "Chaucer's Language Lessons," 48, notes that twenty Chaucer scribes seem to have recognized the peculiarity of this phrase, with some even changing the text to English "Who there?"—a construction, I would add, not found anywhere in Chaucer's writings. For Chaucer and mixed languages of business, see Stanbury, "Multilingual Lists."

26. Butterfield, *Familiar Enemy*, 223–24. For excellent studies of the tale's bilingual puns, see

especially Taylor, "Social Aesthetics," 301–9; and Gerhard, "Chaucer's Coinage."

27. Scattergood, "Originality of the *Shipman's Tale*," 212; Patterson, *Chaucer and the Subject of History*, 330. For the tale's blend of mercantile and sacred ideology, see also Wallace, *Premodern Places*, 106. For Chaucer as bureaucrat, see Carlson, *Chaucer's Jobs*.

28. Kendall, "Great Household in the City," 156. For debt and credit in the tale, see Bertolet, *Chaucer, Gower, Hoccleve*, 83–104. For the tale and merchant time, see Jager, "*Shipman's Tale*." On the *Shipman's Tale* and Bruges, see Wallace, *Premodern Places*.

29. Jones, "Women's Influence," 195.

30. For bedrooms as devotional spaces, see Webb, "Domestic Space and Devotion"; and Clark, "Constructing the Female Subject."

31. This assumes, of course, that the objects represent the contents of the room when it was in use, and not just an assemblage for inventory purposes.

32. For the serious merchant as a medieval trope, see Stillwell, "Chaucer's 'Sad' Merchant."

33. Lefebvre, in *Production of Space*, 41, argues that the development of perspective was the "result of a historic change in the relationship between town and country." On Lefebvre and medieval urban space, see Evans, "Production of Space," 41–56.

34. On the "doll's house" interior, see Panofsky, *Early Netherlandish Painting*, 37, 53.

35. Northern painting prior to the fifteenth century had addressed the relationship between interior and exterior "in one of two ways: the interior was either exposed by showing a more or less complete structure with the front wall removed, or merely implied by the substitution of a tiled pavement for natural rock or grass" (ibid., 57).

36. For other illustrations in the *Chroniques de France*, see *British Library Catalogue of Illuminated Manuscripts*, s.v. "MS Royal 20 C VII." The manuscript may have been commissioned in the late fourteenth century for Edward Langley, Duke of York (1373–1415), according to the British Library account of its provenance.

37. For other images from this manuscript, a Sarum book of hours, see *British Library Catalogue of Illuminated Manuscripts*, s.v. "MS Egerton 2781."

38. Radke, "Giotto and Architecture," 76.

39. White, *Birth and Rebirth of Pictorial Space*, 91.

40. Frugoni, *Distant City*, 108–9 (discussing the *Death of the Knight of Celano*). Benelli, *Architecture in Giotto's Paintings*, 26, 82, references Panofsky's "doll's house" in describing Giotto's schematic interiors.

41. Neuchterlein, "Domesticity of Sacred Space"; Gaimster, "Visualizing the Domestic Interior"; Falkenburg, "Household of the Soul"; and Panofsky, *Early Netherlandish Painting*, 3–7.

42. Falkenburg, "Household of the Soul," 4. In dramatic innovations, Campin sets the Virgin Mary, at the moment of the Annunciation, in a bourgeois living room full of deluxe comforts. Jan van Eyck's *Marriage of Arnolfini* stands a prosperous merchant with his betrothed in a sacramentalized bedroom. On the innovation of the domestic Madonna, see Neuchterlein, "Domesticity of Sacred Space," 67. Burger, in "In the Merchant's Bedchamber," argues that bedrooms, which served both private and public functions in late medieval and early modern Europe, often served as narrative staging.

43. Panofsky, *Early Netherlandish Painting*, 1:19.

44. For online magnification of the objects on Saint Jerome's desk, see *Saint Jerome in His Study* on the Detroit Institute of Arts website, http://www.dia.org/.

45. Frugoni, *Distant City*, 109–10.

46. For a discussion of the manuscript, see Kinch, *Imago Mortis*, 240–44.

47. The *Middle English Dictionary*, s.v. "countour," records, from 1418, "i Cownter with a grene clote"; and Godefroy, *Dictionnaire de l'ancienne langue française*, s.v. "compteur," 2, has "une petite table ronde de drap vert par manière d'un compteur." Robert Lee's counting-house also has "a Table Covered with greene" (Schofield, *Medieval London Houses*, 235). For compounds with *countour* and etymologies, see Cannon, *Making of Chaucer's English*, 268.

48. White, *Birth and Rebirth of Pictorial Space*, 93–102; and Frugoni, *Distant City*, 118–88.

49. For *St. Eligius*, see the discussion in Stuard, *Gilding the Market*, 147–81, esp. 152.

50. For selected illustrations from *Tacuinum* manuscripts from Vienna, Liège, Paris, Rome, and Rouen, see Arano, *Medieval Health Handbook*.

51. Ahmed, *Queer Phenomenology*, 39, 158.

52. Neuchterlein, "Domesticity of Sacred Space," 67.

FOUR

The Vernon Paternoster Diagram, Medieval
Graphic Design, and the *Parson's Tale*

Kathryn Vulić

> And ye shul understonde that orisouns or preyeres is for to seyn a pitous
> wyl of herte, that redresseth it in God and expresseth it by word outward,
> to remoeven harmes and to han thynges espiritueel and durable, and som-
> tyme temporele thynges; of whiche orisouns, certes, in the orison of the
> *Pater noster* hath Jhesu Crist enclosed moost thynges. / . . . / it comprehen-
> deth in it self alle goode preyeres. / The exposicioun of this hooly preyere,
> that is so excellent and digne, I bitake to thise maistres of theologie. . . . /
> This hooly orison amenuseth eek venyal synne, and therfore it aperteneth
> specially to penitence.
>
> —*Parson's Tale*, X 1039, 1042–44

This chapter examines the Paternoster diagram of the Vernon manuscript as an example
of the kind of exegesis mentioned by the Parson. Though the *Parson's Tale* draws the
Canterbury Tales to an end, it defies closure in its last pages by advising its audience to
pray, thereby extending the audience's experience beyond the confines of the text. In this
passage, the Parson explores the role of prayer in the third and final stage of penitence:
satisfaction for one's sins. The Parson moves quickly from explaining the efficacy of prayer
to highlighting the special efficacy of the Paternoster, which he names the most useful
prayer for achieving satisfaction. Perhaps because he wishes to stress "the radical simplicity

of penitence and grace,"[1] he does not talk much about how prayer works other than to indicate that it enacts an unspecified kind of transaction "to remoeven harmes and to han thynges espiritueel and durable, and somtyme temporele thynges," and to "amenuseth eek venyal synne." He also does not explain the connection between the Paternoster and his tale's governing themes, instead demurring, "The exposicioun of this hooly preyere, that is so excellent and digne, I bitake to thise maistres of theologie." It is the responsibility of other writers, these "maistres" he also invoked in his prologue (X 55–60), to take up the task of explaining prayer in more detail. It is also the duty of the devout not just to pray but to continue to learn more about the function and meaning of prayer in order to make their worship more effective.

The Parson's statement gestures toward the numerous prayer expositions that proliferated among other *pastoralia* for the spiritual instruction of the laity after Lateran IV. The majority of these texts foreground the Paternoster for the same reason the Parson does: "in the orison of the *Pater noster* has Jhesu Crist enclosed moost thynges." Jesus himself handed down the prayer to his disciples in the Sermon on the Mount, stating "thus therefore shall you pray" ("sic ergo vos orabitis").[2] Because it was the only prayer Jesus offered as a model, later tradition maintained that it must contain everything essential for which a Christian might ask assistance of God. Due to this biblical authority, the Paternoster is an element of the catechism. Theological *summae* like those in the *Somme le roi* tradition usually contain a section on the Paternoster, and stand-alone texts such as the *Pater Noster of Richard Ermyte*, the *Speculum vitae*, and others explain the Paternoster, and worship in general, at length and in extraordinary detail. There is also a tradition of images used to assert the same points.[3] Such expositions explain, often elaborately, how the prayer helps the worshipper achieve virtue and resist vice.

The Vernon Paternoster diagram (fig. 4.1; appendix) appears to distill the specifically transactional nature of the Paternoster in the straightforward way highlighted by the Parson. He stresses not only the power of prayer "to remoeven harmes" in favor of spiritual and temporal goods, but also the special comprehensiveness of the Paternoster: "it comprehendeth in itself alle goode preyeres." The diagram is an exceptionally compact and explicit example of the kinds of explanatory devotional material to which the Parson points his audience, and it invites meditation of a sort similar to the Parson's own written meditation.[4]

As a supplementary text that performs work of the kind invoked by the Parson, the Vernon diagram comes with an interesting twist: it conveys information both verbally *and* graphically. This beautiful, concise, one-page diagram is, in some respects, an ideal introduction to the Paternoster's hallmark identities: it is the most pearl-like of prayers, simple yet elegant and valuable, while also being extraordinarily complex to understand. How does this diagram envision the relationship between prayer and penance? To what extent does it teach the sort of meditative worship invoked by the Parson? While others

FIG. 4.1 Vernon manuscript Paternoster diagram, Oxford, Bodleian Library MS Eng. poet. a. 1, folio 231v.

have explored the *Parson's Tale*'s relationship with repentance, sin, and similar treatises,[5] my interest here lies in how images can facilitate the sort of devotional work the Parson's text advocates.

I focus on this particular Paternoster exposition for several reasons. First, the Paternoster diagram is not traditionally expository in the way that a devotional poem or treatise is: its layout expects a reader to unpack the meanings of binaries—colors and words, Latin and English, lines and circles, up and down, left and right, and more—to understand how prayer leads a worshipper from vices and to virtues. Second, the prayer's graphic design scaffolding offers unique insights into Paternoster exegesis. Words and images cooperate in the context of the Paternoster diagram in order to teach users how to pray in the manner described by the Parson and gain the prayer's benefits. The diagram communicates by means of productive verbal tensions (between the Latin text and English glosses) and productive visual tensions (devised by color, infill, and graphic layout). It presents information by articulating connections and disruptions among ideas and offering interpretive possibilities to those able to read not just words but also images.[6] The multimedia combination of Latin text, English paraphrase, and abstract artwork teaches the meditating worshipper two distinct lessons about prayer. First, translations that render the Latin text into English paraphrases reveal the methods of praying envisioned by the diagram's designer, emphasizing the *process* of praying rather than simply the ultimate goals. As David Raybin has remarked with respect to Chaucer's *General Prologue*, "The authorial focus is on process, on movement from an unsatisfactory initial condition toward a vaguely defined something better, with a relative disregard for any sense of conclusion or closure."[7] The diagram very much shares this impulse. Second, the diagram's artwork has the effect of destabilizing the meanings of accompanying text in specific ways, productively undermining the authority of either Latin or English as sufficient for praying to God.

The Diagram and Its Tradition

The Paternoster diagram is located in the Vernon manuscript, Oxford, Bodleian Library MS Eng. poet. a.1, on folio 231v.[8] It is a large, square-shaped diagram, in both size and style unlike any other artwork in the manuscript, where most other large-scale artwork consists of half- or quarter-page (or smaller) figural illuminations.[9] Dominated by text and nonfigural drawings, the diagram nearly fills its large page (546 × 394 mm). Appearing roughly halfway through the volume, it seems to have been intended to accompany (probably to introduce) the long poem that follows it, the *Speculum vitae*. The diagram is one of many devotional aids in the manuscript, this one intending to help a worshipper deepen her[10] faith by teaching her how to use an elementary devotional tool—the Paternoster—more effectively. Its unusually abstract nature invites one to peruse it at leisure and read it deeply.

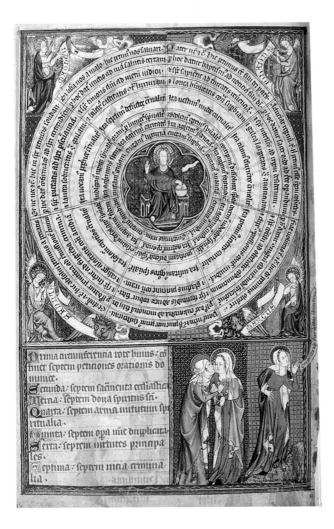

FIG. 4.2 Wheel of Sevens, De Lisle Psalter. London, British Library MS Arundel 83 II, folio 129v.

Diagrams such as this sometimes accompanied texts in late medieval manuscripts, and many survive in codices throughout Europe. The most common devotional model is the wheel *septenarium*,[11] or *rota*, in which seven concentric rings are marked out in wedges, each wedge containing a separate septenary. The Wheel of Sevens in the De Lisle Psalter provides a well-known example (fig. 4.2).[12] Based on diagrams inspired or designed by Hugh of Saint Victor,[13] *septenarium* diagrams gather lists of seven theological principles (such as vices, virtues, corporeal works of mercy, spiritual works of mercy, and sacraments) in order to demonstrate relationships among individual items. Other medieval writers known to include such visual aids with their writings include Bede and Isidore of Seville, who provided diagrams for their respective versions of *De natura rerum*.[14] Robert Grosseteste devoted three-quarters of his confessor's manual *Templum Dei* to "charts, lists, and diagrams."[15] In other words, such diagrams are relatively commonplace in Paternoster

expositions. They are not, however, as structurally and artistically elaborate as the Vernon Paternoster diagram; and despite the sizable amount of septenary artwork still extant, none seems to be a direct antecedent of this diagram.[16]

The diagram reveals the septenary structure of the Paternoster itself, which is made up of seven distinct petitions or requests: the first petition, after the invocation "Our Father who art in heaven," requests that the name of God be hallowed; the second asks for the kingdom of God to come; and so on. The diagram is a nearly square rectangle ruled into nine vertical columns (five columns of decoration that alternate with four columns of text) and sixteen horizontal rows (a top row of titles for each column, a bottom row summing up the relationships of the columns of text to one another, and seven pairs of rows that match a Latin text with an English paraphrase). The columns contain, in order, the Paternoster, the Gifts of the Holy Spirit,[17] the Seven Remedial Virtues, and the Seven Deadly Sins. At its simplest, the diagram indicates that each petition leads a worshipper to a Gift of the Holy Spirit, which leads to a virtue, which in turn combats a vice. The horizontal connections among the individual items are articulated by Middle English connective phrases that link together the vernacular paraphrases. For example, the third petition of the Paternoster says in the first column, *Fiat uoluntas tua sicut in celo & in terra*, which the paraphrase below translates in a roundel as "lord þi wille be do in erþe as it is in heuene" (fig. 4.3). We are told in text flanking the English paraphrase that "Þis priere . . . leduþ a man to" a Gift of the Holy Spirit, in the second column, which "leduþ a man to" a virtue, which in turn "is aȝenst" a vice.[18]

The Paternoster diagram and the *Parson's Tale* have similar contents, although the structure is inverted. In the three main phases of his tale, the Parson first touches briefly on penitence and contrition (subjects not mentioned in the diagram) before moving on to address confession at length (addressing each sin in detail first, then each remedial virtue, *remedium contra peccatum*), and then concluding with satisfaction, the section that briefly mentions prayer. The diagram starts where the tale ends and works backward, moving from prayer (to which the diagram devotes the most space and attention), then to the Seven Gifts of the Holy Spirit (which the *Parson's Tale* mentions in passing; X, 311), and finally concluding with the vices, which are crowded into the right gutter. Both are products of orderly thinking and planning, each creating hierarchies that complement the other by expanding on features not prioritized by the other. Each has content that the other lacks: the *Parson's Tale*'s opening stress on penitence and contrition articulates its author's goals and explains how one may start combatting sin; the diagram's Gifts of the Holy Spirit column helps the designer emphasize the spiritual tools available for combatting sin and the attainability of that task. The overall effect of taking them in together is that one sees how they both acknowledge systems of devotional concepts that are elaborate and interconnected, with each text focusing on a particular concept and leaving other concepts for other texts to unpack. These works and more like them rely on one another to create the full picture.

FIG. 4.3 Roundels enclosing English translations of Latin text above them. Vernon manuscript Paternoster diagram (detail). Oxford, Bodleian Library MS Eng. poet. a. 1, folio 231v.

The diagram is unusual not just among the artwork of Vernon but also for artwork that embellishes manuscripts in general, because it consists almost entirely of text and abstract infill (pen flourishes, vine work, intricate knots, and so on),[19] which occupy the spaces between words.[20] The diagram possesses a single animal figure. The rest consists of geometric shapes, other designs with bilateral symmetry, and abstractions in organic shapes, including foliage. Many designs are inspired by plant life. The designer has imagined a pictorial landscape whose abstract images focus the meditant's attention on relationships among words and concepts.[21] The diagram's abstract nature pushes a user to think abstractly rather than narratively, directing her to engage with ideas rather than stories. Although a narrative is told in a very general sense (petitions leading to gifts, virtues overcoming vice), it is a conceptual narrative that offers merely a framework to help shape meditation.

The Diagram's Form and Function

The Vernon Paternoster diagram incorporates images in a way not anticipated by Pope Gregory's statement that images are texts for the illiterate.[22] It is clearly intended for someone who can read at least one language on the page. Moreover, "manuscript illustrations . . . were not made primarily for the poor and illiterate who could not afford them in any case."[23] The closely spaced columns of roundels cause the diagram to seem organized primarily in columns. At the same time, words between columns articulate a horizontal logic. Tensions between horizontal and vertical readings generate a productive reading experience that becomes more than the sum of its parts. Reading vertically establishes order by grouping related concepts together, while reading horizontally shows other conceptual relationships, as if in small narratives. And even as the diagram is organized with a horizontal and vertical logic, a user is not limited to perceiving connections in these ways. The horizontal and vertical axes create a grid that invites a user to skip from frame to frame, looking for other patterns and organizing principles. The artwork also rewards this rather haphazard method of reading by allowing one to draw conclusions from nonverbal elements, discovering interpretations not verbalized. By inviting one to see many connective possibilities, the diagram communicates through more than words.

By not engaging with the details of the Paternoster, the Parson sidesteps an issue that many Paternoster expositions face: the prayer's Latinity and the likely ignorance of Latin among the expositions' audiences. The Vernon Paternoster diagram confronts this issue, addressing what version of the prayer a worshipper should say, in what language, and with what effect. In the rest of this chapter, I will discuss, first, the language of the Paternoster diagram and, next, the relationships between text and image, to show how the diagram displays the Paternoster's transactional power to help a worshipper acquire gifts and virtues to combat the vices.

Interpretation and the Diagram's English Translations

A first place to start unraveling the graphic and verbal threads of this devotional tapestry is its text, specifically the featured pairings of Latin phrases and English paraphrases that dominate the page. The prayer text directs the diagram and is the first place a reader is likely to start examining its language. The prayer's location in the leftmost column makes it the natural starting point for reading. The large illuminated initials that introduce each petition also attract the eye, giving the prayer visual dominance over the other septenaries.[24]

At first glance, the diagram appears merely to show the apotropaic effects of praying the Paternoster. However, tensions between Latin words and phrases and the sometimes wordy English translations draw attention to the diagram maker's habit of limiting and focusing the Latin concepts, thereby establishing a linguistic hierarchy that the graphic design proceeds to undermine. The English paraphrases draw out the diagram's organizing logic, showing the conceptual links that unite its disparate elements along both horizontal and vertical lines. They naturalize the unusual items included in the list of Seven Virtues by downplaying their uniqueness and showing their coherence. They explain the function of the Latin, showing a worshipper the proper way to say, think, and use Latinate words. They also clarify how the worshipper might reason out connections among the four lists and the individual terms by means of intellectual engagement and meditation, thus demonstrating how a meditative model rather than a recitative one improves the prayerful experience. Wherever the Latin is potentially abstract and open to interpretation, the sometimes lengthy English paraphrases offer clear, precise, and rather overdetermined meanings. They assert two commonplace interpretations of the Paternoster: first, as the Parson himself acknowledges, the prayer helps a worshipper combat sin (even though the prayer itself never explicitly mentions sin); and second, individuals having strong relationships with God and fellow Christians will find help to mitigate sinful tendencies (even though the prayer itself barely refers to the community of worshippers).[25]

Septenary 1: The Paternoster

The Paternoster is typically divided into eight units: an invocation (*Pater noster qui es in celis*) followed by seven individual requests. In order to fit the prayer into the septenary format, the diagram's designer treats the invocation and the first petition as one item, subsuming the invocation to the petition's request. The prayer is accompanied by interlinear translations, together comprising the first and leftmost of the diagram's four septenaries. For the most part, the translations follow the Latin of each petition fairly literally. For example, the translations of the first, third, fourth, and seventh petitions reflect the Latin nearly word for word, with minimal changes made to the Latin syntax to render it into idiomatic English. There are, however, a few significant embellishments. For example, all translations add the term *lord* at the beginning of each petition, stressing the petition's function as a unique prayer, separable from the others and applicable in distinct ways that a worshipper could explore through meditation. The Parson likewise remarks that "the orison of the *Pater noster . . .* comprehendeth in itself alle goode preyeres," suggesting how each individual petition performs its own transaction. The repeated invocation of "lord" requires a worshipper to be aware of her relationship with God, reasserting it with each new petition.

A pair of choices in the text further shapes the worshipper's sense of her relationship with God and the community of Christians. First, the invocation leaves out the pronoun *our* in its translation of *Pater noster*. In other Paternoster expositions, the opening two words teach a lesson: *Pater* precedes *noster* to show the secondary nature of petitioner to divinity. It may be that the decision to drop *our* resulted from the problem of translating the Latin formulation into English syntax, which would have inverted the order of "our" and "father," thereby privileging petitioner over deity.[26] Nevertheless, without the plural pronoun *our* in the first petition, this becomes a prayer said by an individual, not a collective—that is, not "Our Father" but possibly "(My) Father." Indeed, the translation of the first petition would seem to support the function of this diagram as a stimulus for individual meditation rather than for group prayer. By contrast, the paraphrase of the second petition addresses the relationship between God and a community of worshippers. *Adueniat regnum tuum* is translated with an embellishment, "lor thi kyndam mote come *amongus us*" (emphasis added).[27] Although the individual who initiates the prayer in the first line appears to do so alone, the second petition suggests that this individual acts on behalf of the larger Christian population.

The translations of the fifth and sixth petitions, which articulate ways in which the Paternoster helps undo sin, are comparatively liberal. The fifth petition, *Et dimitte nobis debita nostra sicut & nos dimittimus debitoribus nostris*, is slightly expanded to "lord forȝeue us oure dette of synne as we forȝeue oure detteres," which requests that God

forgive spiritual debt, not financial or other temporal debts, whereas the worshipper may be agreeing to forgive debtors of any kind. The first words of the sixth petition, *Et ne nos in ducas*, which potentially cast God as the agent who might lead the worshipper to temptation, become "suffer us not to falle," keeping God as the grammatical agent but leaving ambiguous the cause of falling (suggesting by the context that the sinful are agents of their own destruction but for the intercession of God). *In temptacionem* becomes "in to *synne be* temptacion" (emphasis added), the translation drawing a distinction between temptation to sin and sin itself. The translator's interpolation of the term *synne* echoes its previous addition in the paraphrase of the fifth petition, calling attention to the individual worshipper's responsibility to avoid sin, even though neither petition explicitly refers to sin: in the fifth petition, the *debita* are undifferentiated; in the sixth petition, *temptacionem* could be seen as wholly external to the worshipper. The translations consistently emphasize the worshipper's tendencies to sin and God's ability to mitigate those tendencies. They clarify that the Paternoster has a direct effect in warding off sin even if the prayer itself does not address sin anywhere in its text.

Septenary 2: The Gifts of the Holy Spirit

The Gifts of the Holy Spirit constitute the second septenary column of alternating Latin terms and roundels. In translating the gifts, the translator appears to throw off a yoke (having possibly been inhibited by the biblical origins of his exemplar in the first column) and, after translating the first gift fairly literally, proceeds for the remainder of the column to translate expansively. Several of the translations characterize relationships: (1) of the worshipper with peer Christians (the second gift, *Pietas*, is translated as "Pite of his neyȝbore"); (2) of the worshipper with self (the third gift, *Sciencia*, is translated as "knowi*ng* & wite þat he be not as a best");[28] and (3) of the worshipper with God (the last gift, *Sapiencia*, is translated as "Sauour & liking in his god").

The remaining three gifts show their relevance to fighting sin, with translations that create a horizontal logic by taking some liberties with the Latin, rendering the gifts in terms that emphasize how they ward off evils. The fourth gift, *Fortitudo*, rendered as "strengþe aȝenst his gostli enemees," is matched with the fourth petition, *Panem nostrum cotidianum da nobis hodie.* Fortitude, typically rendered as "strength" or "steadfastness," connotes unwavering constancy to persist in sinlessness against any obstacles. In the diagram, with no stated acknowledgment of this typical meaning, the horizontal logic turns the *panem quotidianum* into a daily dose of strength or, quite literally, physical nourishment that permits one to withstand spiritual assaults. The fifth gift, *Concilium*, "Counsel aȝenst pereles of synne & þis world," follows the same emphasis on sin as *Fortitudo.* Although *Concilium* more often refers to the ways in which one accepts holy counsel, here the paraphrase foregrounds the dangers that *Concilium* prevents. The sixth gift, *Intellectus*, "vndurstonding

wat is good & wat is euel," comes closest of the three terms (all ways of "knowing") to its traditional meaning; here the paraphrase preserves the connotation of discernment, while also sustaining one of the designer's governing concerns: containment of evil.

Overall, the translations of the gifts spell out specific spiritual threats to the individual rather than explicating the subtleties of the gifts themselves. We learn that prayer will help the worshipper resist ghostly enemies (external threats), "beastly" behavior (internal failings), and evil more broadly conceived. The gifts are supplied with concrete translations that limit the applications of the abstractions. The translations, in other words, guide the meditant to seek earthly manifestations of these gifts in her daily life.

Septenary 3: The Virtues

In the third septenary list of alternating Latin terms and roundels, one finds the virtues: *Humilitas, Caritas, Pax, Leticia spiritualis, Paupertas spiritus, Mensura & sobrietas, Castitas.* This selection is idiosyncratic, even to the point of including eight terms (doubling *Mensura & sobrietas*).[29] These sometimes-unique virtues smooth the meditative transition from gifts to vices and highlight the role of self-governance in defeating vice. Two virtues relate to one's attitude toward God and other worshippers, one to a state of internal calm, two to qualities of one's spirit, and two to control over appetites. These are very practical virtues whose meanings are further limited by the translations provided for them and the horizontal logic of each line.

The virtues are translated expansively in the same manner as the gifts. The most minimal translations involve a doubling of English terms: for example, *Humilitas* becomes "mekenesse and lounesse"; *Caritas* becomes "loue & charite"; *Castitas* becomes "Chastite & clannesse." These doublings highlight different senses of the Latin terms and clarify that both meanings are in play. *Pax* and three other virtues receive more expansive translations, each intended to explain how the virtue is enacted in daily life. For example, translating *Pax* as "Pes & reste in herte" clarifies that this virtuous peace is personal and internal. *Leticia spiritualis* is defined not only with a doubling of terms ("murthe" and "lykinge") but also with the phrase "in godus seruise," explaining that a person's devotional acts manifest her spiritual joy. *Paupertas spiritus*, "Pouerte of soule þat is to dispise wordiliche riches in herte," emphasizes spiritual over material poverty. These specific, narrow translations help the horizontal logic of the lines: *Leticia spiritualis*, responding to the "daily bread" petition, leads a worshipper to understand that petition spiritually and to see "daily bread" both as food and as habitual prayerful activity that combats spiritual enemies; *Paupertas spiritus* follows the gift of *Concilium*, making its connections with the debts in the Paternoster and the vice of *Auaricia* much clearer. The seventh and final virtue also receives expansive treatment as the virtue itself is doubled—temperance is articulated as *Mensura*, "mesure in mete," and *sobrietas*, "soburnesse in drinke"—and the translation

limits the virtues to indicate moderation in appetite for food and drink. Although *Gula*, the contrasting (and more inclusive) vice, consists of more component sins than immoderate eating and drinking, this translation indicates that the imagined worshipper needs to watch her diet.

The accumulation of virtues creates a profile of the ideal worshipper—someone who strives to improve her self-rule. Two of the Seven Virtues are specifically to be exercised "in herte" or "in godus seruise" (in internal and devotional contexts, not as acts performed in the world). In these translations, one sees most clearly the function of the diagram as promoting abstract thinking and meditation on the state of the soul.

Septenary 4: The Vices

In the fourth and final septenary list of alternating Latin terms and roundels, one finds the Seven Vices. By contrast with the virtues, the vices included on the diagram are a standard set of terms (for example, these same sins, in nearly the same order, recount their misdeeds in *Piers Plowman*).[30] Also unlike the virtues, these vices receive minimal, almost grudging, translations; in fact, like the Paternoster that frames the page on the opposite side, the vices are minimally translated: four are translated by just a single word, and two others, *Superbia* and *Ira*, by the same doubling of terms found among paraphrases of the virtues: "Pruide & stownesse" and "Wrathe & angur," respectively. The only vice to receive extensive paraphrasing is the fourth, *Accidia*, translated as "Slowthe & heuinesse in godus seruise." Here *Accidia* has been expanded in the same fashion as *Leticia spiritualis*, the virtue that opposes it. Both are defined with a doubling of terms and the phrase "in godus seruise." These translations emphasize the relationship between the fourth petition and the act of praying, indicating that active, engaged prayer is central to devotional work and important enough to be classified as a virtue. Contained within a diagram that fosters meditation, this treatment of the central row emphasizes (in a self-referential way) how the septenary terms and paraphrases hold clues to improve the efficacy of one's devotions.

The diagram's designer may have granted minimal attention to the vices in order to mirror the work that the worshipper is to do: foreground the Paternoster and its benefits and turn away from vice. The paraphrases allow the vices to remain abstract, avoiding the detail that exists elsewhere in the diagram. In this way, they remain token reminders of the threats a Christian faces, without drawing attention away from the other three septenaries by turning them into the meditative focus.

Connective Phrases

The diagram's English connective phrases indicate a causal relationship between praying each petition and earning the gifts and virtues to combat vice. The English connective

phrases are visually prominent, written in red in the largest script on the page (larger than the Latin gifts, virtues, and vices) and repeated seven times. These features emphasize these phrases and imply that the connections are as critical as the septenaries for a reader to note. The repeated language of "þis priere . . . leduþ a man to" casts the prayer text as the grammatical subject that leads a worshipper first to the gifts, then to the virtues that are "aȝenst" the vices, implying that the virtues, not the worshipper, have independent agency to ward off the vices. Unlike expositions of the Paternoster, the diagram does not specify how it is to be used but leaves it to the worshipper to determine the method of devotional engagement—for example, whether the worshipper should speak the prayer or meditate on it, or whether she should reflect on the entire prayer or just one petition.

Though on first glance the diagram appears to pair English and Latin strictly for translation purposes, the two languages function differently in the diagram and suggest that both are essential to the full meaning and effects of the prayer. In the abstract, Latin more closely approximates the language of God, but in practice English more thoroughly teaches prayer application to vernacular readers. The languages are represented as complements of each other, neither one communicating the whole content and each requiring the other to be complete. In this way, a vernacular translation exerts force on the Latin original it supposedly serves.[31]

The Diagram and Graphic Design

The images in the Vernon Paternoster diagram complicate the concepts it presents, offering a more complex argument than what the words offer alone. Specifically, even as the diagram in some respects reinforces a traditional language hierarchy wherein Latin is superior to English, it is English that stands out as the more dominant language because it appears in prominent colors, patterns, locations, and sizes. This visual layout elevates English as an effective mode of communication for theological content, questioning the independent functioning of either language as a means to communicate with the divine. The artwork also wards against the narrow effects of overdetermined translation by conveying a multitude of other meanings to a viewer willing to untangle the diagram and explore its possibilities. The design thereby enacts a destabilization not fully detectable in the translation. In his introduction to *Image on the Edge*, Michael Camille argues that illuminations destabilize textual content by introducing mitigating elements—implied but not articulated—that lead readers to draw conclusions independent of those suggested by the text alone.[32] Embellishments—be they translation or artwork—exert great power over the source text, changing its meaning or overshadowing it entirely. When Latin text, English paraphrase, and diagrammatic art are combined, they may invert the relationship between Latin and English that the diagram articulates verbally.

Layout

Given that pen strokes in shades of red, brown, and green constitute most of the art of the page, the script is just one of a variety of interpretable signifiers that make up this diagram. At first glance, the diagram invites aesthetic appreciation of its composition and design, and then gradually yields its content and purpose as a viewer becomes a close reader of texts and images, connecting the diagram's constitutive elements and discovering relationships. Focusing on deluxe manuscripts for largely aristocratic audiences, Aden Kumler has shown that "rather than merely marking where text begins or ends, or even providing a visual recapitulation or amplification of the vernacular contents of a given treatise or poem, images . . . make their own arguments about the sacraments, the Trinity, religious perfection, and the practice of the faith. Collaborating with the texts they accompany, at times contradicting or revising them, these illuminations appropriated the contents of the pastoral syllabus, rendering saving truths into visible forms and contributing to the pastoral project in ways that often surpassed ecclesiastical expectations of lay religious formation."[33] The "culture of vernacular readership" described by Kumler[34] applies to the female religious audience of the Vernon manuscript, just as her observation that "images . . . make their own arguments" relates to the spatial disposition of art and words on a page. The graphic features of the Vernon diagram guide a reader to a specific kind of worship initiated by its language but then progressing beyond its literal boundaries.

Study of the Paternoster diagram readily demonstrates the notion that art allows a sort of "*visual* translation,"[35] to use another of Kumler's phrases. Contemplation of its design leads a viewer to perceive the commentary implicit within it. An example of nonverbal commentary lies in the abstract forms of the artwork. The diagram resists figural representation, even that which its geometric shapes would naturally suggest. For example, nowhere do the crossing rows and columns stand out visually as a crucifix, though the entire diagram might be seen as consisting of repeated, interlinking crosses. The fact that the illumination is almost all abstract suggests that the diagram engages with text on an intellectual rather than narrative level. Indeed, the artwork provokes abstract analysis and rewards it. Avril Henry notes, for example, that the diagram seems to have been designed to reward numerological analysis. It is laid out in nine columns and sixteen rows, the multiple of which is 144, a number that recalls the number in Revelation of those who ascend to the New Jerusalem (144,000).[36]

Color

The use of color saves the diagram from becoming a jumble of information. Edward Tufte, working in the field of modern graphic design, has shown the effect of diagram color and placement on information accessibility.[37] He is concerned with how the visual

representation of information affects perception of that information, and his methods show how design choices bear consequences. Tufte observes how variables—for example, color, space, information density, typeface, script—aid or obstruct comprehension: "Information consists of *differences that make a difference*" (his emphasis).[38] Tufte's work provides a model for how the colors invite a viewer to experience the diagram. Just as paler and darker colors help differentiate locations on a map, so, too, does the contrast between shades of red, green, and brown create meanings in the diagram.[39]

The specific colors are perhaps not what those familiar with medieval manuscripts might expect. Words from the Bible, especially Jesus's words, are conventionally written in red, as are feast days on calendars, and so forth. Rubrication is a standard feature of medieval textual artistry and production. Against regular text, red stands out strikingly, achieving the desired effect of drawing the eye to the most important text on the page. The visual effect of inserting passages in red among others in brown or black is noted by Chaucer's Pardoner, who states that

> "in Latyn I speke a wordes fewe,
> To saffron with my predicacioun,
> And for to stire hem to devocioun."
> (*Pardoner's Prologue*, VI 344–46)

The image evoked is of the Pardoner concocting a verbal meal into which he sprinkles bright red lines of highly prized text into a drab context. Latin words, the Pardoner tells us, are powerful. Red coloring is a sign of this power.

In the Paternoster diagram, however, the lines of the prayer are not in red but rather in dark brown—the same color used for English translations in the roundels. The "saffron," too, is not sprinkled in sparingly but distributed liberally throughout the diagram. We drown in the exotic red spice (so abundant as to form the background color of the diagram),[40] and, by contrast, the basic "meat" of the text—the dark brown ink—stands out. Indeed, red ink is so prevalent on the page, so similar in tone to the color of the manuscript page, that using more red to reproduce the Paternoster would potentially cause it to blend into the background, just as the red English connective phrases—despite their large size and elaborate penmanship—blend in and somewhat resemble the infill artwork. The dominant red coloration thus constitutes both the textual and the literal framework of the diagram.[41]

Furthermore, the dark brown ink is used for only three kinds of text, all in a modest anglicana hand: (1) the Latin words of the Paternoster; (2) the English translations of all the Latin septenary elements; and (3) the single line of Latin that runs along the bottom of the diagram, explaining the relationships of the septenaries to one another: "Per peticiones peruenitur ad dona per dona ad uirtutes & uirtutes sunt contra uicia" (Through

the petitions, one is brought to the gifts; through the gifts, to the virtues; and the virtues oppose the vices). The contrast of this dark lettering with the large, red textura text and the red-and-green artwork has the effect of calling attention to the most significant text on the page: the Latin words of the Paternoster and the English translations of the Latin septenaries. "Forget the rest," the choice of ink tells us. "These are the important parts." Pride of place is granted to the prayer, which is aligned to the left margin where elaborate initials, spatial orientation, and ink choice reinforce its textual importance. The humble, relatively small brown quadrata script of the prayer (the supreme prayer of divine origins) is granted significance by its placement, elaborate initials, and content. The matching ink color of the Paternoster and all the English paraphrases of Latin septenary items make the paraphrases seem as extensions of the prayer's very meaning.

The final, lowermost line of Latin instruction is written in the same color, size, and script as the Paternoster. Like the petitions, it is introduced by a large initial. Positioned below the seventh petition, it appears as a newly added eighth petition—the prayer's natural conclusion. Consequently, the final line looks like an actual component of the Paternoster, even though a viewer's own experience and an "Amen" cue the end of the seventh petition. Treating the final Latin instruction as an integral part of the prayer implies that the work performed by the diagram—connecting the petitions of the Paternoster with three other septenaries—is actually elemental to the prayer itself. Like the English paraphrases in the roundels, the visual presentation of the final Latin line links the prayer to its consequences.

Shape

The page also makes use of basic shapes to organize its verbal content. The diagram's graphics consist largely of rectangles and lines, but roundels appear at regular intervals, offering focal points among the less eye-catching rectangles. Henry calls attention to how the roundels would have been read: "By a well-known optical effect the eye is drawn to roundels before rectangles, so the Middle English translation of the Pater Noster and of the gifts, virtues, and vices is instantly accessible: the main message may be easily followed in Middle English alone, by reading just the informal script in circles."[42] This well-known effect is supported by scholars of the psychology of art and vision, such as Rudolf Arnheim, who has written about the "visual priority of circular shape."[43] Indeed, the roundels dominate the page. Because circles deviate strikingly from an overall block pattern, the diagram invites speculation about how the content in the roundels relates to the matter around them.

Discussing the hierarchy of scripts, Henry points out the modesty of the English script compared to that of the Latin it translates.[44] Other evidence suggests, however, that the visual impact of the humble English script is substantial. The roundels elevate the English text (already tending to prominence because of the brown ink), giving it visual dominance

over the surrounding text, which literally pales by comparison. Because the writing within roundels concentrates dark ink within a cramped and dense space, it attracts the eye. By choice of ink color and placement, the roundels affirm what conventions of paraphrasing and script choice do not: that the diagram confers a rival privilege on vernacular paraphrase, elevating English by situating it in a standard tool for emphasis (the roundel). The conventions of text writing (rubrication, hierarchy of scripts) keep English in its place, but the conventions of art (color, contrast, shape) give it prominence.

The fact that English text competes with itself visually is instructive. This trend shows how all single elements of text on the page contain at least one trait that potentially elevates it over all other text. For example, the simplicity of the English paraphrases does not prove their insignificance but rather shows their essential content, unobscured by ornament. To give another example, even the repeated connective phrases in the background are accorded artistic respect: they are written in a large, elaborate red lettering that conventionally differentiates and elevates special text, suggesting that the true message of Jesus's prayer lies in connections to be made among theological concepts. The diagram is full of such competing indicators of status (e.g., simple brown ink for Jesus's words, elaborate red lettering for connective phrases), but the ultimate effect is to create unities of red and brown text, with different yet unmistakable claims to authority, all of it insisting that prayer is unified with and inseparable from interpretation.

Sketches

In addition to color and roundel, the diagram makes use of elaborate decorative sketches in the spaces between words. These are almost all geometric or organic pen work. Many of the plant-inspired patterns are of the "stiff-leaf" variety, similar to plantlike sculpture in churches rather than purely naturalistic organic forms.[45] We are not invited to perceive narration here. Many of the largest sketches are "endless," the threads continuing unbroken—a metaphor for the simultaneous simplicity, complexity, and perfection of the Paternoster. Others are interwoven, vinelike knots that have ends, and these can be taken as symbolically representing other, non-septarian systems of thought associated with the prayer: the two ends of the first knot might signify Jesus, human and God at once; the four ends of the third knot might signify the Gospels; the ten ends of the sixth knot might signify the Ten Commandments; and so on.[46] The two kinds of knots (fig. 4.4) offer different models of interpretation. On the one hand, endless knots imply that the verbal items compose an interconnected, self-contained system. On the other hand, the vine knots suggest this devotional system is just one nexus of critical concepts that can extend outward, leading to other spiritual concepts or meditative models. All of the knots consist of mostly diagonal or twisting lines, as if they defy the diagram's horizontal and vertical logic and encourage other reading methods.

FIG. 4.4 Endless knot and knotted vine infill. Vernon manuscript Paternoster diagram (detail). Oxford, Bodleian Library MS Eng. poet. a. 1, folio 231v.

FIG. 4.5 Foliate head. Vernon manuscript Paternoster diagram (detail). Oxford, Bodleian Library MS Eng. poet. a. 1, folio 231v.

An example will illustrate one of the nonlinear ways the diagram can be read in accord with the knot work. The diagram designer is concerned at one point with teaching the worshipper to control her animalistic impulses, as the paraphrase of the third gift makes clear ("knowing & wite þat he be not as a best"). This mention of beastliness is echoed in the diagram's sole figural drawing. In the top right corner, between and slightly above the first virtue *Humilitas*, on the left, and the first vice *Superbia*, on the right, lies a dark-green, square pen sketch of a foliate head, the highest and rightmost decoration in the diagram (fig. 4.5). The word above it ("Contra") and the words below it ("is aʒenst") seem to label the head as contrarian—that is, a figure of opposition. Even though the senses expressed above and below the head are synonymous, their different languages give tension to the site occupied by the foliate head: it fills a space of transition between the two languages.[47] The foliate head similarly serves as a figure of transition between Humility and Pride. As a contrarian figure, it may embody the challenge of combatting the vices (Pride in particular) with the virtues (Humility in particular).

Facial details may also yield evidence about the foliate head's function in the diagram. The cheekbone lines located directly below its eyes appear to extend far to the left and

right, as if designed to connect with the top line of the infill just below the words "Humili-tas" and "Superbia." The cheekbone-to-infill line bisects the rectangle containing the foli-ate head, giving that particular block of infill a clear upper and lower half. Interestingly, none of the other infill in that column follows this same layout, so this infill geometry is unique in the diagram. Consequently, the facial design helps to line up Humility and Pride with the foliate head's top half, associating this virtue and vice with the head's forehead, ears, and eyes. That upper half is the part physically closest to the Latin explanatory phrase at the diagram's top row, "vii Uirtutes Contra vii Uicia," and the pairing of *Humilitas* and *Superbia*. The placement could indicate that a viewer's eyes, ears, and perceptions—that is, her forehead, mind, intellect—are being associated with the Latin in that upper register of the page.

By contrast, the lower half of the head lines up with and points to the English transla-tions of the Latin phrases. The mouth emits three protrusions. Two are trefoil-like sets of leaves emerging from the left and right sides, which each seem to point to the mid- to lower sections of the neighboring roundels containing English translations. The remaining protrusion is a leaf, or tongue, coming from the center of the mouth, pointing downward to the English phrase "is aȝenst." One possible explanation for the foliate head would be that it takes in Latin source material through the eyes and ears and produces English translations. We might go a speculative step further and take the growth of plant mat-ter from the mouth as a visual metaphor for the new, living English of the translation, to which the protruding leaves are pointing. Given that this process is similar to the kind of thought in which a user of the diagram would engage, the foliate head would seem to have something in common with the meditant, who also embodies a transition state between sinfulness and virtue, and occupies a translation site, where the Latin prayer and its associated septenaries come to richer meaning when understood in English.

Although the text aligns with the foliate head's sight, hearing, and mind, the head is a site where flora, fauna, and humanity all blend together. As a sensate being, it seems more lionlike than human.[48] This likeness becomes another productive tension by which the head invites contemplation. Its animal nature raises the possibility that it functions iconi-cally: lions often appear in bestiaries as godly or Christlike creatures, and also in heraldry to emphasize courage and nobility of character. In literary contexts this happens as well; an animal in text or image, especially a lion, is not just a mute beast.[49] Here, the noble, godly lion is made morally ambiguous, its animal status being destabilized and pulling in different directions—toward either the intellectual potential of humans or the unthinking state of plants.

All of these factors suggest that if this head were to be given any space in this diagram, it might fit optimally only into this one topmost corner. Like the stone-and-wood foliate heads that often show up on joints in church architecture, this foliate head occurs at a

significant nexus point, the place where the diagram's key contrasts of English/Latin and virtue/vice come together. The head may be placed there because it complicates these binaries, adding a third and fourth complicated binary, or even a ternary, to the mix: animal/human/plant or, as a figure of translation, a trickier trinity of taking in/thinking about/producing information. A major function of the foliate head may be to invite a spectator to see the many binaries or ternaries evident in it and visible around it, and to meditate on the significance of that multivalence.

This foliate head also shares some responsibilities of the infill, offering the user a chance to consider how images might reinforce the diagram's message. The abundance of knot work in the rest of the infill reminds a user of the tightly woven bonds among the diagram's devotional concepts, recalling the productive spiritual growth that results from internalizing the diagram's lessons. The head adds extra meaning, showing that connections among the diagram's various phrases are complicated and ought not be seen as simple equations or contrasts. It calls attention to the dangers of Pride and its tendency to bring on a host of negative traits that the Paternoster seeks to counteract. It seems no mistake that the beast's head is green, and, indeed, the head looks just human enough to remind one of the green man or wild man found elsewhere in medieval literature, the Green Knight in *Sir Gawain and the Green Knight* being perhaps the most famous incarnation of this figure. This image seems to offer a cautionary gesture toward the consequences of succumbing to Pride: one risks not only one's soul, but also one's humanity.

Just as the knots visually inscribe paths that are not vertical or horizontal, so, too, does this embedded artistic cue connect with disparate elements of the diagram.[50] Returning to the possible connection between the foliate head and the paraphrase of the third gift, which mentions beastliness, this is a conceptual link not facilitated by the diagram's linear design, the beast being quite a distance away and not intuitively connected with the paraphrase by any layout feature. This visual distance violates the stated logic of the diagram (which articulates verbally the linear progression of the diagram across the horizontally aligned terms) but, at the same time, honors its visual cues (the knots in particular).

Conclusion

In his prologue, the Parson says that he will "knytte up al this feeste and make an ende" (X 47) to the pilgrims' tale-telling game. Upon beginning his tale, he immediately reminds his audience of their journey's larger context. As Robert M. Jordan observes, the *Parson's Tale* "is not simply an ending but also a transition, from *a* pilgrimage to *the* pilgrimage,"[51] to "the weyes espirituels that leden fok to oure Lord Jhesu Crist" (X 79). The tale refocuses the pilgrims' attention on the religious fundamentals that have been largely absent from the nominally religious pilgrimage.

Though the Parson makes clear that the Paternoster is one of these fundamentals, he defers explanation of this function to other experts. Lee Patterson argues that Chaucer consistently tightens his source material, and not just by forgoing Paternoster commentary: "The *Parson's Tale* . . . explicitly refuses to broaden its discussion to include anything that is not specifically penitential. When the opportunity arises to discuss the Ten Commandments, Chaucer gracefully declines: 'But so heigh a doctrine I lete to divines'" (957).[52] In omitting such commentary, the tale leaves out elements of catechesis that other penitential manuals often include, and it identifies those related topics as distinct bodies of knowledge to be sought out separately. The Parson calls attention to these exclusions while simultaneously referring to sources for them: one begins to imagine a series of speakers or texts, all interrelated, documenting the milestones of the ultimate pilgrimage. It is as though the *Parson's Tale* suggests an alternative project to that of the *Canterbury Tales*, wherein each new tale-teller offers additional information and assistance for a spiritual journey. This is perhaps the tale-telling game to which the Parson would have preferred to contribute, and for which he invites *quiting* from other religious authorities.

The Paternoster diagram becomes such a work by which to *quite* the Parson, by its articulation of connections between prayer and the satisfaction of sin to which the Parson only alludes. It renders graphically the ongoing intellectual and spiritual journey that the Parson suggests in his text. The designer of the Vernon Paternoster diagram seems to be aware that the Paternoster's workings have to be thoroughly explicated and contextualized because the prayer itself does not spell them out. Translations help to reveal logical links among prayer, virtue, and vice. Artwork offers nonverbal cues to urge a worshipper to evaluate and interpret words on the page, finding connective possibilities beyond language. Word and image work together to provoke deep thought and engagement with the experience of prayer, the words answering questions, the images raising new ones. The diagram's graphic design casts each word as an image, their size, color, and spatial relationships to one another requiring a level of decipherment separate from verbal meanings. The medieval meditant user of the diagram operates less *between* word and image than *within* conflated word and image. Meditating on the diagram requires one to develop reading skills that acknowledge visual and lexical meaning.

The diagram offers a model for how to think about and analyze the language of God. Its graphic design concretely visualizes many implied significations of the Paternoster, yielding up the supreme prayer's meanings within a matrix that immerses a reader in theological concepts, with and without words. In doing exactly the kind of explanatory work that the Parson imagines, the Paternoster diagram elevates a thoughtful, spectating audience to the level of "maistres of theologie" (X 1043) who understand the complexity and nonlinearity of "the righte wey of Jerusalem celestial; / and this wey is cleped Penitence" (X 80–81). The Parson would surely welcome fellow pilgrims who are as knowledgeable as these.

APPENDIX: TRANSCRIPTION OF THE PATERNOSTER
DIAGRAM IN THE VERNON MANUSCRIPT, FOLIO 231V

vii Peticiones.		vii Dona spiritus sancti.
PAter noster qui es in celis sanctificetur. nomen. tuum. Þis preiere [fadur þat art in heuene þi nome be halewed]	leduþ a man to	Timor domini. [Drede of god.]
ADueniat regnum tuum. Þis preiere [lor thi kyndam mote come a mongus us]	leduþ a man to	Pietas [Pite of his ney3bore.]
FIat uoluntas tua sicut in celo & in terra. Þis preiere [lord þi wille be do in erþe as it is in heuene]	leduþ a man to	Sciencia [knowing & wite þat he be not as a best]
PAnem nostrum cotidianum da nobis hodie. Þis preiere [lord oure uche dayes bred 3eue us to day]	leduþ a man to	Fortitudo [strengþe a3enst his gostli enemees.]
ET dimitte nobis debita nostra sicut & nos. dimittimus. debitoribus nostris. Þis preiere [lord for3eue us oure dette of synne as we for3eue oure detteres]	leduþ a man to	Concilium [Counsel a3enst pereles of synne & þis world]
ET ne nos in ducas in temptacionem. Þis preiere [lord suffere us not to falle in to synne be temptacion]	leduþ a man to	Intellectus [vndurstonding wat is good & wat is euel.]
SEt libera nos a malo Amen. Þis preiere [lord þou deliuere us from wikidnesse]	leduþ a man to	Sapiencia. [Sauour & liking in his god]

PEr peticiones peruenitur ad dona per dona ad uirtutes & uirtutes sunt contra uicia

	vii Uirtutes	Contra	vii. Uicia.
leduþ a man to	Humilitas [mekenesse and lounesse.]	Is a ȝenst	Superbia [Pruide & stownesse]
leduþ a man to	Caritas [loue & charite.]	Is aȝenst	Inuidia [Enuie.]
leduþ a man to	Pax. [Pes & reste in herte]	Is a ȝenst	Ira [Wrathe & angur]
leduþ a man to	Leticia spiritualis. [Murthe & lykinge in godus seruise]	Is a ȝenst	Accidia. [Slowthe & heuinesse in godus seruise]
leduþ a man to	Paupertas spiritus. [Pouerte of soule þat is to dispise wordiliche riches in herte]	Is a ȝenst	Auaricia. [Couetise.]
leduþ a man to	Mensura & sobrietas. [Mesure in mete and soburnesse in drinke]	Is a ȝenst	Gula. [Glotonie]
leduþ a man to	Castitas. [Chastite & clannesse.]	Is a ȝenst	Luxuria. [Lecherie.]

NOTES

1. Raybin and Holley, "Introduction," xvii.

2. Matt. 6:9–13. An abbreviated version of the prayer is also given at Luke 11:2–4. Bible text from the Latin Vulgate; translation from the Douay-Rheims.

3. See, for example, the Wheel of Sevens in the De Lisle Psalter (see fig. 4.2 and note 12 below); and the Paternoster Wheel in London, British Library MS Arundel 507, folio 17r (for other images from this manuscript, see *British Library Catalogue of Illuminated Manuscripts*, s.v. "Arundel MS 507"). Henry, in "Pater Noster," 91n8, mentions other *septenarium* diagrams: York, York Minster Dean and Chapter Library MS Addit. 256 (no folio number); Oxford, Bodleian Library MS Bodley 631, folios 186v–187r; Lincoln, Cathedral Library MS 202, folio 224r; and Lincoln, Cathedral Library MS 242, folio 111v.

4. See Bestul, "Chaucer's Parson's Tale"; and Twu, "Chaucer's Vision."

5. See, for example, Wenzel, "Notes on the *Parson's Tale*," esp. 248–51; Newhauser, "Parson's Tale and Its Generic Affiliations"; Raybin, "Manye been the weyes," 23n17; and, most recently and comprehensively, Newhauser, "Parson's Tale."

6. Henry's excellent study ("Pater Noster") explores some essential features, including the pattern breaks in the diagram's use of color. She also discusses the history of Christian *septenaria* and locates the diagram's purpose within the context of the manuscript more generally. In this chapter I examine some features that Henry treats in passing.

7. Raybin, "Manye been the weyes," 15.

8. The full manuscript has been published twice: Doyle's print facsimile, *Vernon Manuscript*, and more recently the DVD-ROM facsimile (Scase, *Facsimile Edition*), which includes an edition of the manuscript's text and descriptions of all its artwork.

9. Many of these illuminations are examined in chapter 4 of Hilmo, *Medieval Images*. There is also a thorough study of the manuscript's borders, miniatures, and initials, and their artists, in Scase, ed., *Making of the Vernon Manuscript*, 127–226.

10. Pearsall, in "Introduction," x–xi, suggests that Vernon was probably compiled for a community of religious women. More recently, the new digital facsimile edition and its companion essay collection largely endorse this view but are open to other possibilities. Doyle, in "Codicology," 16, states that "a fair presumption . . . would be that a large volume of vernacular religious literature would be for nuns or other specially devout women, anchoresses, vowesses, or noble ladies. . . . There are, however, some texts presuming masculine audiences and some explicitly for lay ones, but they may be simply copied from the diverse exemplars." The commentary in the digital facsimile states that "it may be that we are dealing with . . . changing intended audiences" (Scase, "Origins").

11. Doyle, introduction to *Vernon Manuscript*, 9. Though the *septenarium* is the most common circular diagram to be found in devotional works, other circular tables were common as well. The circular *mappa mundi* is a commonplace example, as are zodiac and astronomical charts. The *volvelle* (an object affixed with one or more rotating disks that sometimes hold pointers and that are usually marked on the circumference with information for, e.g., making calculations or determining calendars) became popular in the fifteenth century; see, for example, the zodiac *volvelle* in the Guild Book of the Barber Surgeons of York (London, British Library MS Egerton 2572), folio 51r. There is also a *volvelle* that computes lunar phases in London, British Library MS Egerton MS 848, folio 22r. See these images at *British Library Catalogue of Illuminated Manuscripts*, s.vv. "Egerton MS 2572" and "Egerton MS 848."

12. For other diagrams from this manuscript, see *British Library Digitised Manuscripts*, s.v. "Arundel MS 83." For a discussion of *rota* diagrams, including this one, see Goering and Mantello, eds., *Robert Grosseteste*, 36, 38, 67–68.

13. Katzenellenbogen, in *Allegories*, 63n2, outlines the common features of these septenary wheels and names a number of manuscripts in which such wheels can be seen. Hugh of Saint Victor's diagrams include sketches, maps, and tables of all sorts, including diagrams of the trees of virtue and vice; see Mâle, *Gothic Image*, 106–7. Hugh also seems to have had a habit of rendering his ideas as diagrams and images when trying to reason through the meaning of a biblical passage; see Smalley, *Study of the Bible*, 96.

14. Though my discussion here focuses on tables and diagrams of theological concepts, other kinds of sketches are regularly found with text. For example, Bede's "De locis sanctis" includes ground plans and diagrams of several churches in Jerusalem, and Matthew Paris's *Chronica majora* contains itinerary maps.

15. Goering and Mantello, eds., *Robert Grosseteste*, 7.

16. Though there has not yet been a systematic study conducted on textual or marginal diagrams and tables, many editors refer to the presence or absence of artwork in manuscript sources. Doyle, in *Vernon Manuscript*, 9, states that, although many *septenarium* diagrams exist, he has not encountered any quite like the one in Vernon. Henry, in "Pater Noster," 98, states that she has looked for both textual and tabular sources to no avail. The most recent study is Gottschall, "Lord's Prayer in Circles and Squares."

17. These traits are attributed to the Holy Spirit in Isa. 11:2, and, since Augustine, have been taken to mean that they are gifts the Spirit gives to the faithful. See Augustine, *De doctrina christiana*, bk. 2, chap. 7.

18. There is another way to read this diagram. The singular verbs and syntax make it possible to see each virtue or prayer as combatting a vice, thus suggesting that the prayer itself causes changes in one's access to gifts, virtues, and vices (as opposed to a worshipper initiating a chain reaction by speaking the prayer and making each step across the diagram to cause the next step).

19. By "abstract infill" I mean the overall non-narrative, non-figural artwork that constitutes nearly all the art in the diagram and brings together theological concepts with geometric and organic designs, heightening the intellectual content of the diagram. Such art is defined as "non-narrative" and "non-figural" because it is unlike scenes, such as those of the Passion or other exempla, that evoke narratives and include recognizable creatures or objects (people, buildings).

20. In her study of marginal art on bi- and trilingual pages in the Taymouth Hours (London, British Library MS Yates Thompson 13), Brantley uses the term "'vernacular' images" to describe art that represents vernacular ideas and literary concerns; these images "are neither monumental nor Latinate," and "in spite of their rather high quality, they treat subjects more homely, in a style less formal, than the traditional devotional cycles

around which a book of hours is typically structured" ("Images of the Vernacular," 83). Although Brantley is discussing a variation in the book of hours tradition, I see this diagram enacting a similar disruption, where the art itself—simple in subject but of high quality in execution—is likewise responding to a bilingual moment on the page. Brantley goes on to argue that "this is text embodied as an image, as well as image to be read as text" (104), and that "the popularity of books of hours, with their emphasis on text-and-image combinations, implies that most medieval reading was of this double kind" (105)—conclusions that I believe apply to this image as well.

21. Kessler notes a similar phenomenon in the general habits of decoration in manuscript borders and frames. These kinds of abstract ornaments "create a semantic field in which different levels of reality intermingle, sometimes benignly and other times as arenas of struggle, providing potent places for transformation and confrontation" (*Seeing Medieval Art*, 101). For more on the artist who executed this work, see Farnham, "Border Artists of the Vernon Manuscript"; and Dennison, "The Artistic Origins of the Vernon Manuscript."

22. "The picture is for simple men what writing is for those who can read, because those who cannot read see and learn from the picture the model they should follow. Thus pictures are above all for the instruction of the people" (Gregory I, *Epis. ad Serenum*; as translated by Wladyslaw Tatarkiewicz, cited in Hilmo, *Medieval Images*, 9n42). For more on Gregory's influence on medieval image theory, see Kessler, "Gregory the Great and Image Theory."

23. Hilmo, *Medieval Images*, 14.

24. Henry, "Pater Noster," 91–92.

25. There are certainly other ways whereby this embellished English language offers a specific interpretation of the four Latin systems it teaches. The semantic discrepancies between the English translations and the Latin text put an interpretive burden on the reader, which in turn demands a process of reflection and thought that can introduce the reader to meditative practices and solitary worship on behalf of the collective whole.

26. I find it unlikely that the word *our* was left out by accident. Doyle, in *Vernon Manuscript*, 9, finds that the entire volume was carefully constructed and cautiously revised, and that the diagram's elaborate structure required great skill

to prepare. Given the diagram's attention to detail and evidence of manuscript corrections, it seems likely the omission was deliberate.

27. Here and throughout, I expand abbreviations and keep the spellings as they occur on the page.

28. The DVD-ROM facsimile transcribes this final word as *lyft*; I am grateful to Professor Scase for clarifying for me in personal correspondence that the facsimile transcription takes the word to mean "an evil person" (*Middle English Dictionary*, s.v. "lift," adj., def. 3b, as noun). Although I agree with the rest of the meticulous transcription of this page, to my eyes this admittedly smudged word reads as *best* ("beast"); the vowel in particular appears to me to lack the diacritic and the descender that would help me to see it as a *y*. Given that *Sciencia* ("knowing & wite") refers to the power of cognition, *best* also fits the sense better here in that it specifies how intellect differentiates humans from animals. The *Middle English Dictionary* quotations used to define *wit* are also concerned with differentiating human powers of knowing from bestial; s.v. "wit," n. (compare senses 2a–b with sense 2c).

29. The list of Seven Virtues is notoriously unstable. Although there are common models (e.g., the three Pauline virtues combined with the four cardinal virtues; and the remedial virtues, which offer opposites to the Seven Sins), the list of virtues in this diagram includes some unusual choices.

30. See Pearsall, ed., *Piers Plowman*, 121ff. In treatments of the virtues and the vices, there is frequently far more variation in the choice of virtues. The vices stay fairly stable, the terms largely confined to a short list of ten or so options (*vana gloria*, *tristitia*, and *cupiditas* often make the list as well). The vices, unlike the virtues, have a basis in the Bible, several passages referring generally to seven ills or evils. See Bloomfield, *Seven Deadly Sins*, 34.

31. See Copeland, *Rhetoric, Hermeneutics, and Translation*, 3: "Translation, shaped and informed by the academic systems of rhetoric and hermeneutics, was also a primary vehicle for vernacular participation in, and ultimately appropriation of, the cultural privilege of Latin academic discourse. . . . A chief maneuver of academic hermeneutics is to displace the very text it proposes to serve. Medieval arts commentary

does not simply 'serve' its 'master' texts: it also rewrites and supplants them."

32. Camille, *Image on the Edge*, 10.

33. Kumler, *Translating Truth*, 5–6.

34. Ibid., 10.

35. Ibid., 6.

36. Henry, "Pater Noster," 90n6.

37. The related fields of information and graphic design and of visual literacy and rhetoric are large and growing. Tufte's four books, written between 1983 and 2005, are, in the words of the graphic arts scholar Joel Katz, "the holy quadrinity of books on information design" (*Designing Information*, 218).

38. Tufte, *Envisioning Information*, 65.

39. Ibid., 53–65, 81–94. Scase, in "Description of Fol. 231v," includes a detailed description of the Paternoster diagram, which identifies several shades of red used in the artwork, including light rose, rose, magenta, and even dark lilac, in addition to red. In this part of my argument, I focus exclusively on red *text*, which consistently employs the same pigment throughout the page.

40. Tufte, *Envisioning Information*, 90.

41. See ibid., 53ff., for comparable examples of color and layering. This general effect is also noted briefly in Henry, "Pater Noster," 92, but that article does not discuss the odd inversion of the hierarchy of scripts.

42. Henry, "Pater Noster," 93.

43. See Arnheim, *Art and Visual Perception*, 174 ff.; and also Marr, *Vision*, 215–33, on how human mental processing of visual information depends heavily on information from curves and contours.

44. Henry, "Pater Noster," 93.

45. See Morgan, in "Decorative Ornament," 1, who surveys major changes to book ornament in the thirteenth century and traces their influence forward into the fourteenth and fifteenth centuries.

46. Scase, in "Description of Fol. 231v," identifies these largest sketches as "six-line red and dark green/black penwork rectangles of various foliate designs in reser; work and interlace designs alternating with red script."

47. "Foliate heads" are generally faces or heads, almost always with no necks or bodies, often with "mouth foliage" (leafy plants issuing from the mouth, though sometimes leaves also grow from other sense organs on the head—ears,

nose, eyes). Dinshaw, in "Ecology," surveys the scholarship on the foliate head. On the question of whether the heads are changing into humans or plants, she suggests that they "show these opposing trajectories held in tension. The resultant shape is a creature *both* and *neither* man and plant" (350), and, furthermore, that "the medieval leafy faces suggest different modes of knowing, different consciousness" (354).

48. Scase, "Description of Fol. 231v," identifies this figure as a "lion mask." Lion masks can also have features of foliate heads, and vice versa; see, for example, Stokstad, "Note on a Romanesque Lion Mask."

49. For example, in Oxford, Bodleian Library MS Bodley 764, folios 3r–4v, the lion's three main characteristics are all aligned with aspects of Christ; see De Hamel, *Book of Beasts*, folios

3r–4v; and Barber, *Bestiary*, 23–25. Traditionally, the lion is also the symbol of the evangelist Mark and represents Jesus as heavenly Lord.

50. Henry studies another aspect of the Paternoster diagram: the corner infill that squares off the corners of each roundel. Scrutinizing the patterns that govern color choice, she argues for a reading of the septenary items that depends on whether the infill continues or disrupts the patterns. Her work corroborates my own in suggesting that the artwork is an integral part of the diagram meant to influence a worshipper's interpretation of the language. It ought not be seen as mere decoration.

51. Jordan, *Chaucer and the Shape of Creation*, 229.

52. Patterson, "*Parson's Tale*," 340.

PART II

CHAUCERIAN IMAGESCAPES

FIVE

Standing under the Cross in the *Pardoner's* and *Shipman's Tales*

Susanna Fein

In criticism appearing some thirty years ago, A. C. Spearing and Derek Pearsall described with finesse the differing styles of the *Pardoner's* and *Shipman's Tales*.[1] Spearing observed how, "driven by a feverish energy," the Pardoner's searing exemplum focuses on "swearing by the parts of Christ's body" and even enacts the blasphemy that two members of the Trinity conspired to murder the third. After the youngest reveler dies, the remaining two consume "a sacramental meal that kills its participants." This is a dark tale that leaves readers with "a fearsome apprehension."[2] Of the coolly mercantile *Shipman's Tale*, Pearsall found the wife and monk's calibrated interaction in the garden to be "like making love over the counter," such that "in some strange way the exchange of money seems to legitimate rather than corrupt the encounter." He calls the tale "coldly exhilarating in its total disregard of familiar moral decencies."[3]

Given such incongruities, what might urge us to read these tales together? They reside juxtaposed in the Ellesmere manuscript—and thus, too, in *The Riverside Chaucer*—but evidence suggests that Chaucer set them in different fragments, the tale of the Pardoner conjoined to that of the Physician, and that of the Shipman heading a complex group that includes the Prioress, the pilgrim Chaucer, the Monk, and the Nun's Priest. No linkage occurs between the Host and the Pardoner's final kiss of peace (VI 968) and the Shipman's first couplet: "A marchant whilom dwelled at Seint-Denys, / That riche was, for which men helde him wys" (VII 1–2). Despite such formal and stylistic disjunctures, these tales possess a shared visual poetics tinged with the visionary. Both contain an embedded sign that arises *unseen*, an icon conjured by a figural resemblance, so that in a flash of

recognition the acculturated mind's eye will glimpse it. As I hope to demonstrate here, what links the *Pardoner's* and *Shipman's Tales* is a shared prompting for an audience to apprehend mentally—as if by visionary experience—an image of the crucified Christ.

In both tales, the protagonists dwell in worlds narrowly driven by their own materialist values—avaricious greed and gluttony in one, mercantile wealth and array in the other. They incessantly invoke God in speeches filled with blasphemous curse or insincere oath, and thereby, indeed, their empty pieties do summon God. Meanwhile, eucharistic allusions further hint that God is truly present. The result is a clash of visual perspectives: people see only the physical, while all-seeing God observes them in their blind states of spiritual *un*seeing. This scopic disparity is succinctly articulated in the Pardoner's exemplum when the old man greets the rioters: "Now, lordes, God yow see!" (VI 715), meaning "May *God* see you," that is, benevolently, "May God *watch over* you."[4] A more ominous sense, however, is also conveyed: "May God *judge* you."[5] Moreover, one may equally hear, by exchanging subject and object, "May *you* see God." With perspective reversed, the greeting denotes the ever-elusive matter of beholding and comprehending God. In context, when spoken to three so irreverent men, this last meaning conveys an utterly ironic wish. Although the old man may mean no such irony, the reader who detects this sense will certainly grasp how futile is it that *they* will ever see God. In the *Pardoner's Tale* and the tale that follows, Chaucer sets the general human incapacity to "see" spiritually against glimmering signs of God's real presence. Together, these tales image forth not only worlds of blind human error but also a strong reminder that God is ever watching.

As we seek historicized ways to understand visual signs in Chaucer's art, we may reasonably posit that naming the sacrament of the altar serves a useful function in and of itself for a poet of orthodox fourteenth-century Christian belief. By its enactment among characters, he may suggest that the invisible divine presence has directly entered the narrative, and its coming may activate visionary signs. The sacrament's occurrence cues readers to apprehend in mental image the chief affective icon of the sacrament: Christ hanging on the Cross. In these tales, the icon emerges differently accoutered—that is, either with torturers or with mourners. Prompted by actions set under a tree, the visualization comes as a flash of recognition, while Chaucer's narrative figures blithely carry on, blind to the spiritual meanings they mimic and invoke. The poetic method—combining fictional unlikeness with figural likeness—heightens the moral incongruities that divide God's erring creatures from the Christian essence of God's loving sacrifice.

The Tales in Juxtaposition

Despite the lack of internal linkage between Fragments VI and VII, they appear in sequence in most manuscripts of the *Canterbury Tales*, with the result that the *Shipman's*

Tale typically follows the *Pardoner's Tale*.[6] My argument here does not depend on their juxtaposition, but this order becomes a provocative feature in its favor, suggesting a core iconographical approach being pursued by Chaucer in each one. Clues as to Chaucer's early plans for the *Shipman's Tale* reveal arresting points of contact with the *Pardoner's Tale*. For example, the Pardoner's ambiguity of gender might be set against the Shipman's odd investment in a theme of the "joly body." Critics traditionally stress the *Shipman Tale's* early assignment to the Wife of Bath, hearing vestiges of her voice in its opening:

> He moot us clothe, and he moot us arraye,
> Al for his owene worshipe richely,
> In which array we daunce jolily.
> (VII 12–14)

Fitting with the tone of this attestation is the epilogue to the *Man of Law's Tale*, which has the Shipman preparing to tell a tale at a different point in the *Canterbury Tales*:

> "And therfore, Hoost, I warne thee biforn,
> My joly body schal a tale telle,
> And I schal clynken you so mery a belle,
> That I schal waken al this compaignie."
> (II 1184–87)

The Shipman's concern for a "joly body" resounds, too, in his tale's ending, when the wife tells her husband, "Ye shal my joly body have to wedde; / By God, I wol nat paye yow but abedde!" (VII 423–24). Upon the Shipman's conclusion, the Host exposes the corporeal theme by swearing on *corpus dominus*, shifting the notion to sacred ground, even if by oath:

> "Wel seyd, by *corpus dominus*," quod oure Hoost,
> "Now longe moote thou saille by the cost,
> Sire gentil maister, gentil maryneer!"
> (VII 435–37)

The Host matches, too, the Shipman's final carnal pun on "taillynge" (VII 434) by adding a new one: "saille by the cost" easily yields, by sexual innuendo, "assail along the flanks."[7] A similar preoccupation with the bodily resonates in Chaucer's creation of the indeterminately gendered Pardoner, who famously protests of marriage, speaking to the Wife of Bath: "What sholde I bye it on my flessh so deere?" (III 167). Crude genital insults likewise mark the final testy exchange between the Pardoner and the Host.

A more specific likeness between these tellers occurs in how each compares his smooth-tongued rhetorical skill to the ringing of a bell. Like the merrily clinking Shipman, the Pardoner is a boastful bell ringer of rhetoric:

> "Lordynges," quod he, "in chirches whan I preche,
> I peyne me to han an hauteyn speche,
> And rynge it out as round as gooth a belle."
>
> (VI 329–31)

A bell also rings in his exemplum. Marking a funeral procession, this bell sounds before the regular tolling of prime:

> Longe erst er prime rong of any belle,
> Were set hem [the rioters] in a taverne to drynke,
> And as they sat, they herde a belle clynke
> Biforn a cors, was caried to his grave.
>
> (VI 662–65)

This bell tolls for a dead comrade, alerting the rioters. The Shipman claims that his bell-like voice can awaken the pilgrims. Bell ringing denotes eloquent rhetorical delivery, dead bodies going to burial, listeners called to attention. It conveys heightened awareness and a ritualistic marking of events. These references harmonize, perhaps, with eucharistic moments in the two tales, for a sacring bell was commonly rung to alert praying participants to look up and behold the elevated Host.[8]

The tales of Pardoner and Shipman bear further evocative resonances. Both are situated on the Continent; they share Flanders while the *Shipman's Tale* adds France. The *Pardoner's Tale* opens with a scene of revelry and gambling. In the *Shipman's Tale*, the wife is not only beautiful and companionable but also "revelous" (VII 4). The merchant "rekene[s] and caste[s]" his accounts (VII 216), and although he avoids dice during his dealings abroad (VII 304), he "nedes moste . . . wynne" (VII 371), much like a gambler. The garden scene is timed, like the rung bell in the *Pardoner's Tale*, at prime, beginning before that hour and ending just after it has passed (VII 88, 206). Correspondent to the Pardoner's sermon on gluttony, the houseguest monk has an appetite and must be fed (VII 205, 210–11, 221–23). The meal setup occurs quickly, as if staged for show:

> But hastily a messe was ther seyd,
> And spedily the tables were yleyd,
> And to the dyner faste they hem spedde,
> And richely this monk the chapman fedde.
>
> (VII 251–54)

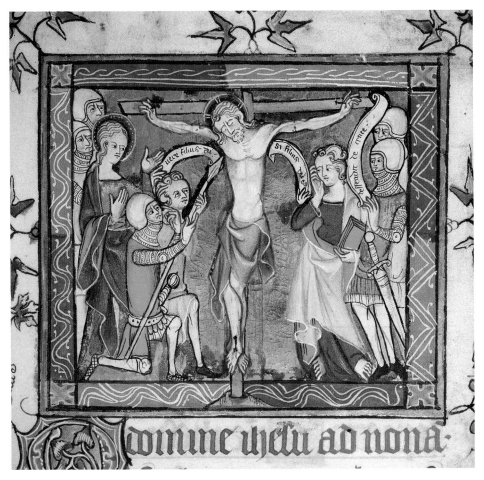

FIG. 5.1 Crucifixion scene with green Cross, soldiers, Mary, and John. Neville of Hornby Hours. London, British Library MS Egerton 2781, folio 49r. Southeast England (London?), circa 1340.

In the final line of this passage, one may ask: *who* has fed *whom*? The chapman dines his guest well, but a Mass preceded the meal. Perhaps the monk officiated, thus offering the Eucharist to the chapman.[9]

In both tales, indeed, the Mass becomes an element to be reckoned with, even if it is present merely by ironic allusion or enacted too speedily. For a devout medieval Christian, the raising of the Host signifies the moment when bread becomes Christ's body. The miracle is enacted when a priest intones the Latin liturgy of supplication from a missal and elevates the wafer.[10] Most lay worshippers observed the rite at least weekly, or even daily if they had access to private chapels. At the moment of Levation, devotees would seek to "see beyond"—that is, apprehend, in the sanctified bread and wine, the living and present *corpus dominus*, typically represented as Christ on the Cross.[11] To assist such ghostly vision, icons of the Crucifixion were illuminated in psalters and books of hours (fig. 5.1),

painted on altars, erected on rood screens, and depicted on parish church walls.[12] Regardless of whether a visual prompt was physically present, the sacrament bears, immanent within itself, the idea of God's sacrificial death being graspably present, and so it invites the participant to "see" an image of Jesus on the Cross.

In the *Pardoner's Tale*, eucharistic allusions are sacrilegiously parodic and mis-situated in a tavern or a wood. In the *Shipman's Tale*, they denote shallow conventions of propriety and domestic affluence. The Pardoner indulges in cake and ale in the tavern before he starts telling what is normally preached with a Mass in a parish church: "heere at this alestake / I wol bothe drynke and eten of a cake" (VI 321–22). In the exemplum itself, the rioters send their youngest member to town to "brynge us breed and wyn" (VI 797), which renders their last meal, after the grisly murder, a black parody of communion.[13] The situation of the merchant in his counting-house, auditing his assets, frames the garden scene in the *Shipman's Tale*, during which the wife and daun John arrange a tryst. The scene concludes with the three coming together to share the Eucharist before a household meal. Here the ritual denotes religion performed by materialists for show, and it suggests another luxury possession: the merchant's lavish household must boast a private chapel.[14]

Unkind Oaths and the Tortured Body in the *Pardoner's Tale*

The *Pardoner's Tale* is consumed by acts of swearing and torture directed at God's body. When the Pardoner speaks against the perversion of our gluttonous nature, he alludes to the miracle of imbibing the living bread and wine, but by his insinuations the Eucharist becomes a God-tearing exercise. The original sin was gluttony, he preaches, for Adam was cast out of paradise for eating "of the fruyt deffended on the tree" (VI 510). Nowadays, because of our enslavement to our bellies, cooks "stampe, and streyne, and grynde, / And turnen substaunce into accident" (VI 538–39) to answer the demands of men's greedy desires. These actions grotesquely parody the Eucharist, wherein the spiritual substance of God becomes the accident of bread.[15] Moreover, the stamping, straining, and grinding involved in food preparation make the cooks seem counterparts to those who violently tortured Christ. Men's tastes are now delighted, perversely, by eating not merely the fruit, but rather the *entire* forbidden tree: "Of spicerie of leef, and bark, and roote" (VI 544).

Prime, the hour that sparks the action of the Pardoner's exemplum, was commemorated as the time during the Passion when Jesus was bound and brought before Pilate, falsely accused, then mocked and taunted by his accusers while he stood silent. It was widely memorialized by those who tied their devotions to the Seven Hours of the Passion. A fourteenth-century Anglo-Norman version has the contemplative pray thus: "I render thanks to you, sweet Lord Jesus Christ, because at the hour of prime you were like a thief bound and led to the court before Pilate, and handed over to him to be unjustly judged."[16]

Such meditations, to be taken up seven times a day, bring about a constant mindfulness of the Passion. The mention of prime in the *Pardoner's Tale* serves largely, however, not to evoke piety but to align the rioters with Christ's abusers. Their actions conform to those of the generic "sinful man" whom Jesus confronts in numerous vernacular lyrics. Speaking from the Cross, he implores humankind to behold his wounds and suffering:

> Senful man, bethink and see
> What peine I thole for love of thee.
> Night and day to thee I grede [*call*],
> Hand and fotes on rode isprede.
> Nailed I was to the tree,
> Ded and biried, man, for thee;
> All this I drey [*suffer*] for love of man.
> But werse me doth, that he ne can
> To me turnen onis [*once*] his eye
> Than all the peine that I drye.[17]

Conjuring up an intense image of Jesus calling from the Cross, his hands and feet nailed, this lyric might once have accompanied a crucifix either drawn on a page or hung on a wall. Or it could have served as a purely verbal prompt for remembering this affective image. What matters is how Christ confronts humankind: even worse than the pain he endured at the Passion, he says, is how humanity habitually ignores its redemptive truth. Sinful man, he says, will not *turn once his eyes* to see the depth of love in God's sacrifice. The meaning—embodied in Jesus's pain and the viewer's empathy—rests in *seeing* the image.

Even though the Pardoner is an avowed hypocrite espousing harsh calculation concerning the fates of souls, he has the capacity to preach a sermon of honest orthodoxy and direct appeal, with rhetorical moments that resemble the pleading Christ of vernacular lyrics. At one point he declaims:

> Allas, mankynde, how may it bitide
> That to thy creatour, which that the wroghte
> And with his precious herte-blood thee boghte,
> Thou art so fals and so unkynde, allas?
> (VI 900–903)

These lines align precisely with Middle English lyrics that carry the refrain "Why art thou to thy Lord unkind?"[18] The Pardoner calls his congregants' sins "alle cursednesse" (VI 895), with a chief type being the "blasphemour of Crist with vileynye / And othes grete" (VI 898–99). He thus castigates parishioners for bearing a hard-hearted complicity

FIG. 5.2 The Warning to Blasphemers painted on a parish church wall. Nine well-dressed young men hold body parts (the subjects of their swearing) as they look on a central pietà in which Mary holds her mutilated son. Broughton, St. Lawrence, Buckinghamshire, late fourteenth century.

in the crucifying of Christ, reminding them of the wounds *they* caused, from which bleeds the precious blood that redeems them. He forces them to see themselves as ungrateful and unnatural (*unkynde*) creatures before their Creator. In the religious lyric tradition, words such as these were very likely to be posed, as in the lines quoted above, as a plaintive plea coming directly from Jesus nailed on the Cross to all who heedlessly pass by.

The rioters become grotesque examples of such obdurate passersby. In the tale's exaggeration of human heartlessness, they blindly *hurtle* by, their deeds exemplifying the full range of sins excoriated by the Pardoner in his sermon. Most of all, their blasphemies perform unending torture on Christ's soft flesh, inflicted gruesomely in a realm where the spiritual miraculously commingles with the physical:

FIG. 5.3 Crucifixion scene with Christ flanked by two thieves and two torturers (and a third in the background) (detail). One soldier raises the sponge with bitter drink to Christ's mouth. Bohun Psalter and Hours. London, British Library MS Egerton 3277, folio 141r. England, circa 1350–1400.

Hir othes been so grete and so dampnable
That it is grisly for to heere hem swere.
Oure blissed Lordes body they totere—
Hem thoughte that Jewes rente hym noght ynough—
And ech of hem at otheres synne lough.
(VI 472–76)

These are men bonded through cruelty, mocking Christ as they rip his body, laughing at "otheres synne"—a phrase by which the Pardoner seals this blasphemous brotherhood, the words *othes* and *otheres* resounding together. Indeed, in the word *otheres* Chaucer coins a dark pun: they swear to each "other" as "oathers."[19] Words of orthodoxy stress "Oure blissed Lordes body," charging the passage with compassionate outrage against the sinning perpetrators. The Pardoner later emphasizes his meaning by repeating it. Vowing to "lyve and dyen ech of hem for oother" (VI 703), the three swear "many a grisly ooth" such that "Cristes blessed body they torente" (VI 708–9). Given such emphatic assertions and bold visualizations, one comes to perceive the rioters as living replicas of Christ's tormenters. With each foul curse by God's heart, nails, or blood, they compound the agony of God during the Passion. The Broughton wall painting of the Warning to Blasphemers literalizes in graphic detail how swearing inflicts bloody fragmentation on Christ's body (fig. 5.2).[20] In the iconographical tradition of Crucifixion imagery, these descriptions evoke well-known scenes of Christ stripped and nailed to the Cross, surrounded by torturers (fig. 5.3).[21]

The rioters' oaths assume an air of bravado, as if cursing within the false safety of bonded manhood gives them a jointly misguided mission of boastful "heroism": "Deeth shal be deed, if that they may hym hente!" (VI 710). Their aim reflects another blasphemous act, "an attempt to usurp Christ's role," as prefigured in the Old Testament: "O death, I will be thy death" (Hosea 13:14).[22] Eventually two will murder the third, the youngest, "ryv[ing] hym thurgh the sydes tweye" (VI 828) as Christ was stabbed

FIG. 5.4 Crucifixion scene with Christ surrounded by two torturers, each raising sponges of bitter drink to his mouth. The two thieves and more soldiers are visible in the background. Medieval roof boss, Norwich Cathedral.

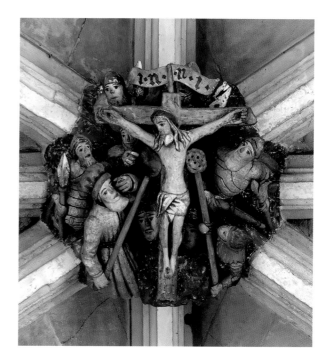

on the Cross. Reenactment is now made literal in twofold fashion: God's body torn by blasphemous oath, a sworn brother betrayed and killed. Two killing a third accords with comparable Passion iconography that focuses on two torturers assailing Christ (fig. 5.4). This figuration conforms to the typical symmetry one finds in medieval illustrations of the Crucifixion: two persons stand to either side of Jesus's body, flanking the Cross.[23] They might be two soldiers, or Longinus on the left, piercing Jesus's side, and the sponge-bearer on the right, offering bitter drink.

Very commonly found in medieval iconography of the Passion is an alternate pair—namely, the two chief mourners, Mary and John the Evangelist. In the *Shipman's Tale*, as we will see, this pairing constitutes a crucial image. In the Pardoner's figural evocation, however, Mary and John are absent, both named only fleetingly elsewhere in the tale.[24] The taverner swears by Mary as he informs the rioters of Death's locale: "By Seinte Marie! . . . / The child seith sooth" (VI 685–86).[25] And, later on, a rioter swears by Saint John as he demands information from the old man: "Thou partest nat so lightly, by Seint John!" (VI 752). While throughout the *Canterbury Tales* Chaucer's characters frequently swear oaths by Jesus's closest disciple to convey a jocular sense of comradery, here lurks an ominous sense, the rioter cloaking a threat in a phrase connoting "my friend."[26] Such menace plays against the old man's gracious yet ambiguous greeting to the three men—"Now, lordes, God yow see!"—a blessing that builds suspense over the men's hastening dooms.

The ensuing dialogue between the old man and the rioters teems with religious blessings and curses that raise a spectral sense that God is present and watchful, though wholly outside the rioters' weak comprehension. The old man utters a blessing: "God be with yow, where ye go or ryde!" (VI 748). In return, a rioter threatens harm and swears by the Mass:

> "Telle where he is or thou shalt it abye,
> By God and by the hooly sacrement!"
>
> (VI 756–57)

He swears by the crucified Lord and the ritual that summons his presence. The final avowal is another blessing from the old man, and it again invokes the redemptive crucifix:

> "God save yow, that boghte agayn mankynde,
> And yow amende!"
>
> (VI 766–67)

So it is, given these explicit prompts, that the oak tree soon encountered in the grove—up the "croked wey," where the three are "so leef / To fynde Deeth" (VI 760–61)—becomes more than the signifier of avarice and death that the rioters will discover. It also betokens the opposite way: redemption and eternal life. The rioters can see the tree and its treasure in only a materialistic manner, and they miss the sacred truth wherein the tree is the Cross on which the bleeding Lord hangs. As present-day embodiments of the very torturers who wounded Jesus at the Passion, the rioters are oblivious to spiritual realities. They are fatally blind to the mercy present before them—indeed, *visibly apprehensible*—were they only to look with spiritual sight. If they were able to gaze on the tree with devotion, they would see the sacred rood of redemption.

Chaucer embeds this vision in the text by re-creating God's torturers in the rioters. The tale's stark, fully glossed reenactment of Christ's body being torn and stabbed, by curse and by homicide, evokes for the medieval Christian reader a nascent emblem. With the associations thus being latently triggered, the resonances come to be fully realized when the rioters reach the tree, the spot of their certain deaths. Under the arboreal "leef" men consume so eagerly, they are now "so leef / To fynde Deeth." At this moment in the exemplum, the devout congregant in the parish church, having partaken of the Mass, will know what to apprehend—that is, precisely, what unseen truth is present, signaled by the sacring bell: the Lord hangs on the tree as a glistening sign of eternal Life. The Pardoner famously closes his sermon with a momentary glimpse of truth—"And Jhesu Crist, that is oure soules leche, / So graunte yow his pardoun to receyve, / For that is best"—only to obscure it with a self-serving and ambiguous remark: "I wol yow nat deceyve" (VI 916–18). It remains the Host's duty to fully gloss the tale with an oath of his own: "by the croys

which that Seint Eleyne fond" (VI 951).[27] Here it is the complexly drawn, aptly named Host—a burly taverner, a mock-priest who by profession supplies wine and bread—who invokes, embraces, and points to the True Cross.

Salutations and Countenances in the *Shipman's Tale*

The *Shipman's Tale* is all about show. Its merchant is similar to his counterpart among the pilgrims, "Sownynge alwey th'encrees of his wynnyng" so that "Ther wiste no wight that he was in dette" (*General Prologue*, I 275, 280). Concealing his state of indebtedness, the Merchant is concerned both with profit and with *seeming* to be wealthy. In a rare bit of moralization, the Shipman offers an opening comment on how such a shallow and duplicitous life is wholly fleeting:

> Swich salutaciouns and contenaunces
> Passen as dooth a shadwe upon the wal;
> But wo is hym that payen moot for al!
> (VII 8–10)

In the tale's first couplet, the merchant is said to be rich "for which men held him wyse." Wealth struts as wisdom, though there seems scant wisdom in a life based on costs. The wife is a beautiful showpiece but expensive. And the merchant—"wo is hym"—must pay dearly to sustain her in a style that holds no permanence or value.

The merchant must keep up appearances and cultivate profitable relationships in order to thrive in business. Human interactions in the tale occur among persons who bear good countenances, pleasant faces, and mannered *chiere*. The well-dressed wife is a fine accessory who increases the merchant's domestic assets. Welcomed as family, the young monk "so fair of face" (VII 28) adds a fashionable show of religion to the household. The word *salutaciouns* describes well the tale's narrative design: a series of greetings and encounters—merchant with monk, with wife; wife with monk, with husband; and so on—and a form of the word figures in the wife's meeting with the monk in the garden:

> This goode wyf cam walkynge pryvely
> Into the gardyn, there he walkyth softe,
> And hym *saleweth*, as she hath doon ofte.
> (VII 92–94)

In one-on-one greetings and conversations, the characters conduct themselves in seemly ways, as they cover their private affairs and stay alert to their next self-advancing move.

As the merchant says at one point, a chapman must keep his affairs concealed until he dies, and, along the way, he must "wel make chiere and good visage" and "pleye / A pilgrymage" (VII 230, 233–34). These are characters so detached from moral concerns or religious virtues that undertaking a pilgrimage would be merely a performance. As many critics have noted, the verbal texture of the *Shipman's Tale* teems with linguistic slippages of sense, Anglo-French cross-borrowings, and rampant punning. Significantly, the word "*cont*enaunces" initiates the technique by commencing a stream of verbal play on terms of *count*ing, ac*count*ing, and keeping up a good front, including in its range even the vulgar French words *con* and *vit* (which plays off French *vis*, "face"), with many of those senses bundled in the final multiple pun on "taillynge."[28]

In this chapter, however, I am less interested in these social meanings (of which there are a wealth in the tale) than in a higher register that exists in the compelling phrase "salutaciouns and contenaunces," a register that seems to be largely neglected in critical literature on the *Shipman's Tale*. Taken together, these words contain a spiritual sense: prayerful salutation directed to God, as may be enacted by a devout layperson, or as may occur via a priest during the sacrament of altar. The ultimate goal of such devotion is greater closeness to God, perhaps even to mystically apprehending God's countenance. The social salutations and fair countenances carried on by the characters of the tale will all pass, as does a shadow. The merchant's devotions involve only money and the maintenance of a good name; he declares that "Of chapmen . . . hir moneie is hir plogh. / We may creaunce whil we have a name" (VII 288–89). With an obvious pun on the sexual sense of "plough," the merchant sees money as his chief instrument. His emphasis on building a *name* in order to borrow (that is, produce by means of debt) comes across as an empty imitation of the Creator, who created the creatures of the world *before* naming them. And in the verb *creaunce*, used here in the sense "obtain credit, borrow money," one may hear how shallow is the merchant's "body of beliefs."[29]

Profane Vows and the Crucifixion in the Tree

This preliminary discussion of the *Shipman's Tale* has introduced its point of visual similarity with the *Pardoner's Tale*. While the protagonists of each are willfully blind to sacred truths, both tales bring to the reader's apprehension the countenance and redemptive power of God as imaged in the Crucifixion. In the *Pardoner's Tale*, Christ's bleeding body hangs invisibly in the massive oak that witnesses the rioters' homicidal blasphemies. Without knowing it, the rioters play the parts of—sacramentally *become*—the torturers of Christ, and when the tree is reached, the rest of the emblem develops as it must, in visionary fashion. The same holy emblem will materialize in the *Shipman's Tale* when the wife and monk make hollow vows under a tree, using religion as a shared language of pious

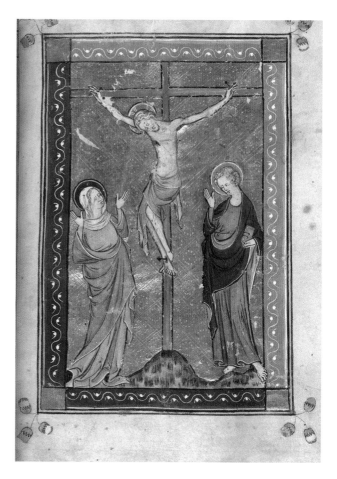

FIG. 5.5 Crucifixion scene with green Cross, Mary, and John holding a book. Hours of Alice de Reydon. Cambridge, Cambridge University Library MS Dd.4.17, folio 12r. East Anglia, fourteenth century.

platitudes while remaining oblivious to the spiritual realities embedded in their words.[30] Here Chaucer activates a different variety of core Crucifixion iconography: Christ on the Cross flanked by his chief grievers, Mary on the left, Saint John on the right. Both are typically shown in an intense state of mourning, with hands raised, while John also holds a book, his own gospel account of the events (fig. 5.5).

Daun John enters the garden with his *portehors* (a breviary, or monk's prayer book) and "hath his thynges seyd ful curteisly" (VII 91). To call his prayers for prime "thynges" likens his activity to the merchant's materialistic accounts, also called "thynges" by the wife (VII 217). His intoning them "ful curteisly" adds further show without substance. This French wife (a *mariée*) soon greets him, and their mutually advantageous transaction begins, where, in exchange for sex, the wife will gain a hundred francs to pay a debt owed for a new dress. A particularly salient aspect of the pair's garden conversation is their frequent, offhand swearing on God's name, with both affirming a troth on the monk's convenient *portehors* (VII 131, 135). Many such prayer books with English, Flemish, or French origins survive, and they are occasionally adorned with a cover illustration of Christ on

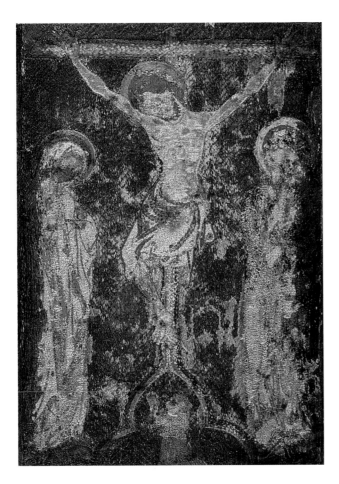

FIG. 5.6 Crucifixion scene with Mary and John, and a small figure kneeling with hands in prayer directly below, embroidered on the back of a book cover. The front depicts the Annunciation. Felbrigge Psalter. London, British Library MS Sloane 2400. England, circa 1300–1325.

the Cross flanked by Mary and John (fig. 5.6). Regardless of whether the monk's book is to be imagined as bearing this emblem, its very presence in the garden scene introduces a sacred object containing prayers on the Passion and, very likely, an illuminated image of the Crucifixion inside its boards.[31] The holding of the book by daun John accords, moreover, with the Saint John iconography.

The swearing in the garden operates much as it does in the *Pardoner's Tale*. Vows naming God cut two ways: characters mouth empty pieties while their actual words—when taken seriously and faithfully—remind a reader that God is present and watchful. Asseverations by God in the *Shipman's Tale* do not violently tear Christ's body. They serve instead to dramatize how profane intentions are being spoken with a patina of socially pious respectability. A cluster of images about bodily rending does develop, but it refers to the wife's body, playing up her sexual nature. After the monk's improper image of the "wery hare / . . . al forstraught" (VII 104–5),[32] a tearing image that causes him to blush and laugh, the wife offers an account of her unsatisfying marriage, affirming that "God woot al" (VII 113) and making appeal to "God that yaf me soule and lyf" (VII 115). When she

concludes her lament with an overdramatic threat to end her own life, the monk responds, "God forbede" (VII 125), urges her to tell her "grief" (VII 127), and swears on his *portehors* never to betray her. She answers with a similar vow—"By God and by this portehors I swere" (VII 135)—and compares her life to that of a suffering saint. When she calls him "cousin," the monk responds with the scene's strongest oath, in which he denies his ties to the merchant, profanes his profession as monk, and invokes God and two prominent French saints:

> "Nay," quod this monk, "by God and Seint Martyn,
> He is na moore cosyn unto me
> Than is this leef that hangeth on the tree!
> I clepe hym so, by Seint Denys of Fraunce,
> To have the moore cause of aqueyntaunce
> Of yow, which I have loved specially
> Aboven alle wommen, sikerly.
> This swere I yow on my professioun.
> Telleth youre grief, lest that he come adoun."[33]
>
> (VII 148–56)

It is this moment that prompts a religiously minded reader to visually perceive the crucifix under which the pair stands—a sacred emblem set in stark contrast to the present action.

The monk's mention of "this leef that hangeth on the tree" triggers the association, so that then glimmers forth, in the leafy tree that stands above the *mariée* and daun John, the familiar icon of Jesus hanging on the Cross—an involuntary reflex for a devout medieval audience. This effect relies on a crucial pun embedded in the word *leef*: it primarily means "leaf" (of a tree), but in a sacred register it means "lief, dear one, beloved" and likely, also, "faith, belief."[34] The wife and the monk are now, peculiarly, shadows of a holy figuration (fig. 5.7), and their subsequent words echo with their own blindness to sacred detail. The oaths continue between them, and a steady consonantal wordplay (*lough, love, lyf, lief*), which had existed in their conversation prior to the monk's forswearing oath and mention of the *leef*, now becomes a notable feature, both stylistic and semantic:

> "My deere love," quod she, "O my daun John,
> Ful lief were me this conseil for to hyde."
>
> (VII 158–59)

The wife raises more unguarded complaints about her husband, protesting lightly—"God shilde I sholde it tellen" (VII 166)—and then swearing: "As helpe me God, he is noght worth at al / In no degree the value of a flye" (VII 170–71).[35]

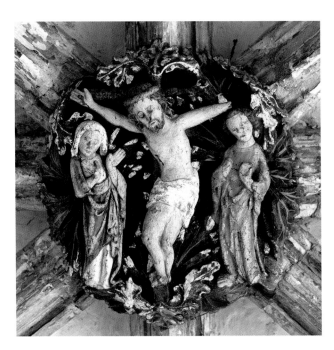

FIG. 5.7 Crucifixion scene with Mary and John in a garden setting. Medieval roof boss, Norwich Cathedral.

These invocations of God lead to the wife's most telling one, expressed when she asks the monk for money:

> "But by that ilke Lord that for us bledde,
> For his honour, myself for to arraye,
> A Sonday next I moste nedes paye
> An hundred frankes, or ellis I am lorn."
> (VII 178–81)

Here the two registers clash at their most sacrilegious. Just as the wife invokes the bleeding Christ, she names her own shallow need for splendid *array* (a new dress), presumably to display herself proudly in church "a Sonday next." Of course, she also says that her debt is due "a Sonday next," so the redemptive debt paid on her behalf by Christ's body—the "unseen" presence in the sacrament—echoes strangely in her words. In the vernacular lyric tradition, Christ's bruised, bloodied body was frequently styled a sorrowful *array* donned willingly by God to redeem humankind:

> Wofully araide,
> My blode, man,
> For thee ran.
> It may not be naide [*denied*],

My body blo and wanne,
Wofully araide.[36]

Such is the refrain of a four-stanza lyric in Middle English that stresses the pain suffered by Jesus on his fair flesh, a suffering affectingly recounted in rhythmic strains:

Thus naked am I nailed, O man, for thy sake.
I love thee: thenne love me. Why slepest thu? Awake!
Remember my tender hert-rote for thee brake,
With paines my vaines constrained to crake.

The lyric "Wofully araide" constitutes a love song from Jesus, dying for love and now crying out to be remembered. This fifteenth-century lyric appears in London, British Library MS Harley 4012, headed by a focalizing image of Jesus on the Cross (fig. 5.8). The wife says that she needs to be well arrayed for "his" honor, referring to her husband and not hearing the other, sacred sense "for Christ's honor" lurking in her words.[37]

The Commendation as Love Troth

The iconography of Mary and John standing under the Cross commemorates the third of Jesus's Seven Words spoken from the Cross as recorded in John's gospel: "When Jesus therefore had seen his mother and the disciple standing whom he loved, he saith to his mother: 'Woman, behold thy son.' After that, he saith to the disciple: 'Behold thy mother.' And from that hour, the disciple took her to his own" (19:26–27).[38] These words, known as the Commendation, were said to mark Jesus's caring concern that his mother be provided for, and also to show his loving regard for intimate earthly bonds. In monastic circles, the Commendation was frequently used—by Peter Abelard, for example—as a justification for monks having spiritual associations and duties in the pastoral care of women; for the opening up of their orders to inclusion of female houses; and even for sanctioning mixed houses or condoning deep spiritual relationships between a monk and a female religious, such as developed between Geoffrey of Saint Albans and Christina of Markyate.[39] Such rationales provoked, of course, internal controversies as well as prurient accusations from other monastic writers, who abjured any female contact whatsoever. This background in monastic culture may have contributed to Chaucer's selection of a monk—daun John— as both lover in a fabliau and shadow figure for the ever-faithful John the Evangelist.

There is also evidence that invoking John in a pledge would designate that oath's inviolability, so that "by Saint John" became shorthand for venerating the sacred moment when John became Jesus's proxy in the care of Mary. In Chaucer's usages and elsewhere,

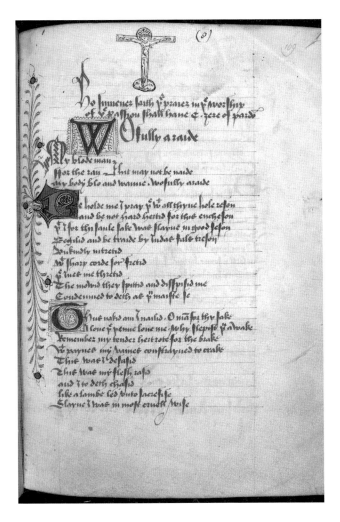

FIG. 5.8 Middle English lyric "Wofully araide." London, British Library MS Harley 4012, folio 109r. East England, circa 1460.

such vows clearly shifted into situations of romantic love and were not felt to be inappropriate to the courtly mode. Given the prevalence of the iconography, Mary and John sometimes tend to look more like a couple than like a mother and surrogate son. There are many instances in medieval Crucifixion art of a patron husband and wife being inserted into the space traditionally assigned to Mary and John (fig. 5.9).[40] This icon of a woman and a man being isolated as the chief witnesses to the Crucifixion was so widespread that many a wooing couple must have stolen glances at the pair under the tree and imagined themselves as the ones so joined by the Lord's Commendation (fig. 5.10).[41]

Further examples from the *Canterbury Tales* are illuminating. Believing the vows of a handsome tercel, the falcon in the *Squire's Tale* explains how she committed herself to him. After a time of happiness he came to depart, and she asked for assurance of his faithfulness:

FIG. 5.9 Crucifixion scene depicting God in Trinity, with portraits of the patron couple praying to Christ on the Cross. The couple appears where Mary and John traditionally stand under the Cross. Pabenham-Clifford / Grey Fitzpayne Hours. Cambridge, Fitzwilliam Museum MS 242, folio 28v. England, early fourteenth century.

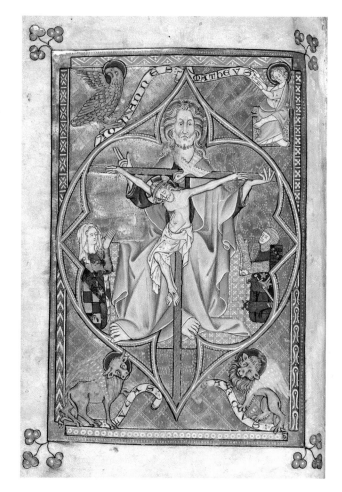

"As I best myghte, I hidde fro hym my sorwe,
And took hym by the hond, Seint John to borwe,
And seyde hym thus: 'Lo, I am youres al;
Beth swich as I to yow have been and shal.'"
(V 595–98)

Taking her beloved by his feathered "hond" and swearing by Saint John is meant to seal the tercel's loyalty in love. Another Chaucerian instance has Thomas's wife in the *Summoner's Tale* flirting with the friar by invoking Saint John:

"Ey, maister, welcome be ye, by Seint John!"
Seyde this wyf, "How fare ye, hertely?"
(III 1800–1801)

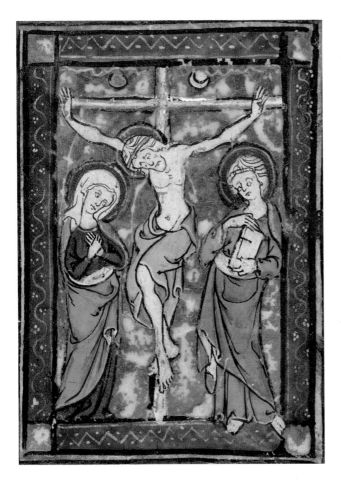

FIG. 5.10 Crucifixion scene in which Mary and John may seem to glance at each other (detail). Alphonso Psalter. London, British Library MS Additional 24686, folio 4r. England, circa 1284–1316.

This encounter chimes with the *Shipman's Tale*'s depiction of a confessor too close to a married woman yet welcome in the name of Saint John. A curious yet telling example comes in the Pardoner's interruption of the Wife of Bath:

> "Now, dame," quod he, "by God and by Seint John!
> Ye been a noble prechour in this cas.
> I was aboute to wedde a wyf; allas!
> What sholde I bye it on my flessh so deere?"
> (*Wife of Bath's Prologue*, III 164–67)

Thinking of his plan to take a wife—a desire now quenched, he says—makes the Pardoner think of Saint John and of "buying it on my flesh," terms that seem borrowed from the language of Christ's sacrifice.

FIG. 5.11 *The Four Leaves of the Truelove*. Frontispiece woodcut to Wynkyn de Worde imprint. London, British Library Huth 102. London, circa 1510.

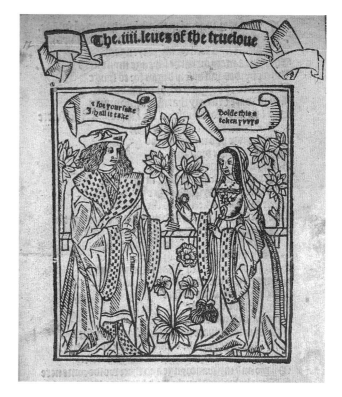

An intriguing correspondence comes from the larger domain of Middle English devotional verse. Chaucer may have known the alliterative stanzaic *Four Leaves of the Truelove*, for he set its main conceit—truelove, an herb of cruciform shape—as a provocative emblem in the *Miller's Tale*.[42] A thematic sound- and wordplay on *lefe*, *lufe*, *lyfe*, *ful*, *foule*, and *fayle*, adapted by Chaucer for the wife and monk's garden encounter, characterizes this poem and is quite effective in the poet's northern dialect.[43] The *Truelove* poet presents the Commendation in a Passion sequence set at the center, where Jesus speaks these words from the Cross:

> "Leve thi wepynge, woman, and mourne noghte for me;
> Take John to thi son, that standes be thi syde.
> John, take Mary to thi moder, for to myrth the,
> To kepe and to comfort, your blys to abyde."
>
> (lines 224–27)

While this scene is often depicted in vernacular writings, its poetic framing in *Truelove* is unusual and highly inventive. In a setup analogous to the Shipman's garden scene, a man recites his hours while strolling in a garden and then spies a grieving maiden.

A bird perched in a tree then preaches a comforting sermon that seems sprung from those very hours as it runs through iconic scenes from illuminated books of hours. The frame tableau—a "couple" in a garden under a tree—comes to be realized in a central emblem of Mary and John standing under the Cross.[44] When *Truelove* was printed for a London audience more than a century after its making, circa 1510, Wynkyn de Worde marketed it in a surprising way, by prefacing it with a woodcut that depicts a couple exchanging a ring under a tree in a garden (fig. 5.11). The romantic woodcut seriously misrepresents the medieval poem's devotional content, but its imagery of two opulently dressed individuals in a highly cultivated garden, under a small tree barren of sacred sign, does translate its piety into a later bourgeois world that the *Shipman's Tale* seems fully to embrace. The image indicates how far the biblical Commendation of Jesus could travel by means of popular reinterpretation and cultural reappropriation.

Conclusion

In the adjacent tales of the Pardoner and the Shipman, Chaucer embeds quiet prompts so that a devout reader may seem to gain a spiritual glimpse of Christ hanging on the Cross. By words of profane avowal, by figural likeness, and by insincere enactments of the Mass, the poet builds intimations of God's real presence being immanent, and he thus weaves unseen counter-meanings into these tales' narrative webs of action and intent. By an important pun, Chaucer underscores the spiritual register and inverted perspective of each tale. The word *leef*—signifying "leaf of a tree, " or someone "being desirous," or something "being dear," or even "belief, faith"—flits into the two tales during moments highly charged with latent symbolism—that is, those precise moments when readers observe the characters standing under a tree and swearing in perverse ways. The old man tells the wastrels that, if they be "so leef / To fynde Deeth," they will discover it up a crooked way under a tree. The term denotes the rioters' avidity to stand under a tree and complete their craven reenactment of torturing God's body. Earlier in the tale, an arboreal *leef* was named as a substance to be ground up by cooks, its eucharistic accident then to be fed to men. In the *Shipman's Tale*, the monk swears that the merchant is no cousin to him, no more than is "this leef that hangeth on the tree!" His words make God's body shine forth as a sacred, countervailing beacon while he and the wife utter such phrases as "that ilke Lord that for us bledde," phrases they would strip of all meaning but are actually unable to do so. The multivalent leaf on the tree—an edible object of cupiditous gluttony in the Pardoner's sermon, a hanging object of dear faith in the next tale—anticipates the sacramental vision to be seen in each one.

In the end, God's omniscient viewpoint becomes the fourth, most unseeable and unknowable, and least critically detected sense embedded in the Shipman's "taillynge" pun:

Thus endeth my tale, and God us sende
Taillynge ynough unto our lyves ende. Amen.

(VII 433–34)

The merchant husband may sexually "tally" his debt on his wife's "tail." And an all-seeing God may "tally" up the pilgrims' "tale-telling," keeping an account of individual debts for the Last Day, when they shall be summoned in the way the Shipman's ringing bell of a voice now awakens and alerts them. The sacramental sightings of the Crucifixion buried in these tales may be seen to coalesce in the succinct, final oaths pronounced by the Host when each teller concludes: to the Pardoner, "by the croys which that Seint Eleyne fond"; to the Shipman, "Wel seyd, by *corpus dominus*." Regarding the Pardoner's performance, he is angry: "I wolde I hadde thy coillons in myn hond / In stide of relikes or of seinturarie" (VI 952–53). The Host does not take lightly, of course, the personal insult given him by the Pardoner, but he may also, perhaps, detest the story's renewed and vigorous torturing of God's body. To the Shipman's tale, the Host's response is merry and jovial, and he adds to its bawdiness by cracking jokes about mariners, monks, and wives. Telling a fabliau that invokes the Crucifixion by parodying and sexualizing Mary and John, Jesus's most intimate mourners, seems to be jolly good fun, well worth an honest "by *corpus dominus*" and some crude teasing. In Harry Bailly's reactions and critiques, we may get the best glimpse of all of God's embodied and disembodied presence in these two narratives. For while the protagonists of both tales surely condemn themselves through false oath and unbelief, the Host's own perspective on the Host being blindly raised in each tale bespeaks both bemusement and clarity of sight.

NOTES

1. Both essays appear in *The Cambridge Chaucer Companion*, edited by Piero Boitani and Jill Mann. See Spearing, "*Canterbury Tales* IV"; and Pearsall, "*Canterbury Tales* II." While my reading takes a different direction, I use these critics' assessments as points of consensus in the vast array of criticism on these tales.

2. Spearing, "*Canterbury Tales* IV," 165–69. On the Trinitarian parody, see esp. Delasanta, "Sacrament and Sacrifice," 47–48; and Toole, "Chaucer's Christian Irony," 41.

3. Pearsall, "*Canterbury Tales* IV," 135–37.

4. For this familiar meaning of the verb *sen*, used here and elsewhere by Chaucer, see *Middle English Dictionary*, s.v. "sen" (v.[1]), sense 23. The phrase is glossed in this manner in Chaucer, *Riverside Chaucer*, 181.

5. *Middle English Dictionary*, s.v. "sen" (v.[1]), senses 12 and 17.

6. See Benson's note on Fragments VI and VII in Chaucer, *Riverside Chaucer*, 910.

7. *Middle English Dictionary*, s.v. "sailen" (v.[1]), and "coste" (n.), senses 1(a) and 2(a).

8. Duffy, *Stripping of the Altars*, 97–98; Rubin, *Corpus Christi*, 58–60; and Nichols, *Seeable Signs*, 244.

9. In the tale's intermingling of the sacramental body with the sexual body, another "food" the merchant and monk share is the wife, who by euphemism is called "beestes" and "beste" (VII 272, 347)—that is, "best goods" and "bodily creature."

10. Rubin, *Corpus Christi*, 63–82; Ross, *Grief of God*, 15, 43–66; Duffy, *Stripping of the Altars*,

91–130; Nichols, *Seeable Signs*, 241–59; and Reinburg, *French Books of Hours*, 188–98.

11. Bynum, "Seeing and Seeing Beyond." Other representations included Christ as the Man of Sorrows or God in Trinity, with formulas sometimes presented in combination. On stories that reinforced belief in the miracle of the altar, see Justice, "Eucharistic Miracle and Eucharistic Doubt."

12. An elaborate crucifix flanked by Mary, John, and angels survives on the medieval rood screen above the altar at Eye, Suffolk; see Ross, *Grief of God*, figure 2.24. For paintings on parish church walls, see Rosewell, in *Medieval Wall Paintings*, 169–72 (figs. 185–89), who remarks that "wall paintings provided fictive altar retables for this sacrament [of the altar]" (170).

13. See Nichols, "Pardoner's Ale and Cake"; and Delasanta, "Sacrament and Sacrifice."

14. Architecturally, the merchant's chapel, dining hall, and bedroom are less well defined than the counting-house and garden. See the chapter by Sarah Stanbury in this volume.

15. The eucharistic resonances of this passage have been often discussed in reference to late medieval theology and English politics. See esp. Nichols, "Pardoner's Ale and Cake," 501–3; Delasanta, "Sacrament and Sacrifice"; and Strohm, "Chaucer's Lollard Joke."

16. "Je te renk graces, douz Sire Jesu Crist, de ce qe a houre de prime fuz come lere lye e mene a la court devant Pylat, e a ly baille pur estre a tort jugie" (London, British Library MS Harley 2253, fol. 139r). See Fein, ed. and trans., *Complete Harley 2253 Manuscript*, 3:300–301. On devotions to the Seven Hours, see esp. Duffy, *Stripping of the Altars*, 225, 237–38; Woolf, *English Religious Lyric*, 234–37; and Wieck, *Book of Hours*, 66, 90.

17. Luria and Hoffman, eds., *Middle English Lyrics*, 208 (no. 215). This lyric appears in John Grimestone's commonplace book (Edinburgh, National Library of Scotland MS Advocates 18.7.21; ca. 1372), folio 124v. See also Brown, ed., *Religious Lyrics of the XIVth Century*, 88 (no. 70).

18. Gayk, in "Early Modern Afterlives of the *Arma Christi*," 287–95, discusses, for example, an indulgence lyric of this type.

19. This pun is not listed in the *Middle English Dictionary*, s.vv. "othen" (v.), "other" (pron.).

20. Rosewell, *Medieval Wall Paintings*, 89–90; Loomis, *Mirror of Chaucer's World*, fig. 168; Gill, "Preaching and Image," 169–71;

Anderson, *Drama and Imagery*, 58–59; and Gayk, "Early Modern Afterlives," 290–91.

21. See Sandler, *Illuminators and Patrons*, 142.

22. Spearing, "*Canterbury Tales* IV," 167.

23. Fliegel, *Higher Contemplation*, 80–99, esp. 88–96.

24. The Pardoner warns against even mild oaths, saying, "Now, for the love of Crist, that for us dyde, / Lete youre othes, bothe grete and smale" (VI 658–59), but when uttered by virtuous characters or preachers, they seem to be regarded as sincere invocations, as in the Pardoner's own phrasing of the injunction ("for the love of Crist . . .").

25. On the taverner's invocation of Mary, see Fein, "Other Thought-Worlds," 344.

26. The mention of John in this particular context may also allude to Rev. 9:6, a text referring to hell's pains, which Chaucer's Parson quotes in Middle English: "And therfore seith Seint John the Evaungelist, 'They shullen folwe deeth, and they shul nat fynde hym; and they shul desiren to dye, and deeth shal flee fro hem'" (X 216).

27. Kendrick, in *Chaucerian Play*, 77–78, provides an interesting discussion of the context of this line.

28. See esp. Taylor, "Social Aesthetics," 301–10; and Kendrick, *Chaucerian Play*, 90–97.

29. *Middle English Dictionary*, s.v. "creaunce" (n.), and compare "creauncen" (v.).

30. On swearing in *Shipman's Tale*, see esp. Richardson, "Facade of Bawdry."

31. Such illustrations are standard in portable books of hours and psalters (Ross, *Grief of God*, 43–66).

32. See Hermann, "Dismemberment, Dissemination, Discourse," esp. 304–6.

33. The phrase "Lest that he come adoun" refers overtly to the merchant, but in a sacred register, which the pair do not hear, it refers to God. The wife's oft-mentioned "grief" is a parody of Mary's sorrow and may even recall the Sword of Sorrow sometimes featured as piercing Mary's heart in Crucifixion images.

34. Derived from the Old English *leaf*, *leof*, and *geleafa*, respectively. See *Middle English Dictionary*, s.v. "lef" (n.[1]), "lef" (n.[2]), and "bileue" (n.). For a Middle English pun on "leaf" and "belief," see the late fourteenth-century alliterative poem *Four Leaves of the Truelove*,

in Fein, ed., *Moral Love Songs and Laments*, 182 (lines 73, 75). While much has been written on bilingual punning in the *Shipman's Tale*, especially on the English coinage of the French *cosin*, "deceive" (see esp. Taylor, "Social Aesthetics," 301–10), the critical pun I note here is wholly English.

35. Toward the end of her speech, the oaths continue but the soundplay shifts from *l—f* to *f—l*, in words that change love talk to terms of failure and another violent tearing apart of her body (recalling a French traitor's execution): "Pardee, I wol nat *faille* yow my thankes" (VII 188), and "but I do, God take on me vengeance / As *foul* as evere hadde Genylon of France" (VII 193–94). One may also hear this soundplay in the phrase "the value of a flye" (VII 171).

36. Luria and Hoffman, eds., *Middle English Lyrics*, 209–10 (no. 218). See also Brown, ed., *Religious Lyrics of the XVth Century*, 156–58 (no. 103).

37. A similar phrase occurs in a similar context near the beginning of the *Shipman's Tale*: a wife needs to be arrayed "Al for his owene worshipe richely" (VII 13).

38. *Douay-Rheims Bible Online*.

39. See the excellent analysis and discussion by Griffiths, "Cross and the *Cura monialium*."

40. Duffy, *Marking the Hours*, 18, 20, 29 (figs. 11, 12, 17).

41. In some manuscript images, the pair seem almost to steal glances at each other, were the viewer desiring to see something romantic. The idea of sealing a vow by invoking Mary and John occurs in a prayer cited by Reinburg, in *French Books of Hours*, 222–23; and in a civic document from Burgundy (ca. 1415) reproduced in Fliegel and Jugie, *Art from the Court of Burgundy*, 297–98. A complex literary version of the vowing trope, set romantically, occurs in *Sir Gawain and the Green Knight*: after the seductive Lady Bertilak invokes "alle þe lufez vpon lyue" (line 1786), that is, the love of God, the love of Christ, and so on (see Tolkien and Gordon, eds., *Sir Gawain and the Green Knight*, 121–22), Gawain counters by swearing on Saint John (line 1788). Later in this same scene he will accept the lady's girdle.

42. Fein, "Why Did Absolom Put a 'Trewelove' under His Tongue?"

43. A preaching bird is called, for example, "Fayr foule full of lufe" (line 40), and the Trinity alighting in Mary is termed "thre lufly lefes" joining "a fourte fela" (line 144).

44. There is not space here to detail more of the plausible correspondences between Chaucer's *Shipman's Tale* and *Truelove*. The nature of one's *array* at Doomsday is a subject addressed in the poem. A theme of God's friendship with humanity is developed in its conceit of a truelove knot, the mystic *nodus amicitiae*. If Chaucer knew this poem, the "love-knotte" (*General Prologue*, I 197) of the pilgrim Monk may be an allusion.

SIX

Disfigured Drunkenness in Chaucer, Deschamps, and Medieval Visual Culture

Laura Kendrick

This interdisciplinary chapter will treat humorous and mocking late medieval representations of the disfiguring effects of excessive wine drinking. It will focus not only on verbal depictions in Geoffrey Chaucer's *Canterbury Tales* and the poetry of Eustache Deschamps (especially his *chanson royale* ironically praising the Order of the *Baboe*, a society of officers of the crown who regularly get drunk together), but also on visual representations of apes serving and drinking wine in the margins of religious and secular manuscripts, and on depictions of monkey business (*babewyns* or *bêtises*) on decorated drinking vessels from England, France, and the Low Countries.

Chaucer, son of an importer of French wines, and Deschamps, who had vineyards on his property at Vertus in Champagne, shared the multifaceted material culture of wine, which is prominent in their poetry. Both royal officers also received substantial gifts of wine. Chaucer was granted by Edward III in April 1374 a daily pitcher of wine for life, and by Richard II in December 1397 a tun of wine per year for life. Both the daily pitcher and the yearly tun were probably equivalent to about a gallon a day.[1] As bailiff of the royal domain of Senlis, Deschamps received obligatory jugs of wine (*pots de vin*) and food from the locals during judicial assizes. In a facetious and festive letter of command (dated after midnight on December 24, 1398), Deschamps even went so far as to outlaw the replacement of the "short, pot-bellied jugs of ancient custom" by newfangled ones that contained less wine.[2] On the positive aspects of wine, Deschamps was more explicit than was Chaucer. In numerous ballads, the French courtier displayed his knowledge and appreciation

of different wines, of good or bad wine years, of what wines to drink or abstain from for different health problems.[3] Chaucer, on the other hand, gave wine a powerful and largely positive role when he used it, even if only in fiction, to motivate and "disinhibit" his *Canterbury Tales*, which begin in convivial potations: "Strong was the wyn, and wel to drynke us leste" (*General Prologue*, I 750). Potent wine, served plentifully and drunk eagerly during a supper at a Southwark inn, puts a motley group of pilgrims in the mood to play the storytelling game the innkeeper proposes for their journey to Canterbury. Wine lowers inhibitions, liberates tongues, and even serves to promote social cohesion—up to a point.

Nevertheless, excessive drinking, or engaging in what might be called "binge drinking" in the company of other drinkers, is the object of both Chaucer's and Deschamps's ridicule. Chaucer in his *Canterbury Tales* made fun of plebian fictional characters (the Summoner, the Cook, the Miller) for their drunkenness on ale as well as wine, whereas Deschamps targeted his companions and himself in short ballads and rhymed burlesque letters of an occasional, festive nature, often dated, that he offered as entertaining interludes to the princes he served. In mocking commemoration of their wine-drinking exploits, Deschamps even identified by name nobles and officers of princely households with whom he was familiar. Chaucer's comedy of drunkenness, like the visual monkey business that goes on in the margins of some Gothic manuscripts, occurs chiefly in the "border space" of the *General Prologue* and the linking interludes that offer commentaries on, in epilogues and preludes, the different tales of the compilation of his *Canterbury Tales*, several of which—the *Man of Law's Tale* (II 743–45, 771–77), the *Summoner's Tale* (III 2043–74), the *Pardoner's Tale* (VI 549–88), and the *Tale of Melibee* (VII 1193–94)—sermonize or apostrophize against and offer examples of the evils of drunkenness: how it obliterates wit, reason, discretion, vigilance, and bodily coordination; how it is particularly dangerous in a ruler or lord; and how it is also dangerous in those whom a ruler trusts for counsel and to whom he entrusts his secrets and his business.

Readers of the *Canterbury Tales* are familiar with Chaucer's comedy of drunkenness and with the humorous incongruities and situational ironies involved in voicing a tale that inveighs against drunkenness by a character who is tipsy, such as the Summoner or the Pardoner, or one who receives gifts of wine, such as the Summoner, the Man of Law, or even Chaucer (the man behind the pilgrim teller of *Melibee*).[4] Deschamps's comedy of drunkenness is not as well known as Chaucer's and will consequently be examined at more length here, but with an eye to what they have in common and what they share with visual depictions of drunkenness that turn the drunkard into a sort of *babewyn* or *baboon*,[5] a comic spectacle of debased humanity.

Chaucer's Disfigured Drunks

A brief review of Chaucer's drunken pilgrim speakers is in order. His mockery tends to focus on the distortion of their faces, as in the apostrophe of the Pardoner's sermon

warning against drunkenness, "O dronke man, disfigured is thy face" (*Pardoner's Tale*, VI 551), or the apostrophe the Man of Law addresses to the drunken messenger of his tale:

> O messager, fulfild of dronkenesse,
> Strong is thy breeth, thy lymes faltren ay,
> And thou biwreyest alle secreenesse.
> Thy mynde is lorn, thou janglest as a jay,
> Thy face is turned in a newe array.
> *(Man of Law's Tale, II 771–75)*

The drunkard's mouth is depicted as open, spilling out bad breath and uncontrolled speech or sound. The ale-drunk Miller, who knows he is drunk by his sound (I 3138), has a huge mouth, both literally and figuratively ("His mouth as greet was as a greet forneys. / He was a janglere and a goliardeys"; *General Prologue*, I 559–60). The grotesquely comic mask of his face is completed by a description of his wide, black nostrils and the wart on the tip of his nose bristling with red hairs like those of a sow's ears (I 554–57). The "fire-red" face of the Summoner is due to his diet, and particularly to his love for "strong wyn, reed as blood" (*General Prologue*, I 635). When he is drunk enough, the Summoner cries out like a madman and "parrots" the few Latin legal phrases he knows, making a fool of himself as he imitates erudition:

> Thanne wolde he speke and crie as he were wood.
> And whan that he wel dronken hadde the wyn,
> Thanne wolde he speke no word but Latyn.
> A fewe termes hadde he, two or thre,
> That he had lerned out of som decree—
> No wonder is, he herde it al the day;
> And eek ye knowen wel how that a jay
> Kan clepen "Watte" as wel as kan the pope.
> But whoso koude in oother thyng hym grope,
> Thanne hadde he spent al his philosophie;
> Ay "*Questio quid iuris*" wolde he crie.
> *(General Prologue, I 636–46)*

The huge cake the Summoner carries like a buckler on his ride to Canterbury and the oversized garland he has placed on his head may be perceived as ridiculous acts of aping chivalry and courtly springtime garlanding.[6] The Summoner's red-faced, garlanded head may also recollect that of the ivy-garlanded Bacchus, god of wine, but in a comically incongruous fashion, for the Summoner's garland is compared to an ale stake, the large clump of ivy hung out on a pole to advertise fresh ale for sale.[7]

The Cook, on the other hand, is pale-faced from drunkenness, with dazed eyes and sour breath. The Manciple deliberately focuses attention on the Cook's yawning, reeking, wide-open mouth:

> "See how he ganeth, lo, this dronken wight,
> As though he wolde swolwe us anonright.
> Hoold cloos thy mouth, man, by thy fader kyn!
> The devel of helle sette his foot therin!
> Thy cursed breeth infecte wole us alle."
> (*Manciple's Prologue*, IX 35–39)

He calls the Cook a "stynkyng swyn" (IX 40) just before addressing him with an ironic "sweet Sir," inviting him to joust at the quintain, and surmising aloud that the Cook has had too much "wyn ape" (ape wine) and is in the playful, foolish stage of drunkenness (that is, "ape-drunk"):[8]

> "Now, sweete sire, wol ye justen atte fan?
> Therto me thynketh ye been wel yshape!
> I trowe that ye dronken han wyn ape,
> And that is whan men pleyen with a straw."
> (IX 42–45)

In no condition to play a knightly game of agility, the Cook promptly loses his balance and falls off his horse. This burlesque joust, which Chaucer dubs "a fair chyvachee of a cook" (IX 50), is the incongruous equivalent of images of women jousting or apes and other beasts imitating humans in the visual drolleries of the upside-down world of the margins of thirteenth- and fourteenth-century manuscripts, to which we will return below.[9] In the way the Manciple makes peace with the Cook after baiting him there is situational irony: the Manciple produces the flask of strong red wine he is carrying on pilgrimage and offers the Cook a long drink from it. This gesture, in turn, elicits from the innkeeper Harry Bailly praise of the wine god Bacchus for his power to turn earnest into game and rancor into love (IX 95–101).

Deschamps's Burlesque Drinking Societies and Drinking Bouts

Deschamps invented burlesque or "joyous" confraternities and societies throughout his life, several of them devoted to drinking, such as the Tavern-Goers ("Fréquentans") and

the Befuddled-by-Drink ("Fumeux"). In the role of Emperor and Lord of the Befuddled-by-Drink, Deschamps versified a mock edict defining the foolish behavior of his subjects. This "ordonnance" is dated December 9, 1368.[10] In the role of Sovereign of Tavern-Goers ("souverain des Fréquentans") of his hometown of Vertus, Deschamps addressed another burlesque ordinance to all the tavern-goers of Vertus in order to prescribe the "proper" behavior of the Fréquentans. The first point: by drinking the best and most expensive wine from morning to evening without leaving the tavern and without eating any solid food, the Fréquentans befuddle their brains until they can no longer speak straight, but only mock and laugh (lines 16–28). This document is dated August 1372 and contextualized as being written on the table of the tavern, bare-elbowed, while drinking strong wine: "Donné sur la table, a nus coutes, / En buvant vin de grant liqueur" (lines 258–59).[11]

Deschamps does not present himself as a participant in but rather as a witness to the "noble" drinking bout at Boissy-le-Châtel, which he commemorates, no doubt tongue in cheek, in his ballad beginning "Je vy en chastel de Boissy."[12] The action takes place in the castle rather than the tavern, where, over the course of the ballad's three strophes, the "host" of drinkers, all familiars and officers of the Duke, are named individually, usually by surname or place name of a family holding, beginning with "Monseigneur le duc d'Orliens," "Jehan monseigneur" (de Bar), (Charles d'Albret) "Lebreth," and their men, that is, their chamberlains, squires, and other officers: (Simon) "Louvet," (Nicolas or Colin de) "Bruneval," "Aufemont," (Alain de) "Beaumont," (Aubert le Flament de) "Canny," (Raoul VI de) "Gaucourt," (Jean de) "Garenciere," (Jean de) "Prunelé," and (Jeannet de) "Croisy" (lines 2–26).[13] This company engages in heavy drinking and loud "crying" as they shout for Beaune wine and drink rounds to one another: "I drink to you!"—"I return it!" ("Je boy a toy!"—"Je le retiens!"; line 15).[14] Deschamps likens the drunken company to a bunch of rowdy schoolboys: "The wine made many schoolboys: / There Louvet earned his baccalaureat" ("Le vin fist moult d'estudiens: / La fut Louvet licencié"; lines 5–6). His tongue loosened by wine, Bruneval shouts over and over, like a madman, the same Latin phrase, *sine dubio* (without doubt), which makes no sense in the situation, but serves as an absurd refrain for this nonsensical ballad:

> Bruneval, par force de vin
> Crioit sur tous comme enrragié:
> *Sine dubio*, c'est latin.
> > (lines 8–10)

The drunken Bruneval reminds us of Chaucer's Summoner, who parrots the little Latin he knows when he is in his cups.

The Burlesque Drinking Order of the *Baboe*

In his *chanson royale* beginning "Un ordre sçay de nouvel establie" (I know of a newly founded order), Deschamps celebrates a new chivalric order of "ape-drunk" officers of the crown called the Order of the *Baboe* (a silly-sounding name to which we will return).[15] Here he speaks as an amused witness, not as an inveterate drinker himself (as with his earlier persona of "Jean Fumée"), nor as "Sovereign of Tavern-Goers," nor even as a member of the "noble company" whose drinking rules and rituals he describes. This ritual consists entirely of offering and drinking wine together in rounds, urging one another to greater drinking exploits, thumping and banging, until there is no wine left to drink. Admission to the Order of the *Baboe* required a test of drinking capacity; no one was admitted without drinking "until his heart [was] drowning in wine." The twenty-five members of this exclusive new order named by Deschamps were all career servants of the French royal line and belonged to one or more of the households of Charles V, Charles VI, the Dukes of Burgundy, and Louis, Duke of Orléans. Most were trusted officers who enjoyed close proximity to the princes they served. For example, eight were chamberlains, three were carving squires, and four were, most appropriately, cupbearers.

Although all of the members Deschamps names to the Order of the *Baboe* are laymen, the language he uses to describe the new order recollects monastic orders and also older, monastic models for chivalric orders (such as the Order of Templars and the Order of Hospitallers) and probably also earlier criticism of their decadence.[16] For example, Deschamps calls the Order of the *Baboe* an abbey ("abbaie") and a convent with, at its head, an abbot ("abbez") directing monks ("moines") (lines 11–12). The rules of this order require total commitment to serving and drinking wine, which may burlesque the celebration of the Mass. The place where "service" is done is once called a church ("eglise"; line 19), twice a house ("maison"; lines 29, 55), and twice an "ostel" (lines 39, 49), which can mean a great household, but also a religious hospice or even an inn. Such heavy drinking cures the sick (lines 44–46). Indeed, the cure for the disfigured faces of many members, who have swollen noses and cheeks ("Car maint y ont gros nés et grosse joe"; line 48), is to drink more wine. Many are unwilling to leave the house (line 49), where they martyr themselves "serving" their order (line 55). This service consists entirely of filling and emptying wine vessels, serving and drinking wine. The religious metaphors heighten the mockery of this most drunken "order" of servants of the crown, a secular order that rivals any festive religious one in its devotion to wine.[17]

Deschamps's Order of the *Baboe* would also seem to take its inspiration from goliardic drinkers' masses that burlesqued religious orders. These were Latin liturgical and eucharistic parodies praising wine or Bacchus in place of God and substituting the tavern for the church. Although fragments survive in many manuscripts from the thirteenth through the sixteenth centuries,[18] these drinkers' masses must have known a broad oral transmission

among the clergy and have been used for entertainment on festive occasions that licensed the pouring of profane content into the forms of well-known liturgical songs and prayers. Rather than imitating the form of Latin drinkers' masses for his burlesque celebration of a new order of heavy drinkers and its devotion to wine, Deschamps used the fixed form of the *chanson royale*, a five-stanza ballad with an envoy used for praise of the Virgin Mary and other pious themes, but which Deschamps himself had developed as a vehicle for giving serious advice to princes.[19] Here, however, his praise is lavished on a company devoted to serving wine, and the only advice he offers, in the envoy addressed to "Prince" (lines 51–56), is to enjoy the comic spectacle of the drunken antics—the "genteel speech and witty remarks" and the "parade"—of the members of the Order of the *Baboe* as they leave their meeting place after a bout of drinking together.

The "noble company" of the Order of the *Baboe* also parodies the fashion among European princes for inventing their own chivalric orders with elite insignia, mottos, livery, and idealistic religious aims. The most famous of these, and the one that proved to be the least ephemeral, was the Order of the Garter, founded by Edward III of England in 1349. This was matched by John the Good's Order of the Star ("Ordre de l'Etoile," also called "Ordre de Notre-Dame-de-la-Noble-Maison"), which he founded in 1351 at a Valois manor with a chapel and a large hall, renamed "Noble Maison," in Saint-Ouen, just north of Paris, and which his son, Charles V, in a charter of 1373, left to his son, the future Charles VI, for his pleasure ("pour son esbattement").[20] The craze for founding chivalric orders was at its height in the last half of the fourteenth century.[21]

These chivalric orders displayed insignia associated with material and spiritual power and nobility (Star, Sword, Golden Shield, True Cross, Crown) or with loyalty symbolized by binding or encircling (Scarf, Garter, Knot, Neck Chain, Collar). Not until nearly the last decade of the fourteenth century did the fashion develop for rebuses, so that a humble object such as a broom sprig (*genêt*) evoked a word or phrase that, in turn, evoked the name of a ruling dynasty or a ruler's motto. Around 1394, Duke Louis of Orléans chose the Porcupine (*Porc-Épic*) as the emblem of a chivalric order, up to then represented by more noble creatures, such as the Swan or the Ermine. Logically, the visual emblem of Deschamps's burlesque Order of the *Baboe* would be a *baboe*. But what is the meaning of this alternately lip-stretching and lip-puckering word that Deschamps seems to have invented?

There is no single English translation of *baboe* that conveys the playful senses and sounds of this polysemous word, which is why I leave it in French. In a footnote to his edition of Deschamps's poem, Gaston Raynaud translated *baboe* as "grimace."[22] This accorded with Frédéric Godefroy's first definition of the word, after which he also gave the definition "moue" (a face one makes).[23] This sense is reinforced by Deschamps's use of the phrase "faire la moue" in line 28 of the poem, where one of the members of the Order of the *Baboe* grimaces or pulls a face at another: "Le Barrois fait a Thorigny la moe." Whereas

the insignia of chivalric orders were noble objects, the burlesque order of heavy drinkers called the Order of the *Baboe* may well have had as its insignia a grimacing face. As we saw in reviewing Chaucer's drunkards, the facial distortion of the drunken man was an object of mockery: "O dronke man, disfigured is thy face." A *baboe* might also be imagined as a "baboonish" grimace, for apes grimace with their mouths, and wine was notorious for bringing out apish behavior in men.

Apes and Wine

The association of drunken men with apes and of apes with wine is an ancient Western tradition attested in writing and in images on drinking vessels. On the outside of a drinking bowl dated about 520 B.C. from an Etruscan tomb, five monkey-headed men perform a balancing act on a seesaw: directly over the fulcrum, one man-monkey tries to place in the outstretched arms of another one a very large, two-handled bowl or crater, while another man-monkey just behind him holds up a drinking horn, and yet another loses his balance and falls backward off the seesaw.[24] Immediately preceding a chapter of his miscellany where he listed the drunken rulers and famous wine lovers of history, the third-century Roman rhetorician Aelian treated the subject of apes and wine. He noted that all brute animals avoid wine and drunkenness; however, apes, along with elephants, were believed to be exceptions, making them easy to catch when drunk.[25] Apes in antiquity were viewed as burlesque, ridiculous imitations of men because of their perceived propensity to imitate human gesture and action, always unsuccessfully, and because of their physical resemblance to humans, which made them seem ugly and misshapen by comparison.[26]

Apes continued throughout the Middle Ages to serve as comically distorted mirrors of and burlesque commentaries on men's behaviors and pursuits, such as drinking wine.[27] We have already referred to verbal, textual associations between wine drinking and baboonish behavior, such as Chaucer's "ape-drunk" Cook, whose state of inebriation is playfully attributed to his having imbibed "wyn ape" (an allusion to the inherent qualities of wine resulting from Noah's use of ape's blood to fertilize his grapevine, as related by the *Gesta romanorum*).[28] Apes were associated with excessive wine drinking also in the visual drolleries found in the margins of many surviving manuscripts, next to texts both religious and profane. The association between apes and wine may also be implicit in the *babewyn* decoration of precious cups and vessels for serving and drinking wine. Unfortunately, the vast majority of these gilded silver vessels, not having survived, are known to us now only by the verbal descriptions of medieval inventories.

Let us begin our exploration of the visual association of apes and wine with a selection of images from books. In the margins of fourteenth-century manuscripts illuminated mainly in France and Flanders there are many drolleries that might be labeled "ape wine."

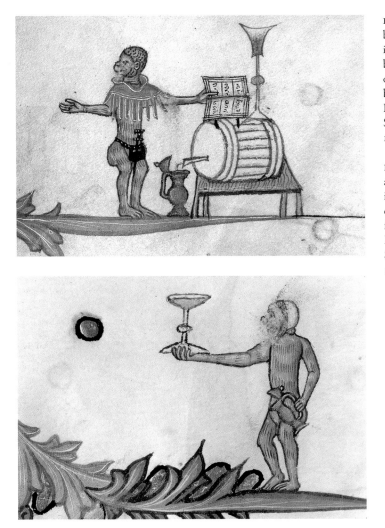

FIG. 6.1 Ape with book drawing wine into flagon from barrel with tall cup on it (detail from bottom margin). Paris, Bibliothèque Sainte-Geneviève MS 143, folio 172r.

FIG. 6.2 Big-nosed ape with flagon offering wide-brimmed cup of wine (detail from bottom margin). Paris, Bibliothèque Sainte-Geneviève MS 143, folio 172v.

Apes draw wine out of a barrel into a flagon, as in a representation of a literate ape wine steward (fig. 6.1) from the Pontifical of Guillaume Durand, probably produced in Avignon between 1357 and 1390 for Pierre de Saint-Martial, who held a series of bishoprics beginning in 1357. On the barrel, standing ready to be offered, along with the full flagon, is a tall, elegant cup or chalice resembling the mid-fourteenth-century King John Cup of King's Lynn in West Norfolk.[29] Apes acting human proliferate in the profane *bas-de-page* drolleries of this Pontifical (a collection of religious prayers and rituals, including the celebration of the Mass).[30] On the verso of this same page, a broad-brimmed, chalice-like cup and flagon are offered to a tonsured ape eating at a table on the other side of the page (fig. 6.2). The ape that performs this service has the swollen-looking nose of a drunkard, which a later hand has smudged and disfigured along with his face.

FIG. 6.3 Apes sitting on table drinking, served by apes bringing large flagon and drawing wine from barrel (detail from bottom margin). Paris, Bibliothèque nationale de France MS fr. 25526, folio 76r.

FIG. 6.4 Apes riding wine barrel, drawing wine into ewers and holding out cup (detail from bottom margin). Oxford, Bodleian Library MS Bodley 264, folio 94v.

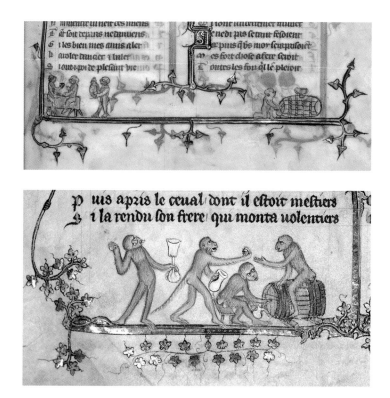

In a mid-fourteenth-century manuscript of the *Roman de la Rose*, a series of *bas-de-page* illuminations shows apes engaged in many human activities, including drawing, serving, and drinking wine (fig. 6.3). In this case, a large bowl with a short foot stands on the wine barrel. In other cases, such as on the lower border of a manuscript of the *Roman d'Alexandre* illuminated by Jehan de Grise between 1338 and 1344, a tailed, whiskered monkey lines up at the wine barrel along with three tailless ones with baboon-like posteriors (fig. 6.4). One ape draws wine from a barrel into an ewer while another holds out a long-stemmed cup. The tailed monkey, next in line to refill its ewer, offers a round object to an ape astride the barrel.

On one page of a mid-fourteenth-century Flemish manuscript of Jacques de Longuyon's *Voeux du Paon* (*Vows of the Peacock*), a seated ape offers a footed, wide-brimmed cup to a horned, bullheaded creature, while a small ewer stands on the table between them (fig. 6.5). On another page, an ape brings a similar chalice-like cup and a flagon to a fantastically long-necked hybrid creature (fig. 6.6).[31] Here we may have a visualized pun: a *babouin* (baboon or ape) makes a gesture linking it to a *babewyn* (fanciful grotesque figure).[32] In the margins of Gothic manuscripts, from the mid-thirteenth to the fifteenth century, a *babewyn* could be a "baboon" engaged in monkey business, aping human behavior, or any burlesque deformation of man or beast.[33]

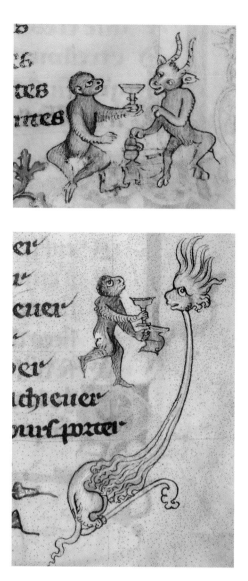

FIG. 6.5 Ape offering cup of wine to horned creature (detail from right margin). New York, Pierpont Morgan Library MS Glazier 24, folio 118r.

FIG. 6.6 Ape offering broad-brimmed cup and flagon of wine to chimerical creature (detail from right margin). New York, Pierpont Morgan Library MS Glazier 24, folio 46r.

Apes as *Babewyns* Decorating Late Medieval Drinking Vessels

Some of the oldest surviving instances of the word *babewyn* describe the figures decorating vessels used for eating and drinking. In a household inventory of Edward II dating from 1324, we learn that he had six gilt cups or bowls ("coupes"), three of them with *babewyns* depicted on the outside ("tailles de hors des babewyns")[34] and three of them enameled with *babewyns* at the bottom of the cup on the inside ("une coupe dorre plein eymelle el founz des babewyns").[35] As the content of the vessel was consumed, and the cup was tipped upside down, the *babewyns* in the bottom would be revealed to the drinker. In addition, Edward II had a gilt ewer decorated with *babewyns* represented in enamel

("garni des esmails taille des babewyns") and a gold-bordered plate with enameled *babe-wyns* in the bottom.[36] The fashion for *babewyn*-covered drinking and serving vessels seems to have lasted in England through at least the 1380s, if we judge from inventories of royal, princely, and ecclesiastical treasuries.

Edward III owned several ewers with *babewyn* decoration: two gilt silver ones were engraved and enameled with *babewyns*,[37] while another three-footed ewer seems to have been shaped like a *babewyn* ("un triper d'un babwyn en guyse d'un eawer"),[38] and yet another ewer is described as having the form of a *babewyn* with a harp ("Item, un babwyn pour un eawer ove une harpe").[39] The register of Duke John of Gaunt records, on April 30, 1372, at the Savoy Hotel, the gift to his sister on her wedding day of a silver ewer, bought from the London goldsmith Nicholas Twyford; this particular ewer was gilt and orna-mented in parts with enamels of "diverses bobunrie" and topped with roses.[40] At this time, dragons and *babewyns* seem to have been the fashion. In a 1372 inventory of Edward III's treasury, we find a matched set of vessels consisting of a gilt silver cup, a ewer, and a pot ("potte"), all enameled with "diverses dragons et babwyns."[41] In 1372 there is also a record of Edward III's gift, to his "loyal knight" William Graunson of Burgundy, of a gilt silver cup enameled with various dragons and *babewyns* ("facez livrer une coupe d'argent susor-rez et eymellez de diverses dragons et baboygnes").[42]

Babewyns and birds were also associated on drinking vessels and other tableware. A sil-ver saltcellar enameled all over with diverse "babewynis & oiselettis" appears in an inventory of 1330 of Edward III's crown jewels.[43] Edward III owned gilded silver cups enameled on the outside with *babewyns*: in one case, a cup was decorated with various *babewyn* fooleries ("diverse babwynrie")[44] and, in another, with both birds and *babewyns* ("des oiseaux et baby-wns").[45] Ecclesiastical officers of the crown could also own such cups; for example, Walter Skirlaw, keeper of the privy seal from 1385 to 1389 and appointee to a series of bishoprics, had a "great silver-gilt cup enameled with babewyns and a knop formed as a bird's nest with three men climbing up to steal the young birds."[46] Among the precious objects once belong-ing to Edward III, Richard II, Queen Anne, and the Duke of Gloucester, which Henry IV had inventoried in 1399, there were five items decorated with *babewyns* or babooneries, two of them also featuring little birds: a small gilded silver ewer with a knob enameled with "babenry,"[47] a tall gilt silver cup enameled with birds that stood on a flat base engraved with "babenry,"[48] another tall gilt silver cup enameled inside and on the inside of its cover with greyhounds and engraved outside with little birds and babooneries ("oysett et babev-enry"),[49] a white earthenware drinking cup ("cruskyn") enameled inside with a *babewyn*,[50] and a pair of gilt silver bottles ("botells") with engravings of "diverses babewynz."[51]

The purpose of inventories was to identify particular precious objects, not only by their weight and materials, but also by their form and decorations or other identifying marks. Although *babewyn* or *babeuenry*, in their various spellings, could serve as generic terms to designate any whimsical composite creation of human and beast or plant (called

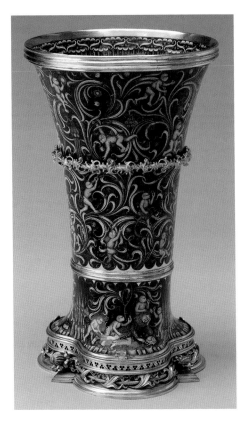

FIG. 6.7 Monkey cup. New York, Metropolitan Museum of Art, Cloisters Collection, 1952.

"hybrids" by art historians today), in many of these English inventories the terms probably refer to humorous scenes of monkey business—that is, of animals, especially apes, imitating men. In the case of the association of apes with little birds, there can be little doubt that *babewyn* means "baboon," for one of the favorite activities of apes was supposed to be trying to catch little birds.[52]

None of these particular *babewyn*-covered vessels seems to have survived, for precious metals were often melted and reused. However, there is one that did: a silver and gold cup thought to be made in the Low Countries for the Burgundian court between 1425 and 1450, which uses a grisaille enamel technique to represent scenes of a peddler or merchant of sundries (articles of clothing and tools) robbed by apes as he naps (fig. 6.7). Because of inventory references to enameled scenes, inside and out, of a *fiera* (fair, farce, market) of apes, this silver beaker, now bereft of its cover, is believed to have been in the collection of Piero de Medici in 1464 and to have belonged, by the end of the sixteenth century, to the Earls of Arundel.[53] It seems probable, however, that the humorous warning of this scene was represented on more than one fancy drinking vessel of the time.[54]

At the bottom of the Metropolitan Museum's virtuoso monkey cup, a band of apes not only takes the sleeping merchant's goods, but removes the very lice from his head and

FIG. 6.8 Apes robbing sleeping peddler. Detail from base of monkey cup. New York, Metropolitan Museum of Art, Cloisters Collection, 1952.

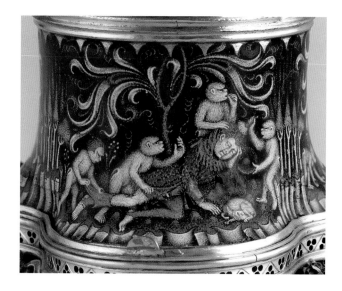

the hose from his legs as he and his little dog doze, completely off their guard (fig. 6.8). While some engage in robbery, others display their booty or inspect or don parts of it, such as belts, gloves, and boots, or make off with these into the flourishing branches of the tree overhead. As one ape peers into an upheld human boot, another holds his nose at the smell of the boot,[55] while an axe-wielding ape grimaces in sticking out its tongue. What, if not drink, has made this merchant so dead to the world, leaving him at the mercy of this band of simian robbers? Perhaps the apes who strip the peddler of his goods and his clothing, or "habit," may also be understood figuratively as a visual allegory of the denuding, dehumanizing effects of drinking too much wine, of allowing the "ape" to take over.

Humorous Humiliations

In the peddler-robbed-by-apes motif depicted on this beautiful early fifteenth-century cup, we may find a moral warning expressed with humor. In contrast, the apostrophe found in the *Man of Law's Tale* condemns drunkenness in no uncertain terms. From the example of the drunken messenger who slept "as a swyn" (II 745) while the private letter he carried was stolen and replaced with a counterfeit, the Man of Law draws the conclusion—fit to chill any lord—that no counsel remains secret in any company where drunkenness prevails: "Ther dronkenesse regneth in any route, / There is no conseil hyd, withouten doute" (II 776–77). Putting a *babewyn*—whether a depiction of monkey business or of a grotesquely composite creature—at the bottom of a cup may have been a playful way of warning against the humiliating, disfiguring effects of drinking too much, especially if the *babewyn* was revealed by the act of imbibing the contents of the cup. The

position of enameled *babewyns* "in fundo," at the bottom of drinking cups and bowls, also bespeaks their "debased" nature. Wherever they are represented, *babewyns* belong at the bottom: at the base of the drinking vessel, at the bottom of the medieval manuscript page, underneath the misericord seat. Objects of curiosity and distorted reflections of human folly, *babewyns* were prized decoration for aristocratic drinking vessels in the fourteenth century, which were used and displayed on festive occasions when wine flowed freely and giddiness and inebriation prevailed. The entertainment value of *babewyns* no doubt exceeded their admonitory value. As we have seen, *babewyn*-ornamented cups were given as gifts by John of Gaunt to his sister on her wedding day and by Edward III to a loyal knight for services rendered. Surely, in such cases, the gift of a *babewyn*-decorated, silver-gilt, enameled drinking cup was intended to please the receiver.

But what of the intention behind the gift of a poem such as Deschamps's *chanson royale* celebrating the Order of the *Baboe*, a burlesque order of mighty drinkers made up of noble officers and servants of the French crown, whom Deschamps called familiarly by their names? In his *Canterbury Tales*, Chaucer ridiculed the drunkenness of fictitious and relatively humble characters who, in turn, made "apes" of one another.[56] Deschamps, on the other hand, burlesqued the drunken antics of noble knights, squires, and officers of the princely households of France, men personally known to him, many of them more highly placed than himself. Deschamps's ridicule, like Chaucer's, often took the form of ironic praise. Yet it is unlikely that the twenty-five men on whom Deschamps chose to confer his Order of the *Baboe* were offended by this "distinction," especially not when it came from a poet who had himself played the roles of Emperor of the Befuddled-by-Drink and Sovereign of Tavern-Goers. Like Chaucer, Deschamps often made fun of himself in his verse, played the fool or the "comedy of myself,"[57] to make his point in an entertaining way. Deschamps did not, however, put himself at the head of such an august "order" of princely officers as that of the *Baboe*; instead, he played the spectator—or even the connoisseur—of the antics of the group of mighty drinkers he convoked. His invitation to "Prince" in the envoy of the poem promised an entertaining spectacle: the drunk and disorderly behavior of this "noble company" as they disbanded after a bout of heavy drinking. Deschamps's tongue was in his cheek when he praised these men for their grand manner, genteel speech, and witty remarks in parting. To amuse, but probably also to encourage more seemly behavior among princely officers, Deschamps made *babewyns* of them and conferred on them his fictitious Order of the *Baboe*.[58]

APPENDIX

Sur l'ordre de la Baboue

 Un ordre sçay de nouvel establie,[59]
 Dont maintes gens se doivent fort loer,
 Et ou l'en doit boire jusqu'a la lie
 Tant qu'es henaps ne doit riens demourer.
5 Et si doit on toudis du pot verser
 Vin es vaisseaulx, l'un l'autre requerir:
 Les requerans y doivent obeir,
 Sanz refuser tout boire, et sanz escroe:
 Ainsi se doit cest ordre maintenir
10 Qui s'appelle l'ordre de la baboe.

 Siffrevast[60] est abbez de l'abbaie;
 De son convent vueil les moines nommer:
 Rocherousse,[61] le Flament[62] ne s'oublie,
 Robert Tesson[63] et Enfernet[64] le ber,
15 De Poquieres[65] le borgne bachelier;
 Pierre vous vueil de la Tremoille[66] offrir,
 Les Bouciquaux[67] qui ce puelent souffrir,
 Harmanville,[68] Regnier Pot,[69] que je loe,
 Car bien se font en l'eglise servir
20 Qui s'appelle l'ordre de la baboe.

 De Jehan Augier[70] convient que je vous die,
 De Saint Germain,[71] Montagu[72] au vis cler,
 Et d'Uguenin[73] a la chiere hardie,
 De Chevenon[74] qui bien se scet huver.
25 Messire Arnoul[75] y scet boire et humer;
 Sempy[76] et Sync[77] s'i scevent contenir:
 Et d'Angenes font la Regnaut[78] venir;
 Le Barrois[79] fait a Thorigny[80] la moe:
 En la maison se scevent bien chevir
30 Qui s'appelle l'ordre de la baboe.

 De ceste ordre qui vient de Normandie
 Ne doy Pierre de la Haie[81] oublier,

Ne Guillaume de l'Aigle,[82] a ceste fie,
Jehan y doit d'Estouteville[83] aler,
35 Robinet doy de Boulongne[84] appeler;
Car puissans est pour l'ordre soustenir
Ou l'en ne doit nul homme retenir,
Se tant ne boit que son cuer en vin noe:
Lors en l'ostel puet moines devenir
40 Qui s'appelle l'ordre de la baboe.

Car, par ma foy, c'est noble compaignie
Ou l'en oit bien tabourer et hurter.
On y sert Dieu du main jusqu'a complie;
Nulz malades n'y puent demourer.
45 L'un a l'autre fait le vin presenter
Tant qu'a boire font touz les poz tarir.
Qui malade est, la se face garir.
Car maint y ont gros nés et grosse joe,
Qui ne scevent de l'ostel departir
50 Qui s'appelle l'ordre de la baboe.

L'envoy

Princes, qui veult rire et soy esjoir,
De biaus parlers et de bons moz oir
Et de chascun la maniere et la roe,
Voise veoir ces gens au departir
De la maison, ou maint sont vray martir,
Qui s'appelle l'ordre de la baboe.

On the Order of the Baboe

I know of a newly founded order,
one that many people should greatly praise,
where one must drink to the dregs,
until nothing remains in the cup,
5 and continually pour wine from the jug
into the drinking vessels, one urging the other,
and they must obey those who urge them,

drink everything without refusal or delay.
Thus must be upheld this order,

10 which is called the Order of the *Baboe*.

Chiffrevast is the abbot of the abbey;
I want to name the monks of his convent:
Rocherousse, the unforgettable Flament,
Robert Tesson and the valiant Enfernet,

15 Poquières, the cross-eyed aspiring knight;
I want to show you Pierre de la Trémoille,
the (two) Boucicauts, who can bear it,
Hermanville, Renier Pot, whom I praise,
because they get served well in the house of worship,

20 which is called the Order of the *Baboe*.

I should tell you about Jean Augier,
Saint-Germain, Montagu with the bright face,
and Huguenin with the bold expression,
Chevenon, who is expert at filling his belly;

25 Sir Arnaud knows how to drink and guzzle there;
Sempy and Sains know how to behave;
and from Angennes they summon Renaud;
Bar pulls a face at Thorigny;
they know how to conduct themselves in the house,

30 which is called the Order of the *Baboe*.

Belonging to this order from Normandy,
Pierre de la Haie must not be forgotten
or Guillaume d'Aigle, this time;
Jean d'Estouteville should go there,

35 and I must summon Robinet de Boulogne,
for his power to support the order,
into which no man should be admitted
unless he drinks until his heart is drowning in wine.
Then he can become a monk in the hospice

40 which is called the Order of the *Baboe*.

For, by my faith, it's a noble company
where one hears loud thumping and banging.

They serve God there from morning to evening.

No man can remain sick there.

45 They offer wine to one another

until they've drunk all the jugs dry.

Whoever is ill gets himself treated there;

for many have swollen noses and swollen cheeks,

who don't know how to leave the hospice,

50 which is called the Order of the *Baboe*.

Envoy

Prince, whoever wants to laugh and amuse himself,

to hear genteel speech and witty remarks,

and the manner and parade of each one,

let him go see these people as they leave

the house, where many are real martyrs,

which is called the Order of the *Baboe*.

NOTES

1. See Crow and Olson, eds., *Chaucer Life-Records*, 112–19, for the documents concerning these gifts, specified as Gascony wine in accounts of 1376–77. Edward III's grant in April 1374 of a pitcher of wine daily to his squire Chaucer is a mark of distinction. The different household offices of English kings in the fourteenth century carried with them daily allowances of wine or ale, the former being more prestigious. Edward II's household and wardrobe ordinances of 1323, for example, defined the different allowances that each category of officer should receive in his chamber in the evening, beginning with the amount of liquids (wine or ale) and continuing with candles, and so forth. The nightly allowances of wine ranged from a "sextier" (about two gallons) to half a pitcher. Among those receiving ale but no wine were the squires of Edward II's chamber and hall, who were allowed a daily gallon of ale. For these ordinances, see Furnivall, ed., *Life-Records*.

2. See Deschamps, *Œuvres complètes*, 8:3–11 (no. 1406). This versified letter commanding the return to ancient customs is presented as a response to the complaints of his staff, especially those "du canivet" (those of the "little knife" used to sharpen quill pens). These scribes, law clerks, valets, and servants have protested against the diminution in quantities of wine (and food) given by the locals to support the bailiff and his staff during the period of assizes in their vicinity. Deschamps defends their common cause and asserts that they eat and drink everything up "for the common profit," without keeping anything in reserve (lines 29–31). He reprimands those who make their presents of wine in containers of reduced capacity due to pedestals (feet) and narrow, "heron-like" necks (lines 79–81), and he orders the use of old-fashioned, pot-bellied jugs that each contain "two gallons, a gallon and a half, or at least a gallon" and the presentation of these jugs in a balanced way, "one in each hand" (lines 84–87). A few lines later, Deschamps generously defines the customary wine ration of his bureaucratic staff as "trois sextiers le jour" (about six gallons a day). He also lists the regional wines it is permissible to offer as gifts, including the wine of his hometown of Vertus (lines 88–95). For some interesting visual examples of medieval wine jugs and pitchers, see Alexandre-Bidon, "Le vaisselier du vin." For a conversion table of old French wine measures, see Henderson, *History of Ancient and Modern Wines*, 386.

3. See Deschamps, *Œuvres complètes*, 7:218–20 (no. 1374), on a bad wine year; and 8:339 (no. 1496, lines 3–15), on wines to avoid to stay in good health. See also Poplin, "Eustache Deschamps et le vignoble," 26–27.

4. Chaucer's denunciations of drunkenness are performed through the mouths of his fictional characters, especially those who do not practice what they preach, such as the Pardoner, who insists on his intent to "drynke licour of the vyne" and his need for "a draughte of moyste and corny ale" to think of a moral tale (VI 452, 315). He then delivers an exemplum-filled sermon that dwells on the evils of drunkenness and, in passing, warns against the highly intoxicating "fumositee" (VI 567) of the Bordeaux or La Rochelle wines adulterated with Spanish white wine and sold in certain London streets. On the authority of the Bible, the Pardoner also condemns giving wine to judicial officials (VI 586–87), perhaps with a nod at those pilgrims who would customarily take gifts in kind (such as wine) while serving at judicial assizes or on peace commissions, such as the Man of Law (I 314) or Chaucer himself, who heard cases as justice of the peace for Kent from 1385 to 1389, at a time when there was not yet any evidence of official remuneration for this (Crow and Olson, eds., *Chaucer Life-Records*, 356). More obviously, the Pardoner's reprimand points to the Summoner, a very lowly judicial officer, who turns customary *pots de vin* into bribes and allows men to keep their concubines and escape judgment in the bishop's court for a mere quart of wine once a year (I 649–51).

5. In this chapter, the term *baboon* will designate any type of ape or monkey, as it did in medieval Europe.

6. See the leafy garlands of the aristocratic figures in the Maying party represented around 1415 in the *Très Riches Heures du Duc de Berry* (Chantilly, Musée Condé MS 65, fol. 5v).

7. "A gerland hadde he set upon his heed, / As greet as it were for an ale-stake. / A bokeleer hadde he maad hym of a cake" (*General Prologue*, I 666–68). On the Summoner as a Bacchus figure, see Bowden, *Commentary*, 256.

8. Tale 159, on the invention of vineyards, in the late thirteenth- or early fourteenth-century *Gesta romanorum*, is one source of the association of different types or stages of drunkenness with four animals (lion, lamb, pig, ape) whose blood Noah used to fertilize his grapevine; drinking

wine could thus produce in man the behavior of an ape: "idle curiosity and foolish joy." See Swan and Hooper, eds., *Gesta romanorum*, 305–6. See also Janson, *Apes and Ape Lore*, 244.

9. Various types of burlesque jousts are indexed by Randall in *Images in the Margins*, 58, where she lists many examples of the activities and antics of apes, but only two of apes serving wine (compare my figs. 6.4, 6.6). For color reproductions of a variety of marginal drolleries, see Nishimura, *Images in the Margins*. See also Camille, *Image on the Edge*.

10. Deschamps, *Œuvres complètes*, 7:312–20 (no. 1398).

11. Ibid., 7:323–31 (no. 1400). Deschamps continued throughout his life to produce burlesques in which he himself played a leading role. For example, in a versified announcement dated October 16–17, 1400, written in the role of "Prince of high eloquence and copious speech" ("Le prince de haulte eloquence / Et de parler en habondance"), Deschamps convoked Francophones to an assembly ("parlement") for the purpose of telling new stories ("nouvelles") every May 3 or 4 at Epernay (7:347–60 [no. 1404, lines 1–2, 8]). In a variant of this convocation, spoken once again in the role of "Lord of high eloquence," Deschamps summoned laymen and clergymen alike to a yearly assembly in May at Lens in Artois to show their mastery of the narrative art of eloquent lying: "To give account of their tall tales" ("Pour compte de ses bourdes rendre") (7:361–62 [no. 1405, lines 10, 20, 30, 36]). As in the lyric poetry competitions of the late medieval *puys*, the winner of this tale-telling contest was to be crowned.

12. Ibid., 7:120–21 (no. 1343). Deschamps's role, as he himself described it in his ballad no. 1125 (6:42–43), was to search out, celebrate, and keep a written record of the deeds of Charles V, Charles VI, Louis of Orléans, and their officers.

13. For these identifications, see Raynaud's index of proper names in ibid., vol. 10.

14. Elsewhere, Deschamps identifies as a Norman custom the drinking of rounds to each person in the company: "Boire a chascun, comme font les Normans" (ibid., 6:190 [no. 1203, line 17]).

15. See the appendix to this article for the entire *chanson royale*, which Raynaud titled "Sur l'ordre de la *Baboue*" (ibid., 5:134–36 [no. 927]), as well as my English translation of it.

16. His audience would surely have heard of the dissolution in 1312 of the Order of the Templars by the "French" Pope Clement V.

17. Deschamps's Order of the *Baboe* seems to have inspired an anonymous poem celebrating wine, food, and sex, beginning "Nous sommes de l'Ordre de Saint-Babouin" (We are of the Order of Saint Baboon), which was set to music by Loyset Compère at the end of the fifteenth century. See Jeffrey, ed., *Chanson Verse*, 1:122. In the songbook manuscript Chantilly, Musée Condé 564, there are also two songs with lyrics sung by a befuddled ("fumeux") persona. These lyrics, one beginning "Puisque je suis fumeux plain de fumé" and the other "Fumeux fume par fumé," would seem to have emanated from the same joyous society as Deschamps's "Charte des Fumeux." From this, Poirion deduced that "the confraternity [of the Befuddled-by-Drink] was not as imaginary as has been supposed" (*Le Poète et le Prince*, 223).

18. Bayless edits and translates several of these drinkers' masses (*Parody in the Middle Ages*, 338–62).

19. Deschamps wrote 138 surviving *chansons royales*, a form whose origin lay in the festive poetry competitions of bourgeois religious associations or confraternities called *puys*, generally devoted to Our Lady and presided over by an elected "Prince." See Deschamps's comments on this form in his treatise on French versification written in 1396, the *Art de dictier* (*Œuvres complètes*, 7:266–92, at 271, 278). For statistical analysis of the prosody and themes of Deschamps's *chansons royales*, see Bliggenstorfer, *Eustache Deschamps*, 181–89.

20. On the founding of these two orders, see Renouard, "L'ordre de la Jarretière et l'Ordre de l'Etoile." See also Pannier, *La Noble-Maison de Saint-Ouen*, 151.

21. In addition to the trend-setting orders of the Garter and the Star, the following orders were founded: by 1353, King Louis of Naples's Order of the Holy Ghost or of the Knot; by 1359, the King of Cyprus's Order of the Sword; by 1364, the Count of Savoy's Order of the Neck Chain; by 1366, the Duke of Bourbon's Order of the Golden Shield; by 1375, the Duke of Anjou's Order of the True Cross; by 1379, Enguerran, Lord of Coucy's Order of the Crown (celebrated by Deschamps in his roundel no. 656 and ballad no. 212 [*Œuvres complètes*, 2:35–36, 4:115]); by 1381, Duke John of Britanny's Order of the

Ermine and King Charles of Naples's Order of the Ship; by 1382, King Charles VI's Order of the Winged Stag ("Cerf Volant"); and, by 1387, his Order of the Broom Sprig ("Cosse de Genêt"). By 1394, Charles's brother, Duke Louis of Orléans, had created his Order of the Porcupine ("Porc-Épic"), also called the Chainmail Neck Guard ("Camail") because the porcupine insignia dangled from a golden chainmail neck covering. See Paviot, "Ordres, devises, sociétés chevaleresques," 273–74.

22. Deschamps, *Œuvres complètes*, 5:134. Still with reference to the Order of the *Baboe*, Raynaud defined *baboe* in the glossary as "joue enflée" (swollen cheek) and as a "name given to a society of heavy drinkers" (ibid., 10:12).

23. Godefroy, *Dictionnaire de l'ancienne langue française*, 1:544–45. Godefroy also lists the noun *babuse*, defined as a foolish or stupid jest or mockery; his examples are all plurals, even the earliest, which occurs in 1342 in Guillaume de Machaut's *Dit du Lyon*: "tant de ruses, tant de fatras, tant de babuses." Deschamps's *baboe* could possibly be a back-formation from *babuses*. The online *Dictionnaire du moyen français* (*DMF*) suggests that *babo(u)e* derives from the root *bab*, meaning "lip." However, the *DMF* lists no earlier attestation of *baboe* in French than Deschamps's late fourteenth-century phrase "ordre de la baboe," which it defines, as Raynaud does, as a society of drinkers. There are only two other medieval examples of *baboe* cited in the *DMF*, both considerably later than Deschamps's usage. In the *sottie* (fools' play) of the *Menus propos*, published in 1461, the word describes a person's face: "Tu portes aussi bien la mine / Qu'onques fist riens d'une baboe." The modern editor of these lines understood *baboe* as baboon, and the expression as the grimace of an ape: "Tu as autant que chose du monde la mine d'un babouin, d'un singe" (For all the world, you have the facial expression of a baboon, a monkey). Although the *DMF* cites this translation, it concludes that the *baboe* alluded to in the *Menus propos* is "an old witch with thick lips" ("vieille sorcière aux grosses lèvres"). The third definition the *DMF* gives for *babo(u)e* is "grimace," with an example drawn from the fifteenth-century Burgundian passion play of Semur, where it refers to Satan grimacing at humans: "You made quite a grimace at us" ("Tu nous as bien faicte la baboe"). In 1552, Rabelais used the expression *faire la babou* in his

narrative of the exploits of Pantagruel and his company of heavy drinkers on a voyage, in ships with figures of various kinds of wine vessels fixed high on their sterns, in search of the oracle of the divine Bottle. Immediately before evoking the "dive Bouteille," Panurge makes a derisive grimace at a companion: "Panurge luy feist la babou, en signe de derision" (Rabelais, *Quart livre*, 497). See also the highly suggestive, albeit later, forms and definitions given by Cotgrave in *Dictionarie of the French and English Tongues*: *babiner* ("to play with the lips; to prattle"), *babion* or *baboin* ("baboon"), *babou* or *faire la babou* ("to bob, or, to make a mow at"), *babouinner* ("to baboonize it; to play the Monkey; to use apish or foolish tricks"), and *babouleur* ("a babler; a reporter of trifles, a teller of lies").

24. This bowl is displayed in Rome in the Villa Giulia Museum, inventory no. 64224. For a photographic reproduction, see Lissarrague, "L'homme, le singe et le satyre," figure 9. On the opposite side of the same drinking bowl, three goats dance on their hind legs to the music of Pan's pipes played by a satyr.

25. Aelianus, *Aelian*, 111 (bk. 2, chap. 40).

26. See Lissarrague, "L'homme, le singe et le satyre," 458. On the laughable ugliness of apes and on apes as a source of humor in antiquity, see McDermott, *Ape in Antiquity*, 109–47. See also 278–80 (no. 478), on a wall painting from Pompeii that burlesques the heroism of Aeneas by representing him and his family as dog-headed baboons with human bodies. As Aeneas flees Troy with his aged father on his back and his son in hand, his predicament recollects that of the ape mother of antique fable (and medieval bestiary tradition), who flees her pursuers with one child on her back and another in her arms.

27. In England, mice were also associated with drunkenness. The expression "dronke[n] as a mous" appears twice in the *Canterbury Tales* (*Knight's Tale*, I 1261; *Wife of Bath's Prologue*, III 246). Visual representations of mice drinking, however, seem to be rare.

28. Swan and Hooper, eds., *Gesta romanorum*, 305–6.

29. For a color reproduction of the King John Cup with its cover, made around 1340, see Alexander and Binski, eds., *Age of Chivalry*, 435–46 (fig. 541).

30. The entire manuscript of the Pontifical of Guillaume Durand is available in color at

http://www.calames.abes.fr/pub/#details?id=BSGA10201 or through the central website of the *Bibliothèque virtuelle des manuscrits médiévaux*.

31. On folio 123v of the same manuscript, an ape in the left margin gets ready to defecate into a chalice-like cup on the page below him, while a chimerical creature below this cup opens its long beak in expectation; a hundred folios earlier, on folio 23v, an ape in the left margin defecates directly into the open mouth of a hybrid monster right below him. On the marginal images of this manuscript, see Leo, *Images, Texts and Marginalia*, 90–92 (for apes). Leo suggests that the marginal image of the ape offering a cup to a horned creature on folio 118r (see my fig. 6.5) could be an illustration of the proverb "He who sups with the devil needs a long spoon" (103). Given the preceding and following marginal images of apes defecating into fancy cups, it seems more probable that the horned creature that accepts "ape wine" participates in a practical joke or *bêtise*.

32. In Anglo-Norman texts from the first quarter of the fourteenth century, we encounter the spelling *babewyn* (with variants *babewene, babeweine, babiene, baboen, baboin, babwin, babwine*). From mid-century on, we encounter in Middle English the same spelling: *babewyn* (with variants *babewynn, babewyne, babwene, babewene, babiwyn, baboyn, babewei, babway, babau*). Despite the many differences of spelling, it is clear that we are dealing with the same word that Deschamps spelled *babouin* (*Œuvres complètes*, 8:202 [no. 1489, line 27]). Only when *babewyn* appears alongside a series of other apes, as in the context of *Mandeville's Travels*, have dictionary makers assigned it the meaning of "baboon" (meaning any sort of ape). Otherwise, in all contexts, a meaning suggesting grotesque deformation is preferred: "a grotesque figure" (*Anglo-Norman Dictionary*) or "a grotesque decorative animal figure; a gargoyle" (*Middle English Dictionary*).

33. Baltrušaitis, *Réveils et prodigies*, 197, makes this connection: "En Angleterre, un nom spécial 'babewyn', littéralement 'babouin'—un singe d'Afrique—qui, en français devient le synonyme d'un grotesque et même d'un enfant folâtre, turbulent, est employé pour une catégorie de ces caprices dès le XIVe siècle" (In England, a special name, "babewyn," literally "baboon"—a monkey from Africa—which became the synonym in French for a grotesque or even for a frolicsome,

turbulent child, was used as a category of such caprices as early as the fourteenth century). A fourteenth-century Latin sermon collection surviving in fifteenth-century manuscripts, the *Fasciculus morum*, puts the emphasis on caprice by defining *babeweis* (or *babaues*) as composite forms combining, for example, the face of a man and the body of a lion (*Middle English Dictionary*).

34. Palgrave, *Antient Kalendars*, 3:125.

35. Ibid., 3:127.

36. Ibid., 3:130, 133.

37. Ibid., 3:177, 178.

38. Ibid., 3:263–64. On the many surviving antique vases shaped like apes, see McDermott, *Ape in Antiquity*, 249–73 (nos. 353–71).

39. Palgrave, *Antient Kalendars*, 3:263.

40. Armitage-Smith, ed., *John of Gaunt's Register*, 2:108: "et une eauer d'argent et surorrez et par parties enaymellez de diverses bobunrie ove cestes de roses coronez, achatez de Nicolas Twyford, queux nous donaismes a nostre tres amee soer le jour de son mariage." Nicolas Twyford, from whom John of Gaunt bought this silver and gilt ewer enameled with various *babewyns*, was a London goldsmith, sheriff of London in 1377 when Nicholas Brembre was mayor. This association suggests that *babewyn*-decorated vessels were locally produced.

41. Palgrave, *Antient Kalendars*, 3:273.

42. Ibid., 3:274. This is the same William Graunson who was, like Chaucer, ransomed by the king in 1360. See Crow and Olson, eds., *Chaucer Life-Records*, 24–25.

43. See Ord, "Inventory of Crown Jewels," 247.

44. Palgrave, *Antient Kalendars*, 3:264.

45. Ibid., 3:265.

46. See Evans, *English Art*, 44.

47. Palgrave, *Antient Kalendars*, 3:317.

48. Ibid., 3:318.

49. Ibid.

50. Ibid., 3:319.

51. Ibid., 3:325–26.

52. In the marginal drolleries of Gothic psalters of the same period, apes are represented more often than any other animal, and they are usually engaged in imitating human actions. One of the activities in which apes engage is catching birds. We see them aping human hunters to reach a bird's nest by climbing a ladder in a tiny, monkey-rich psalter probably made in Ghent in the 1330s, now Oxford, Bodleian Library MS Douce 6 (fol.

99v). There is a reproduction in color of this page in Wirth, *Les Marges à drôleries*, 318 (fig. 4.6.5). Wirth calculates that thirty-six of sixty-four scenes of bird catching in the manuscripts he analyzed depict apes as the hunters.

53. See Young, "Monkeys and the Peddler," 447. For numerous views of this beaker and further information on its provenance, see *Beaker with Apes* (accession no. 52.50) on the Metropolitan Museum of Art website.

54. The story of the sleeping peddler robbed by apes was apparently well known by the middle of the fourteenth century, when it was also depicted in several other media such as illuminated manuscripts, wall paintings, and misericord carvings. For example, there is a sequence of episodes depicting the story in the lower margins of the Smithfield Decretals, folios 149r–151r, a manuscript illuminated in London in the 1340s. See the *bas-de-page* illuminations from this manuscript, several of which include apes, at *British Library Digitised Manuscripts*, s.v. "Royal MS 10 E IV." See also Friedman, "Peddler-Robbed-by-Apes Topos," 91–93.

55. The nose-holding ape's olfactory rejection of the human boot is an interesting reversal of bestiary tradition, which alleges that apes can be caught by enticing them to put on human footwear. Such scenes were often illustrated in fourteenth-century manuscripts of Richard de Fournival's *Bestiaire d'amour*. For example, in a vignette in Paris, Bibliothèque nationale de France MS fr. 1951, folio 8v (online at *Gallica: Digital Library of the National Library of France*), a man puts on and takes off his boots ("chauces") and leaves them behind, while an ape watches from a tree. The ape then climbs down, imitates the man by pulling on the boots, and, no longer able to escape, gets caught by the hunter.

56. "He made the person and the peple his apes" (*General Prologue*, I 706); "And thus she maketh Absolon hire ape" (*Miller's Tale*, I 3389); "Right as hym liste, the preest he made his ape!" (*Canon's Yeoman's Tale*, VIII 1313). The expression "to make his (or her) ape" always rhymes with "jape" (joke) in the *Canterbury Tales* and is used in situations foreshadowing a fairly brutal sort of humiliation, especially butt kissing or bending over and leaving the buttocks exposed, as apes often did in marginal drolleries.

57. The expression "la comédie du Moi" is from Poirion, *Le Poète et le prince*, 232. See also

Roccati, "Sur quelques textes d'Eustache Deschamps," 289–90.

58. In another ballad Deschamps makes grotesque, but in this case anonymous, *babewyns* of his fellow courtiers by zooming in on the details of their chewing mouths at dinner, describing their facial contortions or "grimaces" as they eat, and imagining them as different beasts (*Œuvres complètes*, 5:15–16 [no. 844]). On Deschamps's technique for perceiving people as *babewyns*, see Kendrick, "Humor in Perspective," 149–52.

59. Deschamps, *Œuvres complètes*, 5:134–36 (no. 927). The title is Raynaud's invention.

60. Jean de Chiffrevast, squire of Charles V, chamberlain of the Duke of Burgundy, Jean sans Peur. For more complete details on this person and others, see Raynaud's index of personal names and place names in *Œuvres complètes*, vol. 10, as well as the online database of *Opération Charles VI*.

61. Pierre de la Rocherousse, chamberlain of the Duke of Burgundy.

62. Jean le Flament, treasurer of the king's wars; counselor and financial officer of the Duke of Orléans.

63. Robert Tesson, lord of the castle of Bayeux as of 1383.

64. Guillaume d'Enfernet, treasurer of the king's wars, responsible for taxes from Rouen.

65. Jean de Poquières, cupbearer of the Duke of Burgundy; squire and chamberlain of the duke.

66. Pierre de la Trémoille, chamberlain and counselor of the Duke of Burgundy and of Charles VI of France.

67. Boucicaut was the assumed name of Geoffroi le Meingre, a knight killed at Agincourt, and his more famous brother, Jean le Meingre the younger, chamberlain to Charles VI and marshal of France, founder in 1400 of the chivalric order of the "Dame Blanche à l'escu vert" (White Lady of the Green Shield).

68. Guillaume d'Hermanville, squire of Charles VI.

69. Renier Pot, knight and chamberlain of the Duke of Orléans and later of the Duke of Burgundy.

70. Jean Augier, counselor to Charles VI and financial officer of the Duke of Burgundy.

71. Guillaume de Saint-Germain, royal counselor and prosecutor for the king in Parliament.

72. Jean de Montagu, treasurer of France, grand master of the household of Charles VI.

73. Huguenin de Guisay, squire to Charles VI, royal cupbearer, badly burned in the masquerade of the wild men in 1393. It could be that the first name Huguenin should accompany "de Chevenon" of the following line; if so, this would be the only case in which two lines are devoted to naming one person.

74. Huguenin de Chevenon, squire, carver in Charles VI's household.

75. Arnaud de Corbie, president of the Parliament of Paris, concierge of the palace, chancellor of France.

76. Jean de Sempy, cupbearer to Charles VI in 1383; chamberlain to the Duke of Burgundy.

77. Jean de Sains, master; notary to Charles VI in 1389.

78. Renaud d'Angennes, chief carving squire and counselor to Charles VI; captain of the castle of the Louvre.

79. Henri de Bar, Duke of Bar, childhood companion of Charles VI and his brother Louis.

80. Hervé de Mauny, lord of Thorigny, chamberlain to Charles VI and to Duke Louis of Orléans.

81. Pierre de la Haie, carving squire of the Duke of Burgundy.

82. Guillaume de l'Aigle, chamberlain of the Duke of Burgundy.

83. Jean d'Estouteville, chamberlain of Charles VI and principle cupbearer, captain of Harfleur.

84. Robinet de Boulogne, or Robinet le Tirant de Boulogne, carving squire for Charles V and Charles VI, captain of Reims.

SEVEN

The *Franklin's Tale* and the Sister Arts

Jessica Brantley

Wendy Steiner's influential book *The Colors of Rhetoric* concerns (as her subtitle has it) "problems in the relation between modern literature and painting." Yet her work takes as its point of departure an allusion to medieval literature, in an epigraph drawn from Chaucer's *Franklin's Prologue*.[1] As he prepares to tell his tale, the Franklin insists:

> Colours ne knowe I none, withouten drede,
> But swiche colours as growen in the mede,
> Or elles swiche as men dye or peynte.
> Colours of rethoryk been to me queynte;
> My spirit feeleth noght of swich mateere.
>
> (V 723–27)

This citation not only provides Steiner with her title; it also grounds her work on the modern arts in medieval ideas about the ways in which words and images work together—and also the ways in which they do not. Chaucer's Franklin presumes a fundamental contrast between poetry and painting, between the rhetorical figures he claims he does not know and the visible colors of dye or paint that he does. In making this distinction, Steiner argues, the Franklin "shows the importance of the painting-literature comparison to the issue of artistic truth-telling,"[2] for the tale that follows—which, of course, despite all disclaimers, turns out to be rhetorically ornamented—explores the relation of marital promises (that is, words) and miraculous spectacles (that is, images) to realities. Chaucer's

Franklin provides "a prophetic figure" for Steiner's explanation of why the painting-poetry comparison has been so persistent, which she describes as "the desire of Western art to incorporate life and presence into the work."[3] Despite the temporal distance between Steiner's modernist subjects and Chaucer, her framing gesture acknowledges that the Middle Ages offer a particular and yet lasting version of how texts and images encounter each other.[4] As Steiner might put it, in medieval culture, the interartistic comparison is not "a matter of fashion" but "a matter of philosophy."[5]

But what is that philosophy? The balance of Steiner's book concerns a period very far from the medieval, and her understanding of images owes much to post-Renaissance ideals of mimesis. Studies of the painting-poetry comparison over the *longue durée* typically cite the Middle Ages as an era apart—if they mention it at all—and then proceed to tell a putatively universal story grounded in classical and neoclassical theorizations.[6] Moving seamlessly from Greek and Roman art theory to its Renaissance "rebirth," histories of the sister arts recognize implicitly that postmedieval explorations of the topic do not readily apply to medieval ways of thinking, nor to medieval ways of seeing. But Steiner's initial allusion to Chaucer raises a set of urgent questions that require making sense of this piece of medieval aesthetic history: What is the contemporary philosophy of visual and verbal representation that organizes the explicit interartistic comparison of the *Franklin's Tale*? How do medieval theories of representation account for the workings of texts, the workings of images, and—most of all—the interest and power of combining the two?

These questions prompt a reconsideration of "the desire of Western art to incorporate life and presence in the work." In her study of modernism, Steiner claims that all interartistic combinations seek lively resemblance: verbal art forms, which represent their subjects by convention rather than similitude, turn repeatedly to the more iconic visual arts for help in reaching this goal, while the visual arts, which without language are "dumb," look to textuality for ways of speaking. Indeed, in describing the lists that Theseus constructs in the *Knight's Tale*, Chaucer himself offers praise of the painter's colors as opulent and his technique as realistic:

> Wel koude he peynten *lifly* that it wroghte;
> With many a floryn he the hewes boghte.
> (I 2087–88; emphasis added)

In Steiner's reading, the Franklin's apologia similarly coordinates both poetry and painting with the idea of the "lively," through three of the analytical terms most significant to this debate—painting, rhetoric, and nature. Because the Franklin groups together "colours" of the meadow and paint box, Steiner understands him to endorse a presumed equivalence between the visual arts and natural reality, and his anxiety about associating this iconicity with poetry could reveal his desire for all of the arts to imitate life as closely as they can.

In interpreting the Franklin's association of the sister arts this way, Steiner gestures toward a long history of theorizing about the relation of painting and poetry. Literary pictorialism from the fifteenth to the eighteenth century depended on the ubiquitous embrace of two maxims from the ancient world: Horace's famous equivalence, "Ut pictura poesis" (As is painting, so is poetry), and Plutarch's observation, attributed to Simonides of Ceos, that "Painting is mute poetry, and poetry a speaking picture."[7] Following these powerful axioms, critical commentary on the interartistic comparison has often asserted direct parallels between the arts, either through local analogies between a piece of art and a piece of writing, or through large generalizations about the course of aesthetic history based on parallel developments in two or more art forms.[8] Whether local or general, studies in this tradition presume that words and pictures are necessarily up to the same thing. But if the Horatian correlation is absolute, inherent in Plutarch's formulation are also notes of conflict between the arts: if painting is poetry, is it nonetheless "mute"? Another widespread tradition of thinking comparatively about the arts depends on explicitly outlining their differences and arguing for the primacy of one or another: the *paragone* between poetry and painting, most explicitly conducted in the Renaissance by such figures as Leonardo da Vinci, and taken up by William Shakespeare in *Timon of Athens*.[9] Leonardo's passionate celebration of painting relies on a distinction that is also widespread elsewhere—the idea that words and pictures are separated by the "illusion of the natural sign," in Murray Krieger's phrase. That is, they are separated by the assumption that visual signs resemble their objects in an iconic fashion, whereas verbal art is arbitrary, and merely conventional, in its reference. Reacting most famously against the excesses of pictorialism in the mid-eighteenth century, Gotthold Ephraim Lessing sought to separate the visual and verbal arts along another axis of nature and convention. Seeking to identify what is a more "natural" mode for each art, Lessing made a division between spatial and temporal concerns: whereas the visual arts occupy space, and can be apprehended in an instant, verbal arts occupy time and require a while for their unfolding.[10] From this perspective, literature properly has nothing to do with spatial form, and visual art nothing to do with temporal progression. Critics such as Lessing sometimes claim to be differentiating, without hierarchizing, the arts, but even apart from the *paragone*, the interartistic comparison has often served ideological and political ends. Characterizing disputes such as these as the essential history of relations between the sister arts, W. J. T. Mitchell has shown how ideology drives the illusory preference for one or the other, and even creates the very idea of their difference.[11]

It is difficult to summarize this complicated intellectual history adequately in so brief a space. But, even so, it is clear that the history of the medieval arts and even, I think, the details of the *Franklin's Prologue* trouble the generality of these long-standing tropes of interartistic comparison. As naturalism was not a particular goal of medieval aesthetics, medieval theorists were less concerned with the relative iconicity of picture and word,

or with using the conjunction of the two to create the illusion of the natural sign.[12] As often as one finds the assertion that the arts should be naturalistic, one finds the recognition that they are not. As Isidore of Seville writes, in a well-known passage:

> A picture is an image representing the appearance of some object, which, when viewed, leads the mind to remember. It is called picture (*pictura*) as if the word were *fictura*, for it is a made-up (*fictus*) image, and not the truth. Hence also the term painted (*fucatus*), that is, daubed with some artificial color and possessing no credibility or truth. Thus some pictures go beyond the substance of truth in their attention to color, and in their efforts to increase credibility move into falsehood, just as someone who paints a three-headed Chimera, or a Scylla as human in the upper half and girded with dogs' heads below.[13]

Whereas Chaucer's Franklin seems to ally painted colors with the truthful colors of nature, Isidore aligns them directly with the lying fictions of the poets. Some pictures are fictional precisely because of their attention to "colors" that are artificial. Others shade into falsehood by the famously unmimetic and particularly unnatural image of conjoining three heads on one body, or human heads with dogs'.

Isidore's concern with the particular falseness of hybrid structures is intensified in Bernard of Clairvaux's equally well-known letter to William of Saint Thierry. Although allowing for the utility of art in churches, he remonstrates against some kinds of imagery found in monastic settings:

> But in the cloister, under the eyes of the Brethren who read there, what profit is there in those ridiculous monsters, in that marvellous and deformed comeliness, that comely deformity? To what purpose are those unclean apes, those fierce lions, those monstrous centaurs, those half-men, those striped tigers, those fighting knights, those hunters winding their horns? Many bodies are there seen under one head, or again, many heads to a single body. Here is a four-footed beast with a serpent's tail: there, a fish with a beast's head. Here again the forepart of a horse trails half a goat behind it, or a horned beast bears the hinder quarters of a horse. In short, so many and so marvellous are the varieties of divers shapes on every hand, that we are more tempted to read in the marble than in our books, and to spend the whole day in wonder at these things, rather than in meditating the law of God.[14]

Bernard's concern is in part simply the incursion of the secular world into the cloister ("those fierce lions" and "those fighting knights"). The primary force of his anger, though, is turned against the hybrid images that seem to him "ridiculous," "marvellous," and "deformed"—that is to say, unnatural. Moreover, the saint objects to the interartistic

use of these artificial images: in their "comely deformity" they tempt us to read them in a textual mode that should be reserved for written language. Bernard's invective here has been taken to suggest that he sought natural liveliness in artistic images, or that he aimed to keep the arts separate, but the implications are more complex than they might appear: he also called himself "a sort of chimera" of his age, for example, adopting a mixed corporeal form in metaphor as his own.[15] Moreover, the very intensity of his words reveals that he was arguing against the strongly held opinions of many others: in this historical case, as in so many, vehement prohibitions serve as the best confirmation of what was actually done. We can interpret this famous passage as strong evidence of medieval artists' combining visual objects with textual practices in the service of goals that, as their critics complain, are far removed from any natural resemblance or mimetic liveliness.

Medieval thinkers were not terribly interested in theorizing the relation of poetry and painting, or verbal arts and visual ones, as the only two "sister arts." Instead, they more often compared literature explicitly to architecture, or to music—a wholly temporal and uniconic form.[16] And if postmedieval comparisons between the arts fail to illuminate the painting and poetry of the Middle Ages, the theoretical questions sustaining the distinctions between the arts prove equally irrelevant. The division between the arts so anxiously cited in the theoretical texts of the Renaissance and afterward is difficult to find in the practices of medieval artists.[17] Rather, the medieval imagetext is characterized by the exuberant combination of pictures and words. From the point of view of the Middle Ages, the more interesting question is not how similar painting is to poetry, nor even how to characterize properly their relation, but why the practice of creating composite imagetexts is so persistent. Unlike neoclassical students of the verbal and visual arts, medieval poets and artists routinely made use of the conjunction in practice. As Jean Hagstrum has explained, "Medieval thought, though in theory indifferent to drawing the analogy between painting and poetry, was able to create conditions that favor the development and sophistication of the verbal icon."[18] If theorizing clarifies the distinctions and differences between the visual and the verbal, creating intermedial objects necessarily brings them closer together. But, ironically, the physical closeness of text and image in the Middle Ages does not always imply their equality, nor their interchangeability. The materiality of the medieval artifact is important not in its natural or bodily resemblance to its subject, but in its intricate artificiality. Far from aspiring to natural resemblance, medieval text-and-image combinations often work to emphasize the artificiality of each sign system and to articulate the distance that lies between them.

Medieval artists took up the dictum of Simonides to make their pictures speak, but not to make them lifelike. Rather, illuminated manuscripts, or visionary poems, often provide the medieval artist or writer with a way of expressing the ineffable. Such artifacts become powerful not because they resemble the natural world, but precisely because they do not. As we will see, the combination of words with pictures reaches beyond the

natural toward the supernatural, making medieval pictorialism, even in its secular guises, more sacramental than classical.[19] Together, the two media explore the extremities of representation, gesturing toward a plenitude of experience that, whatever the subject, can best be approached through a combination of forms.[20] Whether we conceive of it as enchantment, charisma, *varietas*, magnificence, or the sublime, historians of medieval aesthetics have recently been exploring similar effects throughout the artistic productions of the period.[21] Medieval imagetexts prioritize function through formal means, emphasizing the posture of the reader or viewer in front of the artwork, and its effects in the world. What Isidore calls "feigned representations" are useful not for their imitation of life, but for their instrumental purpose in prompting various activities in their viewers. For, in fact, lively resemblance can pose some problems for iconoclasts in a culture shaped—in theory, at least—by the second commandment.[22] As the *Lanterne of Liȝt*, an early fifteenth-century Lollard treatise, explains, "þe peyntour makiþ an ymage forgid wiþ diuerse colours til it seme in foolis iȝen as a lyueli creature."[23] Both writers and artists in the late Middle Ages are variously concerned to define their orthodox aesthetics as against such "foolis," defending their images as dead—that is to say, as artificial constructions rather than living things.

Exploring this aspect of medieval aesthetics is a large project, and far beyond the limited scope of this essay.[24] But in an initial effort to think through the suggestive implications of interartistic theory for the medieval sister arts, I take up Steiner's citation of the *Franklin's Prologue* in order to provide an alternative interpretation of Chaucer's engagement with the idea of words and pictures.[25] That engagement is theoretical, rather than material, for Chaucer's tale as a purely literary artifact is not associated in any physical way with the visual arts. But although the *Franklin's Tale* is not a composite imagetext in that most concrete sense, it is a verbal construct that, as Steiner saw, begins by invoking the comparison between the sister arts and continues to depend on it. The tale can be read as Chaucer's treatise on poetry and painting—his theory of the imagetext—for it addresses the relation of words and pictures, not only in its prologue but also in the thematics of its story. In Steiner's reading, Chaucer's Franklin "tries" to "attribute the reality claim of painting to literature." I will suggest that the intermedial theorizing of the tale is not motivated by a desire for increased verisimilitude: "the illusion of the natural sign." Instead, Chaucer uses the interactions between words and created artifacts to heighten a sense of the artificial, the conventional, and the arbitrary in each system of representation. As is clear from the direction of his opening comparison, it is not nature that the Franklin is finally interested in, but the "colours . . . swiche as men dye or peynte"—that is, the status of the visual artifact as a created thing.

As we have seen, the *Franklin's Prologue* begins by affirming a fundamental contrast between visual and verbal languages: the "colours of rhetoryk" have nothing to do with

those that are dyed or painted, for the Franklin claims knowledge of one and modestly disavows the other. It is also a statement that ostensibly denies connections between verbal art (at least) and reality—destroying precisely the kind of comparison that has subtended the idea that pictorialism can bring poetry closer to life. Although the Franklin speaks the apologetic words that eschew rhetorical skill, his self-excusing recalls the modesty topoi employed so often by Chaucer's personae, as they seek proleptically to shield themselves from an audience's censure by claiming insufficiencies of one kind or another. Moreover, of all the characters on the Canterbury pilgrimage, the Franklin's pursuits most closely resemble Chaucer's own biography, for he has served as "knyght of the shire" and "lord" at the "sessiouns" (justice of the peace; *General Prologue*, I 356, 355)—two positions that the poet himself held.[26] In its concern with the relation between illusion and reality, the *Franklin's Tale* comments on the place of the artist and the powers of art.[27] For many reasons, therefore, the passage implies a metacritical comment on Chaucer's own works, introducing the tale as an especially useful one for investigating a Chaucerian poetics of word and image. Here the poet bases his own practice—ironically, of course—on questions about representation raised by the contrast between rhetorical and painterly colors.

What does it mean for a tale-teller—or a poet—to announce his affiliation with the natural world, and ultimately with human-made artifacts, over and above his affiliation with rhetorical techniques? For Steiner, the Franklin's alignment of painted colors with natural ones suggests the important link between visual art and life—as well as a rejection of the literary arts. But his rejection of verbal skill in favor of painterly expertise suggests a fundamental difference between the sister arts: they can be separated. Perhaps, indeed, they can never be brought together. The Franklin offers, from this perspective, a meditation on the reality of objects—both natural and human-made—and the falsity of words. But if words are false, it is an equally false modesty the Franklin professes: he knows rhetorical figures as well as—indeed, perhaps better than—natural and plastic ones. As many have pointed out, the Franklin ironically uses a rhetorical topos to deny his interest in rhetoric.[28] His denial of rhetorical language and acceptance of visual artifacts are conducted *through* rhetorical language itself, both the conventions of authorial self-deprecation and the zeugma that links "colours" of two different kinds. Moreover, Chaucer's Franklin shows himself to be a skilled rhetorician at other moments in the tale, as, for example, when he famously deploys and then deflates an overwrought image of a sunset:

> But sodeynly bigonne revel newe
> Til that the brighte sonne loste his hewe;
> For th'orisonte hath reft the sonne his lyght—
> This is as muche to seye as it was nyght.
>
> (V 1015–18)

Here both literal and metaphorical colors fade: the sun loses his "hewe" while the personified description of the sunset loses its rhetorical power, reduced to the simplest of statements—"it was night." Neither the Franklin's pairing of art and nature nor his separation of art from language can be taken at face value.

The famous "grisly rokkes blake" (V 859) that cause Dorigen so much distress—and that feature as the only real antagonist of the *Franklin's Tale*—have been much considered, for they are Chaucer's most singular addition to the narrative.[29] They are not present in any of the closest sources or analogues, and they focus the narrative and imagistic energy of the poem so tightly that Kellie Robertson, for example, has summarized the moral point of the *Franklin's Tale* entirely in their terms: "Sometimes inanimate objects organize human communities (rather than the other way around) and abstract notions of 'trouthe' are meaningless unless grounded in the matter of the natural world."[30] The importance of the rocks is confirmed not only by a range of modern critics, but by an early scribe of the *Canterbury Tales*, who provides this rubric at the start of the *Franklin's Prologue*: "Hic incipit prologus de Frankeleyn cum fabula sua de Rokkes de Brytaine" (Here begins the prologue of the Franklin with his fable of the rocks of Brittany; Cambridge, Trinity College MS R.3.3, fol. 108r) (fig. 7.1).[31] Breaking from Latin into Chaucer's English at the moment of naming the "rokkes," this multilingual title offers a contemporary reading of the tale's subject as largely geological. Of course, the substance of the tale could be described in terms of other pressing issues: What is "trouthe"? Which character is the most "fre"? What is the nature of "gentillesse"? But, for many of its medieval and modern readers, these more philosophical questions about human interactions are focused primarily through the image of the unyielding, even menacing, stones.

These black rocks, though presumably a natural formation, have the status of artifacts in Chaucer's fiction, for they are ubiquitously conceived within the tale as God's creation: in Dorigen's bitter complaint, they "semen rather a foul confusion / Of werk than any fair creacion" (V 869–70). She describes the rocks as God's "werk unresonable" (V 872), unlike the humans he has made "lyk to" his "owene merk" (V 880). "Merk" means "image" (Chaucer's phrase echoes Gen. 1:26, where God decides, "Make we man to oure ymage and liknesse"), but the word also contains clearly within it the idea of active creation.[32] Although an *imago* might be made, it also might not be, but a mark always implies a marker. One's mark is that which marks one out, but also the mark one makes. In God's case it is both, for he creates man in his own image, thus marking him with his own mark. Both rocks and humans, then, are described as God's creative work, overwriting the natural world ("colours as growen in the mede") with the world of the artist ("swiche as men dye or peynte").

Although the Boccaccian analogues omit them, Chaucer's created rocks do have a more distant precursor in Geoffrey of Monmouth's *History of the Kings of Britain*, where moving a huge set of stones is a feat of Merlin's magic. The magician issues a challenge to "men who were standing around" to demonstrate "whether ingenuity bows to strength or

FIG. 7.1 Incipit to the *Franklin's Prologue*: "Hic incipit prologus de Frankeleyn cum fabula sua de Rokkes de Brytaine." Cambridge, Trinity College MS R.3.3, folio 108r.

strength to ingenuity": "At his order, they gave themselves up with one mind to working machines of all kinds and tried to pull down the circle. Some prepared ropes, others cables, still others ladders to bring down what they sought; but in no way could they succeed. When they were all exhausted, Merlin broke into laughter and made his own machines. Then, when he had set out everything necessary, he lifted the rocks more lightly than anyone could believe."[33] Although Merlin has set up the challenge as a test of strength versus skill, the efforts of the other men hardly differ in kind from his own: they rely on "machines of all kinds" ("multimodis machinationibus"), while he relies on "his own machines" ("suasque machinaciones"). The common use of machines defines both human strength and magic skills as the result of ingenuity, and the transfer of the natural objects as a kind of artifice—a light touch so unnatural as to beggar belief. Wace is even more explicit about this point. In the *Brut*, Merlin challenges the Briton king to create, through the action of moving the stones, an extraordinary aesthetic artifact: "If you want to make a lasting work that will be beautiful and proper and that all ages will talk about, bring here the Carole that the giants made in Ireland, a marvelous and great work of stones set in a circle one on top of the other."[34]

The king expresses astonishment at the idea: "'Merlin,' said the king laughing, 'since the stones are so heavy that no man could move them, who could ever carry them here, as if we had such affection for stones in this kingdom?' 'King,' said Merlin, 'don't you know that ingenuity conquers force? Strength is good and invention is worth more; ingenuity prevails where strength fails. Ingenuity and art create many things that force does not dare begin.'"[35] The rocks that Merlin miraculously moves are not meant to disappear, as Dorigen hopes the ones in Brittany will. Instead, the magician wants to transfer the ring of the giants from Ireland to Stonehenge. He attempts this not because the rocks are feared or despised, but rather because they are valued as a beautiful and wondrous creation. Merlin creates his own new, memorable, and aesthetic artifact through the miraculous relocation of the rocks, rather than denying God's creation by making them vanish. Nonetheless, Chaucer seems to have derived the idea of the miraculous rock-as-artifact from analogues

such as these, and to have developed it by aligning the magical human power that seems to move the rocks with the divine creative power that first formed them.[36]

This rock-as-artifact appears as metaphor earlier in the *Franklin's Tale*. In their attempts at consolation, Dorigen's friends write on her as on a stone, transforming her into the solid matter on which a text or an image—"som figure"—can be inscribed:

> By proces, as ye knowen everichoon,
> Men may so longe graven in a stoon
> Til som figure therinne emprented be.
> So longe han they conforted hire til she
> Receyved hath, by hope and by resoun,
> The emprentyng of hire consolacioun.
>
> (V 829–34)

In this, her friends also transform her into the material of which a work of art is made. The "emprentyng" of form on matter is a philosophical commonplace, but it is also related to ways of thinking about artistic creation. The imprinted "stoon" that Dorigen becomes recalls, of course, the "rokkes blake" of which she is so afraid. In fact, one possibility for the origin of her name is *Droguen*, the name of an imposing rock in the Rochers de Penmarch.[37] Again, this resonance points to a comparison between humans and material artifacts, between God's black rocks that cause Dorigen's sorrow and the engraved stone she becomes through her companions' comforting words. And just as the grieving Dorigen does not remain an imprinted—that is, a consoled—stone, the rocks she so intensely fears do not really go away.

The relation between maker and made thing is again addressed in the description of the tale's pleasure garden, which "May hadde peynted with his softe shoures" (V 907). This is both a natural and an artificial coloring, consistent with the Franklin's vision in the prologue: art and nature form no fundamental contrast, as he proclaims and as his fiction confirms. The tale stops short of saying that painting is natural, however. In fact, it claims that nature is painted: there are no natural pictures in the *Franklin's Tale*, only artificial gardens. Where May—or even Nature herself—becomes a painter through a verbal metaphor, the text-image comparison reveals the productive artificiality of all forms of representation. Just as in the genre of the dream vision, which so often sets its scene in an exquisitely wrought garden, the combination of media here works to heighten the unreality of the landscape. Nature is further overwritten by human artifice (and divine creation) in the Franklin's hyperbolic description of the painted garden. He asserts:

> And craft of mannes hand so curiously
> Arrayed hadde this gardyn, trewely,

That nevere was ther gardyn of swich prys,
But if it were the verray paradys.

(V 909–12)

Here the *locus amoenus* is a product of the "curious" "craft of mannes hand"—that is, it is
a material artifact created as much by human ingenuity as by nature. Both nature and art
are further aligned with God's acts of creation, for the garden is so like "the verray paradys"
that it falls only just short of its beauty and "prys."

If the Franklin's descriptions of the rocks and the garden show nature to be a kind of
artifice, then (to return to Steiner's terms) what is the relation of this artifice to "artis-
tic truth-telling"? The question of whether and how the arts might approximate reality
closely enough to be true is most explicitly urged in the *Franklin's Tale* through the spec-
tacles of the magicians, which present an art in most ways deeply opposed to nature.[38]
If reality in this tale is linked to the intractability of the rocks, unreality is figured in the
flitting and insubstantial images of the "subtile tregetoures" (V 1141)—that is, in what is,
ironically, their "magyk natureel" (V 1125). The real power of the clerks, both in Aurelius's
experience and in his brother's memory, is not only to summon magical spectacles, but
also to make them disappear. As the Franklin describes their visit to the clerk of Orléans:

And whan this maister that this magyk wroughte
Saugh it was tyme, he clapte his handes two,
And farewel! Al oure revel was ago.

(V 1202–4)

The magicians that Aurelius's brother remembers have a similar power, at least in seeming:

And whan hem lyked, voyded it anon.
Thus semed it to every mannes sighte.

(V 1150–51)

The tale holds out the hope of turning inescapable material realities into visions that can
vanish, but finally it testifies to objects that only appear to go away. The magic of illusion
propels the plot, as Aurelius's brother sees:

"For *with an apparence* a clerk may make,
To mannes sighte, that alle the rokkes blake
Of Britaigne weren yvoyded everichon."

(V 1157–59; emphasis added)

And the clerk of Orléans delivers just such a fantasy:

> But thurgh his magik, for a wyke or tweye,
> It *semed* that alle the rokkes were aweye.
> (V 1295–96; emphasis added)

But in the case of the rocky shore, contrary to the revels in the clerk's study, the original illusion is the disappearance of the vision, and the restoration of reality arrives with the implied reappearance of the rocks after just a few weeks.

The *Franklin's Tale* circles, then, about the intractable materiality of the created artifact, posing the question of whether such artifacts can be considered natural, real, or true. Removing the rocks, as Dorigen herself sees, would be a "monstre or merveille" (V 1344) and "agayns the proces of nature" (V 1345)—although it is just this kind of unnatural art she hopes the magicians can create. But if the tale reinforces the reality of even the most artificial objects, it also demonstrates that such objects cannot be separated from the power of language. Rocks that will not go away lead to promises that cannot be unsaid: Dorigen's rash promise to Aurelius is as real in its consequences as anything in the tale. Significantly, the most false illusion is to make these rocks *seem* to go away. We all know they will not, as does Dorigen when she confidently makes a promise "in pley" (V 988) that depends on an impossible thing. The intractable rocks, which at first symbolize a threat to Dorigen's marriage (through the threat they pose to her husband), come to embody the salvation of her marital promise and the most fundamental truth of the tale: they only seem to disappear, just as she only seems in her jest to compromise her "trouthe."[39] That the rocks can signify one thing and also its opposite signals their ultimately arbitrary relation to meaning.

In this, they offer a material version of the verbal confusion adumbrated by the place name "Britayne," which signifies Brittany (V 729), but also "Engelond, that cleped was eek Briteyne" (V 810)—a line that leaves unclear whether "eek" means the place is called both England and Britain, or whether, perhaps, that it, *like Brittany*, is called Britain. Their name is the same, but the difference between these two places, and Arveragus's displacement from one to the other, drives the plot of the tale. Ultimately, neither dangerous artifacts nor dangerous words prove to be closely related to the realities of the natural world. Since Arveragus is not wrecked at sea (even though the rocks remain), and since Dorigen maintains her original "trouthe" (despite the promise she gave), neither the frightening spectacle of the rocks nor the overhasty verbal contract shows any absolute connection to real outcomes. Both words and images are, that is, conventional rather than natural in their relation to reality. Once the arbitrary and artificial conventions of that relation are broken—when Arveragus returns unharmed, and Aurelius decides to release Dorigen from her promise—it becomes plain that they bear no intrinsic relation to what they once signified.

The *Franklin's Tale* is not usually treated as a piece of visionary writing, for it is about making visions go away, or at least seem to do so. It might be considered instead an anti-visionary poem, for it seeks to banish Dorigen's nightmare of nautical disaster by making a real thing, the sinister rocks, disappear from sight. But in showing what a vision is not, the tale also shows what it can be. The visions in the *Franklin's Tale* reveal the existence of the created artifact on the boundary of the natural and the supernatural, for the material existence of the rocks not only raises the question of how human love operates within a courtly framework, but also sets human power against God's power, and explores the place of magic in religion. Although the *Franklin's Prologue* derives the power of human artifice from the power of nature, perhaps implying that visual art is an unproblematically iconic sign, the *Franklin's Tale* finally brings things together with words in a way that moves from nature to art, eschewing lively resemblance.[40] The *Franklin's Tale* links the words of Dorigen's promise with the reality of the rocks in the artificial space of the garden. The way images cannot represent reality (are the rocks gone?), and the way words cannot represent reality (will the promise be honored?), make them both—images and words—only artificially and conventionally connected to their subjects. The Franklin's conflation of images with words makes clear the artificiality of all representation: words in pictures breaking the pictorial illusion, visions in narratives laying bare the formal and artificial structure of those texts.

It would be possible, I think, to write a new history of the sister arts that incorporates the full history of medieval theories of the relation of painting and literature. Such a history would note the dependence of the immaterial vision on the material artifact, both in theory and in practice, but not necessarily in the service of natural likeness. Medieval pictorialism, at least as it is conceived in Chaucer's *Franklin's Tale*, does not inevitably imply the artist's intentions to approximate the creative activities of God, whether through texts that seek the lively embodiment available to the visual arts or through art objects that seek voices. Even the couplet praising the painter of Duke Theseus's lists in the *Knight's Tale* ultimately makes this very point. The painter is able to create a "lifly" image, after all, only because he has bought very expensive colors with which to do it. The effect the juxtaposition creates recalls the more famous lines about the sunset: after he invokes the lofty trope of "lifly painting," the poet brings his rhetorical flight down to earth by noting that whatever artistic effect the painter achieves is far from natural, and instead the result of a commercial transaction dependent on "many a floryn." In this small couplet, as ultimately in the *Franklin's Tale*, Chaucer exposes the mechanisms of both painterly and rhetorical colors, showing them to be a function of art, not nature. Instead of attempting to counterfeit natural resemblance, the combination of words and pictures reveals the constructed nature of all systems of signs. The genre of the medieval imagetext links disparate media to show how they work in concert or at odds with one another—not in the service of verisimilar illusion, but in an effort to explore the limits and capacities of artifice in representation itself.

NOTES

1. See Steiner, *Colors of Rhetoric*, x, 221–26.
2. Ibid., xi.
3. Ibid., xiii, 71.
4. For an extended account of relations between modernism and the medieval arts, see Saler, *Avant-Garde in Interwar England*. Holsinger, in *Pre-modern Condition*, has revealed medievalism, including the relations between text and image implicit in Panofsky's *Gothic Architecture and Scholasticism*, to be the inspiration for certain postmodern ways of thinking.
5. Steiner, *Colors of Rhetoric*, xiii.
6. Among many studies of these questions, I am thinking primarily of Alpers and Alpers, "Ut Pictura Noesis?"; Hagstrum, *Sister Arts*; Heffernan, "Ekphrasis and Representation"; Heffernan, *Museum of Words*; Hollander, "Poetics of Ekphrasis"; Hollander, *Gazer's Spirit*; Krieger, *Ekphrasis*; Mitchell, *Picture Theory*, 83–107; Mitchell, *Iconology*; Praz, *Mnemosyne*; Steiner, *Colors of Rhetoric*; Wagner, "Introduction"; and Wolf, "Confessions of a Closet Ekphrastic." Hagstrum, in *Sister Arts*, 37–56, is the only one of these critics to address the medieval history of these ideas sympathetically. See also Heffernan, *Museum of Words*, 37–45, 61–66; and Praz, *Mnemosyne*, 63–78.
7. Horace, *Satires, Epistles, and Ars Poetica*, 361; and Plutarch, *Moralia*, 346.4 (translated here as "Simonides calls painting articulate poetry and poetry inarticulate painting").
8. The fundamental role of the sister arts in theories of periodization is noted by Krieger, *Ekphrasis*, 3; and Steiner, *Colors of Rhetoric*, 177–96.
9. Leonardo da Vinci, *Treatise on Painting*, 1:3–44; and Shakespeare, *Timon of Athens*, 1.1. For the *paragone* generally, see Hagstrum, *Sister Arts*, 66–70.
10. Lessing, *Laokoon* (1766). For an English translation, see Lessing, *Laocoön* (1984).
11. Mitchell, *Iconology*. For various modern objections to Lessing's schema, see, for example, Frank, "Spatial Form in Modern Literature," 221–40; Krieger, *Play and Place of Criticism*, 105–28 (reprinted in Krieger, *Ekphrasis*, 263–88); Mitchell, *Iconology*, 95–115; and Mitchell, "Spatial Form in Literature."
12. Nichols, "Ekphrasis, Iconoclasm, and Desire." For useful discussions, see Perkinson, *Likeness of the King*, 27–84; Mansfield,

Too Beautiful to Picture, esp. 11–18; and Belting, *Likeness and Presence*.
13. "Pictura autem est imago exprimens speciem alicujus rei, quae dum visa fuerit, ad recordationem mentem reducit. Pictura autem dicta, quasi fictura. Est enim image ficta, non veritas. Hinc et fucata, id est, ficto quodam colore illita, nihil fidei et veritatis habentia. Unde et sunt quaedam picturae quae corpora veritatis studio coloris excedunt, et fidem dum augere contendunt, ad mendacium provehunt, sicut qui Chimaeram tricipitem pingunt, vel Scyllam hominem sursum, caninis autem capitibus cinctam deorsum" (Isidore of Seville, *Etymologiarum*, 19.16.1–2). The English translation is from Isidore of Seville, *Etymologies*, 380.
14. Davis-Weyer, *Early Medieval Art*, 170.
15. Quoted in Carruthers, *Experience of Beauty*, 147. For useful discussion of this famous but complicated statement, see Bynum, *Metamorphosis and Identity*, 113–62; Carruthers, *Experience of Beauty*, 147–49; and Rudolph, "Things of Greater Importance." It is most likely not mixing per se but excessive display (*curiositas*) that is the object of Bernard's scorn.
16. Hagstrum, *Sister Arts*, 47.
17. For the argument against the separation of the arts, see Mitchell, *Picture Theory*, 83–107. Mitchell also explores the histories of both "ekphrastic fear" and "ekphrastic hope" (151–81).
18. Hagstrum goes on: "It also may be that medieval thought stimulated artistic achievement by creating a rich and complex relationship between verbal and plastic form, a relationship in which vision takes the place of observance and in which subservience to reality is supplanted by the oldest imaginative freedom" (*Sister Arts*, 56). Compare Berliner, "Freedom of Medieval Art."
19. The terms are Hagstrum's (*Sister Arts*, 47).
20. See Freedberg, *Power of Images*. As Hagstrum describes the epigrams of Philes, "The object creates the religious emotion of fear and is itself closely associated with the theological quality of grace. Here the wonder is not the one Homer celebrated—the shaping of intractable stone and metal into the likeness of reality—but the introduction of the unseen, the supernatural, into the material" (*Sister Arts*, 49).
21. See, for example, Jaeger, ed., *Magnificence and the Sublime*; Jaeger, *Enchantment*; and Carruthers, *Experience of Beauty*.

22. For interesting reflections, however, on the ways dissent expresses itself through aesthetic forms such as ekphrasis, see Holsinger, "Lollard Ekphrasis."

23. *Lanterne of Liȝt*, 84.

24. For an insightful study of fifteenth-century polemic surrounding the visual and verbal arts, see Gayk, *Image, Text, and Religious Reform*.

25. Steiner provides a full reading of the *Franklin's Tale* in an appendix—a structural sign, perhaps, that it could not be easily accommodated within the primary arguments of the book (*Colors of Rhetoric*, 221–26).

26. See further Blenner-Hassett, "Autobiographical Aspects"; and Brewer, "Class Distinction," 303–4.

27. See, for example, Kolve, "Rocky Shores" (reprinted in Kolve, *Telling Images*, 171–98).

28. For one example, see Steiner herself (*Colors of Rhetoric*, 223).

29. For readings of the rocks' importance, see, for example, Owen, "Crucial Passages," esp. 294–97; Kolve, "Rocky Shores"; and Bleeth, "Rocks." Understandably, more recent object-oriented criticism and ecocriticism has also made much of the rocks; see, for example, Robertson, "Exemplary Rocks"; Rudd, *Greenery*, 139–48; and Cohen, *Stone*, 47–56, 198–200.

30. Robertson, "Exemplary Rocks," 108.

31. I am grateful to Karl Steel's personal blog for bringing my attention to this rubric (see http://medievalkarl.com/2015/05/05/you-know -the-one-with-the-rocks-trinity-college-r-3-3/).

32. Chaucer, *Riverside Chaucer*, 897 (Joanne Rice's note to the *Franklin's Tale*, V 880). Compare also *Middle English Dictionary*, s.v. "mark(e)," n. 1, and *Oxford English Dictionary*, s.v. "mark," n. 1. The word originally meant "boundary" but took on the meaning of "sign, token" through contact with the Old English *gemaercen*. The conjunction gives a greater sense of a sign made deliberately. Biblical quotations are taken from the later Wycliffite version of the *Holy Bible*, edited by Forshall and Madden.

33. "Ad imperium igitur eius indulserunt unanimiter multimodis machinationibus et agressi sunt choream deponere. Alii funes, alii restes, alii scalas parauerunt ut quod affectabant perficerent; nec ullatenus perficere ualuerunt. Deficientibus itaque cunctis solutus est Merlinus in risum suasque machinaciones confecit. Denique, cum queque necessaria apposuisset, leuius quam credi potest lapides deposuit" (cited in Edwards, "Franklin's Tale," 1:252–53).

34. Se tu vuels faire ovre durable,
Ki mult seit bele e covenable
E dunt tuz tens seit mais parole,
Fai ci aporter la carole
Que gaiant firent en Irlande,
Une merveilluse ovre e grande
De pieres en un cerne assises,
Les unes sur les altres mises. (Cited in ibid., 1:254–55)

35. "Merlin," dist li reis, en riant,
"Des que les pierres peisent tant
Que huem nes pureit remuer,
Ki mes purreit ci aporter;
Cume se nus en est regné
Avium de pieres chierté?"
"Reis," dist Merlin, "dunc ne sez tu
Que engin surmunte vertu.
Bone est force e engin mielz valt;
La valt engin u force falt.
Engin e art funt mainte chose
Que force comencer nen ose." (Cited in ibid.)

36. For another kind of rock-as-artifact, see Robertson's discussion of figured stones (*lapides figuratae*), "Exemplary Rocks," 110–23. As examples of *acheiropoieta*, however, figured stones were understood to exhibit images both naturally occurring and seemingly miraculous, side-stepping the question of human artifice altogether.

37. Chaucer, *Riverside Chaucer*, 897 (Joanne Rice's note to the *Franklin's Tale*, V 815). The correspondence is noted by Tatlock, *Scene of the Franklin's Tale Visited*, 38. Compare Lucas, "Chaucer's Franklin's *Dorigen*."

38. For useful discussion of the magicians' art and the poet's art, see Kolve, "Rocky Shores."

39. This point is also made by Owen, in "Crucial Passages."

40. Although Steiner's reading of the *Franklin's Tale* differs from mine, she does acknowledge "the possibility . . . that the story is an intentional falsification of its claim to plain speech, proving instead that *only* through figuration is truth possible" (*Colors of Rhetoric*, 225). I would say that the tale is not so much interested in pinpointing the truth as in exposing the vagaries and ultimately the instability of all representational systems.

EIGHT

Miracle Windows and the Pilgrimage to Canterbury

David Raybin

From every corner of England medieval pilgrims flocked to Canterbury, as does Chaucer with his imagined fellow travelers: "And specially from every shires ende / Of Engelond to Caunterbury they wende" (I 15–16). Indeed, the opening sentence of the *Canterbury Tales* has enshrined Canterbury as one of the world's great pilgrimage destinations, to the point that scholars rarely ask what inspired Chaucer to choose a journey to Canterbury as a frame for his story collection.[1] The question, though, is of some interest. If popular pilgrimage had been his sole stimulus, Chaucer might have chosen Walsingham, the shrine commemorating Mary's triple appearance to the young widow Richeldis in 1061. Or, further afield, he might have chosen any one of the cities he imagines as prior destinations for the Wife of Bath: Jerusalem, Rome, Compostela, Cologne, or Boulogne.[2] Margery Kempe reports that she journeyed to Jerusalem, Rome, and Compostela, along with Canterbury, Walsingham, and quite a few other sites. Nonetheless, the impetus behind Chaucer's choice has hardly been addressed. Even Chaucer's biographers mention Canterbury and its Cathedral only in passing.[3]

This chapter approaches the question by considering Canterbury as both a Chaucerian place and a locus for storytelling. In the first half, I treat Chaucer's Kentish connections (which would have turned his interest toward Canterbury), his occasional references to either Thomas or Canterbury (which reflect the saint's and the city's spiritual renown),

I am indebted to Francine McGregor, Robyn Malo, Rachel Koopmans, and Susanna Fein for their responses to earlier versions of this essay.

and Canterbury Cathedral's eminence as a shrine marked by secular/religious interaction (and thus an apt signifier for both opposing and reflecting the Southwark tavern where the pilgrimage begins). These thematic and biographical factors, familiar to scholars, help to situate Chaucer's choice of Canterbury as his pilgrims' destination. In the second half, I locate an inspirational model for associating storytelling with Canterbury: the Cathedral's magnificent early thirteenth-century windows depicting the miracles of Thomas Becket (fig. 8.1). The ensemble of windows—a widely viewed pictorial rendering of stories about Canterbury pilgrims in medieval England's finest painted glass—anticipates Chaucer's narrative frame.[4] Chaucer's pilgrims journey with a purpose: "The hooly blisful martir for to seke, / That hem hath holpen whan that they were seeke" (I 17–18). That is, they wish to acknowledge the saint who has aided them in sickness. The surviving miracle windows present over forty stories of people healed by Saint Thomas, a few pictured in single panels but most in sequences of two to nine panels.[5] In these depictions, which were created almost two centuries earlier than the *Canterbury Tales*, the Cathedral's artists in glass parallel Chaucer in choosing not only tales of priests and nuns, but also (and mainly) tales of secular people from a wide range of social ranks. Examination of the miracle windows reveals a previously unacknowledged yet likely visual source for the storytelling pilgrimage that becomes the principal structural and thematic feature of the *Canterbury Tales*.

Kentish Chaucer

In Ardis Butterfield's fine collection *Chaucer and the City*, Canterbury is mentioned only once—in the context of a poem describing seven English cities—and not in relation to Chaucer. As Marion Turner writes in her chapter, Chaucer is a *London* poet with deep connections to "Greater London," an area that includes Southwark, Smithfield, and Westminster. Turner's point is that Chaucer's launching the pilgrimage on the south bank of the Thames does not distance the journey—and, by extension, the poet—from London, but locates it in "an important part of the city."[6] The argument reflects Chaucer's association with Greater London from his birth on Thames Street in Vintry Ward to his dozen years of residence over Aldgate and his eventual death in Westminster. It is not my intention to minimize the importance of this association, which is evidenced in myriad instances across Chaucer's poetry.[7] What I wish to consider, in contrast, is that for a good stretch of Chaucer's life—that is, the period during which he was likely writing most of the *Canterbury Tales*—the poet lived and probably worked not so much in London as in Kent.[8]

The *Life-Records* offer abundant evidence of Chaucer's Kent residency.[9] In 1375, Chaucer was granted the wardship of two Kentish heirs possessed of substantial properties in Canterbury, and he profited handsomely from the estate: £104 (ten times his annual salary of £10 at the custom house). Ten years later, in October 1385 (eight months after he had

obtained permission to hire a permanent deputy controller to relieve him of his customs duties at the London wool quay),[10] he was named to a sixteen-member commission of peace in Kent, an indication that he held some status in the county—the other members were magnates, high-ranking lawyers, and rich landowners, including men of importance in Canterbury. Chaucer remained on the commission through July 1389. In the interim, in 1386, he was elected to Parliament as one of two "knights of the shire" representing Kent. In October of that year he gave up his Aldgate lease, and in December successors were appointed to his customs post. In April 1388, he was twice sued for debt in London but was excused from appearing because he was not a London resident: Chaucer is described as "of Kent," and, as dozens of records suggest, he may have been living in Greenwich, where, in March 1390, he would be appointed to a commission investigating the condition of the Thames "walls and ditches" between Woolwich and Greenwich.[11] In July 1389, he was appointed Clerk of the King's Works, which, among other charges, some in London, made him responsible for upkeep at Eltham in the borough of Greenwich, a favored royal estate referenced in the prologue to the *Legend of Good Women*.[12] Shortly after Chaucer's appointment, in March 1390, a devastating storm toppled over a hundred oak trees at Eltham and presumably demanded his attention. In September 1390, he was robbed by highwaymen near "le fowle ok" in Deptford, Kent. Numerous records of the mid-1380s and the 1390s connect Chaucer with Woolwich (just east of Greenwich) and with Combe and Chislehurst (a few miles to the southeast). There is no evidence that Chaucer again lived in London before his retirement to Westminster Close in 1399.

Though scholarship has naturally focused on the possible literary import of Chaucer's well-documented Continental travels (which stand out in the *Life-Records*), he presents himself as determinedly English and is linked loosely to many English places: Surrey, Somerset, Oxford, Lincoln, Cambridge, Norfolk, Suffolk.[13] I stress his Kentish connections because they locate Chaucer on the pilgrimage path to Canterbury at just that time when he seems to have been writing the *Canterbury Tales*. Kentish places that Chaucer names, running roughly west to east, include Deptford, Greenwich, Eltham, Dartford, Rochester, Sittingbourne, Ospringe, Boughton-under-Blean, Harbledown, Canterbury, and Dover. The plethora of references reflects, of course, the route from London to Canterbury to the Channel, but it also signals Chaucer's familiarity with the county. He devoted to no other part of the world such concentrated attention.

Kent, Thomas, and Canterbury in the *Canterbury Tales*

Chaucer uses the place name *Kent* twice, when Alisoun incongruously swears "by Seint Thomas of Kent" that she'll be at Nicholas's "comandement" (*Miller's Tale*, I 3392–93), and when a dreaming Geffrey uses the same oath to declare that the ice on which the

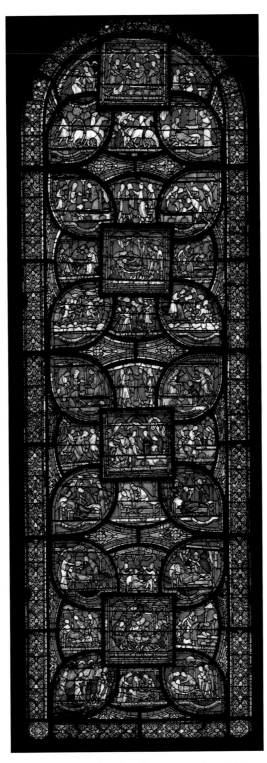

FIG. 8.1 Trinity Chapel Ambulatory window n. II,
Canterbury Cathedral.

House of Fame is built offers "a feble fondament" (*House of Fame*, 1131–32). These are among Chaucer's six citations of Saint Thomas. The other four occur in the Southwark place name "the Wateryng of Seint Thomas" (*General Prologue*, I 826), in the carpenter John's two expletive utterances of "by Seint Thomas" when he worries about Nicholas's health (*Miller's Tale*, I 3425, 3461), and in the Wife's repetition of this oath when she explains why she tore a leaf from Jankyn's book (*Wife of Bath's Prologue*, III 666). Mostly, then, the name *Thomas* is something to swear by, though it also comes into play as that of the bedridden churl in the *Summoner's Tale*, whose name reflects doubting Thomas, the disciple whose groping of Christ's wounds is referenced humorously in Friar John's groping of Thomas's "tuwel" (III 2148), and in two references to the apostle Thomas of India (III 1980, IV 1230).

Chaucer cites Canterbury nine times, gathered toward the beginning and end of his book. Two groups of references frame the *General Prologue*. One designates Canterbury as Chaucer's own destination ("*my* pilgrymage to Caunterbury"; I 22) and that of the pilgrims ("that toward Caunterbury wolden ryde"; I 227; see also I 793, 801). A second specifies the journey's therapeutic purpose. In the Host's words, "Ye goon to Caunterbury— God yow speede, / The blisful martir quite yow youre meede!" (I 769–70; see also I 16). As we will see, this emphasis on healing as a motivation for the journey to Canterbury reflects the theme expressed in each of the stories in the miracle windows.

A third group of references signals the approaching end of the journey. Midway through the *Canon's Yeoman's Prologue*, the Yeoman boasts that his master's skill is such that he could turn "up-so-doun" all the ground from here to "Caunterbury toun" and "pave it al of silver and of gold" (VIII 624–26); the metaphor of glittery gold figures Chaucer's bold representation of his poetic craft.[14] A bit later, the opening of the *Manciple's Prologue* contains a geographical marker—"Bobbe-up-and-doun, / Under the Blee, in Caunterbury Weye" (IX 3)—that announces the city's proximity and balances the earlier naming of "the Wateryng of Seint Thomas," which is the first site named after the pilgrims leave Southwark. The last reference, in the *Retraction*, features Chaucer's unique naming of his book as he revokes "the tales of Caunterbury, thilke that sownen into synne" (X 1086). This final mention of Canterbury—dropped in as a qualifier tying the poet's particular need for Christ's healing mercy to his authorship of seductive tales—recalls the salutary aim of pilgrimage journey.

But, to return to my opening question, why did Chaucer choose Canterbury? The selection of this pilgrimage destination was undoubtedly influenced by the city's centuries-old significance as a quintessential English site of spiritual birth and spiritual/secular conflict. In 597, Pope Gregory the Great dispatched to Canterbury the Benedictine abbot Augustine, who was charged with the task of restoring Christianity to the Saxon kingdom of Kent and, from there, to the pagan island of England. Roman occupation had left a few churches in Canterbury.[15] Augustine quickly turned the city into a major religious

center: he established a large monastery, consecrated the first cathedral in England, and, by Gregory's account, in 597 baptized over ten thousand new Christians at Christmas.[16] Augustine was consecrated as archbishop in 601 (prior to the creation of bishoprics in London and Rochester, which were staffed by his subordinates, and of an archbishopric in York) and, following his death in May 604, performed the miracles requisite for canonization.

Augustine's mission was inspired by two events, one historical, the other likely apocryphal. The historical event was the marriage of the Anglo-Saxon King Æthelberht of Kent to a Christian princess Bertha, daughter of the king of Paris. Gregory may have used the event of the marriage as an entry to reinstituting Christianity in a region where it then held little sway. It is also possible that Æthelberht, influenced by Bertha, was the one who initiated the mission. As a condition of their union, Bertha had brought a French bishop with her to Kent, and she is assumed to have been devout. However, the apocryphal event credits inspiration for the mission solely to Gregory. As Bede relates it, Gregory saw in the Roman slave market two fair-haired Saxon slaves and, upon being told they were called Angles, exclaimed, "Non Angli sed Angeli" (Not Angles, but angels). Learning that their king was named "Aelli," Gregory cried out, "Allaluia!" A mission to Canterbury was clearly part of the divine plan.[17]

The paired anecdotes help to explain Canterbury's early status as a preeminent site for spiritual travel in England. Along with the similarly large and spectacular York Minster, Canterbury Cathedral was one of the two leading seats of ecclesiastical authority in medieval England. But by the twelfth century its major attractions had grown stale. Its most popular shrine was the eleventh-century tomb of Saint Dunstan, an archbishop of Canterbury referenced in the *Friar's Tale* for his mastery over fiends (III 1502). But the lackluster appeal of pilgrimage to Canterbury was infamously and dramatically transformed on December 29, 1170, when Archbishop Becket was brutally slain in the Cathedral, the top of his skull sliced off and his gruesome remains strewn in the north transept.[18] The martyr's blood, bones, hair shirt, and hair breeches were soon reputed to possess healing qualities, and as reports of miracles began to circulate, pilgrims flocked to the site.[19]

Becket had been a complex and not-very-well-liked man, a zealot at odds not only with Henry II, who had named him to the ecclesiastical seat, but also with his fellow English prelates and the local Canterbury monks. His death and subsequent healing interventions drastically refashioned his image. The combination of Becket's many miraculous healings, pro-papist political notoriety, and suddenly extreme popularity led to his swift canonization. He was declared a saint in February 1173.[20] Following the beatification, pilgrims arrived in greater numbers, and most notable among them was the publicly repentant Henry, on whose behalf the four murderous knights claimed to have acted. For his pilgrimage in July 1174, Henry walked barefoot into the Cathedral, dressed in a penitent's sackcloth and ashes, his feet reportedly bleeding.

Cathedral and Tavern as Places of Secular/Religious Interaction

Becket's martyrdom and Henry's public penance were major events—of saint and king—that defined Canterbury as a site of secular/religious interaction. This symbolic valence suggests another reason why Chaucer would have been intrigued by the idea of pilgrimage to Canterbury: the cathedral city fits well the range of tales mingling "sentence" and "solaas" (*General Prologue*, I 798). Compared to Walsingham in Norfolk, Canterbury was propitiously situated. To go to Walsingham, English visitors generally traveled via the cathedral city of Ely, another holy site: the journey, which is still undertaken on the sixty-seven-mile Walsingham Way, went from one holy shrine (Ely) to another (Walsingham). In contrast, Canterbury's eastern Kent location required that most English pilgrims embark from Southwark, the borough situated along the Thames across the one bridge from London. The south bank was then, as it would remain into Elizabethan times, an unsavory quarter. The Tabard, situated just three hundred yards from the Augustinian priory of St. Mary Overie, was itself a fashionable inn, but Southwark itself—on the margins of London, within the urban ambit but outside the city's walls and laws—was an area of brothels, alehouses, and wayward pleasures, and even reputable hostels like the Tabard were spaces for drinking and the mingling of "sondry folk" (*General Prologue*, I 25).[21] Unlike Ely, Southwark was exceptionally well suited for a journey begun with tavern drink and ending with cathedral healing.[22]

Chaucer presents this thematic movement from drunkenness to spiritual health—emblematic of pilgrimage in miniature—in the *Pardoner's Tale*.[23] Perverted allusions to the healing Eucharist pervade this sin-laced tale. Before he begins, the narrator pauses to "bothe drynke and eten of a cake" (VI 322), and he then recounts an exemplum of how death comes to rioters who partake of "breed and wyn ful prively" (VI 797). Shortly after the tale opens by situating its protagonists among tavern sins, a digression traces the "luxurie" of "wyn and dronkenesse" to "dronken Looth /. . . / So dronke he was, he nyste what he wroghte" (VI 484–85, 487), and associates it with the gluttony that is "cause first of oure confusioun" (VI 499). Yet notwithstanding the tale's emphasis on drunkenness, plague, and corporeal death, its message includes salvific healing and the purging of sin: "Jhesu Crist . . . is oure soules leche" (VI 916), and absolution makes one "as clene and eek as cleer / As ye were born" (VI 914–15).

So, too, in the *Canterbury Tales* as a whole, the journey progresses from secular comfort to spiritual healing: from the Tabard Inn's blend of story, supper, and wine to the austere rejection of fable and poetry to which the pilgrims assent when but one tale remains to be told. The *Knight's Tale*'s grim vision, voiced by Egeus—"This world nys but a thurghfare ful of wo, / And we been pilgrymes, passynge to and fro. / Deeth is an ende of every worldly soore" (I 2847–49)—takes on an overtly Christian spiritual valence in the final lines of the *Parson's Tale*, where celestial Jerusalem is figured as the place in which

"alle harmes been passed of this present lyf . . . / . . . ther as the body, that whilom was syk, freele, and fieble, . . . [is] so strong and so hool ther may no thyng apeyren it" (X 1077–78). In thus valorizing pilgrimage as an occasion for spiritual healing, for movement from the constraints of illness to the boundlessness of peace, Chaucer's vision of universally accessible salvific cleansing mirrors the composite story recounted in the miracle windows of Canterbury Cathedral.

The Becket Miracle Windows

On September 5, 1174, a few months after Henry II's public act of penance, fire destroyed much of Canterbury Cathedral. As with Becket's martyrdom four years earlier, the monks drew strength in the face of disaster. Miraculously, it seemed, the crypt housing Saint Thomas's relics survived the fire, and the devastation provided the monks with an opportunity to construct new lodgings. A major building campaign ensued almost immediately, the plan being to create a modern building in the nascent Gothic style, with a layout that could accommodate the already vast influx of pilgrims.[24] The prominent French architect William of Sens initiated the rebuilding of the east end, and his involvement lasted from 1174 until his fatal fall from vault scaffolding in 1179. His replacement was William the Englishman. From 1179 to 1184, perhaps following William of Sens's designs, the English William directed the construction toward accommodating the burgeoning cult of Becket, building Trinity Chapel so that its new shrine was directly above Becket's original tomb in the crypt.

Over the ensuing years, many of the vicissitudes typical of medieval construction occurred. There was a feud between the monks and newly appointed Archbishop Baldwin of Ford (1185–90), who imprisoned them for fifteen months in 1188–89. There was a six-year stint (from July 1207 until May 1213) during which King John forced the new archbishop Stephen Langton and the monks into exile, and there were three years (from November 1215 until May 1218) during which the pope suspended Langton (a leader in the campaign that had forced John to sign the Magna Carta) and removed him from England. And amid the politics there was the artisanal challenge of painting and glazing the enormous sets of windows made possible by the new Gothic style. Given all this, progress was remarkably rapid, with work completed in time for the translation of Becket's bones to the new structure on July 7, 1220.

The result was a triumph for the history of Western art, architecture, and tourism. Becket's shrine was moved up from the crypt to the new east end, where the major features are Corona Chapel, with windows portraying the Tree of Jesse and the Redemption, and Trinity Chapel, with the Becket windows. Today the ambulatory of Trinity Chapel retains seven of the twelve original large-scale stained-glass windows depicting Becket's life, martyrdom, and posthumous miracles.[25] Set at eye level, these windows arrange and

display over forty stories of Saint Thomas's healings, which are free of visual obstruction.[26] Remarkable not just for their number and quality, the windows are also quite extraordinary for how they relate picture stories of a strikingly diverse group of people, both religious and secular, from various social ranks, who were healed by Saint Thomas. These stories and their public depiction clearly demonstrate why we ought to judge the miracle windows a credible source for the pilgrimage frame of the *Canterbury Tales*. In surveying them, I will begin with the six stories in the magnificent window catalogued as "Trinity Chapel Ambulatory n. II" (fig. 8.1), and then I will turn to representative stories in other windows.[27]

At the top of TCA n. II, one finds the story of blind Juliana of Rochester in three panels. To the left, the blind Juliana is led by her father to the tomb, where, in the center, a monk holding a bowl sponges the young woman's face with Saint Thomas's water—that is, water mixed with a small quantity of Becket's blood, which was collected in ampules immediately after his murder. Then, having returned home and now seated beside by her father, Juliana displays her suddenly recovered sight. One may note the girl's sealed eyes in the first panel, a feature drawn from Benedict of Peterborough's account (fig. 8.2).[28] Like Chaucer, the painters paid close attention to details of appearance and character.

Immediately underneath this sequence are six panels displaying the illness and healing of a young herdsman named Richard of Sunieve. In the upper left, the boy takes his horses to pasture. While the long-necked horses—superbly depicted—graze, he foolishly falls asleep in the field and, as a consequence, contracts leprosy (fig. 8.3). In the upper right, Richard's mother, fearing contagion, wears a kerchief over her mouth and feeds him from a distance. The lower left shows Richard at Becket's tomb in Canterbury, where a monk administers Saint Thomas's water. In the center, the boy displays the cure he has received, perhaps to his master and mistress while en route home. The lower right shows Richard's parents returned to Canterbury and giving thanks. The mother's mouth is no longer covered.[29]

Below Richard's tale are two rows of three panels each that illustrate portions of two stories. The upper row delightfully depicts the history of a resuscitated drowned boy, probably the eight-year-old Philip Scot. At the left, we see Philip and his friends at a quarry, where the other boys throw stones at frogs while Philip falls in the water. The artist places Philip at the center of this panel, flanked by four carefully drawn frogs (fig. 8.4). The middle panel shows his friends reporting Philip's drowning to his parents; on the right, the boy's body is retrieved as his grieving parents pray. Philip's subsequent resuscitation is not portrayed. The second depicted tale, of Matilda of Cologne, is more dramatic still. When the unmarried Matilda gives birth, her furious brother kills her lover, and the maddened Matilda kills her baby. The left and center panels show a common medieval treatment for insanity: attendants beat the wild-haired Matilda, first en route to Canterbury, then at Becket's tomb (fig. 8.5). The final panel shows Matilda cured and kneeling in thanks before the tomb, her hair now neatly arranged.

FIG. 8.2 Healing of blind Juliana of Rochester (detail). Trinity Chapel Ambulatory window n. II, Canterbury Cathedral.

FIG. 8.3 Illness and healing of the herdsman Richard of Sunieve (detail). Trinity Chapel Ambulatory window n. II, Canterbury Cathedral.

At the bottom of TCA n. II is the longest of the stories, an extraordinary sequence of nine panels that unfolds the famous account of plague in the household of Jordan Fitz-Eisulf. The three rows reorder the story—they are to be read from bottom to top to center—to highlight the dramatic scene of Becket's appearance by placing it in the middle of the grouping (fig. 8.6). In the bottom row, left, a priest leads six pallbearers at the funeral of the deceased household nurse. In the middle, young William Fitz-Eisulf lies dead of the

FIG. 8.4 Philip Scot (?) drowns as his friends throw stones at frogs. Trinity Chapel Ambulatory window n. II, Canterbury Cathedral.

FIG. 8.5 Mad Matilda of Cologne is beaten at Becket's tomb by her attendants. Trinity Chapel Ambulatory Window n. II, Canterbury Cathedral.

plague before his distraught parents, and, to the right, the parents anoint their son's lips with Saint Thomas's water brought by pilgrims from the saint's tomb. At the top left, the parents promise to offer a gift of gold coins at Becket's tomb if their son is revived. The revived William is then shown (center), happily eating his soup in bed while his parents offer thankful prayer. But when the Fitz-Eisulfs fail to honor their vow of gold coins (top right), Saint Thomas visits the blind Gimp, a spotted leper, whom he instructs to remind them. The central row closes the story: first, Gimp visits the Fitz-Eisulfs, but they continue to disregard their oath (one may note how the wife points away from the leper). Then the middle panel dominates the sequence: Saint Thomas stretches out his sword and swoops in to slay the Fitz-Eisulfs' elder son (fig. 8.7). The center right shows a repentant Jordan Fitz-Eisulf bringing the promised coins to Becket's tomb, accompanied by his wife and young William. There is no record of the elder son being revived.

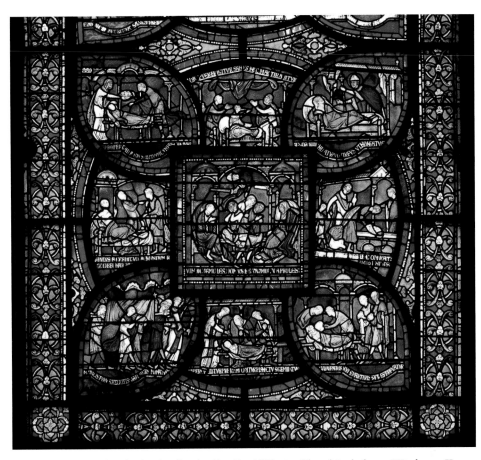

FIG. 8.6 Plague strikes the family of Jordan Fitz-Eisulf. Trinity Chapel Ambulatory Window n. II,
Canterbury Cathedral.

The six other windows display a similarly wide variety of maladies and cures, including
cases of malaria, leprosy, hernia, nightmares (and other dreams and visions), toothache,
paralysis, epilepsy, stomach pains, insanity, crippling accidents, and a collapsed house.
A series of six panels shows the laborer William of Gloucester rescued by Thomas after
he has been buried alive in an accident. A two-panel sequence shows the story of Adam
the forester: the man's neck is pierced through by a poacher's arrow, and then he is cured
(fig. 8.8). A large proportion of the afflicted in the windows mirror Chaucer's own pilgrims
as they journey to Canterbury to thank the saint for cures he had bestowed on them: for
example, Gilbert le Brun, a young boy, dies, is revived by Thomas, and then travels with
his parents to Canterbury to thank the saint. A two-panel sequence portrays the parallel
story of Petronella of Polesworth, a nun afflicted with epilepsy. The first scene shows her
in the course of a fit, surrounded by fellow sisters as she sadly looks down at the ground
(fig. 8.9). Rejecting "hirelings and those who are not true physicians," Petronella travels

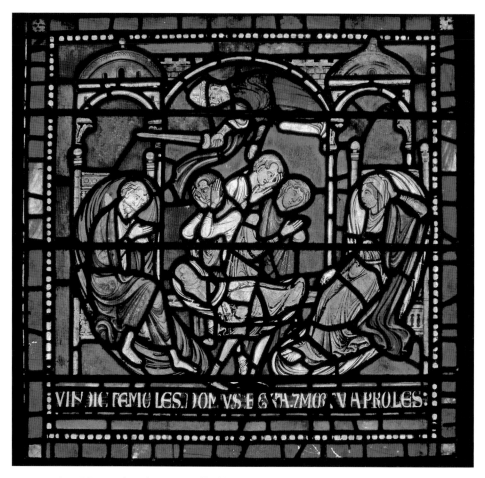

FIG. 8.7 Saint Thomas slays the Fitz-Eisulfs' eldest son. Trinity Chapel Ambulatory window n. II, Canterbury Cathedral.

to Becket's tomb, where the second panel shows her seated at the tomb, bathing her feet in a basin of holy water.[30]

My next illustration is part of a famous local story with a notoriously gruesome scene. In a series of three large and two small panels, Eilward of Westoning, a working man, is convicted of theft and then is blinded and castrated as the judge looks on. The scene of Eilward's punishment is graphic, as one man holds a knife to Eilward's eyes while another cuts his genitals (fig. 8.10). Later, Eilward lies in bed while Thomas heals his wounds. The cured man then distributes alms to the poor and visits Becket's tomb in thanks.

What is a source? And, in particular, regarding the *Canterbury Tales*, do these pictorial windows qualify? All the analogous works included in the 1941 *Sources and Analogues of Chaucer's "Canterbury Tales"* are literary. Editors W. F. Bryan and Germaine

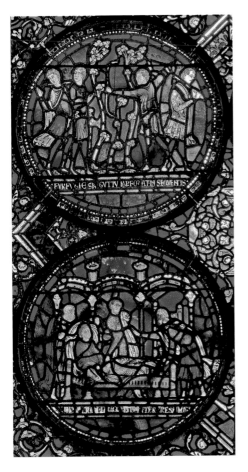

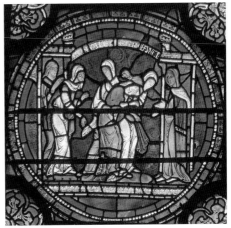

FIG. 8.8 Adam the forester is pierced through the neck by a poacher's arrow. Trinity Chapel Ambulatory Window s. II, Canterbury Cathedral.

FIG. 8.9 The nun Petronella of Polesworth undergoes an epileptic fit. Trinity Chapel Ambulatory Window n. IV, Canterbury Cathedral.

Dempster present them, insofar as is possible, "in the form in which Chaucer presumably may have been acquainted with them."[31] Robert Correale and Mary Hamel write in the 2002–5 *Sources and Analogues of the "Canterbury Tales,"* "Our primary purpose has been . . . to describe . . . all the important known written *literary* sources and analogues of *The Canterbury Tales*."[32] Thomas Farrell's concern in a 2003 essay titled "Source or Hard Analogue?" is to distinguish three categories of influence: literary "sources" that verbal evidence shows Chaucer to have drawn on directly, "hard analogues" from which Chaucer derived specific features, and "soft analogues" that provide context for Chaucer's thinking but that he could not have known.[33] I propose that Chaucer's inspiration for framing his tales as a Canterbury pilgrimage came from a nonliterary source—that is, from the storied miracle windows in Canterbury Cathedral's Trinity Chapel.

I cannot prove this conjecture. Chaucer never mentions the windows and hardly even mentions the Cathedral. The poet does, however, appear to allude to the sanctified hair breeches preserved at Becket's shrine, in Harry Bailly's words at the close of the *Pardoner's Tale*:

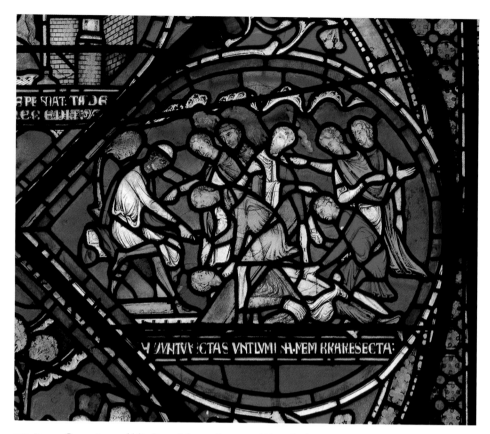

FIG. 8.10 Castration and blinding of the workingman Eilward of Westoning. Trinity Chapel Ambulatory window n. III, Canterbury Cathedral.

> "Thou woldest make me kisse thyn olde breech,
> And swere it were a relyk of a seint,
> Though it were with thy fundement depeint."
> (VI 948–50)[34]

Moreover, Chaucer's sensitivity to the narrative potential of pictorial glass, which he would have observed in churches across England and the Continent, is abundantly evident in his earlier work. The dreaming Chaucerian narrator of the *Book of the Duchess* imagines the richly detailed Trojan narrative shining in the windows of his bedchamber:

> my chambre was
> Ful wel depeynted, and with glas
> Were al the wyndowes wel yglased
> Ful clere, and nat an hoole ycrased,

That to beholde hyt was gret joye.
For hooly al the story of Troye
Was in the glasynge ywroght thus,
Of Ector and of kyng Priamus,
Of Achilles and of kyng Lamedon,
And eke of Medea and of Jason,
Of Paris, Eleyne, and of Lavyne.

(321–31)

And even this meticulous description pales beside the depiction of pictorial glass in book I of the *House of Fame*, where Geffrey finds himself in a "temple ymad of glas" (120), whose walls portray precise scenes from the *Aeneid*, narrated for more than three hundred lines (140–467). David Coley has aptly called this passage a "de facto visual text."[35] The lush detail in this introduction to Geffrey's dream testifies to Chaucer's appreciation of the imagistic artistry abundantly possible in glass:

there were moo ymages
Of gold, stondynge in sondry stages,
And moo ryche tabernacles,
And with perre moo pynacles,
And moo curiouse portreytures,
And queynte maner of figures
Of olde werk, then I saugh ever.

(122–27)

His mildly erotic description of Venus and her entourage betrays a close observation of the color and iconographic detail characteristic of glass panels:

in portreyture
I sawgh anoon-ryght hir figure
Naked fletynge in a see,
And also on hir hed, pardee,
Hir rose garlond whit and red,
And her comb to kembe hyr hed,
Hir dowves, and daun Cupido
Hir blynde sone, and Vulcano,
That in his face was ful broun.

(131–39)

The Becket miracle windows were then, as now, among the finest stained glass in Europe. It is well nigh impossible to imagine that any visitor to Canterbury Cathedral failed to view the spiritual treasure that was Thomas's shrine, or to experience the dramatically lit, brilliantly colored, artistic treasure that was the painted glass. In the mid-fifteenth-century Northumberland manuscript of the *Canterbury Tales*, the anonymous interpolated *Tale of Beryn* is preceded by a 732-line interlude that pursues the adventures of Chaucer's pilgrims in Canterbury.[36] This interlude depicts the more ignorant of these visitors examining and interpreting the miracle windows. While "The Knyghte went with his compers toward the holy shryne,"

> The Pardoner and the Miller and the other lewde sotes
> Sought hemselff in the chirch, right as lewd gotes,
> Pyred fast and poured highe oppon the glase,
> Counterfeting gentilmen, the armes for to blase.
> Diskyveryng fast the peyntour, and for the story mourned
> And ared [*interpreted*] also—right as rammes horned!
> "He bereth a balstaff," quod the toon, "and els a rakes ende."
> "Thow faillest," quod the Miller, "thowe hast nat wel thy mynde.
> It is a spere, yf thowe canst se, with a prik tofore
> To bussh adown his enmy and thurh the sholder bore."
> "Pese!" quod the Hoost of Southwork. "Let stond the wyndow glased."
> <div style="text-align: right">(lines 145, 147–57)[37]</div>

The Miller and Pardoner are poor observers, but their active interpretative efforts reenact those of almost every visitor to Trinity Chapel. Nearly six hundred years later, devotees and tourists continue to study the windows with guidebooks in hand.

Trinity Chapel's anonymous glass artists did not invent their panels' stories. The windows' representations were based on written sources: the mammoth contemporary records compiled by two Cathedral monks. Just a few months after Becket's death, Benedict of Peterborough began to record the accounts of miracles reported by recipients of the martyr's generosity. When Benedict became overwhelmed by the task, the monks commissioned William of Canterbury to join in the task in June 1172.[38] Chaucer may have encountered Benedict's account, for it was retained in the Cathedral's chapter house and was also the "most widely circulated shrine collection of the age," surviving in twenty-five complete or substantial copies.[39] It is conceivable, though less likely, that he somehow came upon William's volume, for which a presentation copy was prepared, at the king's request, for Henry II. Three reasonably full copies of it survive.[40] But, unlike the magnificent windows, the written accounts are, in purely literary terms, prosaic. Although they are extraordinary documentary records, essential for learning the backstories by which

FIG. 8.11 Saint Thomas appears to a sleeping monk. Trinity Chapel Ambulatory window n. III, Canterbury Cathedral.

historians and art historians have understood the windows' iconography, they are unlikely to have been of independent interest to Chaucer. As Rachel Koopmans puts it, "The windows' numerous narratives of Becket's miracles [were] designed to be viewed by every pilgrim visiting Becket's shrine. . . . Still, when one compares the animated figures of these panels, open to view and admired by thousands of tourists, with the texts of the Becket collections, even now locked away in specialist libraries, untranslated and inaccessible to those who cannot read Latin, it seems that some things have not greatly changed."[41]

It is possible that locals or fellow travelers habitually explicated stories for pilgrims, and possible, too, that the Cathedral's monks invited distinguished, literate visitors like Chaucer to hear a Latin reading of the stories in the chapter house. As a storyteller, he would presumably have appreciated the tale-telling. As a composer of dream poems, he may have admired a panel at the top of TCA n. III, in which a saint, presumably Thomas, appears above a sleeping man, quite likely Benedict or William, each of whom begins his collection by reporting Saint Thomas's appearance in a dream (fig. 8.11).[42] "But as I slepte," Chaucer would write of such a vision, "me mette I was / Withyn a temple ymad of glas" (*House of Fame*, 119–20). That he made such a connection is conjecture. What is certain, however, is that Chaucer, like every other pilgrim, would have tracked a well-defined path through the Cathedral, ending up in front of the windows in Trinity Chapel, where the light catches not just the eye but the mind as well.

Chaucer saw in Canterbury Cathedral's miracle windows a collection of stories exquisitely told, all of them linked by pilgrimage and by miracles of Becket's healing. Like Chaucer, the artists who commemorated Becket's martyrdom and miracles portrayed a topsy-turvy world in which a laborer's story might be portrayed as prominently as that of a knight or cleric. As Chaucer did with words, so did these artists fashion in glass a metaphoric paving of the pilgrimage path to Canterbury in the most precious ways available to their art. No literary source has been located for the Canterbury pilgrimage frame. Might not the windows' collected tales have inspired Chaucer's creation? The idea of grateful pilgrimage is scarcely to be found in such generally acknowledged literary framing sources as the *Gesta romanorum*, the *Libro del buen amor*, or the *Decameron*. The idea was right before Chaucer's eyes in Saint Thomas's glass-lit shrine of Canterbury Cathedral.

NOTES

1. In their respective chapters on "The Frame" and "The General Prologue," in Correale and Hamel, eds., *Sources and Analogues*, Cooper and Raymo offer no sources for Chaucer's creation of a pilgrimage frame in which participants tell stories. The closest analogue cited by Cooper appears in lines 46–49 in the B-Prologue to *Piers Plowman*: "Pilgrymes and palmeres pliȝten hem togidere / To seken Seint Iame and seintes in Rome; / Wenten forþ in hire wey wiþ many wise tales, / And hadden leue to lyen al hire lif after" ("The Frame," 1:21–22). Raymo notes an analogue in the opening lines of Adenet le Roi's thirteenth-century romance *Berte as grans piés*, in which the Parisian narrator recounts that a pleasant April Friday inspired him to pray at Saint-Denis, where a monk showed him a book of stories ("General Prologue," 2:6–7).

2. Walsingham and Canterbury were England's two main national pilgrimage sites. When Langland speaks of pilgrimage, he names Walsingham alongside Rome and Compostela (B.Pr.46–54; see also B.5.226), but not Canterbury. When he does mention Canterbury (B.15.444) and Thomas (B.15.522), the context is not pilgrimage but rather conversion and martyrdom. Webb names Walsingham "the most important national shrine of England after or alongside Canterbury" (*Pilgrimage in Medieval England*, 99). The evidence of popular and royal fourteenth-century pilgrimage that she offers might seem to place Walsingham first (see esp. 93–140). Duffy points out that most pilgrimages

"were to sacred sites within one's own region, journeys that might take one no further than the next parish, and rarely further than the nearest market town" ("Dynamics of Pilgrimage," 166).

3. I consulted the biographies of Chaucer by Gardner, *Life and Times*; Howard, *Chaucer*; and Pearsall, *Life of Geoffrey Chaucer*. See also Brewer, *World of Chaucer*; and Rickert, *Chaucer's World*. The idea that Chaucer lived in Kent while writing the *Canterbury Tales* is central to Strohm, *Chaucer's Tale*, published after this chapter was written.

4. Koopmans comments on the windows' distinctively popular audience: "The set of Becket's miracles put on show in Trinity Chapel is the sole miracle collection created in high medieval England for the consumption of ordinary pilgrims" (*Wonderful to Relate*, 201).

5. As Caviness puts it, "To those who had known Becket, or who had visited his miracle-working tomb in the crypt, the setting for the shrine must have been dramatic indeed. The twelve typological windows so ponderously laid out in the western part of the building were now complemented by a phalanx of twelve great windows, which shed their jeweled light on the shrine, and which recounted in over two hundred scenes the life and miracles of the 'Lamb of Canterbury'" (*Early Stained Glass*, 14).

6. Turner, "Greater London," 30.

7. Cooper broaches the possibility that the London *puy* suggested to Chaucer the idea of a storytelling competition, but concludes that "when Chaucer moved the site of his

poetry-competition outside the city walls . . . things changed decisively. . . . When the pilgrim Chaucer rode out of the city to join Harry Bailey and the company of pilgrims in the inn at Southwark, he was turning his back on a certain kind of civic performance as well as on the poetry of princely courts" ("London and Southwark Poetic Companies," 116–17).

8. One must acknowledge that Greenwich is just six river miles downstream from the city on the south bank of the Thames. Chaucer would have been able to cross over to London as needed.

9. Crow and Olson, eds., *Chaucer Life-Records*, esp. 348–478, 490–93, 504–13.

10. Brewer, *World of Chaucer*, 156.

11. Barron, in "Chaucer the Poet," 31, speculates that Chaucer might have taken lodgings in Southwark, perhaps at the Tabard. That would place Chaucer not in Kent but in Surrey.

12. *Legend of Good Women*, F 497. For example, Richard stayed at Eltham in October 1386, when he had troubles with Parliament (Crow and Olson, eds., *Chaucer Life-Records*, 369).

13. Even as he translates from Continental languages, Chaucer consistently self-identifies as English. He may do so in facetious references to struggles with the language: "Who koude ryme in Englyssh proprely" (I 1469); "Chaucer, thogh he kan but lewedly / On metres and on rymyng craftily, / Hath seyd hem in swich Englissh as he kan" (II 47–49); "O Donegild, I have noon Englissh digne / Unto thy malice and thy tirannye!" (II 778–79). Or he may do so in casual references to local English places: "fro Berwyk into Ware" (I 692); "to Londoun unto Seinte Poules" (I 509); "a fairer burgeys was ther noon in Chepe" (I 754); "This carpenter was goon til Osenay" (I 3400). The Canterbury pilgrims are, of course, uniformly English, regardless of their acquaintance with other lands. Only an Englishman would localize tales in Oxenford, in Trumpyngtoun, and in Chepe and Newegate in "oure citee" (I 4365). It makes logical and emotive sense that an Englishman would imagine a journey "from every shires ende / Of Engelond." Chaucer's Kentish connections help to explain why it was "to Caunterbury they wende."

14. Raybin, "And pave it al of silver and of gold."

15. Overlooking Canterbury on a hillside one-third mile east of the medieval city walls,

St. Martin's church is the oldest English church in continuous use. At the time of Augustine's arrival it served as a private chapel for Queen Bertha.

16. Gregory I, *Register*, 8.29; cited by Wood, "Mission of Augustine," 12.

17. Bede, *Ecclesiastical History*, 731. On the legend, see Lavezzo, *Angels*, esp. 27–28.

18. On the decorative scheme of reds and whites used in Trinity Chapel as signifiers of the mingling of Becket's red blood and white brains, see Binski, *Becket's Crown*, 7–9.

19. On the exceptionality of Becket's hair breeches, see Knapp, "Relyk of a Seint."

20. On the rapid dissemination across Europe of artistic images of Becket, see Gameson, "Early Imagery."

21. On Southwark drinking culture and prostitution from the Middle Ages through the sixteenth century, see Carlin, *Medieval Southwark*, 191–229.

22. See Jonassen, "The Inn, the Cathedral."

23. On the *Pardoner's Tale* relics in discourse with the journey to Becket's shrine, see Malo, *Relics and Writing*, 125–47, esp. 140–47.

24. See Hearn, "Canterbury Cathedral and the Cult of Becket."

25. On Becket's shrine, see Blick, "Reconstructing the Shrine"; and Tatton-Brown, "Canterbury and the Architecture of Pilgrimage Shrines."

26. On the windows, see Caviness, *Early Stained Glass*; the meticulous descriptions of each panel in Caviness, *Windows*; the lavish color illustrations in Michael, *Stained Glass*; and Todd, "Quest of the Individual." On the windows as integral to the performance of pilgrimage, see Harris, "Pilgrimage, Performance." For late twelfth- and early thirteenth-century accounts of Becket's miracles, see Abbott, *St. Thomas of Canterbury*; and Koopmans, *Wonderful to Relate*, esp. 9–18, 112–200. Koopmans's book provides an invaluable treatment of medieval English collections of miracle stories, a genre that flourished from circa 1075 to circa 1200, and reached its zenith in Benedict of Peterborough's and William of Canterbury's collections of contemporary reports of Becket's miracles.

27. Caviness writes of this window, "The window is more brilliant and saturated than the others to the west. The grounds are intense blue, appearing greenish black in some lights. Extensive

use of red in the edging lines and draperies, and of a cold yellow, gives a brilliant jewelled effect. A deeper, cooler rose purple is introduced in this window, occasionally a true murrey. As in the other windows, there is much green and white" (*Windows*, 193).

28. Caviness, in *Windows*, 193, cites Benedict. Abbott, in *St. Thomas of Canterbury*, provides Benedict's and William's Latin texts; they have not been translated.

29. Inscriptions on the panels recount the story: (1) PASTOR ALENDORVM. CVR. M PVER EGIT EQVORVM (The boy herdsman performed the task of feeding the horses); (2) SAN[S]VS SOPITVR. LEBRA SVRGENS OPERITVR (He falls asleep healthy. When he rises he is covered with leprosy); (3) OMNIB. ABIECTVS VIX SIC A. MATRE REFECTVS (Cast out by all he is thus scarcely fed even by his mother); (4) LANGVIDVS ERIGITVR. VENIT. ORAT POTAT. ABIVIT (He rises languid, he comes, prays, drinks, goes away); (5) FIT CARO QVE PRIDEM. COLOR 7 VIGOR 7 STATVS IDEM (His flesh becomes as it was before, his complexion and strength and carriage are the same); (6) . . . A MATER DOMVS SVA TOTA (. . . The mother [and] his household [gave thanks]). Texts and translations are taken from Caviness, *Windows*, 194–95.

30. Michael, *Stained Glass*, 206.

31. Bryan and Dempster, eds., *Sources and Analogues*, vii.

32. Correale and Hamel, eds., *Sources and Analogues*, 2:x (my emphasis). They go on to acknowledge that "non-literary sources—such as memory, manuscript production and illumination, and iconography—have influenced the creation of the *Tales*. In years to come, increased interest in these and similar kinds of 'sources' by Chaucerians may very likely play a more important role in shaping the contours of the successor to this volume and future collections of the sources and analogues of Chaucer's work."

33. Farrell, "Source or Hard Analogue?"

34. See Knapp, in "Relyk of a Seint," 13–16, who also notes Erasmus's disgust when he and his companions were invited to kiss the breeches during a visit to Becket's shrine early in the sixteenth century (10–13).

35. Coley, "Withyn a temple ymad of glas," 60.

36. The *Tale of Beryn* is found in Alnwick Castle, Duke of Northumberland MS 455.

37. Bowers, ed., "Canterbury Interlude," 64. This passage, and the Pardoner's behavior in the *Tale of Beryn* more generally, are treated extensively in Barr, *Transporting Chaucer*, 25–52, which appeared after this chapter was written.

38. The artists' dependence on William's and Benedict's accounts has been much debated. Caviness concludes that "at least in the random panels surviving, Benedict's text is used more frequently than William's: fifteen miracles are from Benedict (three of them told differently by William), seven are from William (two of them also told by Benedict), two or three are told by both; sixteen or seventeen of the total forty-one or forty-two are unidentified, but this is either because they represent such common diseases as lameness or leprosy, or because they are isolated scenes such as thanksgiving at the tomb, and not specific enough for exact identification" (*Early Stained Glass*, 147).

39. Koopmans, *Wonderful to Relate*, 3. Koopmans supplies lists of manuscripts containing full or partial copies of Benedict's and William's collections (211–13).

40. Ibid., 147.

41. Ibid., 134.

42. Benedict, I.i, and William, I (cited in Caviness, *Windows*, 187). See also Koopmans, *Wonderful to Relate*, 144, 147–48.

PART III

CHAUCER ILLUSTRATED

NINE

Translating Iconography

Gower, *Pearl*, Chaucer, and the *Rose*

Joyce Coleman

The influence of the *Roman de la Rose* (*Romance of the Rose*) on Geoffrey Chaucer, and on most of the other Middle English writers of his generation, is widely acknowledged. What has been little recognized, however, is the key role the *Rose* seems to have played in the visual formulation of English literary authorship in the late fourteenth and early fifteenth centuries. This chapter will explore how iconography derived from *Roman de la Rose* exemplars was variously reconfigured in (proceeding chronologically by manuscript date) the confession scene in John Gower's *Confessio Amantis* (Oxford, Bodleian Library MS Fairfax 3); the dreamer scene in *Pearl* (London, British Library MS Cotton Nero A.x); and the "sermon" scene in the frontispiece to Chaucer's *Troilus and Criseyde* (Cambridge, Corpus Christi College MS 61).

The *Roman de la Rose*, begun by Guillaume de Lorris circa 1230 and completed by Jean de Meun circa 1270, introduced many features into the medieval culture stream: the first-person-narrating author-persona who falls asleep at the start of the poem; the dream vision in which the author now figures as lover-protagonist (named l'Amant, or "the Lover"); the Lover's entry into an enclosed garden of Love, presided over by Cupid (the god of Love) and Venus; the fiery arrow that the god of Love shoots into the Lover's heart; the dreamer's love quest, which brings encounters with variously allegorized or semi-mythified others; Nature's priest, named Genius because he helps promote regeneration; and, ultimately, consummation with the love object.

In the fourteenth century Guillaume de Machaut torqued this model by sidelining the author-dreamer-protagonist; instead of the Lover, he can be a stranger to or unlucky in love, sometimes a hapless protagonist and sometimes a minor courtier eager to promote the amours of his aristocratic superiors (as Chaucer characterized himself in *Troilus and Criseyde*: "I, that God of Loves servantz serve"; I, 15).[1] Through this humble Machauvian persona, however, often gleams the self-conscious artificer of the dreamworld.

Out of the *Rose* grew a whole culture of love, which was to become synonymous with sophistication across the courts of medieval Europe. As a game, pursued either in literary form or in actual recreations from garland making to mock-tournaments, the love culture offered its players a range of postures and roles to move into and out of, as situations and inclinations suggested.[2] For late fourteenth-century Middle English authors, writing at the edge of Europe in a language read nowhere else, invocations of the *Rose* allowed them to insert themselves into an internationally recognized literary/cultural mode as well as into the ranks of serious vernacular authors. It was also a way of pleasing the Francophilic upper classes whom they served or whose approval they sought—including the teenaged King Richard II, who in the 1380s was consciously emulating the royal milieux of the French and Francophone Continent.[3]

The *Rose*'s literary influence on the major Middle English poets of the late fourteenth century is clear. One of Chaucer's first efforts was a partial translation of the *Roman de la Rose*; his early books are courtly dream visions, in which he not only adopted many lines directly from Machaut and Jean Froissart but also, more importantly, derived his bemused persona from the former; the god of Love motivates the pre-narrative of the prologues to *Troilus* and to the *Legend of Good Women*; and even many of the Canterbury tales involve courtly love directly or as the object of variously positioned critiques. In *Pearl*, another dream vision, the bereaved father's alternating conceptions of his departed daughter as rose and as pearl precisely track his moral confusion, while in *Cleanness* the poet cites Jean de Meun's "clene Rose" directly (line 1057).[4] The action of Gower's *Confessio Amantis* begins as a semi-dream vision (the authorial character does not actually fall asleep, but everything unrolls as if he had) featuring the god of Love and Venus, while its structuring principle is the Lover's confession to Genius. Even William Langland opened *Piers Plowman* with its soon-to-be-dreamer rambling on a May morning and falling asleep by a stream—a classic love-vision opening complicated by the fact that the dreamer is dressed as a hermit and that the ensuing dream is a religious vision. Yet, while willfully embedding his work in the literary trends of Continental courts, each English author reimagined that tradition to suit cultural and personal perspectives, adding features such as stronger plotting, irony, more conventional morality (a preference for married over "secret" love), or deeper spirituality.

The *Rose*'s influence on the Middle English imaginary is echoed, less famously, in the dominance that its iconography asserted over the artists who illustrated major manuscripts

of Gower, the *Pearl* poet, and Chaucer. Apart from exemplars of the *Rose* that these illuminators may have seen on the Continent, *Rose* manuscripts were known to have been in England. "As early as the 1380s," says Julia Boffey, "copies were held in the libraries of the Benedictine priory of St Martin at Dover, and of the Chapel Royal at Windsor."[5] A now-lost *Roman de la Rose* was bought for the twelve-year-old Richard II in 1379.[6] Richard's chamber knight Sir Richard Sturry owned a copy that is still extant (London, British Library MS Royal 19 B.xiii).[7] Other copies are attested from the fifteenth century, one of which survives as London, British Library MS Royal 19 B.xii.[8] The popularity of the *Rose* in England, generally, also means that the likely commissioners and/or viewers of the Middle English adaptations of *Rose* iconography would have been able to recognize them and respond knowledgeably.[9]

Echoing the authors' tactics of literary self-validation, the *Rose*-based images in the manuscripts we will be examining served both to connect the Middle English text to the high status of the French source and to mark out an independent reimagination of the tradition. This is particularly so in that the visual appropriation of *Rose* images was deployed specifically for opening depictions of the author or author-persona, and for the liminal moment before the launching of the narrative itself. We cannot be sure in any of these cases whether credit for the iconographic "translation" should go to the author (for Fairfax 3), to the manuscript's patron or (for Cotton Nero A.x) later owner, to an agent of the patron or owner, to a production supervisor, to the illuminator himself, or to some combination of the above. Yet it is remarkable that, completely independently of one another, the designer of each miniature felt a need to signal the importance of the Middle English author and text being illuminated by drawing on *Rose* imagery. The original viewers of these pictures were invited to display their transcultural sophistication by responding to the intervisual reference. Simultaneously and more subversively, they were offered the opportunity to celebrate the restaging of this prestigious iconography within an English-language context.

Gower: MS Fairfax 3, Folio 8r

John Gower finished the first version of his *Confessio Amantis* (*The Lover's Confession*) in 1390,[10] writing allegedly at the personal invitation of Richard II. The result was a work that seems intended to entertain the young king with a theme derived from the *Roman de la Rose* and the culture of love, while slipping in various moral and political reflections that could possibly help temper Richard's famous impetuosity. Created probably in the last decade of the fourteenth century, Fairfax 3 contains a small pictorial program of two illustrations,[11] one or both of which survive in nineteen of the twenty illuminated *Confessio* manuscripts that have come down to us. The first miniature illustrates the work's

FIG. 9.1 Amans confessing to Genius; John Gower, *Confessio Amantis*. Oxford, Bodleian Library MS Fairfax 3, folio 8r. 1390–99.

moralizing prologue, in which Gower recounts the biblical story of King Nebuchadnezzar's dream. Our concern is with the second image, but to understand it we first need to place it in its textual context.

The book's action begins with the character Amans (Latin for "the Lover")—whom Gower identifies in a gloss as the author "feigning himself to be a lover"[12]—wandering in a May wood, lamenting his unrequited love. Collapsing to the ground, he prays to Cupid and Venus, then immediately sees before him the "kyng of love and qweene both." The king shoots Amans with a "firy Dart" and walks on. The queen of Love, however, decides to help Amans by instructing him to make his "lover's confession" to her priest, Genius (*Confessio Amantis*, 1.98–202, quotes from lines 139, 144). Most of the rest of the long book consists of Genius examining Amans's conscience regarding the seven sins, now conceived of as sins against love; for example, has Amans shown Covetousness by wanting to have many lovers? (5.2453–99).

Fairfax 3 signals the beginning of this process—and of the narrative that flows from it—with an image of Amans kneeling to a seated Genius (fig. 9.1). Scholarly discussion of this imagery in the *Confessio Amantis* has looked to other confession pictures occurring in English manuscripts, such as books of hours, doctrinal treatises, and a *Piers Plowman* miniature (Oxford, Bodleian Library MS Douce 104, fol. 11v).[13] Kathleen Scott, the premier historian of medieval English manuscript art, notes that the gaily gowned and garlanded

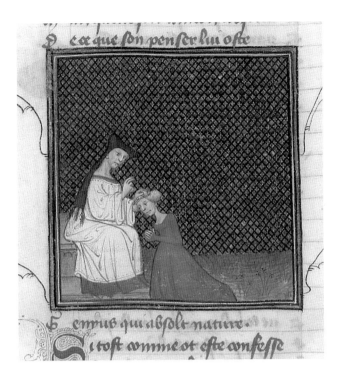

FIG. 9.2 Nature confessing to Genius; Guillaume de Lorris and Jean de Meun, *Le Roman de la Rose*. Paris, Bibliothèque nationale de France MS fr. 12595, folio 139v. 1400–1416.

confessor in Fairfax 3 looks "less like a priest than a disciple of Venus,"[14] but she does not pursue the connection further.

No discussion of the Fairfax confession miniature seems to have considered the context of Amans's confession: situated among the trappings, if not the "reality," of a courtly dream vision; initiated after confrontations with Cupid and Venus; overseen by the love priest Genius. All this narrative furniture is borrowed directly from the *Roman de la Rose*, along with the names of the dream protagonist and the confessor, and the crypto-identification of the Lover with the author. So, for that matter, is the incident, and the imagery, of a confession to Genius. This scene comes late in the *Rose*, after l'Amant has tried and failed to win his beloved (who is, in the poem's allegory, a rosebud). Nature confesses to her priest Genius that she was wrong to subject animals to men, since animals repopulate their kind much more reliably than do men. After several learned digressions, Nature again denounces men and dictates a sermon for Genius to deliver to the god of Love's army, pardoning the sins of all who serve her by promoting reproduction. Genius then absolves Nature and departs to deliver the sermon.

Whoever designed Fairfax 3's confession miniature chose to tie the author's *Rose*-derived conception still more firmly to its source by replicating imagery that would have been equally familiar to his audience. A sampling of the Nature confession scenes in *Rose* manuscripts shows that—unlike the majority of English cognates—most resemble the Fairfax picture in positioning the confessor on a bench and the confessant on her knees

FIG. 9.3 L'Amant before the Garden of Delight; Guillaume de Lorris and Jean de Meun, *Le Roman de la Rose*. Paris, Bibliothèque de l'Arsenal MS 5209, folio 1r. Fourteenth century.

leaning forward. Figure 9.2, from a French manuscript created in the early fifteenth century, resembles the Fairfax confession in its basic elements—except, obviously, for the gender of the penitent.

The designer then combined this scene with another image that occurs frequently at the beginning of the *Roman de la Rose*: l'Amant approaching the walled garden of Love for the first time, with the tops of trees visible above the walls (fig. 9.3). Thus Fairfax 3 positions its confession in front of a curved stand of trees. Genius's green gown (stippled with a small flower pattern in white) and his garland of red roses further connect him to the garden and culture of Love from which Gower borrowed him.

How might a sophisticated late fourteenth-century English viewer of the Fairfax 3 confession miniature have read the image's recombinant iconography? I believe such a viewer would have immediately recognized the threshold moment from the *Rose*, the Lover at the gates of the garden of Love. Seeing a confession scene instead of a lone male, the viewer would have realized that Nature's confession to Genius had been transferred to the Lover, and that this ritual was (as the text would bear out) the means, if any, of the Lover's penetration into the garden. That is, if Amans could learn from Genius the proper way to pursue love, access would be granted to the joys it brings. The green-robed and garlanded Genius, rather than Dame Oiseuse or Lady Idleness (as in the *Rose* itself), becomes the guardian of this particular threshold, and the viewer would be left in suspense as to whether the Lover (who at this point in the *Rose* had not yet found his love object) would ever cross it.

One clear effect of this transposed iconography is the removal of female actors. We see neither Lady Idleness as the gatekeeper nor the seductive woman sometimes shown combing her hair in "overhead shots" of the garden. Nor do we see Nature, who in the *Rose* was

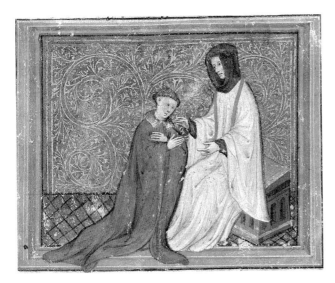

FIG. 9.4 Amans confessing to Genius; John Gower, *Confessio Amantis*. Oxford, Bodleian Library MS Bodley 294, folio 9r. First quarter, fifteenth century.

the object of Genius's ministrations. In parallel with Gower's mixed literary goals, Fairfax 3's confession miniature combines invocations of a female-associated courtly love ethos with suggestions of a more serious (and therefore male-associated) world. This masculine precinct is invoked most clearly by the collar of SS worn by Amans, with its pendant showing a swan—symbols of the wearer's loyalty to the person and family of John of Gaunt, Duke of Lancaster. Another element that adds serious overtones to the Fairfax 3 miniature is the fact that Amans appears to be an old man. Damage to the page makes it hard to be sure, but his face seems haggard and he may have a short white beard. In fact, at the end of the *Confessio* it is revealed that Amans *is* an old man, or has become one over the course of the poem—increasing his resemblance to John Gower himself, who was in his sixties when he wrote the *Confessio*. The Fairfax 3 confession miniature thus mingles political issues—signified in the Lancastrian collar and badge—with the courtly and ludic *Rose* elements communicated through visual references to the *Roman de la Rose*'s garden of Love and confession scenes. The depiction of Amans as an old man tips the image further to the political script, as it emphasizes the more serious life issues that lurk beyond the *Rose* world, and to which Gower as author wished to call King Richard's attention.[15]

As with the text of the *Confessio* itself—whose didactic Latin elements many later copies reduced or dropped—most fifteenth-century iterations of the confession scene reverted the imagery to a more simply enjoyable mode, largely by returning to the *Rose* model of an elegantly dressed young confessant. Figure 9.4 offers a representative example from Oxford, Bodleian Library MS Bodley 294. Comparing figures 9.2 and 9.4, we can see a strong basic similarity, apart from the obvious gender difference. Not only have the political tokens been removed in this version, but the double-*Rose* iconography has been simplified to a straightforward reiteration of the *Rose* confession scene.

The next manuscript in our chronological progression takes the *Rose* connection to a higher level, not just borrowing a scene and a general ethos from the French text but arguably creating a juxtaposition of visual meanings between the English image and its source.

The *Pearl* Poet: MS Cotton Nero A.x, Folio 41r

Cotton Nero A.x is the unique manuscript—the only surviving source—for two of the most famous poems in Middle English, *Sir Gawain and the Green Knight* and *Pearl*. It also contains two other alliterative poems, known as *Cleanness* (or *Purity*) and *Patience*. All four seem to be by the same anonymous poet. Not much more is known than that the dialect of the poems belongs to Cheshire[16] and that the manuscript was probably written in the last quarter of the fourteenth century.[17] Sometime between 1400 and 1415, twelve full-page illuminations were added, four of them illustrating *Pearl*.[18] The images have been often vilified for what, in a typical judgment, Malcolm Andrew and Ronald Waldron have called their "notably crude" quality.[19] Nonetheless, according to Scott, the illuminator was "certainly a professional although probably a regional artist, [who] was demonstrably aware of conventional compositions."[20]

The first of the *Pearl* miniatures—and thus the opening illumination of the manuscript—is usually identified as a variant on the standard dream-vision incipit image. It shows a man lying on a hillside, with trees in the background and a dark shape in front of him (fig. 9.5). The scene corresponds to the opening of the poem, in which a man laments the beautiful pearl that has dropped from his hand into the ground below. The metaphor quickly unravels, or complexifies, into the realization that the lost, now-buried jewel was his not-quite-two-year-old daughter. The first of the poem's twenty sections, lines 1–60, is devoted to the "dream induction," to backstory and the initiation of the dream. The father has returned to the garden where his pearl is buried. He describes both the beautiful flowers growing on her gravesite and his own constant inward struggle to accept her death. Finally, exhausted with grief, he collapses onto the grass and falls asleep. Immediately, his "spyryt þer sprang in space" (his spirit sprang thence into space; line 61), beginning the dream vision.[21]

Discussion of the sleeping/dreaming father-persona in *Pearl*'s opening illumination usually goes no further with the pose than to label it as "conventional." Scott does note an unusual hand position, however. Although the artist was knowledgeable about standard visual imagery in other ways, she feels, he was unaware of the convention for depicting dreaming, as the father "does not support his head in his hand in the traditional manner."[22] Instead, he has both hands stretched awkwardly in front of him. However, a standard *Rose* illumination offers a striking parallel to the *Pearl* image—one that has been noted by Anthony Davenport but not explored at length.[23] This is l'Amant's encounter with

FIG. 9.5 The *Pearl* father asleep on a hillside. London, British Library MS Cotton Nero A.x, folio 41r. 1400–1415.

the fountain of Narcissus. Having entered what he calls alternately the *jardin* (garden) or *vergier* (orchard) of Déduit (Delight) and enjoyed a dance with Delight himself and his company, l'Amant wanders off. Under an ancient pine he discovers a fountain, on whose marble surround is written "ilec desus estoit morz li biau Narcisus" (here below died the fair Narcissus; lines 1435–36).[24]

The narrator pauses at this point to explain the history of Narcissus and Echo—particularly how Narcissus fell in love with his own image in a fountain and lingered by the stream until he died, unable to consummate his desire. Since Narcissus's time, the narrator continues, the god of Love had ordained that whoever looked into the fountain would be seized by a hopeless passion. Foolishly or bravely, l'Amant leans over the fountain himself and is captivated by the reflection of a rosebush. He approaches the bush and sees in it a perfect rosebud, with which/whom he promptly falls in love. Thus his quest, and the rest of the poem, are set in motion.

A large proportion of the fourteenth-century miniatures that show Narcissus or l'Amant at the fountain place him lying on the ground parallel to the water, with his

FIG. 9.6 Narcissus reaching longingly toward the fountain; Guillaume de Lorris and Jean de Meun, *Le Roman de la Rose.* Paris, Bibliothèque nationale de France MS fr. 802, folio 11r. Second quarter, fourteenth century.

arms stretched out to it. Sometimes the artist has painted Narcissus's reflection in the water, or the face of a young woman representing the rosebud, so the viewer can see what the hands are reaching for; other times, as in figure 9.6, there is only water. If one flips figure 9.6, it and the *Pearl* image look like the same scene interpreted by different artists, with some details switched out.

That the resemblance between these *Rose* and *Pearl* miniatures is not accidental is suggested by several visual features. One is the trees in the background of the *Pearl* incipit. The *Rose*'s Amant has been wandering in a *vergier* (orchard), so it is not surprising to see trees behind him. In *Pearl*, the Dreamer is in an *erbere* (line 9; also lines 38 and 1171), or garden, not an orchard (or arbor).[25] There is considerable discussion of flowers (lines 27–35, 43–46) but no reference to trees. Another clue may be the hills on which both *Rose* Lover and *Pearl* father recline. In *Rose* manuscripts created before around 1400, the fountain and its rapt observer(s) are often placed on a hill, although the text says only that the stream emerged from under a pine. The designer of the *Pearl* incipit, in adding both trees and hill to the scene as described by the *Pearl* poet, was arguably drawing on the *Rose*.[26]

In this alignment of iconographic details, however, one element may seem conspicuously absent: the stream. Or it may not; it depends which scholar you agree with. Some describe the father in the incipit miniature as lying by the "flowery mound" under which his daughter is buried.[27] Others identify the shape by which the father lies as a stream,[28] although the poem does not mention any body of water in the *erbere*. A third group

admits to uncertainty. J. A. Lee, for example, notes that "the wavy area below the dreamer, although looking very streamlike, is heavily covered with these flowers and must, therefore, represent the 'huyle,' mound or clump of plants, mentioned in lines 41–44."[29]

Even given the *Pearl* artist's acknowledged defaults of draftsmanship, the serpentine shape in front of the *Pearl* dreamer looks too curvy and too large to be a child's grave mound. It does in fact look more like a meandering stream; but, then, what is one to make of the flowers apparently growing on it? An answer is suggested by an infrared photograph of the image's underdrawing, which reveals two features that suggest a stream.[30] One is that the shape starts at the lower right, then widens and continues left off the page. The second is that the flowers supposedly covering the grave mound seem actually to be rooted to one side or another of the shape, not on or in it. Hatched or parallel, curved lines presumably indicating grass do, however, sprout up from inside the shape. This layout could suggest that the shape is not only a stream but, like the water gushing from under the pine tree in Déduit's *vergier*, a springhead. Rising from the ground at the lower right, it flows off to the left, with flowers along its banks and grasses growing up through the water. This discovery removes any concern that the flowers supposedly growing on the shape eliminate identification of it as a stream.[31] If the shape is a springhead—or even a deliberately ambiguous form that can be read as spring and/or grave mound—then, along with the trees, hillside, and stretched-out arms that already link the *Pearl* incipit image to the *Rose*, it would suggest that the first *Pearl* miniature was designed to recall the fountain of Narcissus. The alleged misplacement of the dreamer's hands thus represents not a fumbling of iconographic convention but a deliberate cross-referencing of iconographies.

The parallel taps into the poet's own close involvement with the *Rose*, inviting the reader-viewer to import into the *Pearl* image some of the interpretations attached to the earlier work. The *Pearl* poet clearly draws on the French poem for his dream vision, garden setting, and modified love quest, as well as for the vocabulary of "luf-daungere" (love denial; *Pearl*, line 11) and "luf-longyng" (line 1152) that he uses to describe the father's feelings for his lost daughter. As clearly, however, the *Pearl* poet also perceived the *Rose* subtext detected by both medieval and modern readers: that pursuit of earthly love or other worldly goods is a misdirection of energies better devoted to the quest for salvation.[32] As John V. Fleming has noted, "The course of action which he [l'Amant] follows in the poem is the typical path of sin as described by innumerable medieval psychologists."[33] Many scholars see *Pearl* as presenting a softer version of this judgment. A. C. Spearing, for example, feels that "we are intended to adopt a critical attitude toward the narrator, even while feeling fully the pathos of his situation."[34]

The *Pearl* incipit's use of the *Rose*, then, is not mere fashion or window dressing, but a deliberate visual echo, intended to call attention to the father's error in grieving the physical loss of a daughter now become a blessed spirit. The miniature suggests that at least one early reader recognized the complex interweave of influences and judgments enacted in

FIG. 9.7 Chaucer reciting
from a pulpit to king and court
(lower register). Cambridge,
Corpus Christi College MS 61,
folio IV. 1400–1415.

the poem. The designer of the image responded to the poet's intertextuality with a corresponding intervisuality, inviting viewers to see in the father lying by the stream, arms outstretched, some of the befuddlement that afflicted the *Rose*'s Narcissus and Amant.

Chaucer: Cambridge, Corpus Christi College MS 61, Folio IV

The last in our series of images brings us to Geoffrey Chaucer, and to what is probably the most reproduced miniature from any Middle English manuscript: the frontispiece

to Cambridge, Corpus Christi College MS 61 (fig. 9.7).[35] A large, handsome volume, Corpus 61 was to have been extensively illustrated—spaces were left for around ninety miniatures—but only the frontispiece was ever painted. The date of the manuscript has been set as late as the early 1420s, in order to fit into the biography of a proposed patron,[36] but the hair and clothing styles shown in the image suggest that Corpus 61 was created between 1400 and 1415.[37] The commissioner or intended recipient is unknown, but the manuscript was clearly designed for a wealthy aristocratic owner—someone who would fit into the audience in the lower register of the frontispiece.

Focusing on that lower register, we see an outdoor setting in which Chaucer is apparently reciting his text to a large group of courtly listeners.[38] The man in cloth of gold who stands before the poet, making direct eye contact with him, is generally understood to represent Richard II. The woman seated in front of the king, in a low-necked gown, most likely represents Richard's queen, Anne of Bohemia. What draws us to the Corpus frontispiece is the following question: whoever designed and painted the image, why did they decide to depict Chaucer reciting his text from a pulpit? The only answer earlier scholars could offer was to compare the scene to religious manuscripts that showed bishops, priests, or monks preaching or expounding from pulpits.[39] But Chaucer was not a cleric, and *Troilus and Criseyde*—which is set in pagan Troy and concerns a secret love affair—could hardly be called a religious text.

Yet again, the *Roman de la Rose* supplies a more likely model. This example takes our survey of *Rose*-based intervisuality into the densest, most intricately meaningful configuration yet. Beyond the transfer of visual plot cues in Fairfax 3's confession scene, and beyond the transfer of implicit religious moral in Cotton Nero A.x's dreamer scene ("Reach for salvation, not fleeting earthly goods"), Corpus 61's sermon scene sets up multiple intervisual, intertextual, and even historical echoes.

The relevant passage in the *Rose* follows directly on the episode of Nature's confession to Genius, which formed the basis of Amans's confession in Fairfax 3. After absolving Nature, Genius, on her orders, flies to the camp of the god of Love and Love's barons. There he is invested with a bishop's robes and mounts into a pulpit to deliver his sermon urging men to engage in reproductive sex, in order to repopulate the world. Genius's words inspire the barons to a final, successful attack on the rosebud's castle, allowing l'Amant to achieve consummation.

Dozens of surviving *Rose* manuscripts offer images of Genius in his pulpit. Sometimes he wears his bishop's miter, but in early manuscripts he tends to sport a simple amice (a kind of hood-hat) and speaks from a pulpit draped like that of Chaucer in Corpus 61 (fig. 9.8). Genius usually looks like a normal cleric delivering a sermon—except that the audience frequently contains a winged and crowned man, the god of Love, and near him, often a woman representing Venus. No surviving depiction of a *Rose* sermon is as fully imagined as that in Corpus 61, but the basic outline is remarkably similar: an unpriestly

FIG. 9.8 Genius preaching to the god and barons of Love; Guillaume de Lorris and Jean de Meun, *Le Roman de la Rose*. New York, Pierpont Morgan Library MS M.324, folio 129r. Circa 1350.

priest or nonclerical male in a pulpit, delivering a mock-sermon on sexual relations, addressing a king and queen (of Love) and their followers.

A visual parallel between Chaucer in a pulpit and a bishop preaching from the Bible does not seem to add anything to the elaborate image in Corpus 61. But a visual parallel between Chaucer and Genius adds many things, all of them consonant with the nature of *Troilus and Criseyde*'s author, text, and audience. First of all, Genius's sermon matches Chaucer's text much more successfully: both are concerned with sex and employ a pagan setting to get away with it. Sylvia Huot sees Genius in the *Rose* as a type of the poet, whose sermon "elaborates an extended metaphor of fruitful sexual coupling as an act of writing."[40] If the designers of the Corpus frontispiece had some such perception, then it made sense for them to put the figure of Chaucer in Genius's pulpit—even more so because Chaucer's alter ego in *Troilus and Criseyde*, Pandarus, seems to "write" the romance of Troilus and Criseyde by maneuvering them into a sexual relationship. Chaucer himself creates an equivalence, imagining Pandarus in Genius's pulpit when he notes that Pandarus was an unlucky lover, "koude he nevere so wel of lovyng preche" (however well he knew how to preach about love; II, 59).

The pulpit and the "preacher" match up exactly, and the audience are not far behind. The figures usually interpreted as Richard II and Anne of Bohemia in the Corpus frontispiece stand in the same position relative to Chaucer as Cupid and Venus hold relative to Genius. The deity-to-royalty equation is already present just under the surface of *Troilus and Criseyde*'s prologue, which repeatedly invokes the god of Love as the master of a group of "loveres, that bathen in gladnesse" (I, 22). This masterful figure makes a repeat appearance in the prologue to Chaucer's next composition, the *Legend of Good Women*. There he offers a *Rose*-based scenario similar to the one presented by Gower at the start of the *Confessio*'s narrative. In the *Legend* prologue, Chaucer's persona has a

dream vision in which the god/king of Love rebukes him for mis-service to love and to women—specifically, for telling the story of Criseyde's betrayal of Troilus (F 329–33). Alceste, the god of Love's consort, defends the poet and orders him to redeem his error by writing stories about good women. In the *Legend* prologue, the crossover of Love/Richard and Venus/Anne is made almost explicit, with the prudent substitution of the mythological character Alcestis—the archetypal good wife who voluntarily died in place of her husband—for the dodgier Venus. Chaucer has Alceste remind Love that he is "a god and eke a kyng" (F 431), alerting readers to the play on identities, and reflecting back on the identity of the god of Love in the *Troilus and Criseyde* prologue. Alceste also names two royal castles when instructing the poet to deliver the finished *Legend of Good Women* to "the quene, / On my byhalf, at Eltham or at Sheene" (F 496–97). The fact that her name begins with an *A*, like Anne's, is another clue to Alceste's identification with the queen of England. A similar reference occurs in *Troilus and Criseyde*, where Chaucer introduces the character of Criseyde with the remark that "Right as oure firste lettre is now an A, / In beaute first so stood she, makeles" (I, 171–72).

This kind of oblique identification was a common trait of coterie poetry—little cues thrown out to create a sense (true or not) that the author and his audience were members of an exclusive inner circle. Gower plays the same game: at the end of the *Confessio*, young lovers appear adorned after "the newe guise of Beawme," or Bohemia (8.2470)—surely a veiled compliment to the fashionable Queen Anne. It seems equally likely that the god of Love who dominates the prologue of *Troilus and Criseyde* was a reference to King Richard. In identifying himself as "I, that God of Loves servantz serve" (I, 15), Chaucer was not only placing himself in a role similar to that of Genius in the *Rose*, but also implying his service (accurately or not) to Richard and his court.

The designers of the Corpus frontispiece, therefore, used the intervisual clue of a lay poet in a pulpit to set up a cascade of crossover identifications: from Genius to Chaucer, from the god of Love and Venus to King Richard II and Queen Anne, and from the barons of Love to the Ricardian court. In doing so, they picked up on cues already present in Chaucer's own invocations of *Rose* parallels: the god of Love, the service to Love, and the service to the servants of Love, invoked in the prologue; and the idea of Pandarus preaching about love. As well, the image's designers played on the expected viewers' ability to recognize and interpret these links—to remember back to a young king whose court the chronicler Thomas Walsingham had described as "more knights of Venus than of Bellona."[41] This time-capsule effect forms the culminating resonance of the Corpus frontispiece: an image created during the reign of Henry IV or at the latest during the reign of Henry IV's son, which presents an idyllic scene of Chaucer reciting his poetry to the court of the man whom Henry IV deposed and probably had murdered in 1399.

What makes this work—as neither bloody hypocrisy nor dangerous insult to Lancastrian majesty—is the Richard/Cupid parallel. The man in cloth of gold before Chaucer

is not the king of England—he does not, in fact, wear a crown (though his wife wears a diadem). He is the god of Love—Richard in play mode, the frivolous, uxorious young man who fumbled a kingdom away. Gloriously attired and proudly erect, he is celebrated, in this presentation, only for his patronage of Geoffrey Chaucer. In showing Chaucer as standing higher in the visual space than his monarch, the Corpus artist deliberately flouted one of the cardinal rules of medieval illumination: that people's height in the picture space reflect their social importance. Priests, however, as representatives of divinity, can stand higher even than kings, and so Chaucer—as a sort of priest through his identification with Genius—is allowed to out-top the hapless Richard. Read through the *Rose*, thus, the Corpus frontispiece becomes a monument to Geoffrey Chaucer, whose greatness earned him royal patronage and left him standing higher, in the view of the early fifteenth century as in later times, than the failed monarch himself.

Conclusion: The Medieval Visual Aesthetic

I have a sneaking suspicion that some medievalists who might read this chapter would think, "Well, of course, it's obvious that English illumination would be influenced by *Roman de la Rose* iconography." But (as far as I am aware) no one has published such an analysis before, and I am not sure why. One general reason may be the atmosphere of low expectations that surrounds Middle English manuscript art. Herbert C. Schulz, for example, states, "It is recognized that medieval English manuscripts in the vernacular are not notable as a class (in contrast to such a group as the books of hours) for the excellence and elaborateness of their decoration." Schulz attributes the difference to the historically low prestige of the English language, offset only in rare cases such as the Ellesmere manuscript of Chaucer's *Canterbury Tales* (San Marino, Huntington Library MS El 26 C 9) and the Corpus manuscript of *Troilus and Criseyde*.[42] As opposed to English-made (mostly religious) manuscripts in Latin, illumination came late to Middle English manuscripts, and it was never as abundant as in French and Burgundian literary exemplars.[43]

More specifically, this same deprecatory attitude has pervaded discussions of iconography. In a 2007 book titled *Tradition and Innovation in Later Medieval English Manuscripts*, Scott allows for some creativity in the illustration programs of the five manuscripts on which she focuses (only one of them in English, none of them literary). However, her general conclusion is that even in these exemplars the iconography "was largely traditional, if at the same time showing a few skimpy signs of change."[44] Earlier in her book Scott remarks that "the phenomenon of recycling subject matter and iconography is observable in a variety of commonly illustrated texts of the [late medieval English] period: missals, psalters, books of hours, chronicles, law books, medical texts, and certain literary texts by contemporary authors such as those of Chaucer, Gower, and Lydgate."[45]

Words such as "traditional" and "recycling" may point to the problem here. Literary scholars are unlikely to speak of Gower or Chaucer simply "recycling" tales taken from Ovid or other sources, and few would any more consider Malory an inferior writer because he draws on traditional stories and language in the *Morte Darthur*. Intentional, meaning-laden manipulation of preexisting models is how the medieval aesthetic largely worked. To appreciate this aesthetic in action, readers or viewers must know the larger literary or artistic context in which the author or illuminator was working, and they must move beyond the end-stopping language of "convention," "tradition," and "imitation" to a more dynamic sense of artistic conceptions in cultural play.

The complex iconographic strategies uncovered in the *Confessio*, *Pearl*, and *Troilus and Criseyde* miniatures discussed above suggest that originality and insight could be expressed in Middle English illumination through an intervisuality that, as we have seen, intelligently complemented the texts' intertextuality. The three miniatures show their designers turning to the *Roman de la Rose* not for rote models but in order to shape the visual presentation of Middle English authorship and of Middle English poetry in the period of its emergence as a valid literary medium. In doing so, they effectively "translated" a prestigious Continental conception of authorship into Middle English.

NOTES

1. Burrow, in "Portrayal of Amans," 6–7, offers a cogent analysis of Machaut's and Froissart's devolution of the *Rose* persona, as it influenced John Gower.

2. Stevens, *Music and Poetry*, 154–202; and Green, *Poets and Princepleasers*, 101–34.

3. Bennett, "Court of Richard II," 9.

4. References to the works of the *Pearl* poet come from *The Poems of the Pearl Manuscript*, edited by Andrew and Waldron.

5. Boffey, "English Dream Poems," 115–16.

6. Clarke, *Fourteenth Century Studies*, 122n1.

7. McFarlane, *Lancastrian Kings*, 185. A digitized color facsimile of this manuscript may be viewed at *British Library Digitised Manuscripts*, s.v. "Royal MS 19 B XIII."

8. Boffey, "English Dream Poems," 116. See *British Library Catalogue of Illuminated Manuscripts*, s.v. "Royal MS B XII."

9. Lynch, "Dating Chaucer," 13; and Boffey, "English Dream Poems," 113.

10. Despite the Latin title, *Confessio Amantis* is a Middle English text—augmented, however, with Latin verses and prose glosses supplied by the author.

11. Most scholars currently doubt the older hypothesis that Gower himself supervised the making, revision, and illustration of Oxford, Bodleian Library MS Fairfax 3. I personally think he did, but as there is not space here to debate the point I will follow the majority view.

12. "[F]ingens se auctor esse Amantem" (gloss next to *Confessio Amantis*, 1.59). References to the works of Gower are from Gower, *English Works*.

13. Scott, "Limner Power," 24–25, and *Later Gothic Manuscripts*, 2:110.

14. Scott, *Later Gothic Manuscripts*, 2:110.

15. See Coleman, "Illuminations in Gower's Manuscripts."

16. *eLALME*. Cotton Nero A.x is classified as LP 26, Grid 397 364.

17. Doyle, "Manuscripts," 92; and Scott, *Later Gothic Manuscripts*, 2:66.

18. Scott, *Later Gothic Manuscripts*, 2:68.

19. Andrew and Waldron, "Introduction," 4.

20. Scott, *Later Gothic Manuscripts*, 2:67; see also Horrall, "Notes on British Library, MS Cotton Nero A x," 196.

21. Unless otherwise indicated, translations are mine. Gollancz, in "Introduction," 9,

proposed that the tail of the father's hat, which the wind seems to be blowing out behind and above the sleeper, is perhaps meant to suggest "that the spirit of the dreamer has 'sped forth into space'"—that is, into his dream vision.

22. Scott, *Later Gothic Manuscripts*, 2:66–68; quotes from 67.

23. Davenport, "*Pearl* and Its Illustrations."

24. References to Guillaume de Lorris and Jean de Meun's *Roman de la Rose* come from the edition of Félix Lecoy.

25. Editions of *Pearl* consistently gloss *erbere* as "garden" (e.g., Andrew and Waldron's edition, 53, note to line 9).

26. At various points, the text of *Pearl* describes the father as lying on a "huyle," "hyul," and "hylle" (lines 41, 1205, 1172). The scholarly consensus is that all these words mean not "hill" but "mound," as in "grave-mound" (see, e.g., Gollancz's edition, 119, note to line 41; and Andrew and Waldron's edition, 326).

27. See, for example, Gollancz, "Introduction," 9; and Gordon, "Introduction," x.

28. See, for example, Edwards, "Manuscript," 202; and Andrew and Waldron, "Introduction," 3.

29. Lee, "Illuminating Critic," 28.

30. Unfortunately, I could not obtain the British Library's permission to reproduce this image. To see it, go to British Library *Medieval Manuscripts Blog* post cited as Harrison, "Gawain Revealed." A detail of an earlier version of the photograph has also been printed in Hilmo, *Medieval Images*, fig. 46, and " Power of Images," 176 (fig. 17).

31. Hilmo, who published an image of the underdrawing in 2004, argues that the curvy shape was created by the original artist or someone else painting a swath of blue over what had previously been "yellow grass," "just a continuation of the flowery meadow on the hillside" (*Medieval Images*, 148, and fig. 46; see also "Power of Images," 176–77 and fig. 17). However, the underdrawing shows that the curvy shape

was outlined as part of the original conception of the picture. The dark color may indeed have been produced by blue painted over yellow, but presumably also as part of the picture's original design. This is because the bright red and white flowers currently visible above the surface of the curvy shape must have been painted in over the blue wash. If they had been painted before the blue was applied, they would have disappeared or at least faded under it.

32. For the famous *querelle de la Rose* or *des femmes*, see Baird and Kane, eds., *La Querelle de la Rose*.

33. Fleming, *"Roman de la Rose,"* 50.

34. Spearing, "Symbolic and Dramatic Development," 4.

35. For more detailed discussion and references on what follows, see Coleman, "Where Chaucer Got His Pulpit." A complete digitization of Corpus 61 is available online; see *Parker Library on the Web*.

36. Scott, "Limner Power," 74.

37. Margaret Scott, *Visual History of Costume*, 53 (plate 44), 56–57 (plates 49–51), 63–66 (plates 58–62). Scott dates the *Troilus and Criseyde* frontispiece to circa 1400 (unpaginated color plate 45).

38. Although the picture is often captioned "Chaucer reading to the court," he does not have a book.

39. Pearsall, "*Troilus* Frontispiece," 72; Salter, "*Troilus* Frontispiece," 17, 19.

40. Huot, *"Romance of the Rose,"* 267.

41. Richard's favorites "milites plures erant Veneris quam Bellonae" (were more knights of Venus than of Bellona) (Walsingham, *Historia anglicana*, 2:156).

42. Schulz, *Ellesmere Manuscript*, 39.

43. Scott, "Illustrations of *Piers Plowman*," 2–4.

44. Scott, *Tradition and Innovation*, 147.

45. Ibid., xi.

TEN

"Qui bien aime a tarde oblie"

Lemmata and Lists in the *Parliament of Fowls*

Martha Rust

From its flowers blossoming "white, blewe, yelwe, and rede" (line 186), to its "colde welle-stremes" sparkling with "smale fishes lighte / With fynnes rede and skales sylver bryghte" (lines 187–89), to its grove of trees, whose rustling "noyse softe" (202) pleasingly accompanies the angelic harmony of birds singing on "every bow" (line 190), to its very air, laced with the fragrance of "every holsom spice and gras" (line 206), the description of the dreamscape of the *Parliament of Fowls* invites a reader or listener to imagine it with multiple senses. At the same time, what the narrator seems most to remember about the walled "park" (line 122) of his dream is what he saw. From his recollection of his first moment in the garden through his description of the Goddess Nature (lines 169–322), the narrator uses verbs of seeing sixteen times, most frequently "I saw" or "saw I."[1] Any member of Chaucer's audience might have responded to this sightseeing account by calling to his or her mind's eye a luxuriant English garden in high summer. For particularly well-read members, these sightings might also have recalled similar scenes in Chaucer's sources for this passage, especially Boccaccio's *Teseida*, with its equal preponderance of verbs of seeing, though in the third person.[2] Less erudite readers might have visualized bookish sites as well: the verdant growths flourishing in the margins of books of hours, which often include a variety of fauna inhabiting their flora, or pastoral scenes at center page in miniatures for the Annunciation to the Shepherds.[3]

FIG. 10.1 Bird names in the *Parliament of Fowls*. Oxford, Bodleian Library MS Fairfax 16, folio 124v.

But if the narrator's recollected acts of seeing in his dream draw readers into seeing it along with him—seeing simultaneously scenes from other books—his recollected act of reading Cicero's *Dream of Scipio* similarly holds the potential of drawing a reader's attention to his or her own act of reading and to the visual features of the book at hand:

> Nat yoore
> Agon it happede me for to beholde
> Upon a bok, was write with lettres olde,
> And therupon, a certeyn thing to lerne,
> The longe day ful faste I redde and yerne.
>
> (lines 17–21)

Noting first his book's script and then his purposeful and prolonged engagement with it, the narrator portrays himself as a bibliophile and ardent reader in action. If a reader encountering this portrayal in any of its fourteen surviving manuscript copies followed

FIG. 10.2 Bird names in the *Parliament of Fowls*. Oxford, Bodleian Library MS Fairfax 16, folio 125r.

the narrator's cue and paused for a moment to "beholde upon" his own book, he could have felt a twinge of pride in comparing it to the narrator's, for unlike his copy of *Scipio's Dream* "write with lettres olde" (later we learn that it is quite worn, "totorn" [110], as well), manuscript copies of the *Parliament of Fowls* are almost exclusively executed in an *au courant* cursive script and set out on pages with wide margins and with stanzas either spaced or clearly marked with paraph marks.[4] With the exception of the copy in the homemade Findern manuscript (Cambridge, Cambridge University Library MS Ff.1.6), all the witnesses begin with decorated initials or show signs of such initials having been either planned for or lost.[5]

Among this group of generally well-wrought instances of the poem, two stand out for having also been equipped with details of page layout that would aid a reader who would emulate Chaucer's purposeful narrator in his seeking through his reading "a certeyn thing to lerne." In both Oxford, Bodleian Library MS Bodley 638 (ca. 1450–75) and MS Fairfax 16 (ca. 1450), the *Parliament* is supplied with running titles that help readers quickly find this particular text.[6] Other devices call readers' attention to aspects of the text they might

FIG. 10.3 Bird names in the *Parliament of Fowls*. Oxford, Bodleian Library MS Bodley 638, folio 102r.

not otherwise have noticed: a red-ink manicule in Bodley 638, for instance, points out the proverbial sentiment "office uncommytted ofte anoyeth" (line 518), while nota marks in Fairfax 16 highlight six passages as being of interest.[7] In addition, the scribes of these two manuscripts have taken the further step (not seen in any of the other witnesses to the poem) of underlining in red ink the names in two lists that Chaucer adapted from earlier works: the names of tragic lovers (lines 286–92), borrowed from Boccaccio's *Teseida* and Dante's *Inferno*; and the names of birds immediately preceding their debate (lines 330–64), borrowed primarily from Alan of Lille's *De planctu Naturae* (figs. 10.1–10.4).[8] Looking beyond the *Parliament* in these two manuscripts, we find that their scribes have underlined words in other Chaucerian texts as well: the Fairfax 16 scribe underlines proper names, place names, and some key terms in all the Chaucerian works in the volume, while the Bodley 638 scribe devotes the same kind of attention only to the *House of Fame*.[9]

The uniform application of underlining to the two lists of names in these copies of the *Parliament*, together with the prevalence of underlining in other Chaucerian works the manuscripts preserve, calls for an explanation that goes beyond attributing it to the

FIG. 10.4 Bird names in the *Parliament of Fowls*. Oxford, Bodleian Library MS Bodley 638, folio 102v.

ingenuity of individual scribes. An examination of the traditional uses and practical effects of underlining in medieval manuscript culture suggests first of all that the underlining in these manuscripts marks Chaucer's poetry as an object of a particular method of study, one in which underlining indicates words with connections to previous texts—connections that are worthy of readerly reflection and comment. Would the owners of Bodley 638 and Fairfax 16 have looked at the many underlined names in these volumes and recognized their allusions to Boccaccio, Dante, Ovid, and Alan of Lille, among others? Considering what we know of these owners' biographies and what we may deduce regarding their education and reading background, it would be prudent to concede "probably not." That said, it would be reasonable to suppose that many of the names would have been remembered from books they had read—or heard read—in the process of learning Latin and French during their youth. In this regard, the underlining of the listed lovers' names and birds' names in the *Parliament* makes an especially powerful visual appeal to memory—memory of a time when lists of words were part of the order of the school day. That was a time in our book owners' lives during which they would also have learned from Cato to read

FIG. 10.5 "Que bien ayme a tarde oublie." Oxford, Bodleian Library MS Fairfax 16, folio 129v.

books and to remember what they had read: "Libros lege. Quae legeris, memento."[10] Having followed Cato's advice and remembered the underlined names from their grammar school years, these book owners and readers might have also improved on Cato by adding a few words to one of the final lines of the *Parliament* in these two manuscripts (figs. 10.5, 10.6), changing "Qui bien aime a tarde oblie" (He who loves well forgets slowly) to "Qui bien aime les livres et la lecture a tarde oblie ce qu'il a lu" (He who loves well books and reading forgets slowly that which he has read).[11]

Words on Lines

The history of underlining in medieval Europe is a history of the practice of identifying words or phrases from a text that bear study in isolation. The word in modern English for such fragments of texts is *lemma*, the etymology of which aptly conveys the technological requirements of such study. A derivation of the Greek word λαμβάνειν (*lambanein*),

FIG. 10.6 "Que ben ayme atarde oblye." Oxford, Bodleian Library MS Bodley 638, folio 110r.

"to take," *lemma* denotes a word or phrase taken out of its original context and recopied in a separate codicological space for purposes of annotation or commentary.[12] In contemporary scholarly editions—*The Riverside Chaucer*, for instance—this kind of word or phrase may be reprinted at the end of the edited text in a section called "Explanatory Notes," where it may appear in bold so as to clearly distinguish it—the lemma—from its commentary. During the Middle Ages the placement of lemmata and their commentaries varied, but wherever they were positioned the medieval equivalent of a boldface font was underlining in red ink. In the following discussion, I will track this red-ink underlining from the margins of biblical texts written in the twelfth century, to pages of apparatus either appended to or wholly separated from the text, to passages inserted within the body of Middle English texts.

As Malcolm B. Parkes has explained, a humble stroke of red or black ink under a word or phrase in a text came into use in twelfth-century Paris as a component of a new system of page design that was then being developed to facilitate academic study of a text.[13] For study of the Bible, this system is perhaps best exemplified in copies of Peter Lombard's

FIG. 10.7 A lemma in a psalter with Peter Lombard's commentary. Oxford, Bodleian Library MS Auct. D. 2. 8, folio 116r (detail).

commentaries on the Psalms and Pauline Epistles, on the pages of which readers had convenient access to the biblical text and to the Lombard's commentaries, including quotations from his sources. Consider, for instance, the Lombard's commentary on Psalm 51 at the top of folio 116r in Oxford, Bodleian Library MS Auct. D. 2. 8 (fig. 10.7).[14] At the top of the left column, verse 7 of the psalm, begun on the facing leaf with "Propterea Deus destruet te in finem; evellet te, et emigrabit te de tabernaculo tuo" (Therefore will God destroy thee for ever: he will pluck thee out, and remove thee from thy dwelling place), concludes with the words "*et* radic*em* tu*am* de terra viventium" (and thy root out of the land of the living).[15] In the column on the right, the thicket of highly abbreviated Gothic minuscule appears impenetrable until we spot the words underlined in red: first "*et* radic*em* tu*am*," which is followed by "evellet" (will pluck), the verb that governs this clause; and then "de t*er*ra viventiu*m*," glossed by "*id est* beatitudine *sanctorum*" (that is, from the blessedness of the saints). There follow two levels of commentary, first a line from Augustine's commentary on this verse, "Radix n*ost*ra caritas e*st*" (Our root is our charity) and then the Lombard's, which incorporates further quotations from Augustine:

> q*ua* radicati sum*us* in te*r*ra viventiu*m*: de q*ua* radix h*ujus, id est* voluntas eradica-t*ur*, q*uia* n*on* est alti*us* fixa p*er* caritatem, *sed* e*st* in pe*t*ra arida *et* sterili, supra q*uam* iacta semina aruer*unt*, q*uia* n*on* h*ab*ebant humore*m*. Ecce Doech, *id est* motus, un*de* loq*uitu*r tit*ulus*. H*ic* est *enim* pulvis que*m* p*ro*jicit vent*us* a facie t*er*r*ae. Vel* radix mali, e*st* cupiditas, q*uae* n*on* parit fructu*m* in te*r*ra viventiu*m*. *Vel* sp*eci*alite*r* de Anti*christ*o loquitu*r*, c*ujus* radix s*unt* ministr*i* ejus, qui *cum* eo ni*h*il h*ab*ebu*nt*, *cum s*anc*t*is.

whereby we are rooted in the land of the living, from which the root of desire is eradicated because it is not established deeply enough through charity but in

parched and barren rock instead, on which scattered seeds wither because they have no moisture. Behold Doeg, "earthly movement," of whom the heading (of the psalm) speaks; he is indeed the dust that the wind sweeps from the face of the earth. Put another way, desire is the root of evil, which does not bear fruit in the land of the living. Or if you will, the verse speaks specifically of the Antichrist, whose root is his ministers, who with him have nothing to do with the sacred.[16]

On visually complex pages such as this one, the red-underlined lemmata amid a profusion of commentary give the clear impression that a lemma is a unit of discourse with significance far in excess of the meaning the same word or phrase had in its original scriptural environment. Indeed, we might apply a metacommentary to the lemma *radicem* from Psalm 51 in MS Auct. D. 2. 8, observing that the lemmata on the margins of a page of Scripture are the roots of many branches of commentary.

As early as the late twelfth century, lemmata were taking root in a variety of new environments. Already they were becoming part of the margins of nonbiblical "scripture"— especially in copies of the *Concordia disconcordantium canonum* (otherwise known as the *Decretum*), the influential harmonization of canon law by the twelfth-century Italian jurist Gratian; in copies of the Justinian *juris civilis* with its gloss by Accursius (ca. 1182–1263); and in copies of Peter Lombard's *Sentences*—where the use of lemmata, underlined either in red ink or the ink of the commentary's text, would seem to have been the norm.[17] Meanwhile, the branches of commentary on the Bible had so proliferated that it became necessary to uproot them, lemmata and all, from the scriptural page and give them their own pages, first at the end of a given biblical text, and eventually in volumes of their own. Known by the term *postilla*, probably an abbreviation of the Latin phrase "post illa verba textus" (after those words of the text), this format for biblical commentary is most extensively realized in the monumental *Postillae perpetuae in universam sanctiam scripturam* of Nicholas of Lyra (1270–1349), which is usually produced in separate volumes for each book of the Bible.[18] Though *postillae* were increasingly removed from the Bible itself, their writers followed the by-now traditional practice of underlining lemmata in red and arranging them in the order of the biblical text so that, with a Bible at hand, a reader using a *postilla* could move easily from commentary to lemma to biblical text, and back the other way: from biblical text to lemma to commentary.

The practice of underlining words and phrases in red ink was eventually applied to copies of Middle English texts as well—most notably to copies of William Langland's *Piers Plowman*—though so far scholars have understood it as a method of lending a given word emphasis rather than as evidence of the commentary tradition cropping up in the terrain of vernacular texts. In this way, C. David Benson and Lynne S. Blanchfield have given the label "emphasized words" to words underlined or boxed in red ink in B-Text manuscripts of *Piers*, and Noelle Phillips builds her examination of the underlining of words in the witness

to *Piers* in Oxford, Corpus Christi College MS 201 on an assumption that the practice is a means of "accenting" them.[19] This is a perfectly reasonable assumption, for certainly underlining words does accent them. What is more, unlike their counterparts in the scholastic setting, underlined words and phrases in copies of Middle English texts are wholly innocent of any accompanying commentary: adopting a figure from the prologue to the *Legend of Good Women*, they are "naked" except for their underlining.[20] That said, in keeping with the etymological sense of *lemma*, most of the underlined items in copies of *Piers Plowman* are "taken" from other texts—from the Bible or the liturgy, for instance—and the same is true of the underlined names in the Bodley 638 and Fairfax 16 copies of Chaucer's *Parliament*. Granting their similarity to lemmata on that score, might underlining in copies of Middle English texts also function to mark such lexical extractions as objects of exegesis, thereby functioning as virtual lemmata, calling forth mental commentaries on the part of readers?[21]

Answering this question in the affirmative would entail locating readers with both some exposure to the *mise-en-page* of scholastic manuscripts and some knowledge of the texts from which the underlined items were taken, which they would use in formulating their mental commentary. In his influential essay "The Influence of the Concepts of *Ordinatio* and *Compilatio* on the Development of the Book," Parkes makes an observation that could be interpreted as a subtle challenge to identify such readers: as that essay draws to a close, he notes the adoption of elements of page design such as running headings, chapter titles, and underlining "even in well-produced copies of vernacular texts which do not presuppose an academic readership."[22] Taking up Parkes's implicit challenge to match readers with a modicum of bookish sophistication to these copies of vernacular texts, I would nominate the narrator of Chaucer's *Parliament*, a lover of books and reading on a quest to learn a certain thing; and, behind him, Chaucer himself, "not a scholar," as Derek Pearsall asserts, but a poet and lover of words whose education and many "day jobs" would have given him the acquaintance with academic books that his own poetry suggests he had.[23] Moreover, for emulators of that example, I would nominate the reading owners of such "well-produced" copies of Chaucer's *Parliament* as Bodley 638 and Fairfax 16. A consideration now of those readers' biographies together with a sketch of the educational options available to men of their day will pave the way for a consideration of the kinds of mental commentary they might have supplied for the underlined names in their copies of the poem.

Two Gentlemen and Their Books

In his introduction to the facsimile of Fairfax 16, John Norton-Smith dubs the manuscript "a good gentleman's library copy," a description that might erroneously call to mind over-stuffed leather-upholstered chairs and tweed jackets were it not for the scholarly books and articles on "gentry culture" that have accumulated since the publication of the Fairfax

16 facsimile in 1983.[24] With the aid of those studies, it is possible to class both manuscripts under consideration here as part of a larger fifteenth-century gentry phenomenon, in which anthologies of lyrics by Chaucer, Lydgate, Hoccleve, Clanvowe, and assorted anonymous poets projected a world of fashionable, aristocratic sentiments and behaviors and constituted "mini-libraries" for their owners.[25] Those gentry owners ranged in wealth and prestige from the Pastons, who rubbed shoulders with the English aristocracy, to provincial landowners like the Finderns of Derbyshire.[26] As readers, though, their social and economic differences were leveled, for these anthologies' overlapping contents bespeak shared connections to the routes through which their exemplars circulated.[27] Thanks to that horizontal network, owners of these collections were members of an extended reading community whose interests also included romances, histories, and works offering advice on how best to conduct oneself in both private and public spheres.[28] The armigerous John Stanley, who owned Fairfax 16, and the anonymous yet evidently Latinate owner of Bodley 638 typify in miniature that reading community, for although these men likely stood on distant rungs of the ladder of late medieval English gentry society, the anthologies of English poetry they owned, Fairfax 16 and Bodley 638, share fifteen texts. In addition, the career and social rank of the former and the marginal comments of the latter suggest a similar level of education, one that would have enabled them to make similar responses to the underlined names in these volumes' copies of the *Parliament*.

Internal manuscript evidence points strongly to John Stanley, Esq. (1400–?1469), as Fairfax 16's commissioner and first owner: the coat of arms in the lower border of its frontispiece is of the Hooton branch of the famous Cheshire Stanley family, while the manuscript's inclusion of English translations of works by Charles d'Orléans helps to single out John Stanley, Esq., as its patron.[29] As Sergeant of the Armory in the Tower (1431–60), this Stanley was charged in 1450 with the safekeeping in Westminster Palace of d'Orléans's close friend William de la Pole, Duke of Suffolk, during which time, as Norton-Smith hypothesizes, he may have come into possession of copies of the poet's works that have been preserved in Fairfax 16. An exemplar of a class Michael Bennett terms "expatriate careerists," men from the northwest of England who pursued favor and influence at court in London, John Stanley, Esq. (hereafter Stanley), held many positions over the course of his career.[30] Among them, it was perhaps his post as "the urbane usher of the household of Henry VI" (1440–55) that had the greatest influence on his taste in literature and that also accounts, as Norton-Smith has observed, for the "'metropolitan' standard" of the frontispiece of Fairfax 16.[31] Indeed, in his discussion of the ownership by Sir John Stanley, Stanley's more famous relative, of an "*édition de luxe*" of Peter Comestor's *Historia scholastica* in its French translation by Guiart des Moulines (now Paris, Bibliothèque nationale de France MS fr. 2), Norton-Smith declares that the poetry gathered in Fairfax 16 "was not 'in the hands of philistines'" but rather "survives as witness to the literary interests of the Stanley family in its various branches."[32]

While it is possible to draw a rough sketch of the owner of Fairfax 16, nothing at all is known about the circumstances of the production of Bodley 638 beyond its scribe's name, "Lyty," about whom we also know nothing beyond his having copied this particular manuscript.[33] The manuscript does preserve many marginal annotations in Latin in a late fifteenth-century hand, which for the purposes of this discussion I will attribute to the manuscript's owner, since the person who made them clearly had possession of the manuscript regardless of whether he was its proper owner.[34] Whoever he was, this "owner" was also an engaged reader and one with an evident familiarity with the advanced language arts curriculum of late medieval England. While he left the margins of the *Parliament* untouched, his marginalia on the Legend of Dido in this manuscript's copy of Chaucer's *Legend of Good Women* point to his possible familiarity with Virgil's *Aeneid* or at least to his facility with Latin. These annotations include "[f]allacia / [a]mantis," next to the lines "Where sen ye oon that he ne hath laft his leef, / Or ben unkynde, or don hire som myscheef" (lines 1260–61, fol. 67r), part of the narrator's address to women on the topic of false lovers; "de lacrimis / viri" next to the line "Therwith his false teres out they sterte" (line 1301, fol. 68r), following Aeneas's speech to Dido defending his imminent departure from Carthage; and "littera" next to "She wrot a lettre anon that thus began" (line 1354, fol. 69r), introducing Dido's letter to Aeneas.[35] Looking beyond the Legend of Dido, we find that this owner also marked the beginning of the letter written by Phyllis in her legend (line 2496, fol. 92r). In the course of their study of Latin, medieval students composed practice letters addressed to a variety of recipients for a variety of occasions. Our annotator's marking of Dido's and Phyllis's letters may reflect that training.[36] If he had also studied the *Aeneid*, as his commentary on the Legend of Dido allows us to suspect, it might have been while pursuing a degree in grammar to become a schoolmaster, which entailed reading Virgil and Priscian.[37] The indications in Bodley 638 that it was owned in the sixteenth century by a school would lend support to the idea that its original owner was a schoolmaster.[38]

What kind of education would a careerist like John Stanley, Esq., bring to his reading of Fairfax 16? And how might the anonymous annotator have acquired the Latin literacy on display in the margins of Bodley 638? And, more specifically, how would those backgrounds shape their responses to the lists of birds and unhappy lovers in Chaucer's *Parliament*, where the names are underlined in the manuscripts they owned? Despite their likely being at least a generation apart in age, Stanley and the Bodley 638 owner probably began their education the way most fifteenth-century male children did, by learning Latin in a grammar school, where the curriculum, which was essentially the same everywhere in England, began with Latin vocabulary, inflexions, and syntax, and proceeded thence to Latin composition and the reading of Latin literature.[39] Having finished grammar school by their late teens, young men of the gentry class might go on to study at Oxford or Cambridge, either to pursue a university degree or, as Nicholas Orme puts it, "to pick up useful

knowledge for lay careers."[40] Students on the "useful knowledge" track might study what Orme calls the "arts of business," learning how to compose and navigate a variety of legal and administrative instruments. Or they might acquire additional training in grammar along with an introduction to logic and civil law before going on to study English law in London.[41] There a young man's study might lead to a career as a lawyer. It could also function, as Orme explains, as "an acceptable way of leaving home, living under supervision, and acquiring useful knowledge for adult life."[42]

At some point in a student's educational career he would also learn French, and his sisters would have learned it as well. Especially for men working in business or administrative positions—men like Stanley—French continued through the middle of the fifteenth century to be a necessary language. For men and women alike, knowledge of French was also considered a "cultural accomplishment," providing access to the world of French literature.[43] Our knowledge of French language instruction in the fifteenth century is much less detailed than our understanding of Latin pedagogy, but several Anglo-Norman treatises on the language do survive, suggesting an increasingly formal approach to teaching it to native English speakers. The earliest of these is the *Tretiz* of Walter of Bibbesworth, which is essentially a vocabulary list presented in narrative form, apparently designed for young children. Although it was composed in the late thirteenth century, its enduring popularity is attested by its survival in sixteen manuscripts and fragments, the latest of which is dated 1420.[44] Two early fifteenth-century works are more academic, as their titles suggest: the *Donait soloum douce franceis de Paris*, by one Richard Dove; and the *Donait François*, a project evidently directed and funded by John Barton of Cheshire and also intended for children.[45] However French was learned, the recent flowering of work on "the French of England" has shown that the language was woven into the fabric of everyday life in England well into the fifteenth century, especially among people of the gentry class or higher.[46]

In the process of acquiring an education like the one I have just sketched, would either Stanley or the Bodley 638 owner have laid eyes on books with lemmata and commentaries like those I described above? And if they recognized the underlined names in Fairfax 16 and Bodley 638 as having been marked for study, would that education also have prepared them to supply a commentary? If either Stanley or the Bodley 638 owner undertook university study, he would probably have pursued the "arts course," which included logic in the form of the *Ars vetus*, portions of Aristotle's *Organon* filtered through Porphyry and translated into Latin by Boethius.[47] Study of this work would have entailed negotiating a complex textual apparatus, for late medieval copies of it are frequently presented with abundant commentary, equipped with red-underlined lemmata.[48] If Stanley had also studied civic law at Oxford or Cambridge, he would likely have worked with a copy of the *juris civilis* with the Accursian commentary, which, as I noted above, was also regularly presented in the margins of the text and supplied with underlined lemmata. Even if not

as a student, though, Stanley is apt to have encountered books with scholarly apparatus the same way Chaucer evidently did, in the course of his varied career as a civil servant.

As for recognizing the underlined names in their books as lemmata—that is, as lexical items taken from prior texts marked out for study and commentary—it might be opined that such acumen is too much to ask of Stanley and the Bodley 638 owner, that the most we can say is that the underlining adds emphasis. After all, even if these readers were savvy negotiators of the scholastic page, the underlined items in their copies of the *Parliament* are missing a key feature that would support a perception of them as lemmata: the commentary that is usually linked with them. We will never know how Stanley and the Bodley 638 owner responded to these underlined names, but I would suggest that two frames for the lists of lovers and birds would have put our readers in a studious mood, thus activating a nuanced apprehension of the lists' red underlining. The first of these frames would be narrative, the *Parliament* narrator's depiction of his own avid and studious reading; the second would be codicological, the scholarly *mise-en-page* of the *Parliament*—and other Chaucerian works— in Fairfax 16 and Bodley 638, which presupposes, if not an academic readership, then one of eager amateurs. Here, too, the *Parliament*'s narrator would stand as an exemplar: his professions of a desire to learn about love *from* books, revealing, as Alexandra Gillespie has put it, that "the love he knows best is love *of* books."[49] Fueled by such a fervent readerly disposition and trained by the typical education I have just described, Stanley and the Bodley 638 owner would have been at once disposed and enabled to study the underlined words in their copies of the *Parliament* and to annotate them mentally with knowledge gained from the textual contexts in which they first met them—to treat them, in other words, as virtual lemmata. A look at those prior contexts now will give us grounds for imagining the kinds of commentaries to which these virtual lemmata might have given rise.

Lovers on Lines, Birds on Lines

In his essay "On the Use of Foreign Words," Theodor W. Adorno asserts that "the true words" are "the found words, the performed words, the artificial words, in short, the made words."[50] While a consideration of the category of true words is beyond the scope of this essay, Adorno's description of them is useful for our purposes because it links a range of activities that might be called forth or recalled in an engagement with either of the two sets of underlined names in the Fairfax 16 and Bodley 638 copies of the *Parliament*; at the same time, it helps to identify certain crucial differences between them, differences that are important to articulate as we consider both the prior texts from which these underlined list items might have been taken as far as readers like Stanley and the Bodley 638 owner were concerned, and the kinds of commentary they might have elicited. Both sets of names are easily "found" on their respective pages thanks to their underlining; in turn,

prior texts for these names can be found in the grammar school curriculum, though their native environments differ: narrative for the list of lovers' names, vocabulary lists for the list of birds. Both sets of names are artificial, one being of personal names and the other of species names. Names in both sets qualify as having been "made": taken together, the lovers have made themselves a name for as many types of failed love; similarly, some of the bird names reflect what they do or how they look, or both. The "frosty feldefare" (line 364), for instance, has been understood to mean both field farer and gray piglet.[51] Finally, both sets of names could have been performed, but here is where they differ most significantly with respect both to their place in the grammar school curriculum and to the kinds of commentary they call forth in their positions as virtual lemmata on the pages of Fairfax 16 and Bodley 638, for a look at their prior texts reveals that commentaries on the lovers' names would tend toward overdetermined allegorical interpretations, while commentary on the birds' names would highlight the possibilities of translation, including the dream of translating the language of birds, a fitting preface to their debate.

For readers like Stanley and the Bodley 638 owner, multiple texts could have come to mind as the prior texts from which the lovers' names were taken, including the French *Roman d'Enéas*, French and English versions of the romances of Tristan and Isolde and of King Alexander, Chaucer's *Troilus and Criseyde*, and Chaucer's *Legend of Good Women*, which is included in both of these volumes. But one text in particular could have come to mind for every male reader: the *Eclogue of Theodulus*. One of the inclusions in the *Auctores Octo*, the standard fifteenth-century language arts reader, the *Eclogue* stages a singing contest between Pseustis (Liar) and Alithia (Truth) before the judge Phronesis (Understanding).[52] Pseustis's songs tell stories from classical mythology; Alithia's answer with stories from the Bible. Naturally, Alithia wins the contest. The poem was written in the ninth century, and as part of the earlier medieval reader, the *Sex Auctores*, it acquired many commentaries, beginning in the eleventh century with one by Bernard Utrecht, followed by one by Alexander Neckam in the twelfth.[53] If a fifteenth-century schoolmaster knew of any of these commentaries, he may have used them to teach from, but the lovers who are featured both in Pseustis's songs and in the *Parliament*'s list—Hercules, Helen, and Scylla (a name not included in either Boccaccio's or Dante's lists)—provide plenty of material for classroom discussion. The story of Scylla, for instance, runs as follows:

> Ardet Scilla thoros—torquebat viscera Minos—
> Purpureo veterem spoliavit crine parentem:
> Sed contempta viro plumas capit incita rostro,
> Vexat ubique pater, curvis sonat unguibus aër.

> Scylla burned with love for Minos' bed (he tormented
> Her heart); she robbed her aged father of his purple hair,

But despised by the hero, she acquired feathers and assumed a beak.
Her father harries her everywhere; the sky resounds with his crooked talons.[54]

Unrestrained libido, a father and daughter turned against each other and then both transformed into birds: this stanza is typical of the *Eclogue* in its sensational and salacious depiction of pagan morality. The songs Alithia sings in response to each of Pseustis's songs drive this message home. Pseustis's song about wanton Scylla is paired with Alithia's about discreet and courageous Esther:

> Coniugis offensum tumido sermone tirannum
> Persidis et Mediae species commovit Edissae:
> In solio Vasti meruit captiva Iocari
> Civibus intentam removens a principe plagam.

> The beauty of Esther moved the ruler of the Persians and Medes
> After he had been displeased by the haughty speech of his wife.
> The captive deserved to be placed on the throne of Vasti,
> While removing from her people the destruction intended by the prince.[55]

In addition to exemplifying the *Eclogue*'s structure, these two songs also display its density of names. Each of the poem's seventy-five songs features at least one name, and some, like these, have as many as three. In this way, the poem functioned, as Orme puts it, "as a little dictionary of mythological and biblical topics."[56] Moreover, as Orme also explains, study of this poem, and of the others in the *Auctores Octo*, involved not only memorization but also detailed grammatical analysis.[57] In other words, the names Scylla, Helen, and Hercules along with hundreds of others in the poem would have been performed to exhaustion by readers of Fairfax 16 and Bodley 638 in their youth, so that, encountering the "lemma" *Silla* underlined in red in the *Parliament*'s list of lovers, they would have been able to comment that she was the one who burned for love of Minos and stole her father's purple hair, in contrast to Queen Esther, who saved her people. Or, put another way, Silla is a root of betrayal, Queen Esther of courage and steadfast loyalty. In a similar manner, readers might perform commentaries on all of the "lemmata" found in this list that would make them synonyms for failure in love, whether through jealousy, adultery, incest, deceit, or some other cause.

Also prompting allegorical and moralizing interpretations are the human qualities attributed to birds in their roll call in the *Parliament*: here we have jealousy, thievery, deceit, cowardice, and many more negative qualities represented. The red underlining in both Fairfax 16 and Bodley 638 is applied solely to the birds' names, however, opening up a view of them as having been "taken" from one or more contexts where they were not

endowed with human traits: Latin vocabulary lists and, potentially, for students of French, the vocabulary lists in the *Tretiz* of Walter of Bibbesworth. Lists of Latin nouns, called *nominales*, survive in many Latin grammatical miscellanies and are easily recognized by the column of *h*'s (for *hic*, *hoc*, or *haec*) running down their left margins, just as the column of *T*'s running down the left margin of the list of bird names in the *Parliament* makes it easy to spot in both manuscript and print copies. The *nominales* were organized by topic, making them easier to memorize than an alphabetical list.[58] In this way, the "Mayer Nominale" begins with Latin words that mean "a beginning," proceeds through one hundred and eighty parts of the human body, sixty-eight names for church officials, twenty-five terms for objects pertaining to the work of scribes, and so on through numerous categories until it arrives at names of birds, where it lists sixty-six, including all thirty-seven that appear in Chaucer's list in the *Parliament*.[59] The *nominale* concludes with words for household furniture: its final three entries are three different Latin words for English "cushion."

One of the ways grammar school students would have "performed" these words was in the common exercise of composing Latin sentences.[60] Several collections of these *latinitas* survive, and a few feature birds.[61] But, ultimately, learning vocabulary is a matter of memorization, a fact foregrounded in a poetic rendition of bird names (the English comes before the Latin in the manuscript):

> Today in the dawnyg I hyrde þo fowles syng
> the names of hem it likyt me to myng [*recollect*][62]
> The parterygg the fesant and þe sterlyng
> the quayle & þe goldefyng and þe lapwyng
> the thrusch þe maueys and þe wodewale
> the Jaye þe popynjaye and the nyghtyngale
> the notthatch þe swalow and the semow
> the chawȝe the cucko þe rooke þe ravyn and the crow.
> Among all þe fowles þat maden gle
> the rere mowse and þe owle cowde I not see.

> Hodie in aurora audiui Volucres canentes nomina quorumlibet placet mihi rememomare videlicet perdicem. ornicem. sturnum coturnicem caduclem vpupam mauiscum ffideculam & luceneam Vlilam psitagum philomela ostellum hIrundinem alceonem monedulam cuculum ffrugellam coruum cornicem Inter omnes volucres que fecerunt illud sonum vespertilionem bubonem non potui videre.[63]

While this speaker's reference to recollection—"the names of hem it likyt me to myng"—evokes the schoolroom practice of vocabulary word recitation, his recollection of hearing the birds sing, which prompts the desire to recite their names, first in English and then in

Latin, aptly depicts the condition of a language learner for whom foreign words are at first as incomprehensible as birdsong, making the feat of translating their names a consolation for not being able to understand their language, unless in a dream. J. A. W. Bennett has remarked that the human qualities Chaucer attributes to the birds in his list "prepares us for the 'parliament' in which the birds will speak."[64] But the sight of the glossary-like column of underlined bird names in their copies of the *Parliament* might also have returned Stanley and the Bodley 638 owner to speaking experiences of their own: the experience of speaking—and hearing themselves speak—the same birds' names in Latin. In this way, in the minds of these fifteenth-century readers, many more names could have been perched in the "branches" stemming from the lemmata "roots"—or in this case, we might say tree trunks—of the underlined birds' names in Fairfax 16 and Bodley 638, affording them the ability to translate them back to the Latin names they had in Alan of Lille's *De planctu Naturae*—the text Chaucer had "taken" them from—despite the good possibility of their never having read it. Such an exercise in mental translation would also have prepared them, expanding on Bennett's observation, to recognize an additional feature of the ensuing "parliament": not only do the birds speak, but they all speak English as well, despite their having many native "languages," following the logic of their representing "foules every kynde / That in this world han fetheres and stature" (lines 365–66).

Chaucer evokes the idea of species of birds each having their own language in his comic reproduction of the sounds of geese, cuckoos, and ducks, "Kek kek! kokkow! quek quek!" (line 499), a line that, in turn, evokes Bibbesworth's French vocabulary. Like the *nominales*, it is also organized by topics, a structure that is slightly disguised by a narrative frame. It, too, begins with parts of the body and then moves on to words for articles of clothing by asking its listeners to get dressed. Breakfast follows, and after many more groups of words, we go outside and eventually learn the names of many birds, including fifteen in the *Parliament*'s list, whose English names are given as glosses, usually in red ink.[65] Even before the section devoted to birds, though, we learn the sounds that many animals make, including sounds for four of the birds Bibbesworth's *Tretiz* shares with the *Parliament*'s bird list—the crane, the swan, the goose, and the duck—some of which are glossed in English. According to Bibbesworth, geese jangle—"Ouwe jaungle," a sound attributed to the "pye" in Chaucer's list (line 345)—while ducks "jaroile," which is glossed in English as "quekez."[66] In Chaucer's list, a crane makes a "trompes soun" (line 344); in Bibbesworth's *Tretiz* it makes a "groule" sound, while the English gloss says it "crekez."[67] Finally, while Chaucer's list notes that swans "syngeth," Bibbesworth contends that they hiss ("recifle"), and the English gloss has it that they "cisses."[68] Taken together, the French bird names and sounds add two more registers of translation—translation of another human language and transcription of various birds' "languages"—our readers could have performed upon seeing the underlined birds' names in their copies of the *Parliament*, a performance that would be supported by a corresponding proliferation of their mental branches of birds, words, and sounds.

More important, in the process of recollecting the French names for the birds that Chaucer lists in English, not to mention the associated renditions of their calls, our readers would have used the lowly underline just as scholars used it in negotiating a page like the one from Peter Lombard's commentaries on the Psalms examined above: that is, as the mark of a word or phrase with an excess of significance waiting to be explored. For biblical scholars, that excess was preserved on the page; for readers of Chaucer's works in Fairfax 16 and Bodley 638, the excess was preserved in their memory for what they had read. In keeping that memory strong and growing, they could have found a model in Chaucer's narrator, who wakes from his dream of speaking birds to return to his beloved books: "I wok, and othere bokes tok me to, / To reede upon, and yit I rede alwey" (lines 695–96).

In sight of these closing lines in Fairfax 16 and Bodley 638 (and in Cambridge, Trinity College MS R.3.19), readers find a parting lemma, this one written in red ink rather than underlined in red ink, the contemplation of which would well reward the avid reading Chaucer's narrator exemplifies: the line "Qui bien aime a tarde oblie" (He who loves well forgets slowly; figs. 10.5, 10.6, following line 679). In her extensive study of this line, Ardis Butterfield traces its passage through a wide variety of literary contexts, from its appearance in the thirteenth century as a refrain in trouvère songs to Gower's use of it in *Miroir de l'Omme* and *Cinkante Ballades*.[69] In summarizing this history, Butterfield uses metaphors that bear a sparkling resemblance to the root and branch metaphors I have used to describe the proliferation of significance an underlined word may signal and shelter: she writes, "'*Qui bien aime*' can serve as a primary instance of how illimitable the textual search for connection becomes. Its prolific history of citation represents the ever-expanding network of textual traces that rush outwards from any text like stars in the expanding universe."[70] We cannot know the connections with other texts Stanley or the Bodley 638 owner may have forged in contemplating this final lemma in their copies of Chaucer's *Parliament*. Whatever those connections were, though, they would have their reading to thank for their ability to make them, and for this reason they could have supplied the lemma with a commentary as rewriting: "Qui bien aime les livres et la lecture a tarde oblie ce qu'il a lu" (He who loves well books and reading forgets slowly that which he has read).

Early in this chapter I identified the two lists I have examined here as lists Chaucer had adapted from earlier works: the list of lovers' names from Boccaccio's *Teseida* and Dante's *Inferno*; and the list of birds' names from Alan of Lille's *De planctu Naturae*. These are surely his immediate sources. The human attributes of the birds, which are also present in *De planctu Naturae*, stand as particularly strong evidence of Chaucer's indebtedness to Alan of Lille for the list of birds. That said, this study of the possible responses to the underlining of lovers' and birds' names by two book owners whose grammar school

education was probably quite similar to Chaucer's suggests that before he knew of the failed lovers in Boccaccio and Dante, and before he knew of the birds in Alan of Lille, he was already storing up names of lovers and birds, "taking" them out of their original contexts to be commented on in new ones. In turn, by underlining these names in the *Parliament*—and proper names, place names, and key terms in other works by Chaucer—the scribes of Fairfax 16 and Bodley 638 produce Chaucer's work as a work of scholarship for nonscholars: people like Stanley or the Bodley 638 owner. Put another way, the scribes produce Chaucer's work after the model of the "olde bokes" (line 24) that the *Parliament* narrator so much enjoys. Like those books, Fairfax 16 and Bodley 638 are designed to yield for their recollecting readers "newe corne from yer to yere" (line 23).

NOTES

1. By contrast, he uses "herde I" and "I herde" three times (lines 190, 198, 247) and the more ambiguous "was I war" and "I was war" once each (lines 218, 298).

2. For the passage in *Il Teseida*, see Boccaccio, *Book of Theseus*, 176–79. McCoy's translation is reprinted in Lynch, ed., *Geoffrey Chaucer*, 299–303. Chaucer's description of the temple of Venus in the *House of Fame* is similarly punctuated with first-person verbs of seeing, which Kolve, in *Chaucer and the Imagery of Narrative*, 41, notes are "clearly intended to make us 'see' in our turn."

3. For an example of this scene, see Wieck, *Painted Prayers*, plates 49 and 50. For many additional examples, see *Digital Scriptorium*, s.v. "Annunciation to the Shepherds."

4. For thorough descriptions of all fourteen manuscript witnesses, see Seymour, *Catalogue*, 15–33. Caxton printed the *Parliament of Fowls* in 1477–78 (STC 5091).

5. The two whose erstwhile decoration may be surmised are Oxford, Bodleian Library MS Arch. Selden B.24 and MS Bodley 638. For further description of the state of decoration in these and the other *Parliament of Fowls* manuscripts, see Seymour, *Catalogue*, 15–33.

6. Fairfax 16 also includes a table of contents written in a contemporary hand. See Norton-Smith, "Introduction," x. On the history of running titles, see Parkes, "Influence," 122–23. See also Rouse and Rouse, "*Statim invenire*," 207–9.

7. Nota marks in Fairfax 16 are placed next to lines 85, 99, 267, 435, 470, and 631, and appear on folios 121r, 123v, 126r, 126v, and 129r. The manicule

in Bodley 638 appears on folio 106r. On this proverb and its manicule, see Gillespie, "Manuscript," 181–83. These two manuscripts, along with Oxford, Bodleian Library MS Tanner 346, are closely related textually. Robinson, in "Introduction," xxxv–xxxvii, summarizes their relations and the scholarly inferences from the same.

8. Boccaccio names Callisto, Atalanta, Biblis, Thisbe, Piramus, and Hercules in *Teseida*, 7.61–62 (see Boccaccio, *Theseid of the Nuptials*). Semiramis, Hercules, Tristran, Paris, Achilles, Helen, and Cleopatra are named in Dante, *Inferno*, 5.58–67 (see Dante Alighieri, *Divine Comedy*). Chaucer's additions are Candace, Dido, Troylus, Scylla, "the moder of Romulus," and Isolde. For Alan's list of birds, see Häring, "Alan of Lille" 813–16 (lines 2.145–95); and Alan of Lille, *Plaint of Nature*. Although Chaucer's and Alan's lists overlap (by my count, ten of Chaucer's thirty-six are not on Alan's list of thirty-five), Chaucer's characterizations of his birds deviate markedly from Alan's. For those, according to Elmes, in "Species or Specious?" 238, Chaucer also drew from Isidore's *Etymologies* and Bartholomeus Anglicus's *De Proprietatibus Rerum*. That said, Elmes still finds that fully twenty-three of the birds on Chaucer's list have descriptions not found in his known sources. Interestingly, the Fairfax 16 scribe largely ignores Chaucer's list of trees (176–82), underlining only "cipresse" and "ew," and the leaf in Bodley 638 that once contained this stanza is now missing.

9. In Fairfax 16, texts not written by Chaucer also have an occasional underlined word or

group of words: for instance, the words "thoght," "lyve," "gost," "chere," "face," "teres," "hert," "thoght," "brest," and "body" are underlined in two consecutive stanzas in Lydgate's "A Complaynt of Lovers Lyfe" (NIMEV 1507, fol. 23v in Fairfax 16, lines 218–28 in Symons, *Chaucerian Dream Visions*). Similarly, in Lydgate's *Reason and Sensuality*, several clusters of proper names are underlined. In the *House of Fame*, both scribes also underline the occupational terms—and associated procedures—enumerated early in the description of Fame's abode (1259–66; fol. 171v in Bodley 638; fol. 171r–v in Fairfax 16). The Bodley 638 scribe also underlines almost every word introduced by "of" in the description of the House of Rumor that begins "Of werres, of pes, of mariages" (1961–76).

10. Chase, ed., *Distichs of Cato*, 14.

11. The proverb "Qui bien aime a tarde oblie" appears after line 679 in these two manuscripts, and in Cambridge, Trinity College Library MS R.3.19 and Caxton's edition (STC 5091). In his explanatory notes for the *Parliament of Fowls*, Charles Muscatine notes that this line has been identified as a proverb by Joseph Morawski and surmises that it may also have been the name of a song (Chaucer, *Riverside Chaucer*, 1002). Butterfield's study of the line reveals that Muscatine and Morawski were both correct even though they had not recognized its complicated history (see below, note 69).

12. *Oxford English Dictionary*, s.v. "lemma," sense 2b: "The heading or theme of a scholium, annotation, or gloss."

13. Parkes, "Influence," 115–16.

14. Oxford, Bodleian Library MS Auct. D. 2. 8 was produced in England in the late twelfth century. See Alexander and Pächt, *Illuminated Manuscripts*, 3: no. 231. For an explanation of the manuscript's system of dots and marginal source attribution, which are also exemplified in fig. 10.7, see Parkes, "Influence," 116 and plate IX.

15. Latin text from *Biblia Sacra Vulgata*; English translation from the *Holy Bible* (both cited in the bibliography).

16. Augustine's commentary from *Enarrationes in Psalmos*, ed. Dekkers and Fraipont, 631, which has "Radix nostra caritas nostra" (rather than "Radix nostra caritas est"). The text of Peter Lombard's commentary is based on my transcription (see fig. 10.7) aided by Migne's edition, *Petri Lombardi*, 191:497B–498A (my translation).

The commentary here is typical of Peter Lombard's approach, which is, as Colish puts it, "to find in his authorities, ways of opening up the text" (*Peter Lombard*, 174). "Doeg" is identified with movement in Augustine's commentary on Psalm 51:9 (635), which Maria Boulding translates as "earthly movement" in Augustine, *Works of Saint Augustine*, 17:28.

17. Parkes notes that in copies of Gratian's *Decretum* and Peter Lombard's *Sentences* further innovations in *mise-en-page* were being developed as early as the second half of the twelfth century. See "Influence," 117. For a survey of the many scholars who wrote commentaries on the *Sentences*, see Rosemann, *Story of a Great Medieval Book*.

18. For the etymology of *postilla*, see the *Oxford English Dictionary*, s.v. "postil." On the development of the genre and a reproduction of a page from Nicholas of Lyra's *Postillae*, see Clemens and Graham, *Introduction to Manuscript Studies*, 184. For numerous additional examples of Lyra's *Postillae*, see *Digital Scriptorium*, s.v. "Lyra."

19. See Phillips, "Seeing Red"; and Benson and Blanchfield, *Manuscripts*, 17–20. See also Alford, "Role of the Quotations." Benson and Blanchfield note that underlined words and phrases also appear in copies of the *Brut*, *Mandeville's Travels*, and the Winchester Malory, and in Chronicles of London (17). Underlining in the English *Brut* has not been systematically documented, but see, for a start on this project, Marvin, "Albine and Isabelle."

20. I allude to the narrator's declaration "For myn entent is, or I fro yow fare, / The naked text in English to declare / Of many a story," in which the "naked text" is one without a gloss (*Legend of Good Women*, G 85–87).

21. These "virtual lemmata" bear some resemblance to contemporary hyperlinks, which are also underlined (or in a font other than that of the main text), except that the "link" here is to memory rather than cyberspace. My thanks to one of this essay's anonymous readers for this illuminating analogy.

22. Parkes, "Influence," 133.

23. Pearsall, *Life of Geoffrey Chaucer*, 32.

24. Norton-Smith, "Introduction," vii.

25. The fifteenth-century enthusiasm for these collections seems to have had its origins in the collections of courtly lyrics compiled by the enterprising scribe John Shirley, who may have

designed them, as Edwards, in "John Shirley," argues, to appeal to readers interested in emulating aristocratic society. All eight manuscripts listed by Boffey and Thompson as examples of this trend include the *Parliament of Fowls* ("Anthologies and Miscellanies," 280, 303n11). I borrow the term "mini-libraries" from Radulescu, in "Literature," 102, who uses it to describe miscellanies owned or produced by gentry families. For an example of an actual library owned by a gentry family, see my note 26.

26. Among the books listed in John Paston II's inventory of his books (written ca. 1475–79) is one described as containing "The Legended off Ladyes, (?La) Bele Dame saunce Mercye, þe Parlement off Byrdys, þe Temple off Glasse." The inventory survives as London, British Library MS Additional 43491 and is printed in Davis, *Paston Letters*, 516–17. For a recent history of the Paston family, see Castor, *Blood and Roses*. Youngs, in "Cultural Networks," 131, infers from the sparse appearance of the Finderns in local records that they were "probably not leading lights" in Derbyshire.

27. On the likely circulation of these exemplars as booklets, see Boffey and Thompson, "Anthologies and Miscellanies," 280–83.

28. For an overview of gentry literary tastes, see Radulescu, "Literature." For a study of the gentry's interest in romance in particular, see Johnston, *Romance and the Gentry*. Youngs, in "Cultural Networks," 120–25, terms these reading communities "reading networks" and delineates several of them.

29. My sketch of Stanley is drawn primarily from Norton-Smith, "Introduction," xiii. See also Wedgwood, *History of Parliament*, 797–99.

30. Bennett, *Community, Class and Careerism*, 250; and Norton-Smith, "Introduction," xiii. On the frontispiece, see Norton-Smith, "Introduction," xii–xiii; and Brantley, "Venus and Christ," esp. 175–77. For an excellent portrait of careerism as exemplified by the rise to fame and fortune of John Stanley, Esq.'s relative Sir John Stanley, see Bennett, 219–23.

31. Norton-Smith, "Introduction," xiii.

32. Norton-Smith, "Bodleian MS Fairfax 16," 203.

33. Lyty signs his name "Lyty" on folios 7r, 38r, 45v, and 209v; and "Lity" on folio 4v.

34. Robinson suggests that the manuscript may have been owned by Lyty himself ("Introduction," xvii).

35. Transcriptions from Robinson, "Introduction," xxxi–xxxii.

36. On letter writing as part of the grammar school education, see Orme, "Education," 72.

37. As Orme explains, a degree in grammar was the qualification preferred for the post of schoolmaster beginning in the mid-fifteenth century (*Medieval Schools*, 170, 223–25).

38. For transcriptions of the numerous sixteenth-century names and notes in the manuscript that give the impression that it was owned by a school, see Robinson, "Introduction," xxxvii–xxxix.

39. For a characterization of the educational needs of the gentry and an outline of the grammar school curriculum, see Orme, "Education," 71–73.

40. Ibid., 74.

41. Orme, *Medieval Schools*, 70. For further details on business education, see pp. 68–73.

42. Ibid., 70.

43. Ibid., 77. See also Putter, "French of English Letters."

44. Cambridge, Trinity College Library MS B.14.40, folios 93r–129r. A list of the manuscripts appears on the *Archives de littérature du Moyen Âge* website (http://www.arlima.net/, s.v. "Walter de Bibbesworth"). The work is edited by Rothwell in Walter de Bibbesworth, *Le Tretiz*; and translated (with Rothwell's text on facing pages) by Dalby, in Walter of Bibbesworth, *Treatise*. See also Kennedy, "*Le Tretiz*."

45. Orme, *Medieval Schools*, 76–77. For thorough descriptions of both texts and an edition of Dove's, see Merrilees, "Donatus and the Teaching of French."

46. For a kaleidoscopic view of this linguistic situation, see the essays collected in Wogan-Browne, ed., *Language and Culture*.

47. See Orme, *Medieval Schools*, 262.

48. The commentary by Walter of Burley was the most common one. See Thomson and Luscumbe, eds., *Catalogue*.

49. Gillespie, "Manuscript," 180. As Dinshaw points out, the root of *amateur* is "love" (*How Soon Is Now*, xv).

50. Adorno, *Notes to Literature*, 2:288.

51. See Lockwood, *Oxford Book of British Bird Names*, s.v. "fieldfare."

52. For an overview of the *Auctores Octo*, see Pepin, *English Translation*, 1–3. See also Cook, "*Ecloga Theoduli*."

53. Guthrie, in "*Ecloga Theoduli*," 80–152, discusses the five major commentaries. She also provides an index of passages in which Chaucer mentions characters that appear in the *Eclogues* (188–219). For a brief account of the *Sex Auctores*, see Pepin, *English Translation*, 2. For a discussion of both readers, see Orme, *Medieval Schools*, 97–105.

54. Latin text from Casaretto, ed., *Teodulo Ecloga*, 20; translation from Pepin, *English Translation*, 38.

55. Casaretto, ed., *Teodulo Ecloga*, 20; and Pepin, *English Translation*, 38.

56. Orme, *Medieval Schools*, 100. Guthrie hypothesizes that the poem might have worked as just this kind of dictionary for Chaucer ("*Ecloga Theoduli*," 187).

57. Orme, *Medieval Schools*, 147–48.

58. For editions of several of them, see Wright, ed., *Volume of Vocabularies*. On memorization of these word lists, see Hüllen, *English Dictionaries*, 4. For a sense of their prevalence in grammatical miscellanies, see Thomson, *Descriptive Catalogue*.

59. Hüllen discusses this *nominale* in detail in *English Dictionaries*, 68–77. It is published in Wright, ed., *Volume of Vocabularies*, 206–43.

60. For an explanation of this practice, see Orme, *English School Exercises*, 5–9.

61. Ibid., 51.

62. *Middle English Dictionary*, s.v. "mingen," sense 3a.

63. Edited in Wright, "Late Middle English Parerga," 116. For a detailed description of the manuscript's contents, see Thomson, *Descriptive Catalogue*, 239–53. The writer glosses the bird names in the Latin version of his verses with their English equivalents.

64. Bennett, "Some Second Thoughts," 140.

65. They are the crane, fieldfare, pheasant, starling, falcon, owl, song thrush, sparrow, robin, cuckoo, stork, swallow, lapwing, and marsh goose. For a study of the glosses, which are a standard part of the text, see Knox, "English Glosses."

66. Walter de Bibbesworth, *Le Tretiz*, 261–62. English glosses are in Rothwell's footnotes.

67. Ibid., 250.

68. Ibid., *Le Tretiz*, 255. French *resiffler* is, more precisely, to hiss again, "siffler une seconde foi." See *Le Grand Robert*, s.v. "resiffler."

69. Butterfield, *Familiar Enemy*, 246–47.

70. Ibid., 247.

ELEVEN

The Visual Semantics of Ellesmere
Gold, Artifice, and Audience

Maidie Hilmo

All the visual features of the lavishly decorated and illustrated Ellesmere manuscript mesh to provide a meaningful reading experience for its privileged audience, then and now.[1] The text of the Ellesmere manuscript (San Marino, Huntington Library MS El 26 C 9) is one of the earliest extant versions of the *Canterbury Tales* and the basis of many modern printed editions such as *The Riverside Chaucer*.[2] It is instructive to see how the layout of the Ellesmere manuscript presents a vision of Chaucer's compilation. The words of the text are, in this manuscript, only one component of an integrated visual program in which different parts interrelate to stimulate a pleasurable reading experience. To adapt a term from computer studies and neuroscience, it is the *visual semantics* of the pages of Ellesmere that will be explored in this study. I concentrate on the interpenetrating levels of meaning that allow audiences to appreciate both immediate and deep aspects of Chaucer's magnum opus. An aggregate of layered visual and verbal elements creates an impression of what some of Chaucer's first readers—the scribe and the artists of Ellesmere—saw in his

This essay is in commemoration of Leonard A. Woods, artist, musician, and poet. I thank the following people for their helpful expertise and kind support during various stages of this project: Kathryn Kerby-Fulton, Denise Despres, Corinna Gilliland, Nicole Eddy, Wayne Hilmo, Anna Larson, and Erica MacHulak. For her help and generosity, special thanks to Vanessa Wilkie, William A. Moffett Curator of Medieval and British Historical Manuscripts at the Huntington Library.

narratives, and how they, in turn, shaped these meanings for aristocratic viewing. My focus here is on ways this manuscript *as it is* can be understood and enjoyed as a visual artifact.

From *Ordinatio* to Visual Semantics and Beyond

In an influential 1976 article, Malcolm Parkes traced the development of the ways in which manuscript books from the twelfth to the fourteenth centuries were laid out and organized, thereby enabling readers to negotiate their content more easily.[3] By the thirteenth century, there existed a book trade catering to academic rather than just monastic readers, and also to the new orders of friars, who required material in an accessible form for preaching purposes. To accommodate these needs, texts were gradually "packaged" to make them easier to navigate. They were divided into sections like chapters and presented with supplemental reading aids, such as paragraph marks, running titles, columns for marginalia, colored inks, decorated capitals, illustrations, abbreviations, summaries, and tables of contents. The term for this manner of organizing and laying out the pages is *ordinatio*. According to Parkes, the Ellesmere manuscript provides the most spectacular example of a text presented with an apparatus that indicates its *ordinatio*.[4]

Since *ordinatio* is a medieval system for data retrieval, I am somewhat emboldened to apply the term *visual semantics* to the present context, in order to go a step further in exploring how the linking of organizational elements stimulates an audience to become holistically involved with many connected levels of verbal and visual discourse.[5] Is there a final meaning, or are there only evocative teasers open for debate? Is interpretation a matter of *ernest* versus *game*? Does beauty exist simply to be enjoyed for its own sake, or may it hold meaning beyond itself?[6] The aristocratic audience of the Ellesmere manuscript would naturally expect, as their due, luxury items of highest quality and beauty. As a status symbol enshrining their high rank, a book would need to appeal to the eyes and also to be manifestly costly and hence a showpiece. As a means of commending Chaucer—a vernacular poet worthy of laureation on vellum—the manuscript would need to garland his work in suitable fashion.

Fellow writers, many of them civil servants like Chaucer,[7] were likely among the earliest readers of the poet's literary works, but the Ellesmere manuscript, made around the time of his passing in 1400 or shortly thereafter, was clearly intended to attract another level of readership. In the cultural politics of the time, it was to the advantage of the new Lancastrian dynasty to be associated with English culture, a fortuitous opportunity for the promotion and elevation of Chaucer's work. The kind of courtly audience that the *Troilus* frontispiece conjures up,[8] more wished-for than actual during the reign of Richard II, was to become realized during the reign of Henry IV and his son, the young prince Henry, at least as far as the commissioners and makers of the Ellesmere manuscript were

concerned. Everything about Ellesmere announces and confirms the aristocratic social identity of its audience.

Gold as a Linking Device: Signifying Status

Materially, the Ellesmere manuscript is larger (399 × 284 mm) and proportionally very much heavier than even *The Riverside Chaucer*, a standard modern edition that weighs down the backpack of many a student. Opened up, its luxurious richness is immediately apparent, including the use of the finest vellum, which alone announces the cultural capital of its text.[9] Its size allows for a generosity of vellum space not only for the placement of the different features of the *ordinatio*, including areas for framing elements, text, glosses, and figural illustrations, but also for the reader's imagination to fill in what was not said or illustrated.

The colors are rich and still bright today. Expense was obviously not an object, just as it would not have been for the Athenian artists who purchased the colors that cost "many a floryn" (I 2088) to paint the temple scenes described in the *Knight's Tale*. Pigments were mixed by hand, so painting was labor-intensive as well as costly, as lamented the medieval artist Alan Strayler when he inscribed his own portrait in the *Catalogue of the Benefactors of St. Alban's Abbey*, stating that he "worked hard on the painting of the present book and has forgiven the three sous and four pence due to him for the colours."[10] That he wrote this in Latin demonstrates a high level of literacy and attests to the competence of many artists, some of whom even illustrated trilingual texts.[11] In cases where they had to follow brief instructions from the compiler, they also had to have a wide repertoire of images to adapt to specific needs, in addition to expert knowledge of pigments and the art of gilding.

The most bewitching impression one gets in seeing the original Ellesmere manuscript is that it shimmers with gold and is even edged with gold. This first impression immediately heightens the senses and increases a viewer's desire to engage further. Gold, especially when present in any quantity, had social and symbolic value in the Middle Ages. Its use in cloth, for instance, was reserved for the highest levels of society and forbidden even to the wives or daughters of knights, at least according to the English sumptuary laws of 1363.

Within the *Canterbury Tales*, gold has both positive and negative associations, assuming a dialectic quality. The Knight, as portrayed in Ellesmere on folio 10r (fig. 11.1), at the beginning of his tale, is not shown wearing a tunic of coarse cloth nor a coat of mail all battle-stained, as described in the *General Prologue*. He is instead accessorized with a gold-tipped scabbard, gold tips on the arming points on his chest, and gold stirrups and spurs (the only gold spurs depicted in the manuscript). Even the trappings on his magnificent horse are embossed all over with gold. He is no longer just the pilgrim Knight of the *General Prologue*; he has become visually assimilated with the victorious Theseus,

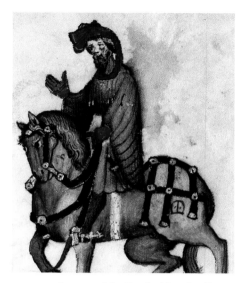

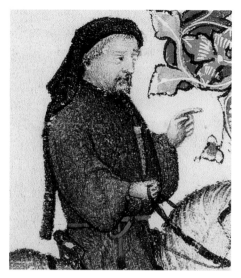

FIG. 11.1 Portrait of the Knight (detail), Elles-
mere manuscript. San Marino, Huntington
Library MS El 26 C 9, folio 10r.

FIG. 11.2 Portrait of Chaucer (detail), Ellesmere
manuscript. San Marino, Huntington Library MS
El 26 C 9, folio 153v.

who at the beginning of the tale has just arrived on the scene. Presented in this fashion,
and as the first pilgrim portrayed in Ellesmere, the Knight can be socially linked with the
circle of readers—perhaps even royal ones—for whom the book was made. Might there
be some suggestion here of Henry IV, the new conqueror of England? The markings on
the Ellesmere Knight's face could conceivably refer to skin problems that afflicted this
king.[12] The Squire, the Knight's son, is portrayed wearing leggings of ermine, a fur reserved
for the use of English royalty and nobility.[13] This could be another case of visual assimi-
lation, in this case of the lower-ranking, young pilgrim narrator of the text assimilated
with Cambuskyn (Genghis Khan), who is mentioned in the adjacent text. It might also
be a discreet reference to the young heir, Prince Henry (later Henry V), who would have
been among the royal family for whom this manuscript might have been destined.[14] In the
Knight's Tale itself, when Theseus enhances the status of Arcite (posing as Philostrate),
he gives him gold "to mayntene his degree" (I 1441), and the tale contains scenes that
glitter with gold as a signifier of the status of the participants, especially in connection
with the tournament, the victory celebrations, and the funeral of Arcite.

On folio 153v of Ellesmere, Chaucer is depicted as a pilgrim-narrator at the beginning
of his prose tale (fig. 11.2). The sole hint of his professional authorship is the gold-painted
penner (pen case) attached to a red cord and hung around his neck. The subject of his first
tale, Sir Thopas, is armed with a shield of red gold (VII 869), but it is not illustrated—nor,
in the Ellesmere design, are other subjects from the tales themselves. The portrait of the
Miller, a pilgrim of lower status, offers a comic example: a proverbial thumb of gold is

FIG. 11.3 Portrait of the Miller (detail), Elles-mere manuscript. San Marino, Huntington Library MS El 26 C 9, folio 34v.

visualized literally in the illustration on folio 34v preceding his tale (fig. 11.3). Less humor-ous is the account in the *Pardoner's Tale*, in which three low-class rioters do not realize that, in finding gold under the tree, they have found Death, whom they initially sought to kill. In the portrait on folio 138r, the Pardoner carries a large gem-studded cross touched with gold (fig. 11.4), although the *General Prologue* tells us it is only alloy (I 699).

Another figure who does not follow his religious calling is the Monk (fig. 11.5). In his portrait on folio 169r, his horse is festooned not only with jingling bells on his bridle (*General Prologue*, I 169–71), but with gold ones all over the horse's trappings. Even his greyhound is given a fancy collar with gold. Whether by coincidence or intent, the mar-ginal gloss right beside the bottom of the portrait (but referring to the content of the fol-lowing stanza) reads, "Lucifer"! Anyone viewing this folio would readily draw the parallel. In the tragedy of Nebuchadnezzar, as related by the Monk, gold is associated with idolatry. Because this ruler required everyone to worship a golden statue he had made, God took away his kingdom (VII 2159–74). Like the Pardoner, the depicted pilgrim Monk does not seem to apply the lessons of his tale to himself.

In the *Friar's Tale*, the pursuit of gold by a summoner is meant to rebound as a sly reference to the pilgrim Summoner. The interrelationship is visualized in a sophisticated, multimodal fashion across facing folios 80v and 81r (figs. 11.6, 11.7). Near the end of his tale, the Friar quotes Psalm 10:8–9 concerning the lion that sits in wait to slay the innocent (III 1657–58; fol. 80v). By way of emphasis, the authoritative Latin source is given in the marginal gloss to the left of the adjacent border. The immediate context in the Friar's text associates summoners, devils, and the pains of hell. On the facing page (fol. 81r), the Sum-moner is illustrated as if he were lying in wait in the thicket of the text ready to pounce on his unsuspecting prey, echoing the description of the summoner in the *Friar's Tale* (III

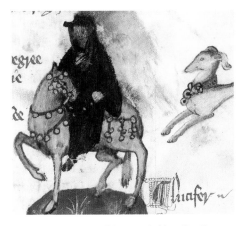

FIG. 11.4 Portrait of the Pardoner (detail), Ellesmere manuscript. San Marino, Huntington Library MS El 26 C 9, folio 138r.

FIG. 11.5 Portrait of the Monk (detail), Ellesmere manuscript. San Marino, Huntington Library MS El 26 C 9, folio 169r.

1376). As if he has emerged from the Friar's narrative, the illustrated Summoner holds up a summons, visually alluding to the forged summons referred to in the *Friar's Tale* (III 1360).

Gold and Ornament: Meaning, Art, and Pleasure

The proper use of gold was not only as a status marker for rich displays of power by the nobility; on a higher level, it was a symbolic indicator of divinity and holiness in much medieval religious art. Gold lettering had been in use since Carolingian times to convey an aura of power.[15] Otto Pächt describes the impact of gold letters "whose radiance eclipses and whose light transcends all."[16] Phillipa Hardman observes that gold "relies on movement to produce the characteristic light-reflecting glister," an effect "enhanced by the mobility of pages" with gold illuminations and meant to "represent moments of interaction between earthly and heavenly realms."[17] In the hagiographic life of Saint Cecilia, as told by the Second Nun, an old man clothed in white miraculously appears to Valerian and shows him a book written in letters of gold. Upon reading the words of gold apostrophizing God, the Father of all, Valerian is immediately converted (VIII 200–215).[18]

In a twelfth-century artist's manual, Theophilus justifies the use of expensive materials for ornamenting religious art. Referring to biblical texts, he asserts that God inspired the builders of the tabernacle so that they might execute their work in gold and precious materials, for "God delights in embellishment of this kind . . . executed under the direction and authority of the Holy Spirit."[19] Of particular relevance to the Ellesmere manuscript is the visual and cultural association of its border decoration with religious books. Kathleen Scott has identified two of the Ellesmere border artists with two of the three artists

appearing in another manuscript made around the same time, Oxford, Bodleian Library MS Hatton 4, which includes an hours and a psalter.[20] This correspondence suggests a crossover not only of artists but also of readers favoring manuscripts with similar decoration. The authority of religious books is, by association with their decorative vocabulary, transferred to vernacular manuscripts such as Ellesmere.

And what of the function of ornament within manuscripts? As Oleg Grabar has argued, it serves an intermediary role, attracting the viewer, acting as a threshold, and connecting areas within the visual field.[21] The viewer of a manuscript like Ellesmere is attracted to the beauty of its execution and, consciously or unconsciously, experiences aesthetic pleasure. Viewers might pause to enjoy, visually trace, or even touch the areas of greatest loveliness. In a corrective to some common misperceptions about medieval art always having a moral function and medieval people having no real sense of beauty, Mary Carruthers argues that they were quite capable of creating and enjoying art "to evoke and shape distinctly aesthetic experiences, not solely to teach moral or theological 'lessons.'"[22] Scott sees ornamental features in manuscripts as serving not only as navigational aids but, concomitantly, as a source of delight.[23] In Ellesmere, the art to be enjoyed is both visual and poetic, the two features being more closely linked in the medieval mindset than in later centuries, when printed editions have generally featured just the text.

Derek Pearsall reminds us that sometimes we forget that Chaucer's poetry, its "language, imagery, syntax, and metre," is "an essential part of his narrative and of the dramatic form" into which it is cast. Its "special capacity" is that it can be read for "what it is in itself" and can be "reread and thought about and written about with repeated and increased pleasure and intensity of satisfaction."[24] These observations also apply to the visual art of the text's material manifestation in the Ellesmere manuscript. Pearsall gives as an example of Chaucer's poetic art the ekphrastic description of the paintings on the temple walls in the *Knight's Tale*, especially the dramatic visualization of the temple of Mars. A forty-six-line passage begins, "Ther saugh I . . ." and ends with an admission that the Knight could not give all the examples even if he wanted to (I 1995–2040). In Ellesmere, folio 22r–v, eight paraph signs, alternating in blue and gold in serial fashion, cause the reader to pause at every stage of the tour as the narrator describes, like John on Patmos, what he saw.[25] This visual mini-pilgrimage within the larger context of the *Canterbury Tales* pilgrimage reinforces the idea of movement toward Canterbury.[26]

Border Ornament and Decorated Letters: Function and Significance

The border ornamentation of the Ellesmere manuscript can be appreciated for both its artistic properties and its dynamic rhythmic flow, which moves an audience along in orderly fashion right up to the end of the manuscript. The borders for the main divisions

of the tales—including each tale's beginning, many of the tales' main subdivisions, and some of the linking passages—are in the style known as *demi-vinet*. Appearing in the margins of some early manuscripts of the *Canterbury Tales*, demi-vinet borders consist, in the words of Margaret Rickert, of "a colored initial on gold ground joining a framework border extending around three sides of the page."[27] The framework borders of Ellesmere have a double bar, one of gold and the other with alternating segments of blue and rose pink, with sweeping graceful curves along the top and bottom of the page, leaving the right side always open. Metamorphosing decorative motifs, including interlace, leaves and flowers, and abstract elements like gold balls and squiggles, punctuate the three-sided framework, sometimes singly or in clusters and floriated scrolls. These recurring border elements pull together Chaucer's disparate narratives, reassuringly indicating artistic control.

The colored decorated initials share the same ornamental vocabulary, colors, and use of gold as the demi-vinet borders that extend from them. Since such border ornament developed as extensions of decorated letters, they remain connected with the text metaphorically.[28] These capitals are part ornament and part letter, forming the first initial of the following text. They are, in a sense, multidimensional in how they unify frame and text. They represent dual symbol systems that supplement and support each other while appealing to two different perceptual faculties. Because of their threshold position, their design transforms one into the other, ornament into letter, creating kinetic energy. As letters, these colored initials initiate a visual rhythm by way of the linearly repeated patterns of rows of calligraphic letters that follow them, in this case, in anglicana formata script.[29] As calligraphy, the letters are in themselves an art form that gives pleasure. This aspect of manuscript books like Ellesmere is lost in printed editions in which the reader looks for content and meaning, or the associations of the words, rather than savoring a more holistic visual-literate experience.

The two largest decorated initials (each six lines high and attached to the borders) occur at the beginnings of the *General Prologue* and the first tale, where they effectively divide the *Canterbury Tales* into two main sections. Other such decorated initials (also known as foliate or *sprynget* initials) attached to the borders range from three to five lines in height. Beyond that, "champs" of various sizes, not attached to borders (although some touch the adjacent border), mark further, secondary divisions within the texts. These champs, instead of being displayed against a gold ground, are themselves gold and are displayed against a rose-pink or blue ground, with sprays often extending from them.[30] At a third level are smaller paraphs in alternating gold and blue, surrounded by pen flourishing in violet and red. These mark smaller divisions and indicate stages in a progress (as in the case of the tour of the temple of Mars), items in lists, or speakers. Sprinkled all through the prose tales, they create a glittering effect.

The *Parson's Tale* garners sixteen out of a total of seventy-one demi-vinet borders, visually emphasizing its message. At the end of this tale, the penitent has discovered what the "fruyt" (X 1076) of penance is, as accentuated by a marginal gloss underscored by a

Whproviden the fruyt of penance

Whproviden the fruyt of penaunce And after the word of ihu crist
it is the endelees blisse of heuene. ther ioye hath no contrarousnesse
of wo ne greuaunce. ther alle harmes been passed of this present lyf
ther as is the sikernesse fro the peyne of helle. ther as is the blisful
compaignye that reioysen hem endeuo euerich of otheres ioye. ther
as the body of man that whilom was foul ꝺ derk · is moore cleer
than the sonne. ther as the body that whilom was syk ꝺ feeble ꝺ
feble · ꝺ mortal · is inmortal ꝺ so strong ꝺ so hool · that ther may
no thyng apeyren it · ther as ne is neither hunger thurst ne coold·
but euery soule replenyssed with the sighte of the parfit knowyng·
of god ꝺ This blisful regne may men purchace by pouerte espiritueel.
and the glorie by lowenesse · the plentee of ioye by hunger and thirst
and the reste by trauaille · And the lyf by mortification of synne·

Heere taketh the makere of this book his leue ꝺ

NOw preye I to hem alle that herkne this litel tretys or rede
that if ther be any thyng in it that liketh hem that they of
thissy thanken oure lord ihu crist · of whom procedeth al
wit and al goodnesse. And if ther be any thyng that displese hem · I
preye hem also that they arette it to the defaute of myn vnkonnynge
And nat to my wyl · that wolde ful fayn haue seyd bettre if I hadde
had konnynge · for oure book seith Al that is writen is writen for
oure doctrine. and that is myn entente ꝺ Wherfore I biseke yow
mekely for the mercy of god that ye preye for me that crist haue mercy
on me and foryeue me my giltes · and namely of my translacions
and enditynges of worldly vanitees the whiche I reuoke in my re
traciouns ꝺ As is the book of Troilus ꝺ The book also of Fame ꝺ The
book of the xxv. ladies ꝺ The book of the Duchesse ꝺ The book of
Seint Valentynes day of the parlement of briddes ꝺ The tales of
Caunterbury thilke that sownen in to synne ꝺ the book of the leon
And many another book if they were in my remembraunce ꝺ and
many a song and many a lecherous lay · that crist for his gre
te mercy foryeue me the synne ꝺ But of the translacion of Boece
de consolacion and othere bookes of legendes of seintes · and
Omelies and moralitee and deuocion that thanke I oure
lord ihu crist ꝺ and his blisful mooder · and alle the seintes of he
uene bisekynge hem that they fro hennes forth vn to my lyues
ende sende me grace to biwayle my giltes and to studie to the
saluacion of my soule · and graunte me grace of verray penite
ce confession and satisfaction to doon in this present lyf thurgh
the benigne grace of hym that is kyng of kynges and preest
ouer alle preestes that boghte vs with the precious blood of his her
te so þⁱ I may been oon of hem at the day of doome that shulle
be saued ꝰ Qui cum patre ꝰ

Heere is ended the book of the tales of Caunterbury
compiled by Geffrey Chaucer · of whos soule ihu crist
haue mercy Amen

FIG. 11.8 End of the *Parson's Tale* and Chaucer's *Retraction*, Ellesmere manuscript. San Marino, Huntington Library MS El 26 C 9, folio 232v.

sweeping foliate scroll growing from the border (fig. 11.8). The gloss reiterates the same phrase found in the main text. The metaphor, as David Raybin observes, links the "roots-flower and pilgrimage images" at the beginning of the *Parson's Tale* to "the opening of the *General Prologue* to provide a frame of imagery within which Chaucer's book may be read."[31] In Ellesmere, this is reinforced visually by the floriated demi-vinets that frame Chaucer's text and link its sections. According to the artistic vocabulary of the Ellesmere plan, the last demi-vinet border, with its attached decorated initial, actually frames the last prose section—Chaucer's so-called *Retraction*—after the end of the *Parson's Tale*. It brings the whole matter back to Chaucer and his writings. The Parson's emphasis on penitence appears to have led to Chaucer's own "confession," even though it inscribes his sinful writings together with his devotional ones for posterity. There is, moreover, an addendum. The concluding sentence in the manuscript—spatially separated from the blocks of prose and introduced by a small paraph—declares the end of Chaucer's compilation of the *Canterbury Tales* and asks Jesus Christ to have mercy on his "soule." Whether this explicit indicates that Chaucer has, at this point, passed into spirit is uncertain.[32] It does, however, return the emphasis on this page back to the "fruyt" that awaits the penitent and Chaucer. The last border, heavily weighted by its position at the end of the manuscript and by the three textual elements on this folio, brackets all its components.

By contrast, at the end of the fifteenth century, Wynkyn de Worde makes multiple use of Caxton's woodcut of all the pilgrims feasting, first at the beginning of the *General Prologue*, then at the passage where the pilgrims feast at the Tabard, and, finally, at the very end of the book. There this fully framed, plain woodcut provides closure and indicates that the promised reward has been attained, whether of the completed earthly journey or the celestial journey (permitting both interpretations).[33] In Ellesmere, however, the open border extends into the personal space of the audience, whose pilgrimage to the "endelees blisse of hevene" (X 1076) is still ongoing.

Putting It All Together: Pilgrim-Authors, Decorated Letters, and Borders

The figural illustrations of the pilgrims, viewed in isolation apart from the rest of Ellesmere's artistic design, have attracted abundant attention in modern scholarship. Yet these illustrations are closely related to the paraphernalia of the demi-vinet borders with their attached decorated initials. It is significant that the pilgrims are not portrayed in the *General Prologue* section but at the beginnings of their respective tales, thereby giving more weight to the latter, while also associating the tales directly with their tellers. This deflects authorial responsibility from Chaucer, who maintains that he merely repeats what they said (*General Prologue*, I 725–42). Gray-haired and serious, he is pictured only at the beginning of his moral tale of *Melibee*. This strategy is different from some later

fifteenth-century manuscripts of the *Canterbury Tales* in which the only figural illustration is that of Chaucer, taking his place as author at the beginning of the entire compilation. For example, in London, British Library MS Lansdowne 851, folio 2r, Chaucer's portrait, in which he appears somewhat younger, is enclosed in a historiated initial connected to a full border, providing entry to the garden of verse that follows.[34]

In Ellesmere, however, it is as if the mounted pilgrim-authors have ridden out of what might have been historiated initials to take on lives of their own—larger and more vital—to perform their roles. In a sense, each figure seems to emanate from the paraphernalia of the border's decorated initial that begins the first word of each tale, either entering from the open side of the demi-vinet border on the recto folios or closely connected to it by floriated sprays on the verso folios. The association of the portraits with the border elements is reinforced both visually (by the colors used) and metaphorically. As Laura Kendrick observes, the Middle English word for border, *bordure*, can also mean "storyteller." If the placement of the Miller, on the wrong side of the border for a verso folio, is intended as a visual pun, then "mocker," "jester," and even "bagpipe" might also be applicable.[35]

On folio 81r, the figure of the Summoner seems to have actually vacated the space left between the open-bracketed foliate scrolls that extend from the decorated initial of the border (fig. 11.7). The sequence of these marginally placed, equestrian portraits in Ellesmere suggests, as Hardman points out, "a natural association between the page-turning impulse . . . and the idea of travelling towards the destination of the narrative journey."[36] The portraits are an important linking device that all interrelate—along with the demi-vinet borders, the decorated letters in their various sizes, and the glosses—to lead viewers on a parallel literary and artistic pilgrimage.

Just as the foliate borders signal artifice,[37] so too do the pilgrim-authors, in their self-consciousness, often deflect responsibility for their lack of style, imagined or real. The foliate border apparatus surrounding the *Franklin's Prologue* and the opening of his tale performs multiple functions. While it gives prominence to the tale's beginning, indicated just over midway down folio 123v by a decorated initial attached to the border, it also distinguishes the prologue, at the top of the page, by a champ (fig. 11.9). Beside this prologue, foliate scrolls extend from the border and bracket a Latin gloss, which refers to it (V 721), quoting the *Satires* of Persius, wherein he says that he never wet his lips in the Hippocrene, a mythical fountain of poetic inspiration sacred to the Muses.[38] In Greek mythology, the name means "Horse's Fountain" since it was formed by the hooves of Pegasus—an interesting detail because in Ellesmere the Franklin's horse determinedly butts against the decorated initial that begins the *Franklin's Tale*.

The Franklin denies knowing "colours" other than those that grow in the meadow or are used in dying and painting (V 723–26). In showing such rhetorical dexterity, he brilliantly displays the very art he modestly denies knowing.[39] In his portrait, the Franklin's expression and gesture seem to embody his affected modesty and his denial of rhetorical skill. His

FIG. 11.9 Opening of the *Franklin's Tale*, Ellesmere manuscript. San Marino, Huntington Library MS El 26 C 9, folio 123v.

FIG. 11.10 Dragon on the border of the *Clerk's Prologue* (detail), Ellesmere manuscript. San Marino, Huntington Library MS El 26 C 9, folio 87v.

FIG. 11.11 Dragon on the border of the *General Prologue* (detail), Ellesmere manuscript. San Marino, Huntington Library MS El 26 C 9, folio 1r.

particolored coat, indicating one of his roles as a justice of the peace (*General Prologue*, I 355), is similar to that worn by the Man of Law (fol. 50v). The Franklin's is, however, more elaborate and has stripes, which add to the *colours* of the page. All the elements of this illuminated page work seamlessly together to provide a visual analogy to the rhetorical play of Chaucer's text: the colorfully attired Franklin calls attention to himself by his self-referential gesture; his horse nudges the decorative paraphernalia of initial attached to the border, which in turn sprouts foliate scrolls, one of them bracketing the equestrian portrait itself, and another, even larger, bracketing the marginal annotation concerning classical rhetorical style.

In another grand display of verbal and artistic virtuosity, a similar relationship of elements operates on the facing folios introducing the Clerk. In the *Clerk's Prologue*, the Host asks the Clerk to tell a merry tale in a plain style rather than a high style, with "colours" (IV 16) more suitable for a kingly audience. Of course, while agreeing to do so, the Clerk instead proposes a tale he learned from Petrarch, the poet laureate of Italy, whom Death has now slain. As if to make the point, on folio 87v, a small wingless dragon crawls away along the bottom of the foliate border and looks back (fig. 11.10), in contrast to the dragon at the bottom of the border at the beginning of the *General Prologue* (fol. 1r), which looks forward and points its wing to direct the viewer to turn the page (fig. 11.11).[40]

The *Clerk's Prologue* continues at the top of the following folio 88r (fig. 11.12), where he says that Petrarch first described the country in which his story begins. Beside this comment, as if to confirm the Clerk's authoritative source, a marginal Latin gloss gives the first part of Petrarch's account. Looking toward the first stanza of his tale, the Clerk himself holds up one of his treasured books, a red-covered one presumably containing Petrarch's original text. This round-faced Clerk does not wear threadbare clothes, but his horse is indeed as lean as a rake (*General Prologue*, I 287), perhaps to make a subtle comment on the Clerk's priorities.

The placement of the Physician at the beginning of his tale, on folio 133r, might reflect a similar mild critique that the artistic designer could not resist, given the perception that

FIG. 11.12 End of the *Clerk's Prologue* and beginning of the *Clerk's Tale*, Ellesmere manuscript. San Marino, Huntington Library MS El 26 C 9, folio 88r.

FIG. 11.13 End of the *Franklin's Tale* and beginning of the *Physician's Tale* with portrait of the Physician, Ellesmere manuscript. San Marino, Huntington Library MS El 26 C 9, folio 133r.

may have prevailed then, as now, that the rich always have better medical care (fig. 11.13). This critique is implied because the Physician, richly robed and fur-trimmed, looks up toward the lines above him mentioning the "greet richesse" and many friends (VI 4) of the knight Virginius. He holds up a urinal, the iconographic symbol of his trade, but what is most interesting about the portrait is that his horse seems to peer into and beyond the depth of the vellum surface just at the passage describing the artistry of Nature, who formed the beautiful daughter of Virginius. In this passage, which is largely original to Chaucer,[41] Nature describes herself as the ultimate artist. Chaucer, via the Physician, places Nature under the jurisdiction of God, with whom she is in full accord and in whose service she works. Despite the pagan source of this concept, this passage places all within the Christian framework as part of God's plan. The best of the classical artists of history— Pygmalion, Apelles, and Zeuxis (named in the text, at VI 14–16, and referred to in the marginal gloss)—cannot counterfeit Nature, no matter how hard they work to forge or carve or paint. In the *Physician's Tale*, the daughter is not only peerless in beauty, but a thousandfold more virtuous than beautiful.

Responses by Audiences Internal and External to the *Canterbury Tales*

The tales of the Physician, Clerk, and Franklin all concern extreme trials suffered by women. As with several other tales, the pilgrims' communal responses not only supply links between tales but also allow the Ellesmere audience to debrief, as it were, by helping them contextualize and assess each tale's impact. In the case of the *Physician's Tale*, the responses are straightforward and reflect the values of a just and humane society in righting wrongs and feeling pity. After Virginius brings his daughter's head to the false judge, the community rallies and casts the judge in prison, where he slays himself, while a confederate has his death sentence commuted to exile. Among the pilgrim audience, the Host expresses horror and pity, draws a moral about Fortune's gifts, praises the doctor, whom he likens to a prelate, and then hurriedly passes on and asks the Pardoner to tell a tale of mirth or trickery. The other pilgrims, who have no stomach for ribald stories following such a tale, convert the request to a moral tale instead.

Responses to the *Clerk's* and *Franklin's Tales* are more complex. At the close of the *Clerk's Tale*, the people of Saluzzo celebrate the restoration of Griselda to her husband (IV 1122–23); Griselda is once more stripped, but this time to be clothed in cloth of gold (IV 1117);[42] and everything ends happily as son succeeds father as lord. Next, the Clerk justifies his telling of the tale not so that every woman should follow Griselda in her humility, but as an example to everyone to be constant in the adversity God sends us for our own good—the reason Petrarch wrote this story (IV 1147–48), as glossed on folio 101r. He then introduces a lighter note by addressing lords not to look for any Griseldas

FIG. 11.14 "Lenvoy de Chaucer" (detail), Ellesmere manuscript. San Marino, Huntington Library MS El 26 C 9, folio 101v.

nowadays because their "gold," however fair the coin be to look at, would prove to be alloyed with brass (IV 1163–69).

The Clerk ends his "ernestful matere" by announcing a "song" for wives, asking God to maintain them in their mastery (IV 1170–76). At the bottom of folio 101v (fig. 11.14) in Ellesmere, this is followed by Chaucer's envoy. It begins with a three-line decorated initial attached to the demi-vinet border, marking what was considered important on this folio. Here Chaucer, as indicated by the title, bursts into the narrative, taking over the Clerk's voice. He cries out in "open audience" (IV 1179), both mourning Griselda's death and warning that no man should test his wife's patience or expect to find a Griselda. As an antidote to the extreme morality of the *Clerk's Tale*, he addresses wives, instructing them to behave in opposite fashion.[43] As if this still is not enough, the Host weighs in on the following folio. The title introducing him does not merit a demi-vinet border; instead, a two-line-high champ accompanies his response that, rather than a barrel of ale, he wishes his wife had heard this legend. The next folio begins the *Merchant's Prologue*, in which the Merchant responds by taking the Clerk's story to refer to the pains of matrimony, especially for men: he suffers from a shrewish wife who is the exact opposite of Griselda in patience.[44]

At the end of his tale, introduced in Ellesmere by a two-line champ on folio 133r (fig. 11.13), the Franklin asks his audience who was the most "fre" (V 1622). In Boccaccio's two versions of the tale, this question is expanded. In *Filocolo*, it is extensively debated at leisure by a mixed audience of young people, and, at the end, the final word seems to favor the husband because he stood to lose his honor.[45] At the end of the *Decameron* version, the question is addressed to the ladies, with the answer suggesting it was the lover who was most generous because he gave up the catch he had pursued for so long and could have had.[46]

Chaucer's text appears to leave the question open, but the makers of the Ellesmere manuscript intervened on folios 130v–131r in a particularly dramatic and unusual fashion. The pages containing Dorigen's suicide speech are weighed down by small gold champs and Latin glosses introduced by gold and blue paraph signs (fig. 11.15). This is one of the

FIG. 11.15 List of chaste wives in the *Franklin's Tale*, Ellesmere manuscript. San Marino, Huntington Library MS El 26 C 9, folio 131r.

passages featuring Dorigen's emotional and psychological life, as Susanna Fein observes. Dorigen's "true wifehood," Fein says, "is the tale's moral core, and preserving her chastity depends on her own stamina and a protective providential world."[47] The passage in Ellesmere features Dorigen's crisis by ornamentally emphasizing the choice she faces, suicide or dishonor. Dorigen recalls the numerous chaste women who chose death in order to preserve their virginity or wifely fidelity. Here *The Riverside Chaucer* presents a thirty-one-line passage (V 1426–56) as a continuous block, with no paragraph indentations, and most readers likely skim over the passage. Ellesmere, however, introduces each woman with a champ for which room has been left at the beginnings of the relevant lines in the text, indicating that these were part of the plan and not just added by an enthusiastic limner after the scribe had finished his task.[48] Fourteen of these successive gold letters introduce Demotion's daughter, Scedasus's daughter, a Theban maiden who slew herself after being defiled by Nicanor, another Theban maiden after a Macedonian ravished her, Nicerates's wife, the beloved of Alcibiades, Alcestis, Penelope, Laodamia, Portia, Artemisia, Teuta, Bilia, and Rhodogone and Valeria (both mentioned in one line).

What purpose could all this visual and verbal emphasis serve? Is it a misogynist ploy to hammer in models of wifely fidelity for the Ellesmere audience or just an indication of the sort of reading matter to which Dorigen was exposed? In any case, these exempla are what she calls to mind until her husband shows up and asks her why she is weeping. After prompting her to reveal the cause of her distress, Arveragus tells her to go to Aurelius to keep her "trouthe" since that is the highest thing a man can have (V 1478–79). Here Dorigen's conflict regarding chastity is recast to another kind of honor, that of keeping her oath.

But the gold letters do not feature this latter kind of honor, which is mostly associated with aristocratic men. Instead, and in the context of the *Canterbury Tales*, they seem rather to recall the gold letters in the book mentioned in the *Second Nun's Tale* about Saint Cecilia, another of Chaucer's many tales that deal with the subject of chastity. In the *Franklin's Tale*, the list of women who died for the sake of preserving their honor, and so were accorded gold letters, gives each one individual identity and substance.[49] The list also emphasizes their individual and collective psychological impact on Dorigen, highlighting the crux of her dilemma. Although these chaste women are from the pre-Christian era, they reflect medieval Christian values. As Fein frames it, citing Chaucer's *Boece*, Dorigen's "wifely chastity exemplifies a powerful, civilizing virtue, the 'allyaunce perdurable' that, despite the men's lusty desires for arms and action, ensures that cosmic forces stay within the boundaries set by love."[50]

Readers of Ellesmere would likely recall the litanies of saints featured in books of hours and psalters, from the late tenth-century Ramsey Psalter to the early fourteenth-century Gorleston Psalter, both with the names of each saint listed beginning with a gold letter.[51] In the Ruskin Hours (Los Angeles, J. Paul Getty Museum, MS Ludwig IX 3, fol. 105v), made around 1300, the litany includes not only the saints, introduced by alternating gold and blue initials, but also a small miniature beside each, including one for Saint Cecilia holding a book.[52] This sort of extratextual reading matter would have been familiar to the Ellesmere audience and relates to the way they would likely have responded to the appeal of the heroine martyrs featured in so golden a manner. These folios, by their very uniqueness in the Ellesmere design scheme, are a telling comment on the kind of readers who would also have been expected for this manuscript.

I suggested above that the portraits of the Knight with his gold adornments and the Squire with his ermine leggings are presented in a manner with which aristocratic readers, even possible royal male recipients of the book, could identify. I would like to modify this now to include among readers a family's women. Just as women from royal and noble families were often among the commissioners and readers of books of hours, so, too, ought they to be included among the Ellesmere manuscript's readers.[53] Ellesmere encourages upper-level women readers by its positive representations of the women pilgrims.

Like those of the Knight and the Squire, the portrait of the Wife of Bath, the only secular woman pictured, was upgraded to accord her a higher status than is warranted by the *General Prologue* description or by her own *Prologue*.[54] The Wife's portrait is placed

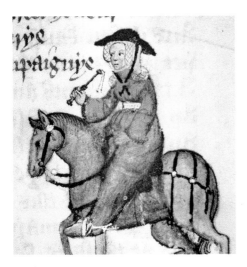

FIG. 11.16 Portrait of the Wife of Bath (detail), Ellesmere manuscript. San Marino, Huntington Library MS El 26 C 9, folio 72r.

at the beginning of her tale on folio 72r, and, by proximity, it partially assimilates her with the tale's "elf-queene with her ioly companignye" (*Wife of Bath's Tale*, III 860), the adjacent line of the text at which she gazes (fig. 11.16). Her social position is further elevated by her accouterments, including her fur-trimmed sleeves and her gold belt; not only that, other than the Knight's and the Monk's, hers is the only horse fitted with gold stirrups and, like the Knight's, has gold bosses. Her outsized hat has been moderated and her sexual excesses downplayed by the concealment of red hose and "gat" teeth (*General Prologue*, I 456, 468). While she has not lost all her lively characteristics—she still has a riding "whippe" (*Wife of Bath's Prologue*, III 175), but it is not overly large, and her look is resolute rather than brazen—she has taken on some of the gentle values emphasized by her choice of tale.

The other two portraits of women in Ellesmere, both nuns, reaffirm a conservative stance.[55] The Wife of Bath does not seem old enough to have weathered five husbands, but the Prioress (fol. 148v) has aged and has white hair, suggesting a certain gravitas. Like the portrait of the Wife of Bath, this one has been visually edited as a "corrective" to her *General Prologue* description, which does not quite accord with the tone of her narrative. Instead of a small red mouth suitable for a courtly lady (*General Prologue*, I 153), her mouth is turned down slightly as if in disapproval of the usurious practices mentioned in the adjacent text and emphasized in the marginal annotation. Her horse is even more aggressively condemnatory, actually butting the border (and displacing its alignment).[56] The rosary on her left wrist indicates her piety, but there is no visible brooch shown at its end, thereby eliminating any ambiguity about the meaning of its inscribed text. Both the Prioress and her horse are elegantly presented with only the degree of ornament that accords with her status: her cloak has a simple trim and the horse's bosses appear to be silver.

The portrait of the Second Nun on folio 187r is similar in conception to that of the Prioress, even though made by a different artist, suggesting close collaboration. Both portraits

are fittingly adapted to reinforce the spiritual import of their tales about virgin martyrs. Because there is no description of her in the *General Prologue*, the Second Nun's portrait is entirely the creation of the artist, who has echoed the visualization of the Prioress. Like her superior, the Second Nun has white hair and wears a pleated wimple. As "chapeleyne" (secretary; *General Prologue*, I 164) to the Prioress, she is literate, a point further emphasized by her translation of the life of Saint Cecilia. Although her stance is more humble, her speaking gesture is somewhat comparable to that of Chaucer reciting his work as shown in the *Troilus* frontispiece.[57] Like the subject of her tale, this educated woman might well have come from royal stock (reflecting the lines of text her portrait faces), but in this case she has clearly chosen poverty. Her fine horse (not starved like the Clerk's horse) has no fancy trappings at all; it looks somewhat fiercely and defensively at the passage concerning Cecilia's desire to remain a virgin. Plain and self-effacing, the Second Nun embodies a spiritual ideal of the religious life. The portraits of the two nuns both suit their tales and serve as exemplary models for upper-class women who might consider choosing a religious life.

What all this suggests is that Ellesmere has shaped Chaucer's opus in a way that would have been suitable for perusal by an elite circle of family and friends, whether of a single gender or mixed, as a single audience. Group reading appears to have been fairly common among the upper classes. In *Troilus and Criseyde* (II, 80–105), Criseyde and her ladies, while being read to by a maiden, stop listening and pause to look at and repeat the rubricated lines in a copy of the *Thebaid*, giving us a glimpse of a possible small-group scenario. In Chrétien de Troyes's *Yvain*, the hero and his company come upon a garden where they see a maiden reading a romance to her lordly father, who is reclining upon his elbow on a silken rug, shortly to be joined by a lady who is her mother.[58] Illustrations of the writings of Christine de Pizan give a sense of the courtly settings for reading groups. One copy of *Le Livre des trois vertus*, for example, depicts women surrounding a crowned woman with her hand raised over a book.[59] A manuscript of *La Cité des dames* portrays Christine herself before three figures as she points to an open book on a table in her study.[60]

Audience responses in the *Canterbury Tales* and in works by Boccaccio and Petrarch suggest further how such groups would interact. Not only would they listen and, as in the case of Ellesmere, read and look closely at the pages; they would also presumably sometimes enter into the "game," debating among themselves, as do the Canterbury pilgrims, the questions raised in many of Chaucer's tales. One can even imagine children among the Ellesmere audience who might continue the game playing. The *Tale of Sir Thopas*, with its distinctive layout, is almost like a board game for those trying to figure out the sequence in which to read the lines (fols. 151v–153r).

How would the highborn audiences of Ellesmere have reacted not just to the serious issues raised by the fictions of the Physician, Clerk, and Franklin, but also to the more scurrilous concerns of pilgrims such as the Friar and Summoner? In the latter's prologue, where he responds angrily to the Friar's portrayal of a fictional summoner,

the Summoner describes a visionary account of friars swarming in and out of the devil's arse. Ellesmere folio 81r features three massive interlaced knots with foliate extensions in the border beside this account (fig. 11.7). This conglomeration is unique to this folio, although the individual components are not. Regardless of whether this was intended by the manuscript's designers to call attention to the passage, it does serve mnemonically to help readers locate it more quickly when rereading. Joanna Frońska has shown how a chain of associations develops in using a book many times, "unexpected at first glance."[61] She references Hugh of Saint Victor, who stated that "when we read books, we study to impress on our memory through our mental-image-forming power [*per imaginationem*] not only the number and order of verses or ideas, but at the same time the color, shape, position, and placement of the letters, where we have seen this or that written, in what part, in what location (at the top, the middle, or the bottom) we saw it positioned, in what color we observed the trace of the letter or the ornamental surface of the parchment."[62]

Nothing is made overtly explicit in Ellesmere's elegant framing of the Summoner's account. Aristocratic ladies might respond to this passage in Ellesmere as did those in the *Decameron* to Dioneo's: "As they listened to Dioneo's story, the ladies at first felt some embarrassment, which showed itself in the modest blushes that appeared on all their faces. Then, glancing at one another and barely managing to restrain their laughter, they giggled as they listened."[63] This sort of strategy among "ladies" of any day allows them to enjoy risqué material without loss of dignity. Likewise, all of the upper-class audience could enjoy the crude mirth and brutal outcomes of some tales because they are told by churls, who are presented as such in the figural illustrations. The pilgrims' rejoinders model and cover a variety of ways to respond even as the tales are sanitized and aestheticized by the beautiful framing ornament in Ellesmere.

In discussing the medieval taste for debate-worthy questions and artful play, Carruthers observes that "artefacts are always in play exactly on the ground created through the tension between figment and actual."[64] This insight applies also to the Ellesmere manuscript, an art object to be looked at and "read" as a play on vellum and an entertainment. In the end there is no end, for, as Grabar concludes, "by providing pleasure, ornament also gives to the observer the right and the freedom to choose meanings."[65]

NOTES

1. Ellesmere manuscript high-resolution images of the pilgrims can be viewed online at *Digital Scriptorium*, s.v. "EL 26 C 9."

2. Lines numbers, included in brackets, are from Chaucer, *Riverside Chaucer*, but transcriptions from the Ellesmere manuscript are my own.

3. Parkes, "Influence."

4. Ibid., 134.

5. See, for instance, Fei, "Visual Semantics Stratum." The term *visual semiotics* has also been used; see, for example, Camille, "Book of Signs."

6. See Trupia, "Semantics of Beauty," 33–64.

7. These would have been "a self-conscious, connected, knowing circle of committed and active, perhaps politically active, readers," including "laymen, notaries, judges, and chancellors";

see Kerby-Fulton and Justice, "Scribe D," 222. Scribe D, John Marchant, worked on another *Canterbury Tales* manuscript mentioned below: Oxford, Corpus Christi College MS 198; see online at *Early Manuscripts at Oxford University*.

8. Cambridge, Corpus Christi College MS 61, folio 1v, circa 1415–25. It is reproduced in figure 9.7 of this volume.

9. Erne, "Words in Space," 105.

10. Quoted in Driver and Orr, "Decorating and Illustrating the Page," 115. For the portrait in London, British Library MS Cotton Nero D.vii, folio 108r, see *British Library Online Gallery*, s.v. "The Illuminator Alan Strayler, in Thomas Walsingham, Catalogue of the Benefactors of St. Albans Abbey."

11. See Emmerson, "Visualizing the Vernacular."

12. McNiven, "Problem of Henry IV's Health."

13. Norris, *Medieval Costume and Fashion*, 283.

14. Hilmo, *Medieval Images*, 180–86.

15. Pächt, *Book Illumination*, 70. See, for example, the Harley Golden Gospels, early ninth century, folio 45v, which can be viewed in color digital facsimile online at *British Library Digitised Manuscripts*, s.v. "Harley MS 2788."

16. Pächt, *Book Illumination*, 76.

17. Hardman, "Mobile Page," 101.

18. From Eph. 4.5–6; Chaucer, *Riverside Chaucer*, 945 (Florence H. Ridley's note to *Second Nun's Tale*, VIII 201).

19. Theophilus, *On Divers Arts*, 77–78.

20. Scott, "An Hours and a Psalter." Compare, for example, folio 87v of Ellesmere with folio 56r of MS Hatton 4 in which the border and the decorated initial are remarkably similar. See *Bodleian Image Library*, s.v. "Hatton 4."

21. Grabar, *Mediation of Ornament*.

22. Carruthers, *Experience of Beauty*, 11.

23. Scott, "Design, Decoration, and Illustration," 31.

24. Pearsall, "Towards a Poetics," 112.

25. By way of comparison, the Hengwrt manuscript, Aberystwyth, National Library of Wales, Peniarth MS 392D (*olim* Hengwrt MS 154), likely an earlier version of the *Canterbury Tales* also written by the Ellesmere scribe, has seven paraph signs, missing the one at line 2024. While my intention is not to compare variances in all other manuscripts, it is interesting to note that

the scribe of Cambridge, Cambridge University Library MS Dd.4.24 adds paraph signs only at the three main stages—that is, at the beginning of the tour, at who is seen in the middle of the temple, and then at who is painted in the tower above; see Da Rold, ed., *Dd Manuscript*, folios 26v–27r. Compare *Knight's Tale*, I 1995, 2011, 2028; and Dd.4.24, lines 1137, 1151, 1169.

26. As McKinley notes, Chaucer creates a similar aesthetic pilgrimage in the *House of Fame*, to which she parallels the practice of visiting English pilgrimage churches ("Ekphrasis as Aesthetic Pilgrimage").

27. Rickert, "Illumination," 562.

28. Scott, *Dated and Datable English Borders*, 9.

29. Kerby-Fulton, "Geoffrey Chaucer's 'Cook's Tale,'" 16–19.

30. Rickert, "Illumination," 562. Alexander, in *Decorated Letter*, 21, gives an interesting account of how payment for making different letters was recorded for a pontifical for Pope Benedict XIII (1394–1409), including "letters called *champides* (that is plain gold letters on blue and magenta ground decorated with white filigree)."

31. Raybin, "Manye been the weyes," 13.

32. Partridge suggests that these rubrics "can be attributed to Chaucer himself" ("Makere of this Boke," 138).

33. See Hilmo, "Illuminating Chaucer's *Canterbury Tales*," 286–88.

34. London, British Library MS Lansdowne 851, folio 2r; the five borders within the manuscript are demi-vinets. See *British Library Catalogue of Illuminated Manuscripts*, s.v. "Lansdowne MS 851." For further examples, see Oxford, Bodleian Library MS Bodley 686, folio 1r, and Tokyo, Takamiya MS 24, folio 1r (now on loan at the Beinecke Rare Book and Manuscript Library, Yale University), both reproduced in Hilmo, "Illuminating Chaucer's *Canterbury Tales*," figs. 8 and 10 (for discussion, see 254–66). On Chaucer and metaphoric gardens of verse, see Hilmo, *Medieval Images*, 165–67.

35. Kendrick, *Animating the Letter*, 217–25, esp. 223: "In French, a *bordon* (in Anglo-Norman, a *burdun*) was a bagpipe."

36. Hardman, "Mobile Page," 108.

37. Despres, "Portals," with reference to Lightbown, *Mediaeval European Jewellery*, 380–81, plate 64.

38. See Persius, *Satires*, Pro.1–3.

39. See Chaucer, *Riverside Chaucer*, 896 (Joanne Rice's notes to the *Franklin's Prologue*, V 716–28, 723–26).

40. Frońska, "Turning the Pages," 205.

41. Chaucer, *Riverside Chaucer*, 902 (C. David Benson's note to the *Physician's Tale*, VI 9–117).

42. In Petrarch's *Historia Griseldis*, 1:128–29, she is simply clothed "solitis vetibus" (with her accustomed garb; line 388).

43. Hengwrt, folio 190v, likewise includes the envoy and attributes it to Chaucer. It is introduced by a two-line-high blue Lombard capital with extensive marginal pen flourishing in red. This suggests that Adam Pinkhurst, the probable scribe of both Ellesmere and Hengwrt, knew and wanted to emphasize that these lines are Chaucer's own addition. On the identification of Pinkhurst, see Mooney, "Chaucer's Scribe."

44. The artistic designer of Takamiya MS 24, folio 106r, uses Griselda's name as the running title at the top of the page. The name is unusually enlarged in size and, on rectos, the first letter is illuminated in gold, surrounded by extensive pen flourishing in purple. This mid-fifteenth-century manuscript includes Lydgate's *Life of Saint Margaret*. It might have been intended as a wedding gift for Margaret Beaufort, Countess of Richmond, whose patron saint was Margaret. See Manly and Rickert, "Recorded Manuscripts," 621–22; and Boffey, "Lydgate's Lyrics and Women Readers," 143.

45. See extracts in Kolve and Olson, eds., *Geoffrey Chaucer*, 393–403.

46. Kolve and Olson, eds., *Geoffrey Chaucer*, 406. See also Boccaccio, *Decameron*, 730–31.

47. Fein, "Boethian Boundaries," 210.

48. Hengwrt has eleven paraph signs for this same passage (fols. 162v, 163r), indicating that Pinkhurst did want to emphasize them. This might have happened spontaneously because he missed the first one and then, perhaps realizing the content, added little marks in the same ink as the text in the margins to indicate where the paraphs were to go. There are no marginal source glosses beside these lines in Hengwrt. Oxford, Corpus Christi College MS 198, folios 168v–169r, has no particular distinguishing marks for this passage (see online at *Early Manuscripts at Oxford University*). London, British Library MS Harley 7334, folios 159v–160r (viewable at *British Library Digitised Manuscripts*, s.v. "Harley MS 7334"), does not distinguish this passage in any way except that the husband's response receives a blue paraph sign with red pen flourishing in the margin beside line 1467.

49. I am grateful to Corinna Gilliland for this observation.

50. Fein, "Boethian Boundaries," 211.

51. See the Ramsey Psalter, folios 209r–210v, and the Gorleston Psalter, folio 211r (which includes the name "Cecilia," the subject of the *Second Nun's Tale*), online at *British Library Digitised Manuscripts*, s.vv. "Harley MS 2904" and "Add MS 49622," respectively.

52. For the Ruskin Hours, see the J. Paul Getty Museum Collection, s.v. "Ruskin Hours."

53. See Reinburg, "For the Use of Women," 4.

54. For a fuller discussion of the Wife of Bath, including other fifteenth-century portrayals, see Hilmo, "Illuminating Chaucer's *Canterbury Tales*," 276–80.

55. See Hilmo, "Iconic Representations."

56. The only other border that is displaced is that beside the portrait of Chaucer, whose tale follows that of the Prioress in Ellesmere order. It would seem that the original plan, as indicated by the underdrawings, still partly visible in the case of the Prioress, was altered in the finishing process to accommodate these two portraits. Her rigidly straight back (originally more curved) and the repelling gesture of her right hand counter the forward thrust of her horse.

57. See Hilmo, in "Iconic Representations," 128–30, for further details and related images.

58. Chrétien de Troyes, *Le Chevalier au Lion*, 163–66 (lines 5341–5450). I am grateful to Nicole Eddy for this reference.

59. New Haven, Yale University Library Beinecke MS 427, folio 49v. See also *Beinecke Digital Collections*, s.v. "Livre des trois vertus"; and Image ID 1357957.

60. London, British Library MS Harley 4431, folio 290r; see online at *British Library Digitised Manuscripts*, s.v. "Harley MS 4431."

61. Frońska, "Turning the Pages," 208 and n. 75.

62. Quoted in Carruthers, *Book of Memory*, 264.

63. Boccaccio, *Decameron*, 48.

64. Carruthers, *Experience of Beauty*, 21.

65. Grabar, *Mediation of Ornament*, 237.

TWELVE

Drawing Out a Tale

Elisabeth Frink's *Etchings Illustrating Chaucer's "Canterbury Tales"*

Carolyn P. Collette

The Middle English lexicon did not include the verb *to illustrate*. The noun *illustration* gained currency only in the fifteenth century and conveyed the idea of mental illumination or enlightenment; its use as a term denoting a picture or image accompanying a written text by representing some event in that text did not arise until the early nineteenth century. So, in a way, we might say that, although medieval books were often lavishly decorated with images, they were not illustrated in our sense of the word. The semantic field of the Middle English term *illustration* as "enlightenment" overlaps the semantic fields of Middle English words that did refer to the function and effect of images, particularly those that appeared in conjunction with, or in proximity to, a text they were assumed to clarify and illuminate. Both *enluminen* and *portrayen* refer to painting or decoration through images, with a goal, on the one hand, of shedding light on, discovering light in, or imputing light to a topic; or, on the other, of representing some element of a text so that it might be better comprehended. The etymological roots of these words, Latin *illustrare*, *lustrare*, and Anglo-Norman *purtraire* (from Latin *protrahere*), are centered in concepts of clarification and elucidation. Neither the Latin root verbs nor their Middle English and Anglo-Norman derivatives offer mental space for the concept that illustration may be a projection of an artist's interpretation

I am grateful to the Mount Holyoke College Archives and Special Collections for access to the College's volume of Elisabeth Frink's *Etchings Illustrating the Canterbury Tales*, a gift of Virginia Ross, Class of 1966.

as much as an illumination of a text, a distinction which this essay explores. Elisabeth Frink's illustrations of the *Canterbury Tales* do not necessarily seek to illumine Chaucer's text so much as to translate and appropriate it to the illustrator's own evolving interests. In art, as in language, the notion of translation comprises alteration and change, potentially resulting in adaptation to a new use, often by rendering an original in a new medium or form. Translation as transformation does not displace a text so much as create new dimensions of meaning, perhaps unexpected, perhaps recognizable as explicit manifestation of what has been implied in the work but never before called forth. Illustrating a text—literally translating it from words to images—can be a kind of illumination, of course, but one that depends on a correlative imagination: an artist interpreter who is not always a partner with the artist and can exercise a separate transformative imagination. Elisabeth Frink has been praised for her ability to reveal unexpected dimensions in her subjects, as the art critic Hilton Kramer observed in noting her gift for unexpected revelation: "Art can't be just a thought, a projected idea; it has to make visible something which you can see that wasn't previously there."[1] The pages that follow consider how and in what ways Elisabeth Frink's images of the *Tales* show what was not "previously there," asking how and if they illuminate, translate, or contradict the thematic and narrative lines of the tales they illustrate.

Who Was Elisabeth Frink?

Elisabeth Frink (1930–1993) was no mere illustrator, although before undertaking the *Tales* project (1972) she had illustrated *Aesop's Fables* (1968) and would go on to illustrate the *Odyssey* (1974) and the *Iliad* (1975) for the Folio Society.[2] She brought a reputation as an excellent sculptor and also a clear set of interests as well as philosophy to the *Tales*. A mid-twentieth-century British sculptor who worked largely in bronze, she used her art to embody ideas and emotions in human and animal figures. She is said to have been influenced in regard to style and technique by Rodin, whose work she saw in Paris, by Degas's bronzes and horses, and by the French sculptor Germaine Richier, whose own work favored human-animal hybrids, a genre Frink later embraced. In a 1980 interview, she herself specifically cited Alexander Calder as one of the sculptors she most admired because of his ability to translate emotion into form, praising him for the "spirit of freedom and humanity in his work."[3] By the time she began the *Tales* project, she had already established a reputation as an outstanding talent. Her work varied in subject, including a remarkable series of religious statuary of which *Walking Madonna* (1981) for Salisbury Cathedral, *Risen Christ* (1992) for Anglican Cathedral, Liverpool, and *St. Edmund* (1976) for St. Edmundsbury Cathedral are examples. She did a series of walking men, standing men, and seated men, as well as a series of male heads. Perhaps her most immediately engaging work was the series of animal representations—cats, hogs, dogs, baboons, and horses—that she created.

Pamela Simpson has described them as possessing "an expressive humanism that related them to both classical sculpture and post–World War II Existentialism."[4]

Over the course of her career she returned repeatedly to several representative images that she developed early in her work. These signature subjects were the male body,[5] horses, and malevolent birds. Each of these forms represented an elemental anxiety Frink expressed and confronted in her art. In his introduction to the *Catalogue Raisonné* of her work, her son Lin Jammet identifies the anxieties of her wartime adolescence as responsible for the complex interplay of emotions—from fear of male aggression to affirmation of the generous power of the human spirit—that energized her work: "The aggressor is a consistent theme in her repertoire, but with this bad comes the good. This is reflected in her portrayals of the vulnerable, the faithful and the courageous, human and animal forms striving for a peaceful and normal existence."[6] Julian Spalding places Frink's work within the larger context of post–World War II art in general, identifying a geometry of fear apparent in attenuated limbs and distorted proportions that characterizes her work and the work of mid-century European sculptors. He ties this artistic style to Picasso's pervasive influence: "Overarching them all, the extraordinary, now almost classical, but still pioneering imagination of Picasso. It was as if a fire had passed through nature, leaving man and beast charred and wracked where they stood, cast forever in their throes of agony: the aftermath of war."[7]

Frink was consistent in describing her work as "about what a human being or an animal feels like, not necessarily what they look like."[8] Not a literalist, she sought the "essence of human and animal forms," particularly the "freedom of spirit" within each.[9] Often her work suggests how that spiritual freedom is bound and confined by a culture of dominance and war. Although she chose to illustrate a series of great literary works of the Western canon, she described herself as "not literary" and once said of herself, "I'm a non-intellectual."[10] She worked on what interested her. Not concerned with whether her work would sell, she did not accept commissions unless she was interested in the subject.[11] Yet, despite her assertion that she was not an intellectual, she was thoughtful, frank, and articulate about what did interest her—the male form, horses, and how the two interact. Her early work explored the dominant male, as "aggressive, mindless, physical and predatory."[12] By the early 1970s, the period of her work on the *Tales*, this type had morphed into a "new male." Overt aggression, tamed to an extent but always imminent, gave way to implicit dominance. Of her development in this period, Spalding writes that "her art charts a progress from fear, aggression and heroism, through anguished suffering, resignation and stoicism to a troubled peace that has within it the seeds of brutalism and the inevitability of destruction."[13] In the late 1960s, Frink worked on the man-beast theme in sculpting men on horses, reflecting both the classical tradition of equestrian statues and her interest in the way rider and horse move as one. She continually refined her figures, pushing the conventional boundaries of representation without moving fully into abstraction.[14]

Frink held her life and her art in dynamic tension. Her recurrent male nudes represent simultaneous strength and vulnerability, a combination she once described as "the wonderful thing about men."[15] Through art, she struggled to express the concomitant beauty and terror of the human world and its close connection to the animal world. Her equestrian statues, evoking classical images of power, are, in her hands, images of human-animal spiritual union. Frink regarded the horses not so much as representations of actual horses but as representations of the "spirit of horses," their wildness and energy.[16] Indeed, recognizing the bond between human and animal energy occupied her throughout her career.[17] Her art is largely representational, but its unique iconography conveys an expressionist dimension suffused with her own emotion. Spalding stresses the apparent seriousness of Frink's art, saying, "There isn't a smile in the whole of her *oeuvre*, much less a laugh."[18] Happiness may well be virtually absent from her art, yet friends recalled her love of life as well as her passionate commitment to her art. A 1945 trip to Italy taught her that "art was something you lived not with or by but *in*."[19] And she lived her craft every moment of the day.

A Leap of Confidence: The *Canterbury Tales* Project

The *Canterbury Tales* volume reflected Frink's continuing interests, and it grew out of her bold audacity as an artist. To prepare for her work, she rented a studio on Lant Street in Southwark, where over the course of several months she mastered the craft of etching, and through trial and error perfected it into an art, before undertaking work on the volume. She etched directly onto copper plates; she said it was "more fun" and "more dangerous." Her philosophy of life, reflected in the creation of the volume, was that "you have to become uninhibited."[20] She was not a careful person either in her personal life or in her approach to her art, but rather someone who embraced experience of all kinds. It is intriguing to realize that her Lant Street studio in Southwark is said to have been close to the George coaching inn, once a starting place for the Canterbury pilgrimage.[21] For many people things seem to fall apart; for Elisabeth Frink everything was connected, it seems. A tremendous synergy opened new paths and horizons in the *Tales* edition, resulting in what the feminist art critic Sara Kent described in 1978 as "superbly sensuous male and female creatures presented with a Picassoesque lustiness and perfection of line."[22] The images for the *Tales* celebrate humans in a variety of relationships through bold, humorous, sensuous depictions.

The *Tales* project was not Frink's idea. It was proposed by her husband and supported by Waddington Galleries, which showed and backed her work. The Chaucer volume followed the earlier success of a volume illustrating Aesop's *Fables*. But the *Canterbury Tales*

volume literally got out of hand. It appeared in what approximates a double-folio size, illustrated by nineteen etchings hand-drawn directly onto copper plates, etched by Frink herself. The 100 percent cotton paper was specially made by J. Barcham Green, a specialty papermaking firm in Kent. Each sheet for the book measured 648 × 927 millimeters. All sheets of paper were hand-fed into a letterpress printing machine that used ink specially manufactured by Malcolm Wade & Co. in London. Frink told the *Daily Telegraph* that the edition was "going to be a slightly unusual book," which she hoped might be published as a paperback one day.[23] The initial print run of three hundred volumes sold in 1972 for £650–£675. Her biographer, Stephen Gardiner, describes the volume as "an extravaganza, a collector's item *par excellence*, and . . . ludicrously overblown."[24] The volume is almost impossible to lift or move. It sits in front of you, challenging your expectations. The only way to experience it is to turn its pages and look directly down at them from a considerable height. For a Chaucerian, it offers a new perspective on the *Tales*, in every sense of the word. Its depictions of the tales, focused on men, horses, and sex, remind one of how powerfully individual perspective can shape the art and craft of interpretation and thereby transform a text.

The edition illustrates Nevill Coghill's 1951 translation of Chaucer's *Canterbury Tales*, a lively, readable, and (some might say) breezy version of Chaucer, designed for modern audiences, for whom it uses twentieth-century idioms. As a translation it is already at one remove from Chaucer's text, owing to the linguistic choices it makes both to translate the Middle English and to keep a regular iambic rhythm as well as Chaucer's rhyme patterns.[25] Frink's images take the reader of the illustrated text yet another step away from Chaucer, for they illustrate Coghill as much as Chaucer. There is no hint in the biography of Frink's life that she would have been familiar with the original Middle English *Tales*, so it seems that Frink worked almost exclusively from Coghill's translation. Each of the nineteen images she created for the edition appears with an appropriate excerpt of Coghill's translation right below it, in a font that appears to be a kind of informal modern cursive.

In the early 1970s, Coghill was better known than most Chaucerians in part because of this translation, but largely because he was connected with a successful West End play, a musical of the *Tales* that had run since the late 1960s. The play combined some of the bawdier elements of the *Tales* with humor and music and ran for over two thousand performances. Given the success of the play, Coghill, connected to both the academy and the wider culture of the time, was a natural choice for Frink to join as a collaborator.

What Coghill actually thought of his illustrator is a matter of conjecture. His introduction to the volume is a masterpiece of tact—an expression of overt enthusiasm qualified by a degree of detectable consternation. Acutely aware of Frink's etchings as the product of a new and different sensibility, he praises her "sculptor's visual commentary," reflecting how Chaucer strikes a contemporary. He ventures that no century but the

twentieth could have produced the illustrations, and that the etchings speak in a "new voice of our own time, of things familiar and beloved, but freshly seen." Afloat in this sea of modernity, he grabs a lifeline of authority and quotes Chaucer to acknowledge the perennially generative power of Chaucer's art: "For out of olde feldes, as men seyth, / Cometh al this newe corn from yere to yere" (*Parliament of Fowls*, 22–23). To authorize Frink's "new corn," he aligns Chaucer's and Frink's narratorial ways, their "clear simplicity of presentation," and their common search for a distinctive "idiom or style." He asserts that Frink's work shares with Chaucer's a fundamental sense of fun. And he recognizes that, in drawing illustrations for the *Tales*, she has drawn out something new that is both Chaucer and also Frink: "As each etching is better for a knowledge of the story it comments on, so each story . . . is the better for her comment; we see what is essential in it in a clearer light, or perceive some unexpected nuance, or touch or quality or intensity of feeling—of pathos, of magnanimity, of doom, of irony, of laughter."[26] And he goes on to describe what he encountered:

> One of the surprises of her vision is that so many figures are for the most part nudes, or near-nudes, almost invisibly clad, whereas Chaucer is full of details of dress; this may be what gives these etchings their classical, sculptural quality, seen also in the splendid horses in certain etchings, and the pattern of their hooves. If there is some loss of local colour in the matter of dress, there is a gain in universality; the figures we see might be our own; in a way the blank three faces of the ruffians in the *Pardoner's Tale* are more expressive for us than if they had the detail of a Dürer. . . . These etchings, then, speak of Chaucer for our own times, as Burne-Jones and William Blake spoke for theirs, and earlier still the Ellesmere manuscript. There is always more to see in Chaucer.[27]

The issue Coghill grapples with, of course, is the fact that Frink's illustrations are largely interpretations, not illustrations, of Chaucer's scenes in the modern sense. Nevertheless, Coghill clings to the ancient principle that illustrations are illuminating, and that Frink's images are illustrations in the radical Latin sense of *lustrare*, that they are created to shine light on Chaucer's poetry. But try as he might, Coghill finds Frink's new approach unsettling, because it seems to bypass the poet. The illustrations are provocative and stimulating. They do bring new corn out of old fields, as Coghill suggests, but they exist as a parallel text, not as images subordinate to a notion of representation of Chaucer's creation of events or characters. They illustrate both what is and what is not actually there in Chaucer's poetry, inviting consideration of the perennial question of the imbrication of an author's intention and a reader's inference in interpretation. Like her illustration in the *Iliad* of the tears Achilles's horses shed for their lost charioteer, Frink's illustrations

arise out of the combination of empathic imagination and inference that lies at the heart of critical practice.

Reading Frink's Chaucer

Elisabeth Frink created nineteen illustrations for the *Tales*.[28] Although it is very unlikely that she would have been familiar with Chaucer criticism, it is nevertheless noteworthy that the *Tales* edition predates the explosion of criticism that occurred in the last quarter of the twentieth century, including feminist criticism, gender studies, new historicism, and postmodern critical theory. For Frink, the literal level of the text opened the way for her own imagination to play. Her long-standing interest in the male figure and in horses led her to emphasize various elements of the tales, often representing what is "there" in the text but not explicitly described. The first illustration, to the *General Prologue*, depicts the pilgrims unconventionally, not mounted and riding out in small groups, easily iden- tifiable in reference to Chaucer's description of their clothing, appearance, and horses, but rather in two large groups, one facing right, the other left. Some faces in the front are sketched in, others remain largely shapes without features, while the horses seize our attention (fig. 12.1). Although Chaucer almost always mentions the horses the pilgrims ride, comparatively little critical attention has been paid to the fact that horses in general are crucial to the pilgrimage. Frink's illustration does not distinguish types of horses so much as it emphasizes horses, reminding us of the essential partnership between horse and rider in medieval culture, doing so, in large part, by foregrounding the horses' legs and feet to suggest kinetic and potential energy. She selects a scene Chaucer does not describe and shapes it to her own interests. We do not see the pilgrims in the Tabard as a group, nor do we see them serially as described by Chaucer; rather, we see them defined by the energy implicit in the foregrounded horses' hooves.

The second illustration also clearly departs from, yet builds on, the literal text. It depicts Theseus in the *Knight's Tale* at the moment when the Theban widows stop his triumphal return to Athens and seek his help in recovering and burying their dead hus- bands (fig. 12.2). Chaucer describes the widows kneeling two by two along the side of the road. Frink's women stand as images of sorrow, confronting a man who regards them from a position of power. Mounted on a stallion, he addresses those who must walk, and whose unshod feet dominate the lower part of the scene. The women exercise a kind of reciprocal power by surrounding Theseus, whose eyes, like his horse's, seem slightly startled, although his gaze is direct. Frink here translates the petitioning posture of the women: a plea for intercession and help on the part of beseeching women becomes a moment when sorrow and injustice change the course of power and authority. Together, Theseus and the women form two halves of a circle; Theseus occupies the right "half," and two groups of women,

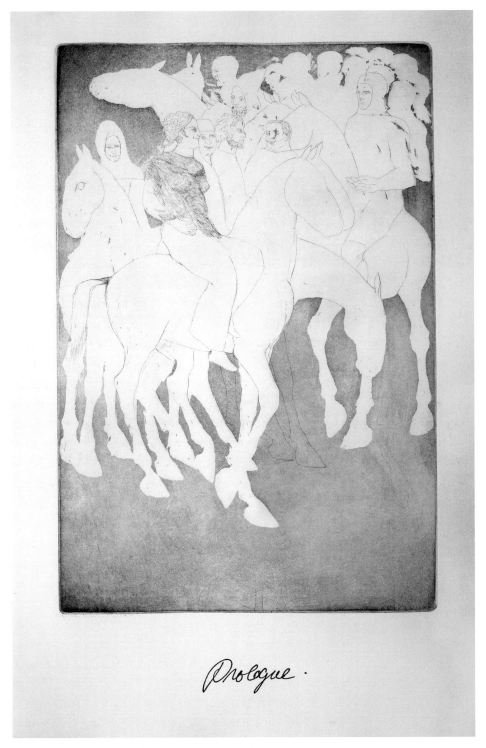

FIG. 12.1 Elisabeth Frink's illustration of the *General Prologue*.

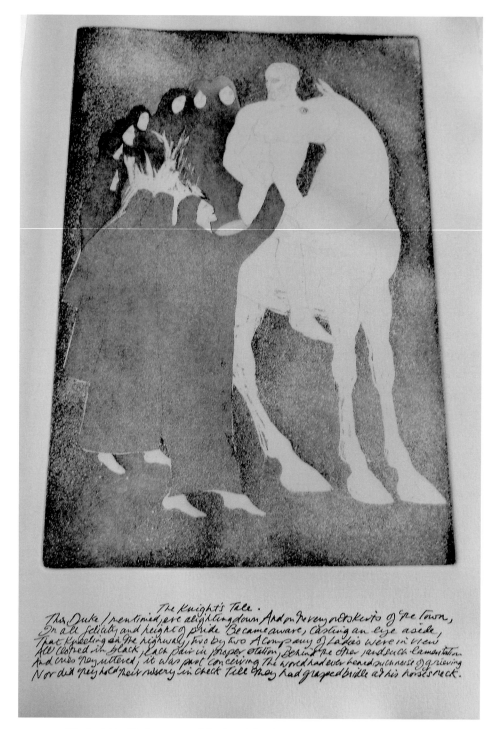

The Knight's Tale.

This Duke / mentioned, ere alighting down And on the very outskirts of the Town,
In all felicity and height of pride Became aware, casting an eye aside,
That kneeling on the highway, two by two A company of Ladies were in view
All clothed in black, each pair in proper station, Behind the other, and such lamentation
And cries they uttered, it was past conceiving The world had ever heard such noise of grieving
Nor did they hold their misery in check Till they had grasped bridle at his horse's neck.

FIG. 12.2 Elisabeth Frink's illustration of the *Knight's Tale*.

six in the upper quadrant and three in the lower quadrant, complete the pattern. The way that both Theseus and the women form the figure of a circle suggests the existential unity of their apparently disparate positions. Victor and victim are roles we are all called on to play at different times. The petitioning women announce their former high status. The circle reflects the nature of their request: a speech about the variability of Fortune, and a reminder that they were once duchesses and queens, concludes with a plea for elemental human compassion for funeral rites unperformed (Coghill, 44).

The dominant mounted man, literally and figuratively elevated above the station of women, appears again in Frink's choice of image for the *Clerk's Tale*, which once more depicts a scene that does not actually appear in Chaucer's poem: a meeting of Griselda and Walter in the countryside of Saluzzo (fig. 12.3). Griselda's slight form, her bare feet, and the goat she seems to be leading symbolize her relationship to nature and underscore the distance between the two of them. Once more, as is typical in these illustrations, the human figures are only minimally sketched in. We know more about the goat than we do about Griselda, but what is significant here is that she is gazing at Walter. The composition of this image is not the unifying image made for the *Knight's Tale*, but still a whole composed of two oppositional halves: Walter on the left, riding a stallion; Griselda on the right. Although they are in the same frame, they are not in any sense a unified pair. In the *Clerk's Tale*, Chaucer, like his source Petrarch, emphasizes that it is Walter who watches Griselda from a distance, observing her demeanor and comportment. Here the two are met in what looks like a woodland scene. Frink selects a stanza that describes how Walter has been intrigued by her sober beauty, seen from afar while he rides over his lands. But the focus here is not on Walter, large as his figure is; rather, it is on Griselda. Her goat seems startled, and perhaps Griselda does too, as the backward glance she gives Walter suggests. Knowing the story, one senses that Griselda has just apprehended some sort of threat and seems vaguely aware of its power, as her clenched right hand might indicate. Readers of the tale also know the threat Walter will pose to Griselda, and will recall Griselda's courage and strength as she matches Walter's tests with her own *stille wille*, a thematic rhyme Chaucer repeats in describing her thoughts throughout the tale. Frink's image here, then, is yet another representation of what is implicit but not literal. The initial distance between Walter and Griselda—a distance Walter seeks to erase as he seeks to erase her agency and will—is a distance that dominates the tale because Walter cannot believe it does not exist, and so he continually tests his wife.

A third image of a mounted man alters the pattern of these two images. Frink chooses to illustrate Chaucer's *Tale of Sir Thopas* (fig. 12.4), selecting the passage that both describes Sir Thopas's shield of "golden red / Emblazoned with a porker's head" (Coghill, 199) and depicts the comic hero with a plumed helmet (an object not mentioned among the accoutrements brought forth in the poem to dress and arm Thopas). Thopas sits astride what is

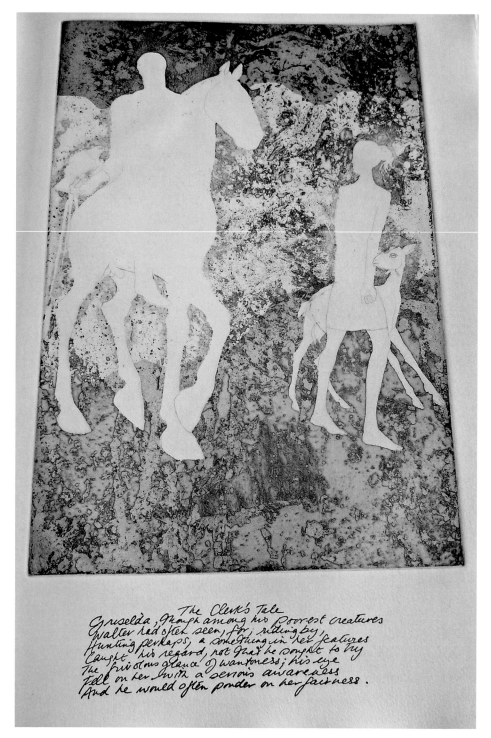

The Clerk's Tale

Griselda, though among his poorest creatures
Walter had often seen, for, riding by,
Hunting perhaps, a something in her features
Caught his regard, not that he sought to try
The frivolous glance of wantonness; his eye
Fell on her with a serious awareness
And he would often ponder on her fairness.

FIG. 12.3 Elisabeth Frink's illustration of the *Clerk's Tale*.

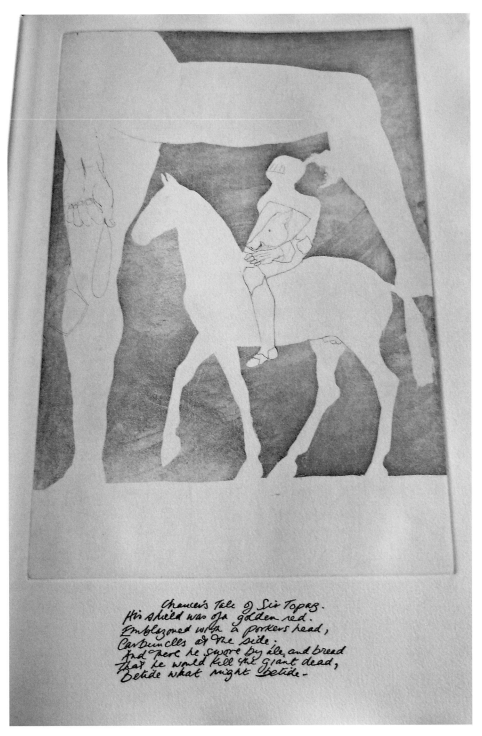

FIG. 12.4 Elisabeth Frink's illustration of Chaucer's *Tale of Sir Thopas*.

clearly not a destrier but rather the palfrey Chaucer mentions. Thopas's comic adventure is framed by the legs of the giant holding a sling, whose missiles had caused Sir Thopas to retreat to safety earlier in the poem. It seems that this giant is not only huge but also naked. His hand and weapon are all the detail Frink provides, but his open stride and the absence of any details of clothing suggest a kind of raw elemental power quite at odds with the gently stepping palfrey, the simple, smiling porker's head on the shield, and the carefully armed Thopas, who looks a bit like a bug about to be squashed under the upraised foot of the giant.

The giant's naked leg is part of a visual pattern of representation of male power partially apparent in the sketchy delineation of the figures of both Theseus and Walter (figs. 12.2, 12.3). It appears in the two illustrations of the *Miller's Tale*, of events at the shot window, and it appears in the threatening outlines of the three rioters against that of the old man in the *Pardoner's Tale*, where the focus is not on the mysterious wisdom and warning of the old man, but on his weak age and the rioters' youthful male strength (fig. 12.5). Their triune unity and menacing aspect are conveyed by a large figural mass which has three heads, five legs, and two arms. Throughout her work Frink sought to come to terms with how to represent the fact of male physical power and its effects. In both the case of the giant in *Sir Thopas* and that of the three young men of the *Pardoner's Tale*, representation erases identity and focuses attention on aggression by emphasizing size.

The *Tales* illustrations provide at least four additional scenes where women must confront or negotiate male power and desire. The first is the image Frink creates to illustrate the moment in the *Physician's Tale* when Virginius is about to kill Virginia (fig. 12.6). His stance is wide open; he seems to be ready to wield the sword that appears in outline over Virginia's head—symbol, perhaps, of the powers that have controlled her fate throughout the tale. Once more, the naked male figure with a minimal face confronts a barefoot woman whose identity resides in her implied gender. Like the women in the *Knight's Tale*, she seems to be speaking, and her father seems, too, to be about to say something. But the sword dominates the image and unites the two figures; the symbol of male power and dominance overhangs her head, suggesting her essential powerlessness. But although Virginius does kill his daughter Virginia, the tale tells a different story from the one the illustration tells. Chaucer's tale includes long expressions of Virginius's despair, his love for his daughter, and Virginia's strength in grief. After lamenting her fate to die a maid, she "riseth up" (VI 247),[29] invites her father's deadly stroke, and then faints. At that point Virginius cuts off her head. All the complexity of their interaction is occluded in Frink's etching by the naked image of male power standing over kneeling female supplication. In Chaucer's story, which attained the status of an exemplary tale of women's virtue in both Roman and early modern culture, Virginia's strength after despair is celebrated as a means of saving the republic. Frink's image does not match the optimistic acceptance of an allegorical, exemplary reading of the tale, focused as it is on the threat of violence,

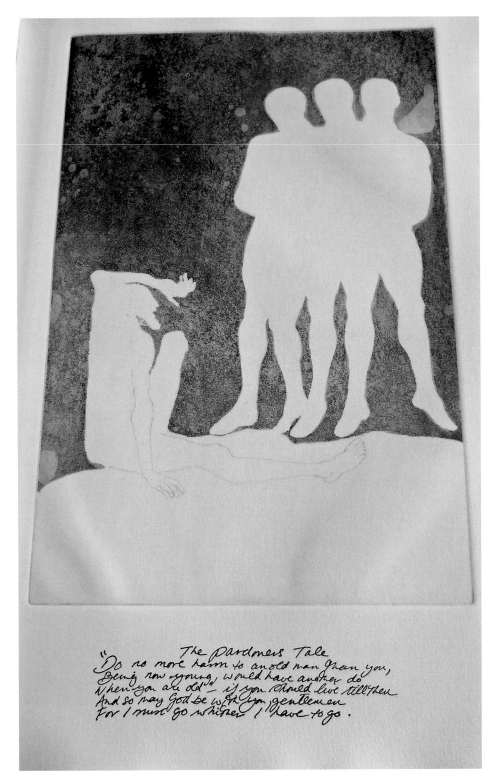

The Pardoners Tale

"Do no more harm to an old man than you,
Being now young, would have another do
When you are old" — if you should live till then
And so may God be with you gentlemen
For I must go whither I have to go.

FIG. 12.5 Elisabeth Frink's illustration of the *Pardoner's Tale*.

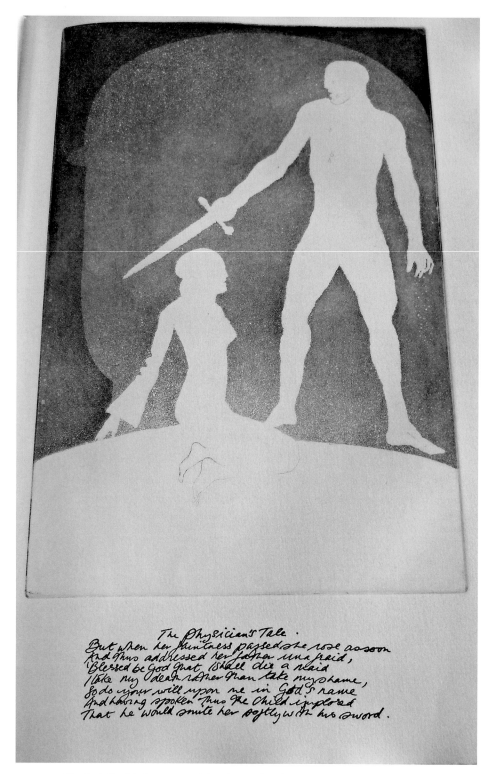

The Physician's Tale.
But when her faintness passed she rose as soon
And thus addressed her father unafraid,
'Blessed be God that I shall die a maid
I take my death rather than take my shame,
So do your will upon me in God's name
And having spoken thus the Child implored
That he would smite her softly with his sword.

FIG. 12.6 Elisabeth Frink's illustration of the *Physician's Tale*.

nor does it give Virginia her due, for after lamenting her fate Chaucer says she arises to accept it. If she had not, if she had had not exercised her volition, the tale could hardly have developed its exemplary function.

A different image of male-female relationships, with a different valence, appears in Frink's illustration of the *Franklin's Tale*, for which she creates a scene where Dorigen and Aurelius stand on the edge of the rocky cliffs of Brittany (fig. 12.7). Dorigen stands firmly, pointing out the rocks, while Aurelius, clearly a strong and powerful man, stands looking at her, with one arm bent by his side and the other hanging loose. His stance is much more casual than Virginius's in the image for the *Physician's Tale*, perhaps indicating his relatively subordinate status here, the petitioning lover attending his lady. But this scene never happens in the tale; Dorigen and Aurelius meet and talk about love and the rocky coast of Brittany in a wooded walk, a garden where she and her friends disport themselves (Coghill, 432–33). Aurelius seizes his moment to talk to her and she refuses his request, then takes pity on his sorrow and sets up the impossible proposition that she would acquiesce to his request when the rocks disappear. The illustration does suggest her strength and relatively strong position as the beloved and desired lady, and it captures the essential elements of the tale: the desiring male, the resistant female, and the rocky coast of Brittany. But the Dorigen who appears here is not the Dorigen of the tale who is so reduced by grief—first, at her fear about the rocks and, later, by her distress at having to keep her rash promise—that she is virtually unable to function. Frink's Dorigen is a heroine in control of herself, the Dorigen of the beginning of the story. Frink elides Dorigen's journey from happiness through despairing anxiety to reunion with her husband—an emotional and experiential trajectory that is central to tale's ostensible message, concluding as it does with multiple instances of forbearance and forgiveness.

A third and fourth instance of the power symbolized by the male in relationship with a female appears in the illustration of the *Manciple's Tale* in the moment when, horrified by what he has done to his wife, Phoebus turns on the crow and plucks out his white feathers and robs him of his sweet voice (fig. 12.8). The naked body of the wife lies on the bed with a peaceful expression. Phoebus, whose figure is largely blank, his nakedness suggested by his bare chest, has the terrified crow in his grip and is plucking out its feathers. The wife's expression is very similar to that of Cecilia in her martyrdom in Frink's illustration for the *Second Nun's Tale* (fig. 12.9). Frink pictures Cecilia as relaxed, smiling, calm, in an image that is both amusing and semi-erotic, for she is naked to the waist and lies in the bath with her knees bent, clearly at ease, as if she were some London debutante bathing before a dance. Behind her, the shadowy forms of the heads and shoulders of four male figures hint that naked Cecilia is not martyred privately. Her serene expression, like the wife's expression in the illustration for the *Manciple's Tale*, suggests women's ability to transcend the world of violence and pain created by men. The composition of the image of Phoebus, his dead wife, and the crow—with its patterns of multiple triangulations linking

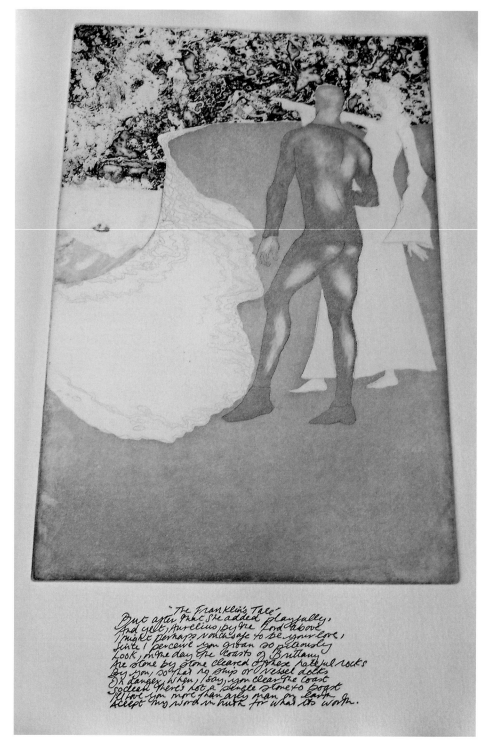

FIG. 12.7 Elisabeth Frink's illustration of the *Franklin's Tale*.

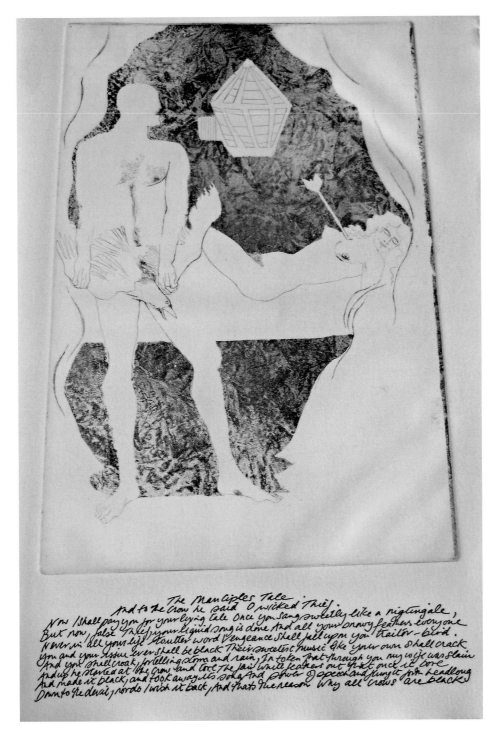

FIG. 12.8 Elisabeth Frink's illustration of the *Manciple's Tale*.

FIG. 12.9 Elisabeth Frink's illustration of the *Second Nun's Tale.*

the wife, the bird cage, and Phoebus—suggests the tangled relationships that connect all three. Phoebus is upright, looking toward his dead wife, from whose body an arrow to the heart protrudes. The crow, the malevolent bird of Frink's imagination, is angry and terrified, a teller of destructive tales. The lines of Phoebus's destructive power run toward the wife and down toward the crow, which is positioned over his genitalia.

Frink was very clear that she was not a literalist. She sought to represent the essence of things. In the images discussed above, she indeed found a way to represent something central and essential in the *Tales*. Her interests in men, horses, and human sexuality function, as Coghill says, to draw out something new. We perceive previously hidden patterns and themes: the way the three young men of the *Pardoner's Tale* might appear to an old man; or Theseus's position both above and among the Theban widows; or the distance between Griselda and Walter, for example. Frink does not radically alter the tales by illustrating nonexistent moments, but she selects her imaginary moments with an eye to what is essential in the narrative line of each story. The image for the *Prioress's Tale*, for example, delineates the body of the little boy and his mother, and represents the ecclesiasts as shadowy outlines. The center of emotion and action in the tale is the mother and the child, and Frink's image underscores this. The power and energy of the *Manciple's Tale* image, with its crossing lines of composition and connection, represent Phoebus's rashness and the interconnection of his music, his wife, and the crow with his self-destruction and now-ruined happiness. At times, though, as in the cases of the *Reeve's Tale* and the *Shipman's*, images of energetic copulation seem to belie the larger point of the tales. Aleyn and John are anxious for revenge, and the miller is anxious to preserve his "estate" (fig. 12.10). Sex here seems a secondary issue, a tool to achieve a desired end, rather than an end in itself. So, too, in the *Shipman's Tale*, where the image of a lusty, strong monk fondling the naked wife on his naked lap deflects attention from the story's metaphors of money and value, and the circulation of debts and repayments (fig. 12.11). The images are lively, imaginative, humorous: the sleeping miller has a kind of serene expression in the midst of all that is going on in his bedroom. Surely Frink's humor is at play here.

For all its artistic excellence and for all Frink's talent, her illustrated Chaucer will not be everybody's Chaucer. The imputed universal appeal of his poetry is not matched by the appeal of an illustrator who has been so wise in so many respects and so constrained by her own preoccupations in others. Nevertheless, illustration as interpretation engages us, as we think through just why an image seems to open new ways to understanding, or to foreclose them. In considering Frink's illustrations and thinking about her vision of the *Canterbury Tales*, we perforce reexamine our own interpretations. As Coghill put it, there is always something new to see in Chaucer, but the "new" may be the result of creative response in the reader. An artist like Elisabeth Frink responded to Chaucer through her own art, participating in the imaginary world he created by contributing her own imaginative dimension to the *Tales*.

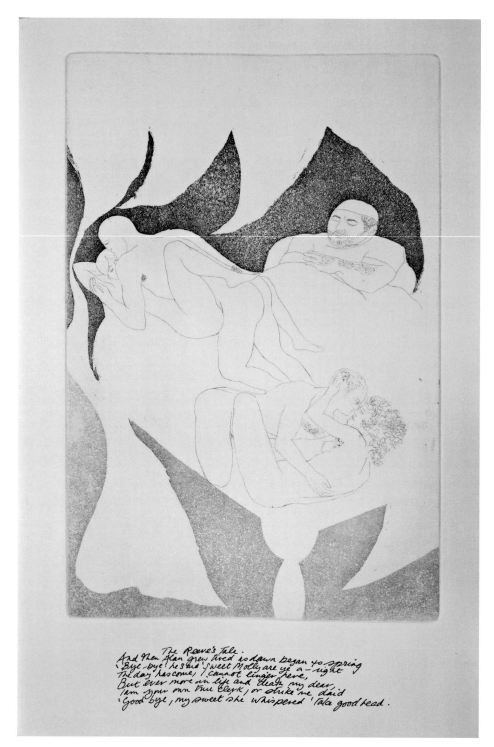

The Reeve's Tale.
And then Alan grew tired as dawn began to spring
'Bye-bye! he said 'sweet Molly are ye a - right
The day has come, I cannot linger here,
But ever more in life and death my dear,
I am your own true Clerk, or strike me dead
'Good bye, my sweet she whispered 'take good heed.

FIG. 12.10 Elisabeth Frink's illustration of the *Reeve's Tale*.

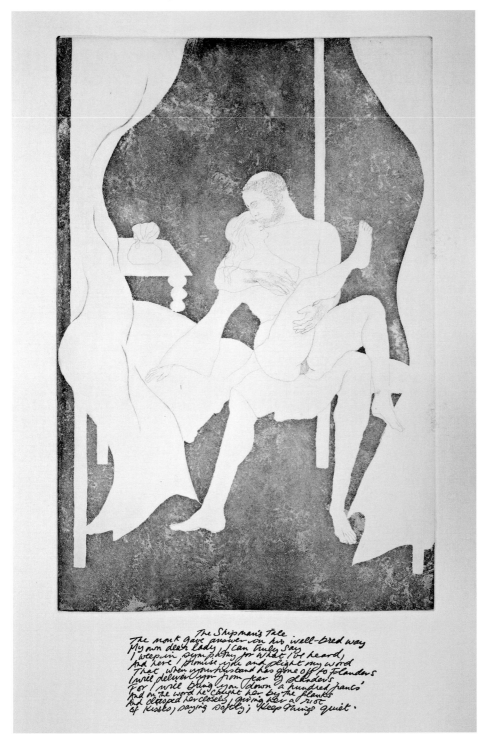

The Shipman's Tale

The monk gave answer in his well-bred way
"My own dear lady, I can truly say
I weep in sympathy for what I've heard,
And here I promise you and plight my word
That when your husband has gone off to Flanders
I will deliver you from fear of slanders'
For I will bring you down a hundred francs'
And on the word he caught her by the flanks
And clasped her closely, giving her a riot
Of kisses, saying softly; "Keep things quiet."

FIG. 12.11 Elisabeth Frink's illustration of the *Shipman's Tale.*

NOTES

1. Quoted in Spalding, "Frink," 11.

2. The *Canterbury Tales* were illustrated by etchings; the other three illustrated works by lithography. Images of Frink's work are available online; images from the *Canterbury Tales* volume are best searched for by the name of the tale.

3. Frink, Kent, and Kramer, "Sculpture and Watercolor," 82.

4. Simpson, "Review," 59.

5. Frink found the male body physically attractive: "I enjoy looking at the male body and this has given me . . . the impetus and energy for a purely sensuous approach to sculpted form. I like to watch a man walking and swimming and running and being" (ibid.).

6. Jammet, "Foreword," 7.

7. Spalding, "Frink," 13.

8. Frink, Kent, and Kramer, "Sculpture and Watercolor," 82.

9. Ibid.

10. Ibid., 85–86.

11. Spalding, "Frink," 10. Frink wrote of her negotiations with the commissioners of a bronze statue of the risen Christ for the Anglican Cathedral in Liverpool, "The big figure I'm working on now started with the Liverpool Cathedral committee wanting to have a Christ on the façade of the building above the west door. I wanted it to be a very simple, primitive figure. The one thing I didn't want was the usual limp Christ figure, and I didn't want drapes or any clothing at all. For me this resurrected Christ definitely has a personal meaning, similar to that of the Green Man heads. They all symbolize a rebirth, a renewal of spirit and mind" (Ratuszniak, "Catalogue Raisonné," 189).

12. Mullins, *Art of Elisabeth Frink*, 1.

13. Spalding, "Frink," 9.

14. Hartog, in "Towards a Modern Art History," 25–26, engages the subject of representation in late twentieth-century art, specifically in regard to understanding Frink's choice to create representational forms: "The task for art history is to discover and describe a non-conservative strand of figurative sculpture which critically questions its own conditions, or which uses apparently old means to come up with new answers. . . . What is distinctive about Frink is not *that* she made figures but *how* she did so."

15. Spalding, "Frink," 14.

16. Frink, Kent, and Kramer, "Sculpture and Watercolor," 104–5.

17. In the etchings to the tales, Frink connects men and horses in several ways, including almost always showing the horses' male genitalia, as if to stress sexual unity across the human-animal divide/continuum.

18. Spalding, "Frink," 9.

19. Ibid., 13.

20. Gardiner, *Frink*, 174–75.

21. Ibid., 175.

22. Frink, Kent, and Kramer, "Sculpture and Watercolor," 105.

23. Gardiner, *Frink*, 176.

24. Ibid., 177.

25. Coghill's translation was first published by Penguin, which has subsequently reprinted and reedited it multiple times. It does not use the Ellesmere order, but instead the Furnivall-Skeat order of fragments A–I. Citations are from Chaucer, *Chaucer: The Canterbury Tales*, by page number.

26. Coghill, "Introduction," in Frink, *Etchings Illustrating the Canterbury Tales*.

27. Ibid.

28. Frink illustrated the *General Prologue, Knight's Tale, Miller's Tale, Reeve's Tale, Summoner's Prologue, Clerk's Tale, Merchant's Tale, Squire's Tale, Franklin's Tale, Physician's Tale, Pardoner's Tale, Shipman's Tale, Prioress's Tale, Tale of Sir Thopas, Nun's Priest's Tale, Second Nun's Tale,* and *Manciple's Tale.*

29. Interestingly, Coghill uses here the past tense verb "rose," perhaps negating the energy that Chaucer's present tense injects into Virginia's sorrowful compliance.

Abbott, Edwin A. *St. Thomas of Canterbury: His Death and Miracles.* 2 vols. London: A. & C. Black, 1898.

Adorno, Theodor W. *Notes to Literature.* Edited by Rolf Tiedemann. Translated by Shierry Weber Nicholsen. 2 vols. New York: Columbia University Press, 1991–92.

Aelianus, Claudius. *Aelian: Historical Miscellany.* Edited and translated by Nigel G. Wilson. Cambridge, MA: Harvard University Press, 1997.

Ahmed, Sara. *Queer Phenomenology: Orientation, Objects, Others.* Durham: Duke University Press, 2006.

Alan of Lille. *The Plaint of Nature.* Translated by James J. Sheridan. Toronto: Pontifical Institute of Mediaeval Studies, 1980.

Alexander, J. J. G. "Art History, Literary History, and the Study of Medieval Illuminated Manuscripts." *Studies in Iconography* 18 (1997): 51–66.

———. *The Decorated Letter.* New York: George Braziller, 1978.

Alexander, J. J. G., and Otto Pächt. *Illuminated Manuscripts in the Bodleian Library, Oxford.* 3 vols. Oxford: Clarendon Press, 1966–73.

Alexander, Jonathan, and Paul Binski, eds. *The Age of Chivalry: Art in Plantagenet England, 1200–1400.* London: Royal Academy of Arts, 1987.

Alexandre-Bidon, Danièle. "Le vaisselier du vin (XIIe–XVIe siècle): Contribution à l'histoire du goût." *L'Atelier du Centre de recherches historiques* 12 (2014). http://acrh.revues.org/5917.

Alford, John A. "The Role of the Quotations in *Piers Plowman.*" *Speculum* 52 (1977): 80–99.

Alpers, Svetlana, and Paul Alpers. "Ut Pictura Noesis? Criticism in Literary Studies and Art History." *New Literary History* 3 (1972): 437–58.

Amtower, Laurel. "Authorizing the Reader in Chaucer's *House of Fame.*" *Philological Quarterly* 79 (2000): 273–91.

Anderson, M. D. *Drama and Imagery in English Medieval Churches.* Cambridge: Cambridge University Press, 1963.

Andrew, Malcolm, and Ronald Waldron. "Introduction." In *The Poems of the Pearl Manuscript: Pearl, Cleanness, Patience, Sir Gawain, and the Green Knight,* 5th ed., edited by Malcolm Andrew and Ronald Waldron, 1–26. Exeter: University of Exeter Press, 2007.

Anglo-Norman Dictionary. Aberystwyth University and Swansea University. http://www.anglo-norman.net/.

Arano, Luisa Cogliati, ed. *The Medieval Health Handbook: Tacuinum Sanitatis.* New York: Braziller, 1976.

Les Archives de littérature du Moyen Âge. http://arlima.net/.

Armitage-Smith, Sydney, ed. *John of Gaunt's Register (1371–1375).* 2 vols. London: Camden Society, 1911.

Arnheim, Rudolf. *Art and Visual Perception: A Psychology of the Creative Eye.* Berkeley: University of California Press, 1974.

Augustine. *De doctrina christiana.* In *Patrologiae cursus completes . . . series latina,* edited by J.-P. Migne, 34:39. Paris, 1880.

———. *Enarrationes in Psalmos.* Edited by Eligius Dekkers and Johannes Fraipont. Corpus Christianorum Series Latina 38, 39, and 40. Turnhout: Brepols, 1956.

———. *The Works of Saint Augustine: A Translation for the 21st Century.* Edited by Edmund Hill, John E. Rotelle, and Boniface Ramsey. Hyde Park, NY: New City Press, 1990.

Backhouse, Janet. *The Luttrell Psalter.* London: British Library, 1989.

Baird, J. L., and J. R. Kane, eds. and trans. *La Querelle de la Rose: Letters and Documents.* Chapel Hill: University of North Carolina Press, 1978.

Baltrušaitis, Jurgis. *Réveils et prodiges: Les métamorphoses du gothique.* Paris: Flammarion, 1988.

Barber, Richard W., trans. *Bestiary: An English Version of the Bodleian Library, Oxford MS Bodley 764.* Woodbridge, UK: Boydell Press, 1992.

Barr, Helen. *Transporting Chaucer.* Manchester: Manchester University Press, 2014.

Barron, Caroline M. "Chaucer the Poet and Chaucer the Pilgrim." In *Historians on Chaucer,* edited by Stephen H. Rigby, 24–41. Oxford: Oxford University Press, 2014.

Baswell, Christopher. *Virgil in Medieval England: Figuring the "Aeneid" from the Twelfth Century to Chaucer.* Cambridge: Cambridge University Press, 1995.

Bayless, Martha. *Parody in the Middle Ages: The Latin Tradition.* Ann Arbor: University of Michigan Press, 1996.

Bede, the Venerable Saint. *The Ecclesiastical History of the English People.* Edited by Bertram Colgrave and R. A. B. Mynors. Oxford: Clarendon Press, 1969.

Beinecke Digital Collections. http://beinecke .library.yale.edu/tags/digital-collections.

Belting, Hans. *Likeness and Presence: A History of the Image before the Era of Art.* Translated by Edmund Jephcott. Chicago: University of Chicago Press, 1990.

Benelli, Francesco. *The Architecture in Giotto's Paintings.* Cambridge: Cambridge University Press, 2012.

Bennett, J. A. W. *Chaucer at Oxford and Cambridge.* Toronto: University of Toronto Press, 1974.

———. "Some Second Thoughts on *The Parliament of Fowls*." In *Chaucerian Problems and Perspectives: Essays Presented to Paul E. Beichner, C.S.C.,* edited by Edward

Vasta and Zacharias P. Thundy, 132–46. Notre Dame: University of Notre Dame Press, 1979.

Bennett, Michael J. *Community, Class and Careerism: Cheshire and Lancashire Society in the Age of "Sir Gawain and the Green Knight."* Cambridge: Cambridge University Press, 1983.

———. "The Court of Richard II and the Promotion of Literature." In *Chaucer's England: Literature in Historical Context,* edited by Barbara A. Hanawalt, 3–20. Minneapolis: University of Minnesota Press, 1992.

Benson, C. David, and Lynne S. Blanchfield. *The Manuscripts of Piers Plowman: The B-Version.* Cambridge: D. S. Brewer, 1997.

Berliner, Rudolf. "The Freedom of Medieval Art." *Gazette des Beaux-Arts,* ser. 6, 42 (1945): 263–88.

Bertolet, Craig E. *Chaucer, Gower, Hoccleve, and the Commercial Practices of Late Fourteenth-Century London.* Burlington, VT: Ashgate, 2013.

Bestul, Thomas. "Chaucer's Parson's Tale and the Late-Medieval Tradition of Religious Meditation." *Speculum* 64 (1989): 600–619.

Biblia Sacra Vulgata. Stuttgart: Deutsche Bibelgesellschaft, 1969.

Bibliothèque virtuelle des manuscrits médiévaux. http://bvmm.irht.cnrs.fr/.

Binski, Paul. *Becket's Crown: Art and Imagination in Gothic England, 1170–1300.* New Haven: Yale University Press, 2004.

———. "The Heroic Age of Gothic and the Metaphors of Modernism." *Gesta* 52 (2013): 3–20.

Bleeth, Kenneth A. "The Rocks and the Garden: The Limits of Illusion in Chaucer's *Franklin's Tale.*" *English Studies* 74 (1993): 113–23.

Blenner-Hassett, Roland. "Autobiographical Aspects of Chaucer's Franklin." *Speculum* 28 (1953): 791–800.

Blick, Sarah. "Reconstructing the Shrine of St. Thomas Becket, Canterbury Cathedral." In *Art and Architecture of Late Medieval Pilgrimage in Northern Europe and the British Isles,* 2 vols., edited by Sarah Blick and Rita Tekippe, 1:405–41. Leiden: Brill, 2005.

Bliggenstorfer, Susanna. *Eustache Deschamps: Aspects poétiques et satiriques.* Tübingen: A. Francke, 2005.

Blodgett, E. D. "Chaucerian *Pryvetee* and the Opposition to Time." *Speculum* 51 (1976): 477–92.

Bloomfield, Morton W. *The Seven Deadly Sins: An Introduction to the History of a Religious Concept, with Special Reference to Medieval English Literature.* East Lansing: Michigan State College Press, 1952.

Boccaccio, Giovanni. *The Book of Theseus.* Translated by Bernadette McCoy. New York: Medieval Text Association, 1974.

———. *The Decameron.* Translated by G. H. McWilliam. 2nd ed. London: Penguin, 1995.

———. *Theseid of the Nuptials of Emilia (Teseida delle Nozze di Emilia).* Translated by Vincenzo Traversa. New York: Peter Lang, 2002.

Bodleian Image Library. http://bodley30.bodley.ox.ac.uk:8180/luna/.

Boffey, Julia. "English Dream Poems of the Fifteenth Century and Their French Connections." In *Literary Aspects of Courtly Culture: Selected Papers from the Seventh Triennial Congress of the International Courtly Literature Society, University of Massachusetts, Amherst, USA, 27 July–1 August 1992,* edited by Donald Maddox and Sara Sturm-Maddox, 113–21. Cambridge: D. S. Brewer, 1994.

———. "Lydgate's Lyrics and Women Readers." In *Women, the Book, and the Worldly: Selected Proceedings of the St. Hilda's Conference,* vol. 2, edited by Lesley Smith and Jane H. M. Taylor, 139–49. Woodbridge, UK: D. S. Brewer, 1995.

Boffey, Julia, and John J. Thompson. "Anthologies and Miscellanies: Production and Choice of Texts." In *Book Production and Publishing in Britain, 1375–1475,* edited by Jeremy Griffiths and Derek Pearsall, 279–315. Cambridge: Cambridge University Press, 1989.

Boitani, Piero. *Chaucer and the Imaginary World of Fame.* Cambridge: D. S. Brewer, 1984.

Bowden, Muriel. *A Commentary on the General Prologue to the "Canterbury Tales."* New York: Macmillan, 1948.

Bowers, John M., ed. "The Canterbury Interlude and Merchant's Tale of Beryn." In *The "Canterbury Tales": Fifteenth-Century Continuations and Additions,* edited by John M. Bowers, 55–164. Kalamazoo: Medieval Institute Publications, 1992.

Brantley, Jessica. "Images of the Vernacular in the Taymouth Hours." In *Decoration and Illustration in Medieval English Manuscripts,* edited by A. S. G. Edwards, 83–113. London: British Library, 2002.

———. "Venus and Christ in Chaucer's *Complaint of Mars*: The Fairfax 16 Frontispiece." *Studies in the Age of Chaucer* 30 (2008): 171–204.

———. "Vision, Image, Text." In *Oxford Twenty-First Century Approaches to Literature: Middle English,* edited by Paul Strohm, 315–34. Oxford: Oxford University Press, 2007.

Brewer, Derek. "Class Distinction in Chaucer." *Speculum* 43 (1968): 290–305.

———. *The World of Chaucer.* Cambridge: D. S. Brewer, 1992.

British Library Catalogue of Illuminated Manuscripts. http://www.bl.uk/catalogues/illuminatedmanuscripts.

British Library Digitised Manuscripts. http://www.bl.uk/manuscripts.

British Library Online Gallery. http://www.bl.uk/onlinegallery/.

Brody, Saul N. "Making a Play for Criseyde: The Staging of Pandarus's House in Chaucer's *Troilus and Criseyde.*" *Speculum* 73 (1998): 115–40.

Brown, Carleton, ed. *Religious Lyrics of the XIVth Century.* 2nd ed. Revised by G. V. Smithers. Oxford: Clarendon Press, 1952.

———, ed. *Religious Lyrics of the XVth Century.* Oxford: Clarendon Press, 1939.

Brown, Michelle. "The Historical Context and the Commentary." In *The Luttrell Psalter: A Facsimile,* 1–55. London: British Library, 2006.

Brown, Peter. "'Shot Wyndowe' (Miller's Tale, I.3358 and 3695): An Open and Shut Case?" *Medium Ævum* 69 (2000): 96–103.

Bryan, W. F., and Germaine Dempster, eds. *Sources and Analogues of Chaucer's "Canterbury Tales."* New York: Humanities Press, 1941.

Buckmaster, Elizabeth. "Chaucer and John of Garland: Memory and Style in the First Fragment." *Medieval Perspectives* 1 (1986): 31–40.

———. "Meditation and Memory in Chaucer's *House of Fame.*" *Modern Language Studies* 16 (1986): 279–87.

Bullón-Fernández, María. "Private Practices in Chaucer's *Miller's Tale.*" *Studies in the Age of Chaucer* 28 (2006): 141–74.

Burger, Glenn. "In the Merchant's Bedchamber." In *Thresholds of Medieval Visual Culture: Liminal Spaces*, edited by Elina Gertsman and Jill Stevenson, 239–59. Woodbridge, UK: Boydell Press, 2012.

Burrow, J. A. "The Portrayal of Amans in *Confessio Amantis.*" In *Gower's "Confessio Amantis": Responses and Reassessments*, edited by A. J. Minnis, 5–24. Woodbridge, UK: D. S. Brewer, 1983.

Butterfield, Ardis, ed. *Chaucer and the City*. Cambridge: D. S. Brewer, 2006.

———. *The Familiar Enemy: Chaucer, Language, and Nation in the Hundred Years War.* Oxford: Oxford University Press, 2009.

Bynum, Caroline Walker. *Metamorphosis and Identity*. New York, Zone Books, 2001.

———. "Seeing and Seeing Beyond: The Mass of St. Gregory in the Fifteenth Century." In *The Mind's Eye: Art and Theological Argument in the Middle Ages*, edited by Jeffrey F. Hamburger and Anne-Marie Bouché, 208–40. Princeton: Princeton University Press, 2006.

Camille, Michael. "The Book of Signs: Writing and Visual Difference in Gothic Manuscript Illumination." *Word and Image* 1 (1985): 133–48.

———. *Image on the Edge: The Margins of Medieval Art.* Cambridge, MA: Harvard University Press, 1992.

———. "Laboring for the Lord: The Ploughman and the Social Order in the Luttrell Psalter." *Art History* 10 (1987): 423–54.

———. *Mirror in Parchment: The Luttrell Psalter and the Making of Medieval England.* Chicago: University of Chicago Press, 1998.

Cannon, Christopher. *The Making of Chaucer's English: A Study of Words.* Cambridge: Cambridge University Press, 1998.

Carlin, Martha. *Medieval Southwark*. London: Hambledon Press, 1996.

Carlson, David R. *Chaucer's Jobs*. New York: Palgrave Macmillan, 2004.

Carruthers, Mary. *The Book of Memory: A Study of Memory in Medieval Culture.* 2nd ed. Cambridge: Cambridge University Press, 2008.

———. *The Craft of Thought: Meditation, Rhetoric, and the Making of Images, 400–1200.* Cambridge: Cambridge University Press, 1998.

———. *The Experience of Beauty in the Middle Ages.* Oxford: Oxford University Press, 2013.

———. "Italy, *Ars Memorativa*, and Fame's House." *Studies in the Age of Chaucer, Proceedings*, ser. 2 (1986): 179–88.

Casaretto, Mosetti, ed. *Teodulo Ecloga: Il Canto della Verità e Della Menzogna.* Florence: SISMEL, 1997.

Castor, Helen. *Blood and Roses: One Family's Struggle and Triumph during the Tumultuous Wars of the Roses.* New York: HarperCollins, 2006.

Caviness, Madeline Harrison. *The Early Stained Glass of Canterbury Cathedral circa 1175–1220.* Princeton: Princeton University Press, 1977.

———. *The Windows of Christ Church Cathedral, Canterbury.* London: British Academy, 1981.

Chase, Wayland Johnson, ed. *The Distichs of Cato: A Famous Medieval Textbook.* Madison: University of Wisconsin Press, 1922.

Chaucer, Geoffrey. *Chaucer: The Canterbury Tales.* Translated by Nevill Coghill. New York: Penguin, 1951.

———. *The Riverside Chaucer.* 3rd ed. Edited by Larry D. Benson. Boston: Houghton Mifflin, 1987.

Chrétien de Troyes. *Le Chevalier au Lion (Le Chevalier au Lion [Yvain]).* Edited by Mario Roques. Paris: Librairie Honoré Champion, 1975.

Cicero. *De oratore.* Edited and translated by E. W. Sutton and H. Rackham. Cambridge, MA: Harvard University Press, 1954.

Clark, Robert L. A. "Constructing the Female Subject in Late Medieval Devotion." In *Medieval Conduct*, edited by Kathleen Ashley and Robert L. A. Clark, 160–82. Minneapolis: University of Minnesota Press, 2001.

Clarke, Kenneth Patrick. *Chaucer and Italian Textuality.* Oxford: Oxford University Press, 2011.

Clarke, Maude V. *Fourteenth Century Studies.* Oxford: Clarendon Press, 1937.

Clemens, Raymond, and Timothy Graham. *Introduction to Manuscript Studies.* Ithaca: Cornell University Press, 2007.

Cohen, Jeffrey Jerome. *Stone: An Ecology of the Inhuman.* Minneapolis: University of Minnesota Press, 2014.

Coin People (*jeton* image). http://www.coinpeople.com/index.php/topic/10572-french-jetons/.

Coleman, Janet. *Ancient and Medieval Memories: Studies in the Reconstruction of the Past.* Cambridge: Cambridge University Press, 1992.

Coleman, Joyce. "Illuminations in Gower's Manuscripts." In *The Routledge Research Companion to John Gower,* edited by R. F. Yeager, Brian Gastle, and Ana Sáez-Hidalgo. New York: Routledge, forthcoming.

———. "New Evidence about Sir Geoffrey Luttrell's Raid on Sempringham Priory, 1312." *British Library Journal* 25 (1999): 103–28.

———. "Where Chaucer Got His Pulpit: Audience and Intervisuality in the *Troilus and Criseyde* Frontispiece." *Studies in the Age of Chaucer* 32 (2010): 103–28.

Coley, David K. "'Withyn a temple ymad of glas': Glazing, Glossing, and Patronage in Chaucer's *House of Fame.*" *Chaucer Review* 45 (2010): 59–84.

Colish, Marcia. *Peter Lombard.* 2 vols. Leiden: Brill, 1994.

Cook, Patrick. "The *Ecloga Theoduli.*" In *Medieval Literature for Children,* edited by Daniel Kline, 188–203. London: Routledge, 2003.

Cooper, Helen. "Chaucerian Representation." In *New Readings of Chaucer's Poetry,* edited by Robert G. Benson and Susan J. Ridyard, 7–29. Cambridge: D. S. Brewer, 2003.

———. "The Frame." In *Sources and Analogues of the "Canterbury Tales,"* 2 vols., edited by Robert M. Correale and Mary Hamel, 1:1–22. Cambridge: D. S. Brewer, 2002–5.

———. "London and Southwark Poetic Companies: 'Si tost c'amis' and the *Canterbury Tales.*" In *Chaucer and the City,* edited by Ardis Butterfield, 109–25. Cambridge: D. S. Brewer, 2006.

Copeland, Rita. *Rhetoric, Hermeneutics, and Translation in the Middle Ages: Academic Traditions and Vernacular Texts.* Cambridge: Cambridge University Press, 1991.

Correale, Robert M., and Mary Hamel, eds. *Sources and Analogues of the "Canterbury Tales."* 2 vols. Cambridge: D. S. Brewer, 2002–5.

Cotgrave, Randle. *A Dictionarie of the French and English Tongues.* London: Adam Islip, 1611.

Cotton Nero A.x Project. http://www.gawain.ucalgary.ca/.

Crow, Martin M., and Clair C. Olson, eds. *Chaucer Life-Records.* Oxford: Clarendon Press, 1966.

Dante Alighieri. *The Divine Comedy.* 3 vols. Edited and translated by Charles S. Singleton. Princeton: Princeton University Press, 1980–82.

Da Rold, Orietta, ed. *The Dd Manuscript: A Digital Edition of Cambridge University Library, MS Dd.4.24 of Chaucer's Canterbury Tales.* http://www.Chaucermss.org/Dd.

Davenport, Anthony. "*Pearl* and Its Illustrations." Talk delivered at the Tenth Annual Summer Conference of the London Old and Middle English Research Seminar, Institute of English Studies, University of London, June 19, 2010.

Davis, Norman, ed. *Paston Letters and Papers of the Fifteenth Century.* Oxford: Clarendon Press, 1971.

Davis-Weyer, Caecilia. *Early Medieval Art, 300–1150: Sources and Documents.* Toronto: University of Toronto Press, 1986.

De Hamel, Christopher. "Introduction." In *Book of Beasts: A Facsimile of MS Bodley 764.* Oxford: Bodleian Library, 2008.

Delany, Sheila. *Chaucer's "House of Fame": The Poetics of Skeptical Fideism.* Chicago: University of Chicago Press, 1972.

Delasanta, Rodney. "Sacrament and Sacrifice in the *Pardoner's Tale.*" *Annuale Mediaevale* 14 (1973): 43–52.

Dennison, Lynda. "The Artistic Origins of the Vernon Manuscript." In *The Making of the Vernon Manuscript: The Production and Contexts of Oxford, Bodleian Library, MS Eng. poet. a. 1,* edited by Wendy Scase, 171–226. Turnhout: Brepols, 2013.

Deschamps, Eustache. *Oeuvres complètes.* 11 vols. Edited by A.-H.-E. de Queux de St-Hilaire and Gaston Raynaud. Paris: Firmin Didot, 1878–1903.

Despres, Denise. "Portals." Talk delivered at Medieval Materiality: A Conference on the Life and Afterlife of Things, University of Colorado at the Boulder Center for Medieval and Early Modern Studies, October 24, 2014.

Dictionnaire du moyen français. http://www.atilf.fr/.

Digital Scriptorium. http://bancroft.berkeley.edu/digitalscriptorium/.

Dinshaw, Carolyn. "Ecology." In *A Handbook of Middle English Studies*, edited by Marion Turner, 347–62. Chichester, UK: John Wiley and Sons, 2013.

———. *How Soon Is Now? Medieval Texts, Amateur Readers, and the Queerness of Time.* Durham: Duke University Press, 2012.

Douay-Rheims Bible Online. http://www.drbo.org/.

Doyle, A. I. "Codicology, Palaeography, and Provenance." In *The Making of the Vernon Manuscript: The Production and Contexts of Oxford, Bodleian Library, MS Eng. poet. a. 1*, edited by Wendy Scase, 3–25. Turnhout: Brepols, 2013.

———. "The Manuscripts." In *Middle English Alliterative Poetry and Its Literary Background*, edited by David Lawton, 88–100. Cambridge: D. S. Brewer, 1982.

———, ed. *The Vernon Manuscript: A Facsimile of Bodleian Library, Oxford, MS Eng. poet. A.1.* Cambridge: D. S. Brewer, 1987.

Driver, Martha, and Michael Orr. "Decorating and Illustrating the Page." In *The Production of Books in England, 1350–1500*, edited by Alexandra Gillespie and Daniel Wakelin, 104–28. Cambridge: Cambridge University Press, 2011.

Duffy, Eamon. "The Dynamics of Pilgrimage in Late Medieval England." In *Pilgrimage: The English Experience from Becket to Bunyan*, edited by Colin Morris and Peter Roberts, 164–77. Cambridge: Cambridge University Press, 2002.

———. *Marking the Hours: English People and Their Prayers 1240–1570.* New Haven: Yale University Press, 2006.

———. *The Stripping of the Altars: Traditional Religion in England, 1400–1580.* New Haven: Yale University Press, 1992.

Dyer, Christopher. *Standards of Living in the Later Middle Ages: Social Change in England, c. 1200–1520.* Cambridge: Cambridge University Press, 1989.

Early Manuscripts at Oxford University. http://image.ox.ac.uk/.

Edwards, A. S. G. "John Shirley and the Emulation of Courtly Culture." In *The Court and Cultural Diversity: Selected Papers from the Eighth Triennial Congress of the International Courtly Literature Society, the Queen's University of Belfast, 26 July–1 August, 1995*, edited by Evelyn Mullally and John J. Thompson, 309–18. Woodbridge, UK: D. S. Brewer, 1997.

———. "The Manuscript: British Library MS Cotton Nero A.x." In *A Companion to the "Gawain"-Poet*, edited by Derek Brewer and Jonathan Gibson, 197–220. Woodbridge, UK: D. S. Brewer, 1997.

Edwards, Robert R. "The Franklin's Tale." In *Sources and Analogues of the "Canterbury Tales,"* 2 vols., edited by Robert M. Correale and Mary Hamel, 1:211–65. Cambridge: D. S. Brewer, 2002–5.

eLALME: An Electronic Version of "A Linguistic Atlas of Late Mediaeval English." http://www.lel.ed.ac.uk/ihd/elalme/elalme_frames.html.

Elmes, Melissa Ridley. "Species or Specious? Authorial Choices and *The Parliament of Fowls*." In *Rethinking Chaucerian Beasts*, edited by Carolynn Van Dyke, 233–47. New York: Palgrave Macmillan, 2012.

Emmerson, Richard K. "Middle English Literature and Illustrated Manuscripts: New Approaches to the Disciplinary and the Interdisciplinary." *Journal of English and Germanic Philology* 105 (2006): 118–36.

———. "Visualizing the Vernacular: Middle English in Early Fourteenth-Century Bilingual and Trilingual Manuscript Illustrations." In *Tributes to Lucy Freeman Sandler: Studies in Illuminated Manuscripts*, edited by Kathryn A. Smith and Carol H. Krinsky, 187–204. London: Harvey Miller, 2007.

Emmerson, Richard K., and P. J. P. Goldberg. "'The Lord Geoffrey Luttrell had me made': Lordship and Labour in the Luttrell Psalter." In *The Problem of Labour in Fourteenth-Century England*, edited by James Bothwell, P. J. P. Goldberg, and W. M. Ormrod, 43–63. York: York Medieval Press, 2000.

Enders, Jody. *The Medieval Theater of Cruelty: Rhetoric, Memory, Violence.* Ithaca: Cornell University Press, 1999.

Erne, Lukas. "Words in Space: The Reproduction of Texts and the Semiotics of the Page." In *The Space of English*, edited by David Spurr and Cornelia Tschichold, 99–118. Tübingen: Gunter Narr, 2005.

Evans, Joan G. *English Art, 1307–1461.* Oxford: Clarendon Press, 1949.

Evans, Ruth. "The Production of Space in Chaucer's London." In *Chaucer and the City*, edited by Ardis Butterfield, 41–56. Cambridge: D. S. Brewer, 2006.

Falkenburg, Reindert. "The Household of the Soul: Conformity in the Merode Triptych." In *Early Netherlandish Painting at the Crossroads: A Critical Look at Current Methodologies*, edited by Maryan W. Ainsworth, 2–17. New York: Metropolitan Museum of Art, 2001.

Farnham, Rebecca. "Border Artists of the Vernon Manuscript." In *The Making of the Vernon Manuscript: The Production and Contexts of Oxford, Bodleian Library, MS Eng. poet. a. 1*, edited by Wendy Scase, 127–47. Turnhout: Brepols, 2013.

Farrell, Thomas J. "Source or Hard Analogue? *Decameron* X, 10 and the *Clerk's Tale*." *Chaucer Review* 37 (2003): 346–64.

Fei, Victor Lim. "The Visual Semantics Stratum: Making Meaning in Sequential Images." In *New Directions in the Analysis of Multimodal Discourse*, edited by Terry D. Royce and Wendy L. Bowcher, 196–207. Mahwah, NJ: Lawrence Erlbaum, 2007.

Fein, Susanna. "Boethian Boundaries: Compassion and Constraint in the Franklin's Tale." In *Drama, Narrative, and Poetry in the "Canterbury Tales,"* edited by Wendy Harding, 195–212. Toulouse: Presses Universitaires du Mirail, 2003.

———, ed. *Moral Love Songs and Laments.* Kalamazoo: Medieval Institute Publications, 1998.

———. "Other Thought-Worlds." In *A Companion to Chaucer*, edited by Peter Brown, 332–48. Blackwell Companions to Literature and Culture. Oxford: Blackwell, 2000.

———. "Why Did Absolom Put a 'Trewelove' under His Tongue? Herb Paris as a Healing 'Grace' in Middle English Literature." *Chaucer Review* 24 (1991): 302–17.

Fein, Susanna, ed. and trans., with David Raybin and Jan Ziolkowski. *The Complete Harley 2253 Manuscript.* 3 vols. Kalamazoo: Medieval Institute Publications, 2014–15.

Finley, William K., and Joseph Rosenblum, eds. *Chaucer Illustrated: Five Hundred Years of "The Canterbury Tales" in Pictures.* New Castle, DE: Oak Knoll Press, 2003.

Fisher, John H. "The Three Styles of Fragment I of the *Canterbury Tales*." *Chaucer Review* 8 (1973): 119–27.

Fleming, John V. "Chaucer and the Visual Arts of His Time." In *New Perspectives in Chaucer Criticism*, edited by Donald M. Rose, 121–36. Norman, OK: Pilgrim, 1981.

———. *The "Roman de la Rose": A Study in Allegory and Iconography.* Princeton: Princeton University Press, 1969.

Fliegel, Stephen N. *A Higher Contemplation: Sacred Meaning in the Christian Art of the Middle Ages.* Kent: Kent State University Press, 2012.

Fliegel, Stephen N., and Sophie Jugie. *Art from the Court of Burgundy: The Patronage of Philip the Bold and John the Fearless, 1364–1419.* Cleveland: Cleveland Museum of Art, 2004.

Forshall, Josiah, and Frederic Madden, eds. *The Holy Bible, Containing the Old and New Testaments, with the Apocryphal Books, in the Earliest English Versions Made from the Latin Vulgate by John Wycliffe and His Followers.* 4 vols. Oxford: Oxford University Press, 1850.

Frank, Joseph. "Spatial Form in Modern Literature." *Sewanee Review* 53 (1945): 221–40.

Freedberg, David. *The Power of Images: Studies in the History and Theory of Response.* Chicago: University of Chicago Press, 1989.

Friedman, John B. "The Peddler-Robbed-by-Apes Topos: Parchment to Print and Back Again." *Journal of the Early Book Society* 8 (2008): 87–120.

Frink, Elisabeth. *Etchings Illustrating Chaucer's "Canterbury Tales."* Introduction and translation by Nevill Coghill. London: Waddington, 1972.

Frink, Elisabeth, Sarah Kent, and Hilton Kramer. "Sculpture & Watercolor, 1964–1979." *Massachusetts Review* 21 (1980): 81–108.

Frońska, Joanna. "Turning the Pages of Legal Manuscripts: Reading and Remembering the Law." In *Meaning in Motion: The Semantics of Movement in Medieval Art*, edited by Nino Zchomelidse and Giovanni Freni, 191–214. Princeton: Princeton University Press, 2011.

Frugoni, Chiara. *A Distant City: Images of Urban Experience in the Medieval World*. Translated by William McCuaig. Princeton: Princeton University Press, 1991.

Furnivall, F. J., ed. *Life-Records of Chaucer*. Vol. 1, pt. 2. London: K. Paul, Trench, Trübner, 1876.

Gaimster, David. "Visualizing the Domestic Interior in the European Late Medieval to Early Modern Transition: Cross-Referencing Archaeological and Iconographic Sources." *Tahiti* 4 (2012). http:// tahiti.fi/04-2012/dossier/.

Gallica: Digital Library of the National Library of France. http://gallica.bnf.fr/.

Gameson, Richard. "The Early Imagery of Thomas Becket." In *Pilgrimage: The English Experience from Becket to Bunyan*, edited by Colin Morris and Peter Roberts, 90–107. Cambridge: Cambridge University Press, 2002.

Gardiner, Stephen. *Frink: The Official Biography of Elisabeth Frink*. New York: HarperCollins, 1998.

Gardner, John. *The Life and Times of Geoffrey Chaucer*. New York: Vintage Books, 1978.

Gayk, Shannon. "Early Modern Afterlives of the *Arma Christi*." In *The Arma Christi in Medieval and Early Modern Material Culture: With a Critical Edition of "O Vernicle,"* edited by Lisa H. Cooper and Andrea Denny-Brown, 273–308. Burlington, VT: Ashgate, 2014.

———. *Image, Text, and Religious Reform in Fifteenth-Century England*. Cambridge: Cambridge University Press, 2010.

Gerhard, Joseph. "Chaucer's Coinage: Foreign Exchange and the Puns of the *Shipman's Tale*." *Chaucer Review* 17 (1983): 341–57.

Gill, Miriam. "Preaching and Image: Sermons and Wall Paintings in Later Medieval England." In *Preacher, Sermon, and Audience in the Middle Ages*, edited by Carolyn Muessig, 154–80. Leiden: Brill, 2002.

Gillespie, Alexandra. "Manuscript." In *A Handbook of Middle English Studies*, edited by

Marion Turner, 171–85. Hoboken, NJ: John Wiley, 2013.

Godefroy, Frédéric. *Dictionnaire de l'ancienne langue française et de tous ses dialects du IXe au XVe siècle*. 10 vols. Paris: F. Vieweg, 1880–1902.

Goering, J. W., and F. A. C. Mantello, eds. *Robert Grosseteste: Templum Dei*. Toronto: Pontifical Institute of Mediaeval Studies, 1984.

Goldberg, P. J. P. "The Fashioning of Bourgeois Domesticity in Later Medieval England: A Material Culture Perspective." In *Medieval Domesticity: Home, Housing, and Household in Medieval England*, edited by Maryanne Kowaleski and P. J. P. Goldberg, 124–44. Cambridge: Cambridge University Press, 2008.

Gollancz, Israel. "Introduction." In *Pearl, Cleanness, Patience, and Sir Gawain: Reproduced in Facsimile from the Unique Ms. Cotton Nero A.x in the British Museum*, 7–44. EETS o.s. 162. London: Milford, 1923.

Goodall, Peter. "'Allone, withouten any compaignye': Privacy in the First Fragment of the *Canterbury Tales*." *English Language Notes* 29 (1991): 5–15.

Gordon, E. V. "Introduction." In *Pearl*, edited by E. V. Gordon, ix–lii. Oxford: Clarendon Press, 1953.

Gottschall, Anna. "The Lord's Prayer in Circles and Squares: An Identification of Some Analogues of the Vernon Manuscript's Pater Noster Table." *Marginalia: The Website of the Medieval Reading Group at the University of Cambridge* 7 (2008). http://www .marginalia.co.uk/journal/archives.php.

Gower, John. *The English Works*. 2 vols. Edited by G. C. Macaulay. EETS e.s. 81 and 82. London: K. Paul, Trench, Trübner, 1900–1901.

Grabar, Oleg. *The Mediation of Ornament*. Princeton: Princeton University Press, 1992.

Le Grand Robert de la langue Française. 2nd ed. Paris: Le Robert, 2009.

Green, Richard Firth. *Poets and Princepleasers: Literature and the English Court in the Late Middle Ages*. Toronto: University of Toronto Press, 1980.

Gregory I. *Epis. ad Serenum*. In *Patrologiae cursus completes . . . series latina*, edited by J.-P. Migne, 77:1128. Paris, 1880.

———. *Register*. Edited by Paul Ewald and Ludo M. Hartmann. MGH Epistolae 1 and 2. Berlin: Weidmann, 1887–99.

Griffiths, Fiona J. "The Cross and the *Cura monialium*: Robert of Arbrissel, John the Evangelist, and the Pastoral Care of Women in the Age of Reform." *Speculum* 83 (2008): 303–30.

Guillaume de Lorris and Jean de Meun. *Le Roman de la Rose*. 3 vols. Edited by Félix Lecoy. Classiques français du moyen âge 32, 35, 38. Paris: Champion, 1965–70.

Guthrie, Shirley Law. "The *Ecloga Theoduli* in the Middle Ages." Ph.D. diss., Indiana University, 1973.

Hagstrum, Jean. *The Sister Arts: The Tradition of Literary Pictorialism and English Poetry from Dryden to Gray*. Chicago: University of Chicago Press, 1958.

Hamburger, Jeffrey F. Review of *Image on the Edge*, by Michael Camille. *Art Bulletin* 75 (1993): 319–27.

Hanning, Robert W. "Introduction." In *The Canterbury Tales*, translated by Peter Tuttle, notes by Robert W. Hanning, xiii–xlii. New York: Barnes and Noble, 2007.

———. "Telling the Private Parts: 'Pryvetee' and Poetry in Chaucer's *Canterbury Tales*." In *The Idea of Medieval Literature: New Essays on Chaucer and Medieval Culture in Honor of Donald R. Howard*, edited by James M. Dean and Christian K. Zacher, 108–25. Newark: University of Delaware Press, 1992.

Hardman, Phillipa. "The Mobile Page: 'Special Effects' in Some Late Medieval Manuscripts." In *Tributes to Kathleen L. Scott: English Medieval Manuscripts: Readers, Makers, and Illuminators*, edited by Marlene Villalobos Hennessy, 101–13. London: Harvey Miller, 2009.

———. "Presenting the Text: Pictorial Tradition in Fifteenth-Century Manuscripts of the *Canterbury Tales*." In *Chaucer Illustrated: Five Hundred Years of "The Canterbury Tales" in Pictures*, edited by William K. Finley and Joseph Rosenblum, 37–72. New Castle, DE: Oak Knoll Press, 2003.

Häring, Nikolaus M. "Alan of Lille, *De planctu naturae*." *Studi medievali*, ser. 3, 19 (1978): 797–879.

Harris, Anne F. "Pilgrimage, Performance, and Stained Glass at Canterbury Cathedral." In *Art and Architecture of Late Medieval Pilgrimage in Northern Europe and the British Isles*, 2 vols., edited by Sarah Blick and Rita Tekippe, 1:243–81. Leiden: Brill, 2005.

Harrison, Julian. "Gawain Revealed." *Medieval Manuscripts Blog*, British Library. February 23, 2014. http://britishlibrary.typepad.co.uk/digitisedmanuscripts/2014/02/gawain-revealed.html.

Hartog, Arie. "Towards a Modern Art History of the Figure: Observations on Elisabeth Frink." In *Elisabeth Frink: Catalogue Raisonné of Sculpture, 1947–93*, edited by Annette Ratuszniak, 25–33. London: Lund Humphries, 2013.

Haydock, Nickolas. "False and Sooth Compounded in Caxton's Ending of Chaucer's *House of Fame*." *Atenea* 26 (2006): 107–30.

Hearn, M. F. "Canterbury Cathedral and the Cult of Becket." *Art Bulletin* 76 (1994): 19–53.

Heffernan, James A. W. "Ekphrasis and Representation." *New Literary History* 22 (1991): 297–316.

———. *Museum of Words: The Poetics of Ekphrasis from Homer to Ashbery*. Chicago: University of Chicago Press, 2004.

Henderson, Alexander. *The History of Ancient and Modern Wines*. London: Baldwin, Cradock and Joy, 1824.

Henry, Avril. "'The Pater Noster in a table y-peynted' and Some Other Presentations of Doctrine in the Vernon Manuscript." In *Studies in the Vernon Manuscript*, edited by Derek Pearsall, 89–113. Cambridge: D. S. Brewer, 1990.

Hermann, John P. "Dismemberment, Dissemination, Discourse: Sign and Symbol in the *Shipman's Tale*." *Chaucer Review* 19 (1985): 302–37.

Hersh, Cara. "'Knowledge of the Files': Subverting Bureaucratic Legibility in the *Franklin's Tale*." *Chaucer Review* 43 (2009): 428–54.

Hilmo, Maidie. "Iconic Representations of Chaucer's Two Nuns and Their Tales from Manuscript to Print." In *Women and the Divine in Literature before 1700: Essays in Memory of Margot Louis*, edited by Kathryn Kerby-Fulton, 107–35. Victoria, BC: ELS Editions, 2009.

———. "Illuminating Chaucer's *Canterbury Tales*: Portraits of the Author and Selected Pilgrims." In *Opening Up Middle English Manuscripts: Literary and Visual*

Approaches, by Kathryn Kerby-Fulton, Maidie Hilmo, and Linda Olson, 245–89. Ithaca: Cornell University Press, 2012.

———. *Medieval Images, Icons, and Illustrated English Literary Texts: From the Ruthwell Cross to the Ellesmere Chaucer.* Aldershot, UK: Ashgate, 2004.

———. "The Power of Images in the Auchinleck, Vernon, *Pearl*, and Two *Piers Plowman* Manuscripts." In *Opening Up Middle English Manuscripts: Literary and Visual Approaches*, by Kathryn Kerby-Fulton, Maidie Hilmo, and Linda Olson, 153–205. Ithaca: Cornell University Press, 2012.

Hollander, John. *The Gazer's Spirit: Poems Speaking to Silent Works of Art.* Chicago: University of Chicago Press, 1995.

———. "The Poetics of Ekphrasis." *Word and Image* 4 (1988): 209–19.

Holley, Linda Tarte. *Chaucer's Measuring Eye.* Houston: Rice University Press, 1990.

Holsinger, Bruce. "Lollard Ekphrasis." *Journal of Medieval and Early Modern Studies* 35 (2005): 67–89.

———. *The Premodern Condition: Medievalism and the Making of Theory.* Chicago: University of Chicago Press, 2006.

The Holy Bible: Translated from the Latin Vulgate and Diligently Compared with Other Editions in Divers Languages (Douay, A.D. 1609; Rheims A.D. 1582). New York: Beiziger, 1914.

Horace. *Satires, Epistles, and Ars Poetica.* Translated by H. Rushton Fairclough. Cambridge, MA: Harvard University Press, 1961.

Horrall, Sarah M. "Notes on British Library, Ms Cotton Nero A x." *Manuscripta* 30 (1986): 191–98.

Howard, Donald R. *Chaucer: His Life, His Works, His World.* New York: E. P. Dutton, 1987.

———. *The Idea of the "Canterbury Tales."* Berkeley: University of California Press, 1976.

Hugh of Saint Victor. "The Three Best Memory Aids for Learning History." Translated by Mary Carruthers. In *The Medieval Craft of Memory: An Anthology of Texts and Pictures*, edited by Mary Carruthers and Jan Ziolkowski, 32–40. Philadelphia: University of Pennsylvania Press, 2002.

Hüllen, Werner. *English Dictionaries, 800–1700: The Topical Tradition.* Oxford: Clarendon Press, 1999.

Huot, Sylvia. *The "Romance of the Rose" and Its Medieval Readers: Interpretation, Reception, Manuscript Transmission.* Cambridge: Cambridge University Press, 1993.

Hussey, Maurice. *Chaucer's World: A Pictorial Companion.* Cambridge: Cambridge University Press, 1967.

Isidore of Seville. *Etymologiarum.* In *Patrologiae cursus completes . . . series latina*, edited by J.-P. Migne, 4:436. Paris, 1880.

———. *The Etymologies of Isidore of Seville.* Translated by Stephen A. Barney. Cambridge: Cambridge University Press, 2006.

Jaeger, C. Stephen. *Enchantment: Charisma and the Sublime in the Arts of the West.* Philadelphia: University of Pennsylvania Press, 2012.

———, ed. *Magnificence and the Sublime in Medieval Aesthetics: Art, Architecture, Literature, Music.* New York: Palgrave Macmillan, 2010.

Jager, Eric. "The *Shipman's Tale:* Merchant's Time and Church's Time, Secular and Sacred Space." In *Chaucer and the Challenges of Medievalism: Studies in Honor of H. A. Kelly*, edited by Donka Minkova and Theresa Tinkle, 253–60. Frankfurt am Main: Peter Lang, 2003.

Jammet, Lin. "Foreword: The Dressing Room." In *Elisabeth Frink: Catalogue Raisonné of Sculpture, 1947–93*, edited by Annette Ratuszniak, 7–8. London: Lund Humphries, 2013.

Janson, H. W. *Apes and Ape Lore in the Middle Ages and Renaissance.* London: Warburg Institute, 1952.

Jeffrey, Brian, ed. *Chanson Verse of the Early Renaissance.* 2 vols. London: Tecla Editions, 1971–76.

John of Garland. *The Parisiana poetria of John of Garland.* Edited and translated by Traugott Lawler. New Haven: Yale University Press, 1974.

Johnston, Michael. *Romance and the Gentry in Late Medieval England.* Oxford: Oxford University Press, 2014.

Jonassen, Frederick B. "The Inn, the Cathedral, and the Pilgrimage of the *Canterbury Tales.*" In *Rebels and Rivals: The Contestive Spirit in "The Canterbury Tales,"* edited by Susanna Fein, David Raybin, and Peter C. Braeger, 1–35. Kalamazoo: Medieval Institute Publications, 1981.

Jones, Sarah Rees. "Women's Influence on the Design of Urban Homes." In *Gendering the Master Narrative: Women and Power in the Middle Ages*, edited by Mary C. Erler and Maryanne Kowaleski, 190–211. Ithaca: Cornell University Press, 2003.

Jordan, Robert M. *Chaucer and the Shape of Creation: The Aesthetic Possibilities of Inorganic Structure.* Cambridge, MA: Harvard University Press, 1967.

J. Paul Getty Museum Collection. http://www.getty.edu/art/collection/.

Justice, Steven. "Eucharistic Miracle and Eucharistic Doubt." *Journal of Medieval and Early Modern Studies* 42 (2012): 307–32.

Katz, Joel. *Designing Information: Human Factors and Common Sense in Information Design.* New York: John Wiley, 2012.

Katzenellenbogen, Adolf. *Allegories of the Vices and Virtues in Medieval Art from Early Christian Times to the Thirteenth Century.* New York: Norton, 1964.

Kelly, Douglas. "The *Fidus interpres*: Aid or Impediment to Medieval Translation and *Translatio*?" In *Translation Theory and Practice in the Middle Ages*, edited by Jeanette Beer, 47–58. Kalamazoo: Medieval Institute Publications, 1997.

Kelly, Henry Ansgar. "Chaucer's Arts and Our Arts." In *New Perspectives in Chaucer Criticism*, edited by Donald M. Rose, 107–20. Norman, OK: Pilgrim, 1981.

Kendall, Elliot. "The Great Household in the City: The *Shipman's Tale*." In *Chaucer and the City*, edited by Ardis Butterfield, 145–61. Cambridge: D. S. Brewer, 2006.

Kendrick, Laura. *Animating the Letter: The Figurative Embodiment of Writing from Late Antiquity to the Renaissance.* Columbus: Ohio State University Press, 1999.

———. "Les 'bords' des 'Contes de Cantorbéry' et des manuscrits enluminés." *Bulletin des Anglicistes Médiévistes* 46 (1994): 926–38.

———. *Chaucerian Play: Comedy and Control in "The Canterbury Tales."* Berkeley: University of California Press, 1988.

———. "Humor in Perspective." In *Chaucer: Contemporary Approaches*, edited by Susanna Fein and David Raybin, 135–58. University Park: Penn State University Press, 2009.

———. "Linking the *Canterbury Tales*: Monkey-Business in the Margins." In *Drama, Narrative, and Poetry in the "Canterbury Tales,"* edited by Wendy Harding, 83–98. Toulouse: Presses Universitaires du Mirail, 2003.

———. "Making Sense of Marginalized Images in Manuscripts and Religious Architecture." In *A Companion to Medieval Art: Romanesque and Gothic in Northern Europe*, edited by Conrad Rudolph, 274–94. Oxford: Blackwell, 2006.

Kennedy, Kathleen. "*Le Tretiz* of Walter of Bebbesworth." In *Medieval Literature for Children*, edited by Daniel Kline, 131–42. London: Routledge, 2003.

Kerby-Fulton, Kathryn. "Geoffrey Chaucer's 'Cook's Tale' (Two Versions)." In *Opening Up Middle English Manuscripts: Literary and Visual Approaches*, by Kathryn Kerby-Fulton, Maidie Hilmo, and Linda Olson, 2–28. Ithaca: Cornell University Press, 2012.

Kerby-Fulton, Kathryn, and Steven Justice. "Scribe D and the Marketing of Ricardian Literature." In *The Medieval Professional Reader at Work: Evidence from Manuscripts of Chaucer, Langland, Kempe, and Gower*, edited by Kathryn Kerby-Fulton and Maidie Hilmo, 217–37. Victoria, BC: ELS Editions, 2001.

Kessler, Herbert L. "Gregory the Great and Image Theory in Northern Europe during the Twelfth and Thirteenth Centuries." In *A Companion to Medieval Art*, edited by Conrad Rudolph, 151–72. Oxford: Blackwell, 2006.

———. *Seeing Medieval Art.* Peterborough, ON: Broadview, 2004.

Kinch, Ashby. *Imago Mortis: Mediating Images of Death in Late Medieval Culture.* Leiden: Brill, 2013.

Klitgård, Ebbe. "Chaucer's Narrative Voice in the *House of Fame*." *Chaucer Review* 32 (1998): 260–66.

Knapp, Daniel. "The Relyk of a Seint: A Gloss on Chaucer's Pilgrimage." *ELH* 39 (1972): 1–26.

Knox, Philip. "The English Glosses of Walter of Bibbesworth's *Tretiz*." *Notes and Queries*, n.s., 60 (2013): 349–59.

Kolve, V. A. *Chaucer and the Imagery of Narrative: The First Five "Canterbury Tales."* Stanford: Stanford University Press, 1984.

———. "Rocky Shores and Pleasure Gardens: Poetry vs. Magic in Chaucer's *Franklin's Tale*." In *Poetics: Theory and Practice in Medieval English Literature*, edited by Piero Boitani and Anna Torti, 165–95. Cambridge: D. S. Brewer, 1991.

———. *Telling Images: Chaucer and the Imagery of Narrative II*. Stanford: Stanford University Press, 2009.

Kolve, V. A., and Glending Olson, eds. *Geoffrey Chaucer, "The Canterbury Tales": Nine Tales and the "General Prologue."* New York: Norton, 1989.

Koopmans, Rachel. *Wonderful to Relate: Miracle Stories and Miracle Collecting in High Medieval England*. Philadelphia: University of Pennsylvania Press, 2011.

Kowaleski, Maryanne. "The French of England: A Maritime *Lingua Franca*?" In *Language and Culture in Medieval Britain: The French of England, c. 1100–1500*, edited by Jocelyn Wogan-Browne, 103–17. York: York Medieval Press, 2009.

Krieger, Murray. *Ekphrasis: The Illusion of the Natural Sign*. Baltimore: Johns Hopkins University Press, 1992.

———. *The Play and Place of Criticism*. Baltimore: Johns Hopkins University Press, 1967.

Kruger, Steven F. "Imagination and the Complex Movement of Chaucer's *House of Fame*." *Chaucer Review* 28 (1993): 117–34.

Kumler, Aden. *Translating Truth: Ambitious Images and Religious Knowledge in Late Medieval France and England*. New Haven: Yale University Press, 2011.

Langland, William. *"Piers Plowman": A Parallel-Text Edition of the A, B, C, and Z Versions*. 2nd ed. 3 vols. Edited by A. V. C. Schmidt. Kalamazoo: Medieval Institute Publications, 2011.

The Lanterne of Liȝt. Edited by Lilian M. Swinburn. EETS o.s. 151. London: Kegan Paul, Trench, Trübner, 1917.

Lavezzo, Kathy. *Angels on the Edge of the World: Geography, Literature, and English Community, 1000–1534*. Ithaca: Cornell University Press, 2006.

Lee, J. A. "The Illuminating Critic: The Illustrator of Cotton Nero A.X." *Studies in Iconography* 3 (1977): 17–46.

Lefebvre, Henri. *The Production of Space*. Translated by Donald Nicholson-Smith. Oxford: Blackwell, 1991.

Le Goff, Jacques. *Marchands et banquiers du moyen âge*. Paris: Presses Universitaires de France, 1956.

Leo, Domenic. *Images, Texts and Marginalia in a "Vows of the Peacock" Manuscript (New York, Pierpont Morgan Library MS G24) with a Complete Concordance and Catalogue of the Peacock Manuscripts*. Leiden: Brill, 2013.

Leonardo da Vinci. *Treatise on Painting (Codex Urbinas Latinus 1270)*. Translated by A. Philip McMahon. Introduction by Ludwig H. Heydenreich. 2 vols. Princeton: Princeton University Press, 1956.

Lessing, Gotthold Ephraim. *Laocoön: An Essay on the Limits of Painting and Poetry*. Translated by Edward Allen McCormick. Baltimore: Johns Hopkins University Press, 1984.

———. *Laokoon: Oder über die Grenzen der Malerie und Poesie*. Berlin: C. F. Voss, 1766.

Lewis, Charlton T., and Charles Short. *A Latin Dictionary Founded on Andrews' Edition of Freund's Latin Dictionary*. Oxford: Clarendon Press, 1879.

Lightbown, Ronald W. *Mediaeval European Jewellery, with a Catalogue of the Collection in the Victoria and Albert Museum*. London: Victoria and Albert Museum, 1992.

Lissarrague, François. "L'homme, le singe et le satyre." In *L'Animal dans l'antiquité*. Edited by Barbara Cassin and Jean-Louis Labarrière, 455–72. Paris: Vrin, 1997.

Lockwood, W. B. *The Oxford Book of British Bird Names*. Oxford: Oxford University Press, 1984.

Loomis, Roger Sherman. *A Mirror of Chaucer's World*. Princeton: Princeton University Press, 1965.

Lucas, Peter J. "Chaucer's Franklin's *Dorigen*: Her Name." *Notes and Queries*, n.s., 37 (1990): 398–400.

Luria, Maxwell S., and Richard L. Hoffman, eds. *Middle English Lyrics: Authoritative Texts, Critical and Historical Backgrounds. Perspectives on Six Poems*. New York: Norton, 1974.

Lynch, Kathryn L. "Dating Chaucer." *Chaucer Review* 42 (2007): 1–22.

———, ed. *Geoffrey Chaucer: Dream Visions and Other Poems*. New York: Norton, 2007.

Mâle, Émile. *The Gothic Image: Religious Art in France of the Thirteenth Century*.

Translated by Dora Nussey. New York: Harper, 1958.

Malo, Robyn. *Relics and Writing in Late Medieval England*. Toronto: University of Toronto Press, 2013.

Manly, John M., and Edith Rickert. "Recorded Manuscripts." In *The Text of the "Canterbury Tales": Studied on the Basis of All Known Manuscripts*, 8 vols., edited by John M. Manly and Edith Rickert, 1:606–45. Chicago: University of Chicago Press, 1940.

Mansfield, Elizabeth C. *Too Beautiful to Picture: Zeuxis, Myth, and Mimesis*. Minneapolis: University of Minnesota Press, 2007.

Marks, Richard. "Sir Geoffrey Luttrell and Some Companions: Images of Chivalry c. 1320–50." *Wiener Jahrbuch für Kunstgeschichte* 46–47 (1993–94): 343–55.

Marr, David. *Vision: A Computational Investigation into the Human Representation and Processing of Visual Information*. San Francisco: W. H. Freeman, 1982.

Marvin, Julia. "Albine and Isabelle: Regicidal Queens and the Historical Imagination of the Anglo-Norman Prose *Brut* Chronicles." *Arthurian Literature* 18 (2001): 143–91.

McDermott, William C. *The Ape in Antiquity*. Baltimore: Johns Hopkins University Press, 1938.

McFarlane, K. B. *Lancastrian Kings and Lollard Knights*. Oxford: Clarendon Press, 1972.

McIntosh, Angus, M. L. Samuels, and Michael Benskin. *A Linguistic Atlas of Late Mediaeval English*. 4 vols. Aberdeen: Aberdeen University Press, 1986.

McKinley, Kathryn. "Ekphrasis as Aesthetic Pilgrimage in Chaucer's *House of Fame* Book I." In *Meaning in Motion: The Semantics of Movement in Medieval Art*, edited by Nino Zchomelidse and Giovanni Freni, 215–32. Princeton: Princeton University Press, 2011.

McNiven, Peter. "The Problem of Henry IV's Health, 1405–1413." *English Historical Review* 100 (1985): 747–72.

McQuillan, John T. "Who Was St Thomas Lancaster? New Manuscript Evidence." In *Fourteenth-Century England IV*, edited by J. S. Hamilton, 1–25. Woodbridge, UK: Boydell Press, 2006.

McSheffrey, Shannon. *Marriage, Sex, and Civic Culture in Late Medieval London.*

Philadelphia: University of Pennsylvania Press, 2004.

Mead, Jenna. "Chaucer and the Subject of Bureaucracy." *Exemplaria* 19 (2007): 39–66.

Merrilees, Brian. "Donatus and the Teaching of French in Medieval England." In *Anglo-Norman Anniversary Essays*, edited by Ian Short, 273–91. Anglo-Norman Text Society Occasional Publications Series 2. London: Birkbeck College, 1993.

Michael, M. A., with Sebastian Strobl. *Stained Glass of Canterbury Cathedral*. London: Scala, 2004.

Middle English Dictionary. Edited by Hans Kurath, Sherman Kuhn, and Robert E. Lewis. Ann Arbor: University of Michigan Press, 1952–95. http://quod.lib.umich.edu/m/med/.

Minnis, A. J. *Medieval Theory of Authorship: Scholastic Literary Attitudes in the Later Middle Ages*. 2nd ed. Philadelphia: University of Pennsylvania Press, 1988.

———. *Oxford Guides to Chaucer: The Shorter Poems*. Oxford: Oxford University Press, 1995.

Mitchell, W. J. T. *Iconology: Image, Text, Ideology*. Chicago: University of Chicago Press, 1986.

———. *Picture Theory: Essays on Verbal and Visual Representation*. Chicago: University of Chicago Press, 1994.

———. "Spatial Form in Literature: Toward a General Theory." *Critical Inquiry* 6 (1980): 539–67.

Mooney, Linne R. "Chaucer's Scribe." *Speculum* 81 (2006): 97–138.

Morgan, Nigel. "The Decorative Ornament of the Text and Page in Thirteenth-Century England: Initials, Border Extensions, and Line Fillers." *English Manuscript Studies* 10 (2002): 1–33.

Mullins, Edwin. *The Art of Elisabeth Frink*. Park Ridge, NJ: Noyes Press, 1973.

Muscatine, Charles. *Chaucer and the French Tradition: A Study in Style and Meaning*. Berkeley: University of California Press, 1957.

Myers, A. R. "The Wealth of Richard Lyons." In *Essays in Medieval History Presented to Bertie Wilkinson*, edited by T. A. Sandquist and M. R. Powicke, 301–29. Toronto: University of Toronto Press, 1969.

Neuchterlein, Jeanne. "The Domesticity of Sacred Space in Fifteenth-Century Netherlands." In *Defining the Holy: Sacred Space in Medieval and Early Modern Europe*, edited by Andrew Spicer and Sarah Hamilton, 49–79. Aldershot, UK: Ashgate, 2005.

Newhauser, Richard. "The Parson's Tale." In *Sources and Analogues of the "Canterbury Tales."* 2 vols. Edited by Robert M. Correale and Mary Hamel, 1:529–613. Cambridge: D. S. Brewer, 2002–5.

———. "The Parson's Tale and Its Generic Affiliations." In *Closure in the "Canterbury Tales": The Role of the Parson's Tale*, edited by David Raybin and Linda Tarte Holley, 45–76. Kalamazoo: Medieval Institute Publications, 2000.

Nichols, Ann Eljenholm. *Seeable Signs: The Iconography of the Seven Sacraments, 1350–1544*. Woodbridge, UK: Boydell and Brewer, 1994.

Nichols, Robert E., Jr. "The Pardoner's Ale and Cake." *PMLA* 82 (1967): 498–504.

Nichols, Stephen. "Ekphrasis, Iconoclasm, and Desire." In *Rethinking the Romance of the Rose: Text, Image, Reception*, edited by Kevin Brownlee and Sylvia Huot, 133–60. Philadelphia: University of Pennsylvania Press, 1992.

Nishimura, Margot McIlwain. *Images in the Margins*. Los Angeles: J. Paul Getty Museum, 2009.

Nolan, Barbara. "Chaucer's Poetics of Dwelling." In *Chaucer and the City*, edited by Ardis Butterfield, 57–75. Cambridge: D. S. Brewer, 2006.

Norris, Herbert. *Medieval Costume and Fashion*. 1924. Reprint, Mineola, NY: Dover, 1999.

Norton-Smith, John. "Bodleian MS Fairfax 16 and Sir John Stanley's Ownership of MS B.N. français 2." *Notes and Queries*, n.s., 30 (1983): 202–3.

———. "Introduction." In *Bodleian Library MS Fairfax 16*, vii–xx. London: Scolar Press, 1979.

Opération Charles VI. http://www.vjf.cnrs.fr /charlesVI/.

Opie, Iona, and Peter Opie, eds. *The Oxford Dictionary of Nursery Rhymes*. Oxford: Oxford University Press, 1951.

Ord, Craven. "Inventory of Crown Jewels, 3 Edward III, from a Record in the Exchequer." *Archaeologia* 10 (1792): 241–60.

Orme, Nicholas. "Education." In *Gentry Culture in Late Medieval England*, edited by Raluca Radulescu and Alison Truelove, 63–83. Manchester: Manchester University Press, 2005.

———. *English School Exercises, 1420–1530*. Toronto: Pontifical Institute of Mediaeval Studies, 2013.

———. *Medieval Schools: From Roman Britain to Renaissance England*. New Haven: Yale University Press, 2006.

Owen, Charles A. "The Crucial Passages in Five of the *Canterbury Tales*: A Study in Irony and Symbol." *Journal of English and Germanic Philology* 52 (1953): 294–311.

Oxford English Dictionary. 2nd ed. 20 vols. Edited by John Simpson and Edmund Weiner. Oxford: Oxford University Press, 1989.

Pächt, Otto. *Book Illumination in the Middle Ages*. London: Harvey Miller, 1984.

Palgrave, Francis. *The Antient Kalendars and Inventories of the Treasury of His Majesty's Exchequer*. 3 vols. London: G. Eyre and A. Spottiswoode, 1836.

Pannier, Léopold. *La Noble-Maison de Saint-Ouen: La villa Clippiacum et l'Ordre de l'Etoile d'après les documents originaux*. Paris: A. Franck, 1872.

Panofsky, Erwin. *Early Netherlandish Painting: Its Origins and Character*. 2 vols. New York: Harper and Row, 1971.

———. *Gothic Architecture and Scholasticism*. Latrobe, PA: Archabbey Press, 1951.

Parker Library on the Web. https://parker .stanford.edu/parker/.

Parkes, Malcolm B. "The Influence of the Concepts of *Ordinatio* and *Compilatio* on the Development of the Book." In *Medieval Learning and Literature: Essays Presented to Richard William Hunt*, edited by J. J. G. Alexander and M. T. Gibson, 115–43. Oxford: Clarendon Press, 1976.

Partridge, Stephen. "'The Makere of this Boke': Chaucer's *Retraction* and the Author as Scribe and Compiler." In *Author, Reader, Book: Medieval Authorship in Theory and Practice*, edited by Stephen Partridge and Erik Kwakkel, 106–53. Toronto: University of Toronto Press, 2012.

Patterson, Lee. *Chaucer and the Subject of History.* Madison: University of Wisconsin Press, 1991.

———. "The Parson's Tale and the Quitting of the *Canterbury Tales.*" *Traditio* 34 (1978): 331–80.

Paviot, Jacques. "Ordres, devises, sociétés chevaleresques et la cour, vers 1400." In *La Cour du Prince: Cour de France, cours d'Europe, XIIe–XVe siècle.* Edited by Murielle Gaude-Ferragu, Bruno Laurioux, and Jacques Paviot, 271–99. Paris: Champion, 2011.

Pearl, Cleanness, Patience and Sir Gawain: Reproduced in Facsimile from the Unique Ms. Cotton Nero A.x in the British Museum. Edited by Sir Israel Gollancz. EETS o.s. 162. London: Milford, 1923.

Pearsall, Derek. "The *Canterbury Tales* II: Comedy." In *The Cambridge Chaucer Companion,* edited by Piero Boitani and Jill Mann, 125–42. Cambridge: Cambridge University Press, 1986.

———. "Introduction." In *Studies in the Vernon Manuscript,* edited by Derek Pearsall, ix–xi. Cambridge: D. S. Brewer, 1990.

———. *The Life of Geoffrey Chaucer.* Oxford: Blackwell, 1992.

———, ed. *Piers Plowman: A New Annotated Edition of the C-Text.* 2nd ed. Exeter: University of Exeter Press, 2008.

———. "Towards a Poetics of Chaucerian Narrative." In *Drama, Narrative, and Poetry in the "Canterbury Tales,"* edited by Wendy Harding, 99–112. Toulouse: Presses Universitaires du Mirail, 2003.

———. "The *Troilus* Frontispiece and Chaucer's Audience." *Yearbook of English Studies* 7 (1977): 68–74.

Pepin, Ronald E., trans. *An English Translation of "Auctores Octo," a Medieval Reader.* Lewiston, NY: Edwin Mellen Press, 1999.

Perkinson, Stephen. *The Likeness of the King: A Prehistory of Portraiture in Late Medieval France.* Chicago: University of Chicago Press, 2009.

Persius. *The Satires.* Translated by A. S. Kline. http://www.poetryintranslation.com/.

Peter Lombard. *Petri Lombardi Parisiensis quondam Episcopi Sententiarum Magistri in Totum Psalterium Commentarii.* In *Patrologiae cursus completes . . . series latina,* edited by J.-P. Migne, vol. 191. Paris: Apud Garnier, 1844–55.

Petrarch, Francesco. *Historia Griseldis (Epistolae Seniles XVII.3).* Edited and translated by Thomas J. Farrell. In *Sources and Analogues of the "Canterbury Tales,"* 2 vols., edited by Robert Correale and Mary Hamel, 1:108–29. Cambridge: D. S. Brewer, 2002–5.

Phillips, Noelle. "Seeing Red: Reading in Oxford, Corpus Christi College MS 201's *Piers Plowman.*" *Chaucer Review* 47 (2013): 439–64.

Phillips, Susan E. "Chaucer's Language Lessons." *Chaucer Review* 46 (2011): 39–59.

Plutarch. *Moralia.* Translated by Frank Cole Babbitt. Cambridge, MA: Harvard University Press, 1936.

The Poems of the Pearl Manuscript. 5th ed. Edited by Malcolm Andrew and Ronald Waldron. Exeter: University of Exeter Press, 2007.

Poirion, Daniel. *Le Poète et le prince: L'évolution du lyrisme courtois de Guillaume de Machaut à Charles d'Orléans.* Paris: Presses Universitaires de France, 1965.

Poplin, François. "Eustache Deschamps et le vignoble." *Histoire et sociétés rurales* 5 (1996): 24–34.

Powrie, Sarah. "Alan of Lille's *Anticlaudianus* as Intertext in Chaucer's *House of Fame.*" *Chaucer Review* 44 (2006): 246–67.

Praz, Mario. *Mnemosyne: The Parallel between Literature and the Visual Arts.* Princeton: Princeton University Press, 1970.

Pseudo-Cicero. *Rhetorica ad Herennium.* Edited and translated by Harry Caplan. Cambridge, MA: Harvard University Press, 1954.

Putter, Ad. "The French of English Letters: Two Trilingual Verse Epistles in Context." In *Language and Culture in Medieval Britain: The French of England c. 1100–c. 1500,* edited by Jocelyn Wogan-Browne, 397–419. York: York Medieval Press, 2009.

Quiney, Anthony. *Town Houses of Medieval Britain.* New Haven: Yale University Press, 2003.

Quintilian. *Institutio Oratoria.* Edited and translated by H. E. Butler. Cambridge, MA: Harvard University Press, 1946.

Rabelais, François. *Quart livre.* Edited by Mireille Huchon. Paris: Gallimard, 1994.

Radke, Gary M. "Giotto and Architecture." In *The Cambridge Companion to Giotto*, edited by Anne Derbes and Mark Sandona, 76–102. Cambridge: Cambridge University Press, 2004.

Radulescu, Raluca. "Literature." In *Gentry Culture in Late Medieval England*, edited by Raluca Radulescu and Alison Truelove, 100–118. Manchester: Manchester University Press, 2005.

Randall, Lilian. *Images in the Margins of Gothic Manuscripts*. Berkeley: University of California Press, 1966.

Ratuszniak, Annette. "*Catalogue Raisonné*." In *Elisabeth Frink: Catalogue Raisonné of Sculpture, 1947–93*, edited by Annette Ratuszniak, 40–191. London: Lund Humphries, 2013.

Raybin, David. "'And pave it al of silver and of gold': The Humane Artistry of *The Canon's Yeoman's Tale*." In *Rebels and Rivals: The Contestive Spirit in "The Canterbury Tales,"* edited by Susanna Fein, David Raybin, and Peter C. Braeger, 189–212. Kalamazoo: Medieval Institute Publications, 1981.

———. "'Manye been the weyes': The Flower, Its Roots, and the Ending of the *Canterbury Tales*." In *Closure in the "Canterbury Tales": The Role of the Parson's Tale*, edited by David Raybin and Linda Tarte Holley, 11–43. Kalamazoo: Medieval Institute Publications, 2000.

Raybin, David, and Linda Tarte Holley. "Introduction." In *Closure in the "Canterbury Tales": The Role of the Parson's Tale*, edited by David Raybin and Linda Tarte Holley, xi–xxi. Kalamazoo: Medieval Institute Publications, 2000.

Raymo, Robert R. "The General Prologue." In *Sources and Analogue of the "Canterbury Tales,"* 2 vols., edited by Robert M. Correale and Mary Hamel, 2:1–85. Cambridge: D. S. Brewer, 2002–5.

Reinburg, Virginia. "'For the Use of Women': Women and Books of Hours." *Early Modern Women* 4 (2009): 235–40.

———. *French Books of Hours: Making an Archive of Prayer, c. 1400–1600*. Cambridge: Cambridge University Press, 2012.

Renouard, Yves. "L'ordre de la Jarretière et l'Ordre de l'Etoile." *Le Moyen Age* 4 (1949): 281–300.

Rentz, Ellen. "Representing Devotional Economy: Agricultural and Liturgical Labor in the Luttrell Psalter." *Studies in Iconography* 31 (2010): 69–97.

Reyerson, Kathryn L. "The Merchants of the Mediterranean: Merchants as Strangers." In *The Stranger in Medieval Society*, edited by F. R. P. Akehurst and Stephanie Cain Van D'Elden, 1–13. Minneapolis: University of Minnesota Press, 1997.

Richardson, Janette. "The Facade of Bawdry: Image Patterns in Chaucer's *Shipman's Tale*." *Chaucer Review* 32 (1965): 303–13.

Rickert, Edith. *Chaucer's World*. New York: Columbia University Press, 1948.

Rickert, Margaret. "Illumination." In *The Text of the "Canterbury Tales": Studied on the Basis of All Known Manuscripts*, 8 vols., edited by John M. Manly and Edith Rickert, 1:561–605. Chicago: University of Chicago Press, 1940.

Riddy, Felicity. "'Burgeis' Domesticity in Late Medieval England." In *Medieval Domesticity: Home, Housing, and Household in Medieval England*, edited by Maryanne Kowaleski and P. J. P. Goldberg, 14–36. Cambridge: Cambridge University Press, 2008.

———. "Looking Closely: Authority and Intimacy in the Late Medieval Urban Home." In *Gendering the Master Narrative: Women and Power in the Middle Ages*, edited by Mary C. Erler and Maryanne Kowaleski, 190–211. Ithaca: Cornell University Press, 2003.

Robertson, D. W., Jr. *A Preface to Chaucer: Studies in Medieval Perspectives*. Princeton: Princeton University Press, 1962.

Robertson, Kellie. "Exemplary Rocks." In *Animal, Vegetable, Mineral: Ethics and Objects*, edited by Jeffrey Jerome Cohen, 93–123. Washington, DC: Oliphaunt Books, 2012.

Robinson, Pamela. "Introduction." In *Manuscript Bodley 638: A Facsimile*, xvii–xliv. Norman, OK: Pilgrim Books, 1982.

Roccati, G. Matteo. "Sur quelques textes d'Eustache Deschamps témoignant de la fonction comique du poète de cour." In *Le Rire au Moyen Âge dans la littérature et dans les arts*, edited by Thérèse Bouché and Hélène Charpentier, 283–97. Bordeaux: Presses Universitaires de Bordeaux, 1990.

Rosemann, Philipp W. *The Story of a Great Medieval Book: Peter Lombard's Sentences.* Peterborough, ON: Broadview, 2007.

Rosewell, Roger. *Medieval Wall Paintings.* Woodbridge, UK: Boydell and Brewer, 2008.

Ross, Ellen M. *The Grief of God: Images of the Suffering Jesus in Late Medieval England.* Oxford: Oxford University Press, 1997.

Rouse, Richard H., and Mary A. Rouse. "*Statim invenire*: Schools, Preachers, and the New Attitudes to the Page." In *Renaissance and Renewal in the Twelfth Century*, edited by Robert L. Benson and Giles Constable, with Carol D. Lanham, 201–25. Cambridge, MA: Harvard University Press, 1982.

Rowland, Beryl. "Bishop Bradwardine, the Artificial Memory, and the *House of Fame.*" In *Chaucer at Albany*, edited by Rossell Hope Robbins, 41–62. New York: Burt Franklin, 1975.

———. "'Owles and Apes' in Chaucer's *Nun's Priest's Tale*, 3092." *Mediaeval Studies* 27 (1965): 322–25.

Rubin, Miri. *Corpus Christi: The Eucharist in Late Medieval Culture.* Cambridge: Cambridge University Press, 1991.

Rudd, Gillian. *Greenery: Ecocritical Readings of Middle English Literature.* Manchester: Manchester University Press, 2007.

Rudolph, Conrad. *The "Things of Greater Importance": Bernard of Clairvaux's Apologia and the Medieval Attitude towards Art.* Philadelphia: University of Pennsylvania Press, 1990.

Saler, Michael T. *The Avant-Garde in Interwar England: Medieval Modernism and the London Underground.* Oxford: Oxford University Press, 1999.

Salter, Elizabeth. "Medieval Poetry and the Visual Arts." In *Essays and Studies, 1969*, edited by Francis Berry, 16–32. London: John Murray, 1969.

———. "The '*Troilus* Frontispiece.'" In *Troilus and Criseyde: A Facsimile of Corpus Christi College Cambridge MS 61*, 15–23. Cambridge: D. S. Brewer, 1978.

Sandler, Lucy Freeman. *Gothic Manuscripts, 1285–1385.* 2 vols. London: Harvey Miller, 1986.

———. *Illuminators and Patrons in Fourteenth-Century England: The Psalter and Hours of Humphrey de Bohun and the Manuscripts of the Bohun Family.* London: British Library, 2014.

———. "Political Imagery in the Bohun Manuscripts." In *Decoration and Illustration in Medieval English Manuscripts*, edited by A. S. G. Edwards, 114–53. London: British Library, 2002.

———. *Studies in Manuscript Illumination, 1200–1400.* London: Pindar, 2008.

———. "The Word in the Text and the Image in the Margin: The Case of the Luttrell Psalter." *Journal of the Walters Art Gallery* 54 (1996): 87–99.

Scase, Wendy. "Description of Fol. 231v: Decoration/Reading Apparatus." In *A Facsimile Edition of the Vernon Manuscript: Oxford, Bodleian Library MS. Eng. poet. a. 1*, edited by Wendy Scase, with software by Nick Kennedy. Bodleian Digital Texts 3. Oxford: Bodleian Library, University of Oxford, 2011. DVD-ROM.

———, ed. *The Making of the Vernon Manuscript: The Production and Contexts of Oxford, Bodleian Library, MS Eng. poet. a. 1.* Turnhout: Brepols, 2013.

———. "Origins, Contents, and Purpose of the Manuscript." In *A Facsimile Edition of the Vernon Manuscript: Oxford, Bodleian Library MS. Eng. poet. a. 1*, edited by Wendy Scase, with software by Nick Kennedy. Bodleian Digital Texts 3. Oxford: Bodleian Library, University of Oxford, 2011. DVD-ROM.

Scase, Wendy, ed., with software by Nick Kennedy. *A Facsimile Edition of the Vernon Manuscript: Oxford, Bodleian Library MS. Eng. poet. a. 1.* Bodleian Digital Texts 3. Oxford: Bodleian Library, University of Oxford, 2011. DVD-ROM.

Scattergood, John. "The Originality of the *Shipman's Tale.*" *Chaucer Review* 11 (1977): 210–31.

———. "The *Shipman's Tale.*" In *Sources and Analogues of the "Canterbury Tales,"* 2 vols., edited by Robert M. Correale and Mary Hamel, 2:565–81. Cambridge: D. S. Brewer, 2002–5.

Schofield, John. *Medieval London Houses.* New Haven: Yale University Press, 1994.

———. "Social Perceptions of Space in Medieval and Tudor London Houses."

In *Meaningful Architecture: Social Interpretations of Buildings*, edited by Martin Locock, 188–206. Brookfield, VT: Avebury, 1994.

Schulz, Herbert C. *The Ellesmere Manuscript of Chaucer's "Canterbury Tales."* Revised by Joseph A. Dane and Seth Lerer. San Marino, CA: Huntington Library, 1999.

Scott, Kathleen L. *Dated and Datable English Manuscript Borders, c. 1395–1499.* London: Bibliographical Society, 2002.

———. "Design, Decoration, and Illustration." In *Book Production and Publishing in Britain 1375–1475*, edited by Jeremy Griffiths and Derek Pearsall, 31–64. Cambridge: Cambridge University Press, 1989.

———. "An Hours and a Psalter by Two Ellesmere Illuminators." In *The Ellesmere Chaucer: Essays in Interpretation*, edited by Martin Stevens and Daniel Woodward, 87–119. San Marino, CA: Huntington Library, 1995.

———. "The Illustrations of *Piers Plowman* in Bodleian Library Ms. Douce 104." *Yearbook of Langland Studies* 4 (1990): 1–86.

———. *Later Gothic Manuscripts, 1390–1490.* 2 vols. London: Harvey Miller, 1996.

———. "Limner Power: A Book Artist in England, c. 1420." In *Prestige, Authority, and Power in Late Medieval Manuscripts and Texts*, edited by Felicity Riddy, 55–75. York: York Medieval Press, 2000.

———. *Tradition and Innovation in Later Medieval English Manuscripts.* London: British Library, 2007.

Scott, Margaret. *A Visual History of Costume: The Fourteenth and Fifteenth Centuries.* London: Batsford, 1986.

Seymour, M. C. *A Catalogue of Chaucer Manuscripts.* Vol. 1, *Works before the "Canterbury Tales."* Aldershot, UK: Scolar Press, 1995.

Shakespeare, William. *The Riverside Shakespeare.* Edited by G. Blakemore Evans, with J. J. M. Tobin. 2nd ed. Boston: Houghton Mifflin, 1997.

Simpson, Pamela H. "Review of *Elisabeth Frink, Sculpture and Drawings, 1950–1990: Essays by Bryan Robertson*." *Woman's Art Journal* (Spring–Summer 1991): 59.

Smalley, Beryl. *English Friars and Antiquity in the Early Fourteenth Century.* Oxford: Blackwell, 1960.

———. *The Study of the Bible in the Middle Ages.* 2nd ed. Oxford: Blackwell, 1952.

Smith, D. Vance. *Arts of Possession: The Middle English Household Imaginary.* Minneapolis: University of Minnesota Press, 2003.

Smith, Kathryn. "Margins." *Studies in Iconography* 33 (2012): 29–44.

———. *The Taymouth Hours: Stories and the Construction of the Self in Late Medieval England.* London: British Library, 2012.

Smyser, H. M. "The Domestic Background of *Troilus and Criseyde*." *Speculum* 31 (1956): 297–315.

Spalding, Julian. "Frink: Catching the Nature of Life." In *Elisabeth Frink: Catalogue Raisonné of Sculpture, 1947–93*, edited by Annette Ratuszniak, 9–24. London: Lund Humphries, 2013.

Spearing, A. C. "The *Canterbury Tales* IV: Exemplum and Fable." In *The Cambridge Chaucer Companion*, edited by Piero Boitani and Jill Mann, 159–77. Cambridge: Cambridge University Press, 1986.

———. "Symbolic and Dramatic Development in *Pearl*." *Modern Philology* 60 (1962): 1–12.

Staley, Lynn. *Languages of Power in the Age of Richard II.* University Park: Penn State University Press, 2005.

Stanbury, Sarah. "Derrida's Cat and Nicholas's Study." *New Medieval Literatures* 12 (2010): 155–67.

———. "Multilingual Lists and Chaucer's 'The Former Age.'" In *The Art of Vision: Ekphrasis in Medieval Literature and Culture*, edited by Andrew James Johnston, Ethan Knapp, and Margitta Rouse, 36–54. Columbus: Ohio State University Press, 2015.

———. "Visualizing." In *A Companion to Chaucer*, edited by Peter Brown, 459–79. Oxford: Blackwell, 2000.

Steiner, Wendy. *The Colors of Rhetoric: Problems in the Relation between Modern Literature and Painting.* Chicago: University of Chicago Press, 1982.

Stevens, John. *Music and Poetry in the Early Tudor Court.* Lincoln: University of Nebraska Press, 1961.

Stillwell, Gardiner. "Chaucer's 'Sad' Merchant." *Review of English Studies* 20 (1944): 1–18.

Stokstad, Marilyn. "A Note on a Romanesque Lion Mask." *Yale University Art Gallery Bulletin* 37 (1979): 20–23.

Strohm, Paul. "Chaucer's Lollard Joke: History and the Textual Unconscious." *Studies in the Age of Chaucer* 17 (1995): 23–42.

———. *Chaucer's Tale: 1386 and the Road to Canterbury.* New York: Viking, 2014.

Stuard, Susan Mosher. *Gilding the Market: Luxury and Fashion in Fourteenth-Century Italy.* Philadelphia: University of Pennsylvania Press, 2006.

Swan, Charles, and Wynnard Hooper, eds. and trans. *Gesta romanorum; or, Entertaining Moral Stories.* 1876. Reprint, New York: Dover, 1959.

Symons, Dana M., ed. *Chaucerian Dream Visions and Complaints.* Kalamazoo: Medieval Institute Publications, 2004.

Tatlock, John S. P. *The Scene of the Franklin's Tale Visited.* London: Kegan Paul, Trench, Trübner, 1914.

Tatton-Brown, Tim. "Canterbury and the Architecture of Pilgrimage Shrines in England." In *Pilgrimage: The English Experience from Becket to Bunyan*, edited by Colin Morris and Peter Roberts, 108–40. Cambridge: Cambridge University Press, 2002.

Taylor, Karla. *Chaucer Reads the "Divine Comedy."* Stanford: Stanford University Press, 1989.

———. "Social Aesthetics and the Emergence of Civic Discourse from the *Shipman's Tale* to *Melibee.*" *Chaucer Review* 39 (2005): 298–322.

Theophilus. *On Divers Arts: The Foremost Medieval Treatise on Painting, Glassmaking, and Metalwork.* Translated by John G. Hawthorne and Cyril Stanley-Smith. New York: Dover, 1979.

Thomas, A. H., ed. *Calendar of Plea and Memoranda Rolls Preserved among the Archives of the Corporation of the City of London at the Guildhall, 1364–1381.* Cambridge: Cambridge University Press, 1929.

———, ed. *Calendar of Plea and Memoranda Rolls Preserved among the Archives of the Corporation of the City of London at the Guildhall, 1381–1412.* Cambridge: Cambridge University Press, 1932.

Thomson, David. *A Descriptive Catalogue of Middle English Grammatical Texts.* New York: Garland, 1979.

Thomson, Rodney M., and D. E. Luscumbe, eds. *Catalogue of Medieval Manuscripts of Latin Commentaries on Aristotle in British Libraries.* Vol. 1, *Oxford.* Turnhout: Brepols, 2011.

Thrupp, Sylvia. *The Merchant Class of Medieval London.* Chicago: University of Chicago Press, 1948.

Todd, Mary Lewise Barry. "The Quest of the Individual: Interpreting the Narrative Structure of the Miracle Windows at Canterbury Cathedral." M.A. thesis, Florida State University, 2007.

Tolkien, J. R. R., and E. V. Gordon, eds. *Sir Gawain and the Green Knight.* 2nd ed. Revised by Norman Davis. Oxford: Clarendon Press, 1967.

Toole, William B. "Chaucer's Christian Irony: The Relationship of Character and Action in the *Pardoner's Tale.*" *Chaucer Review* 3 (1968): 37–43.

Les Très Riches Heures du Duc de Berry. http://www.christusrex.org/www2/berry.

Trupia, Piero. "The Semantics of Beauty: The Grammar of the Sign and the Phenomenological Gaze for a Knowledge of Reality beyond the Sign." In *Beauty's Appeal: Measure and Excess*, edited by Anna-Teresa Tymieniecka, 33–64. Dordrecht: Springer, 2008.

Tufte, Edward. *Envisioning Information.* Cheshire, CT: Graphics Press, 1990.

Turner, Marion. "Greater London." In *Chaucer and the City*, edited by Ardis Butterfield, 25–40. Cambridge: D. S. Brewer, 2006.

Twu, Krista Sue-Lo. "Chaucer's Vision of the Tree of Life: Crossing the Road with the Rood in the *Parson's Tale.*" *Chaucer Review* 39 (2005): 341–78.

Wagner, Peter. "Introduction: Ekphrasis, Iconotexts, and Intermediality—the State(s) of the Art(s)." In *Icons—Text—Iconotexts: Essays on Ekphrasis and Intermediality*, edited by Peter Wagner, 1–40. Berlin: Walter de Gruyter, 1996.

Wallace, David. *Premodern Places: Calais to Surinam, Chaucer to Aphra Behn.* Oxford: Blackwell, 2004.

Walsingham, Thomas. *Historia anglicana*, 2 vols. Edited by Henry Thomas Riley. London: Longman, Green, Longman, Roberts and Green, 1862–64.

Walter de Bibbesworth. *The Treatise of Walter of Bibbesworth.* Translated by Andrew Dalby. Totnes, UK: Prospect Books, 2012.

———. *Le Tretiz Together with Two Anglo-French Poems in Praise of Women*. Edited by William Rothwell. London: Anglo-Norman Text Society from Birkbeck College, 1990.

Webb, Diana. "Domestic Space and Devotion in the Middle Ages." In *Defining the Holy: Sacred Space in Medieval and Early Modern Europe*, edited by Andrew Spicer and Sarah Hamilton, 27–47. Aldershot, UK: Ashgate, 2005.

———. *Pilgrimage in Medieval England*. London: Hambledon and London, 2000.

Wedgwood, Josiah C. *History of Parliament: Biographies of the Members of the Commons House, 1439–1509*. London: His Majesty's Stationery Office, 1936.

Wenzel, Siegfried. "Notes on the *Parson's Tale*." *Chaucer Review* 16 (1982): 237–56.

White, John. *The Birth and Rebirth of Pictorial Space*. 3rd ed. Cambridge, MA: Belknap Press, 1987.

Wieck, Roger S. *The Book of Hours in Medieval Art and Life*. London: Sotheby's Publications, 1988.

———. *Painted Prayers: The Book of Hours in Medieval and Renaissance Art*. New York: George Braziller, 1997.

Wirth, Jean. *Les Marges à drôleries des manuscrits gothiques*. Geneva: Droz, 2008.

Wogan-Browne, Jocelyn, ed., with Carolyn Collette, Maryanne Kowaleski, Linne Mooney, Ad Putter, and David Trotter. *Language and Culture in Medieval Britain: The French of England c. 1100–c. 1500*. York: York Medieval Press, 2009.

Wolf, Bryan. "Confessions of a Closet Ekphrastic: Literature, Painting, and Other Unnatural Relations." *Yale Journal of Criticism* 3 (1990): 181–200.

Wood, Ian. "The Mission of Augustine of Canterbury to the English." *Speculum* 69 (1994): 1–17.

Wood, Margaret. *The English Mediaeval House*. London: Studio Editions, 1994.

Woods, William F. *Chaucerian Spaces: Spatial Poetics in Chaucer's Opening Tales*. Albany: SUNY Press, 2008.

Woolf, Rosemary. *The English Religious Lyric in the Middle Ages*. Oxford: Clarendon Press, 1968.

Wright, C. E. "Late Middle English Parerga in a School Collection." *Review of English Studies*, n.s., 6 (1951): 114–20.

Wright, Thomas, ed. *A Volume of Vocabularies: Illustrating the condition and manners of our forefathers, as well as the history of the forms of elementary education and of the languages spoken in this island, from the tenth century to the fifteenth; Edited from MSS in public and private collections*. London: privately printed, 1857–73.

Yates, Frances A. *The Art of Memory*. Chicago: University of Chicago Press, 1966.

Young, Bonnie. "The Monkeys and the Peddler." *Metropolitan Museum of Art Bulletin*, n.s., 26 (1968): 441–54.

Youngs, Deborah. "Cultural Networks." In *Gentry Culture in Late Medieval England*, edited by Raluca Radulescu and Alison Truelove, 119–33. Manchester: Manchester University Press, 2005.

EDITORS

SUSANNA FEIN and DAVID RAYBIN are editors of the *Chaucer Review*. They have also coedited two previous collections of Chaucer criticism: *Chaucer: Contemporary Approaches* (Penn State, 2010) and *Rebels and Rivals: The Contestive Spirit in "The Canterbury Tales"* (Medieval Institute Publications [MIP], 1991). In addition, they have directed five NEH Summer Seminars on *The Canterbury Tales*.

CONTRIBUTORS

JESSICA BRANTLEY is Professor of English at Yale University. She is the author of *Reading in the Wilderness: Private Reading and Public Performances in Late Medieval England* (Chicago, 2007), as well as numerous articles on the relations of text and image in late medieval reading, including the chapter "Vision, Image, Text," in *Twenty-First-Century Approaches to Literature: Middle English*, edited by Paul Strohm (Oxford, 2007). Her current project is a literary history of the late medieval book of hours.

JOYCE COLEMAN is the Rudolph C. Bambas Professor of Medieval English Literature and Culture in the English Department at the University of Oklahoma. Her research on late medieval literary reception, performance, and patronage has led to a book, *Public Reading and the Reading Public in Late Medieval England and France* (Cambridge, 1996), and many articles. Her current focus is on the "iconography of the book," the cultural conceptions of literature encoded in manuscript images of authorship and audienceship. She recently coedited with Mark Cruse and Kathryn A. Smith an interdisciplinary anthology, *The Social Life of Illumination: Manuscripts, Images, and Communities in the Late Middle Ages* (Brepols, 2013).

CAROLYN P. COLLETTE is Professor Emeritus of English Language and Literature at Mount Holyoke College. A widely published scholar, her recent work includes *Rethinking Chaucer's "Legend of*

Good Women" (Boydell and Brewer, 2014); *In the Thick of the Fight: The Writing of Emily Wilding Davison, Militant Suffragette* (Michigan, 2013); *The Later Middle Ages: A Sourcebook*, coedited with Harold Garrett-Goodyear (Palgrave Macmillan, 2010); and the articles "Waging Spiritual War: Philippe de Mézières, *The Order of the Passion* and the Power of Performance," in *War and Peace: Critical Issues in European Societies and Literature, 800–1800*, edited by Albrecht Classen and Nadia Margolis (De Gruyter, 2011), and "Topical and Tropological Gower: Invoking Armenia in the *Confessio Amantis*," in *John Gower, Trilingual Poet: Language, Translation, and Tradition*, edited by Elisabeth Dutton, John Hines, and Robert F. Yeager (D. S. Brewer, 2010).

ALEXANDRA COOK is Associate Professor of English at the University of Alabama. She studies the relationship of late medieval poetry to its classical and late antique literary forebears. She is particularly interested in tracing intellectual movements across periods and in thinking about how medieval texts negotiate the past. Inspired by her relocation to the Deep South, she is concomitantly pursuing an interest in southern medievalism. Recent articles have appeared in *Neophilologus*, *English Studies*, and the *South Central Review*.

SUSANNA FEIN is Professor of English at Kent State University. She has published extensively on Middle English poetry, with emphases on manuscript studies, lyrics, alliterative verse, and Chaucer. Her

books include the Consortium for the Teaching of the Middle Ages (TEAMS) editions *Moral Love Songs and Laments* (MIP, 1998) and *John the Blind Audelay: Poems and Carols* (MIP, 2009), and the three-volume edition and translation *The Complete Harley 2253 Manuscript*, with the collaboration of David Raybin and Jan Ziolkowski (MIP, 2014–15). She has also edited four collections that focus on individual literary manuscripts and their scribes, most recently *Robert Thornton and His Books: Essays on the Lincoln and London Manuscripts*, coedited with Michael Johnston (Boydell and Brewer, 2014), and *The Auchinleck Manuscript: New Perspectives* (Boydell and Brewer, 2016).

MAIDIE HILMO taught English and Art History at Northern Lights College and Chaucer courses at the University of Victoria. Her interests include the function of images in illustrated Old and Middle English manuscripts. She coauthored *Opening Up Middle English Manuscripts: Literary and Visual Approaches* with Kathryn Kerby-Fulton and Linda Olson (Cornell, 2012). She is the author of *Medieval Images, Icons, and Illustrated English Literary Texts: From the Ruthwell Cross to the Ellesmere Chaucer* (Ashgate, 2004) and coeditor of two collections of essays. She is currently working on a study of the illustrations in the Gawain manuscript for the online Cotton Nero A.x Project.

LAURA KENDRICK is Professor Emeritus at the Institute for Cultural and International Studies of the Department of

Humanities at the Université de Versailles/ Paris-Saclay and member there of the center DYPAC (DYnamiques PAtrimoniales et Culturelles). She has written books and articles on medieval comedy, play and game, and satire in verbal and visual forms, including *Animating the Letter: The Figurative Embodiment of Writing from Late Antiquity to the Renaissance* (Ohio State, 1999) and *Chaucerian Play: Comedy and Control in the "Canterbury Tales"* (California, 1988).

ASHBY KINCH is Professor of English at the University of Montana, where he teaches medieval literature. He has published articles on Old and Middle English lyric poetry, as well as several articles and a coedited anthology on Alain Chartier's literary influence, *Chartier in Europe*, with Emma Cayley (D. S. Brewer, 2008). His work on visual culture includes articles on the ekphrastic writing of the contemporary American poet Cole Swensen. His recent book *Imago Mortis: Mediating Images of Death in Late Medieval Culture* (Brill, 2013) examines the art and literature of death and dying in the early fifteenth century.

DAVID RAYBIN is Distinguished Professor Emeritus of English at Eastern Illinois. He was named CASE-Carnegie Illinois Professor of the Year in 2011. He has authored numerous articles on Chaucer and medieval French poetry and is coeditor of *Closure in "The Canterbury Tales": The Role of the Parson's Tale*, with Linda Tarte Holley (MIP, 2000). Most recently,

he translated the Anglo-French poetry and prose for the three-volume *Complete Harley 2253 Manuscript*, edited by Susanna Fein (MIP, 2014–15).

MARTHA RUST is Associate Professor of English at New York University. Her book *Imaginary Worlds in Medieval Books: Exploring the Manuscript Matrix* (Palgrave Macmillan, 2007) demonstrates the interpretive power of conceptualizing the medieval manuscript as a virtual realm called forth by a reader's engagement with a book's play of picture and text. In her current book project, *Item: Lists and the Poetics of Reckoning in Late Medieval England*, she seeks to develop a theory of the written list as a device that functions within three signifying domains: those of words, of pictures, and of things.

SARAH STANBURY is Distinguished Professor in the Arts and Humanities at the College of the Holy Cross. A recipient of fellowships from the NEH and the Guggenheim Foundation, she has published widely on the visual culture of late medieval England, including *The Visual Object of Desire in Late Medieval England* (Pennsylvania, 2008); *Women's Space: Place, Patronage, and Gender in the Medieval Church*, coedited with Virginia Raguin (SUNY, 2005); the TEAMS edition of *Pearl* (MIP, 2001); *Writing on the Body: Female Embodiment and Feminist Theory*, coedited with Katie Conboy and Nadia Medina (Columbia, 1997); *Feminist Approaches to the Body in Medieval Literature*, coedited with Linda Lomperis (Pennsylvania, 1993); and *Seeing*

the Gawain-Poet: Description and the Act of Perception (Pennsylvania, 1991). She is currently writing a book on domestic architecture in Chaucer's writings.

KATHRYN VULIĆ is Associate Professor of English at Western Washington University. Her teaching and research interests include devotional literature, manuscript studies, Chaucer and other Middle English poets, and vernacular writing. She has published on the audiences and circumstances of composition of late medieval writings, and the influence of prayer and meditative habits on the forms and content of Middle English texts. Her most recent project is a collection titled *Readers, Reading, and Reception in Medieval English Devotional Literature and Practice (Disputatio)*, coedited with C. Annette Grisé and Susan Uselmann (Brepols, 2016).

INDEX OF MANUSCRIPTS

White, John, 50
Wieck, Roger S., 214 n. 3
wild man, 78
William de la Pole, 205
William of Canterbury, 170–71, 173 n. 26, 174
 n. 38
William of Gloucester, 165
William of Saint Thierry, 142
William of Sens, 161
William the Englishman, 161
windows, xx–xxi, 154–74, *157, 163–68, 171*
Windsor, 179
wine. *See* drunkenness

Wirth, Jean, 137 n. 52
"Wofully araide," 105–6, *107*
woman with distaff image, 15
Woods, William F., 57 n. 4
Woolwich, 156
Wynkyn de Worde, xvi, *110,* 111, 229

Yates, Frances, 36, 37 n. 4
Youngs, Deborah, 216 n. 26
York, 159
Yorkshire, 44

Zeuxis, 235